New

# New Reality

Vanessa Pearse

V
PRESS

Published by Vulpine Press in the United Kingdom in 2024

ISBN: 978-1-83919-659-1

www.vulpine-press.com

To Pauline, for all the wonderful years of friendship so far – with the promise of many more to come. Thank you for always believing in me. It matters.

# Insights I Wish I'd Had Sooner

I was reared by a narcissist.

I have lived most of my life with feelings of shame, loneliness and grief; grief for what I never knew especially when I was young. I never knew the childhood security of being loved for just being; I never knew carefree; I never knew I was good enough.

It is only in recent years that I came to know the full definition of a narcissist, and I came to understand how my upbringing had shaped me. I experienced repeated rejection as a child, and rejection is what I subconsciously came to expect. I learned to be on high alert for the next assault, physical, verbal, or both.

That sense of not being good enough still has a voice in my head and I'm still trying to dial myself down from high alert mode.

I've seen the movie *The Wisdom of Trauma*; I've read Gabor Maté's books. I know that I was a model to become some class of fuck-up: an alcoholic; a drug addict; prematurely dead by my own hand. Along the way I was rescued by some significant people who chose to look out for me, to believe in me, and to be there for me. Now, after years of self-exploration and trauma processing, on a good day, the worst I call myself is a recovering perfectionist! On a bad day, I am triggered and I revert to form.

My recovery is an ongoing journey that will end when my life's own journey does.

There was no singular big moment of illumination for me, more an intermittent flickering of light, like a trail of candles lit to show me better possibilities. My darkest times shed more light than my better times did; they cast it onto memories that I knew were there but that my mind had chosen to bury.

Back before I had the self-awareness that I have now, outside of the immediacy of wherever I called home, I'd worn the face, and I'd stuck to the script: the answer to 'how are you?' was, 'I'm grand', or, 'I can't complain'. Whenever I said 'I'm grand', I remembered my grandfather's retort: 'That is a matter of opinion, and not yours to have.' If I said, 'I can't complain', I thought, *I could complain, but who the fuck cares to hear?*

Slowly, I came to see my part in my struggles, and I came to appreciate that beneath other people's faces, lay their own struggles. If I deserved compassion, then they did too. They no more knew of my baggage than I knew of theirs.

At the height of some of my darkest times, people often commented to me, 'Sure, you've a great life.'

*A great life? Bullshit! You think you know me? You don't know shit about me.*

I hadn't actually ever said that out loud to anyone, but I'd come close. They were just like I had been; they believed the other person's life was better than their own. And then again, some suffered simply from the best of Irish begrudgery. They'd begrudge you a good life and begrudge you even more if your tale of woe was worse than their own. I am still working things out; especially who and what I need in my life, and who and what I need rid of.

# Chapter 1

## Meeting Stephen

It was my third day at the Criminal Courts. Plenty of time had passed as I'd waited to be called, plenty of time to read my book and sit on my post-menopause, widened bottom.

The judge released us earlier than expected that afternoon. I decided to saunter into town and then get the bus home. But I changed my mind when a Luas opened its doors just as I was walking on the section of raised path that served as the tram stop from the courts to town; I tapped my Leap card on the scanner and took up position gazing out the window at some unfamiliar, grungy parts of Dublin. The spring sun was finding gaps between buildings and when we arrived at Abbey Street, it shed a shaft of warm light onto the platform where I disembarked. I felt the joy of being in no hurry, and set off to stroll the remaining five or so kilometres home. I carelessly headed in the right general direction, turning up streets that, as far as I could remember, I'd never walked before, lost in the mood of mindless exploration of the city that I called home.

I came to a bridge over the Royal Canal and took the steps down to its banks, down to where the whiff of piss and danger lingered but the tender sunshine took the edge off it. I tiptoed gingerly over broken bottles, beer cans, cigarette litter and plastic bags; It was a laughingly far cry from the romantic scene painted by the words of Kavanagh's

poem, *Canal Bank Walk*; Kavanagh didn't mention the sight or smell of human shit or other excrement along the Grand Canal that he wrote about. Before me stretched the Royal Canal's stilly waters with its tangle of weeds glistening green between the dull shades of floating rubbish; if I fell or was pushed in, would it be the weeds or the rubbish that would envelope me? Bodies had been found there; one, floating in a suitcase, carved up and headless. The papers said the head had been taken on a bus to Tallaght; I visualised a person in a dark hoodie sitting on the number 145, the head in a box on their knee. I saw them lifting the lid to see if the eyelids flickered as the bus bumped along; I wondered, why Tallaght?

I walked under a low bridge, feeling conspicuous in my well-cut raincoat worn over a loose dress and shiny, comfortable boots. This might be where I get attacked. No one would ever know if I ended up under those slimy weeds, in the depths of that watery dump. Something caught my eye at the edge, it bobbed against the canal wall, large, bloodied and phallic; I gulped at the sight of it. Could it actually be…? With a chilling shiver running down the length of my back, I looked closer and saw it for what it was, a slightly bent white-pudding, one end cut roughly off, its label the colour of blood. I grimaced and disgust turned to relief as I walked from under the bridge onto the open track. Above me, rows of low-rise blocks of corporation flats loomed and the phrase *bandit country* sprung to mind. Up, between me and my way forward, lurked three raggedy men, one worse than the other, hanging in their crooked huddle; symbiotic in their attachment – if one was to lean too far, all three would collapse, probably into the annals of the foetid waters. They clung to the necks of bottles barely covered by brown paper bags, intermittently bringing the bottles to their mouths and slugging their contents. One man spilled most of his over the other two – *Do you drink much, a doctor asks. No doctor, sure I spill most of it.* I stopped and stared, wondering if I should turn back.

2

One man looked straight at me and I saw unexpected kindness in his eyes; it was there between the yellow and the bloodshot. He made to move himself and the others out of my path. I watched as together they floppingly faltered and floundered.

'Wha' de fuck…' one slurred.

The voice was young and something familiar in it caught my attention. His face peered up from under a baseball hat pulled down parallel to a barely visible nose. The face too was familiar. He stumbled and I instinctively stepped forward as if I might save him from the mesh of the water. There was no splash as he slipped noiselessly into a heap. His ripped tracksuit bottom exposed a long, dirty hairy leg; what was left of the trackies' bold Nike swoosh was reduced to half an X. I was stuck in forward motion, and stopped only when I was one small step away from him. His head lifted and his eyes widened with shared recognition. I shuddered.

*It is Stephen; it is the skeleton of Stephen.*

His eyes were vague and sunken into black sockets, his cheekbones stood high and sharp, and his lips were thin and barely visible beneath the stubble and the dirt. It was Stephen, who I used to call a gym bunny; Stephen who I used to tease about his rock-solid, oversized six-pack; Stephen who loved my home-cooked meals and our noisy family dinners.

'Stephen,' I said.

'Martha,' he didn't quite say. It was more a quiet, breathy whisper expressed as he turned his face away from me.

I stood still, my mouth open. Matt had told me about Stephen, but I hadn't really processed it; I hadn't had the head space then to accept how bad things were for him. It had all started at a post-match party in their third year of college. Stephen had had another great match. The team had won the final, years on the top college team lay ahead for him. Matt had had a good match too. Back then, they both

took their sport seriously. Stephen had started drinking younger than Matt but he didn't drink too much too often, Matt said. And he never did drugs then, he was certain.

I wondered what 'Didn't drink too much' meant by Matt's measure. I thought Matt had drunk too much, too often since he'd turned eighteen, and I'd very little say in the matter. I'd battled to keep him away from it until as late into his teens as possible. I'd told him to tell all his friends that his bat of a mother would ground him for half of eternity if she caught him drinking; he'd only be telling the truth, I'd insisted.

My father had been an alcoholic; I wasn't going to leave much on that front to chance. I'd done a year-long, research-based parenting course on alcohol abuse, and all the evidence said that the younger people are when they start drinking, the greater the chance that they'll have a drink problem. Some parents think that they can teach their children to drink sensibly – let them practice at home – but the research says that's a fool's game, and whatever boundaries we set for our children, we can expect them to blow them. If we tell them they can have two beers then they'll have four. For all that, I can't claim too much credit when it came to keeping Matt off the booze, his commitment to sport had been key.

Once he was eighteen, my only hope was his sport and there were many times I felt the drink until drunk culture was winning, and the war was being lost. *That* party was always going to be a big party, it had been the last big match before their real focus would be on their studies. It was to be the party to end all parties. For Stephen, that is just what it turned out to be.

They had all given it welly, lots of drink and more. When he told me about it, Matt had been keen to stress that he'd only had drink. Matt had seen Stephen as he left the party; Stephen seemed to be making good progress with Helen, a girl he had been besotted with since

forever. Matt had given Stephen the thumbs up and Stephen had responded in kind as Matt went out the door with a girl on each arm; the father of one was giving him a lift home and the other girl needed his support.

The day after the party, messages started flying. Matt thought it was just some typical over-the-top reaction from the girls, especially from Melissa, Helen's so-called best friend. He did what Grandad would have advised, he said, and passed no remark. PNR, we called it on our family; Zara had given Matt a T-shirt with those three letters big and bold on it which, ironically, garnered many remarks every time he wore it! With his own massive hangover to deal with, Matt hadn't bothered to open the messages. On Monday, he walked into the university restaurant and made his way over to his mates, sitting where they always sat for their Monday morning meetups, in a circle around two tables by the window.

He said a general 'Hi.' Some said it back, others remained strangely silent.

James greeted Matt and looked up at him with a wry smile and Matt pulled up a chair beside him and asked, 'What's up, Bro?'

'Stephen's up. That's what.' James had whispered before standing up from the group, giving Matt the vibe that he should follow.

*Stephen's up*: James's words…

The Stephen I was looking at, there by the banks of the canal, wasn't up. We had all loved him, but we had let him down.

I took another step towards him; his face was still turned away. I reached out my hand.

'Stephen?'

He turned and looked at my proffered hand. The Stephen I knew would never be so rude as to reject it. He took it and I pulled him up and into my arms. I felt his hard collarbone against the side of my head. I felt the sobs rising from his chest and sensed his tears. I shed

tears for him and for the guilt of my own inadequacy. He didn't pull away from me – his old good manners, perhaps.

That was the thing about Stephen, Matt said, he never wanted to offend anyone. He deserved the same respect, I thought, as I became aware of the smell of strong stale sweat and old dirt from him. I moved my hands up to his shoulders, shoulders that had once been wide and straight and solid. I gently separated us and looked into his face and at his hollow cheeks, where white tear trails ran down through the otherwise even dirt.

'I'm going to stop off for a coffee and snack near here,' I said. 'I'd love if you would join me?'

It wasn't a lie; I had been planning to stop in the café because I wasn't sure I'd make it home without the necessary post-menopause pee stop.

Stephen nodded, but then shook his head, rubbed the palms of his hands down his shabby jacket and looked at his torn trackies. He looked at me with another shake of his head.

'You're grand,' I said, taking his arm and leading him the few hundred yards to the café. In hindsight, I was probably overly bolshie in my gesture; I remember feeling the tension building in his body the nearer we got to the door of the café.

I chose a table outside beside some smokers. I hated smoking but I reckoned the smoke might be a welcome screen to the worst of the odours coming from Stephen.

A waitress was sent over to us – a girl in her late teens with a monochrome of heavy orange foundation and equally orange lipstick. I was sure there was a lovely young face under that mask of muck. She stood at arm's-length from us and handed two menus to me. She sniffed the air a few times, narrowed her eyes, turned up her nose, and looked from me to Stephen and back to me, wearing her judgment in her

gestures and grimaces. I reminded myself that I might have done the same at her age.

I forced a smile and asked what she would recommend for a man with a big appetite.

'The soup of the day is French onion, and the special is fish and chips and mushy peas,' she replied.

'Does that sound good to you Stephen?' I asked.

'Yes, thank you Martha.' Stephen spoke directly to me, not looking at the waitress who was at most five years younger than him and who, in his previous life, might have flirted with him a little, maybe even been charmed by him. He didn't slur his words; our encounter on the canal seemed to have sobered him up.

'One soup, and one fish and chips, please,' I said. 'And I'll have some of your squishy rhubarb cake and a flat white, as well, please.' I looked at Stephen. 'What would you like to drink?'

'Eh, em. Tea. Tea would be good, please.' His voice was slow and gravelly. I remembered back to when it was breaking and had gone from deep to high-pitched mid-sentence and I'd struggled not to laugh, which had been made impossible by a deadpan Zara echoing his deep to high-pitched tones. She was a cruel mimic. His voice was no longer the strong, deep voice of the post-puberty Stephen.

The waitress still didn't look at him, she looked at her pad; she didn't write anything in it.

'One tea too, please,' I said, looking from her face to her pad.

She scratched a few letters down but didn't move other than to sniff loudly and bring her hand up to cover her nose and mouth.

'Thank you,' I said, dismissing her as politely as I could muster.

I felt like giving her a piece of my mind, telling her about treating all people with respect, but for Stephen's sake, I resisted. You can't expect respect if you don't give it, Mum always says. Stephen and I sat in silence.

I was thinking about an interview I'd heard on the radio with a former drug addict who'd turned her life around, gone to college, and got a degree. She'd said that we need to rethink how we treat drug addicts: we treat them like the scum of the earth, and the more we treat them like that, the worse we make them feel, and then the more they rely on drugs to escape their shitty low self-esteem and miserable lives. Drug addicts, like everyone else, need connections and often the only people willing to connect with them are other drug addicts. I'd never thought about it like that until I heard her interview. Like most people, I'd been given to crossing the street rather than coming face-to-face with someone I'd labelled, rightly or wrongly, a dangerous drug addict. I'd nearly turned back when I'd seen the huddled group that afternoon along the canal and, if I had, I'd have turned my back again on Stephen.

Stephen started to shiver and I looked at him fearfully, wondering if his body was starting to scream for its next fix, and if it was, what would I do? He started rubbing his hands up and down his thighs with increasing intensity. I realised that the sun had slipped behind a cloud and I was feeling cold too. I hoped it was just cold Stephen was experiencing.

The waitress put paper serviettes and cutlery down on our table and before she rushed away, I managed to say 'Could you bring the tea now, please?'

'Yeah.' She rolled her eyes, turned, and walked away.

'It's okay. I can wait,' Stephen said in a near whisper.

'I know but…I'm sorry Stephen but the manners on that one. They're normally so friendly here and I've never seen her before.'

Stephen looked down at the table and unwrapped the cutlery from the serviette and set the knife, fork, and spoon out on the table in a place setting. He was still shivering.

'I've had worse – *much* worse. Who can blame her?' He looked at me, expecting a response.

'It's not easy, I'd say.'

'I get by.'

I put my hand on his and he looked down at them; my clean, soft hand resting on his dirty, thin one, bloody with uncleaned cuts. A lump rose into the back of my throat and my eyes welled up. I swallowed hard but I couldn't stop the tears that ran down my face. I opened my mouth to speak but I couldn't find any words that didn't sound patronising, or just plain wrong.

'We were all very fond of you Stephen…'

'Until…' He grimaced.

'Not until anything…other than until we stopped seeing you.'

'Thanks,' he said, then looked at his hands. 'I think I'd better wash these before I eat.' He rose from the table, turning his head to look around him.

'They're down that way on the right,' I said, not wanting him to have to ask the waitress.

I watched him go and noticed his shiny white trainers. *Some things don't change*, I thought.

When he came back to the table, five or more minutes later, his face and hands were scrubbed clean, his hair was wet and slicked back, and I could smell the lavender soap from the bathroom clinging to his skin.

He had no sooner sat down when one of the regular waitresses, an older lady, appeared with his tea and soup.

'There you go, son, get that into you, dear.' With a broad smile she put the tea, soup and bread down and gave him a tap of encouragement on his shoulder.

I returned her smile as a silent thank you for her kindness.

'Thank you.' Stephen looked up at her as he spoke.

'You're welcome,' she said, with a warm wink.

'Eat away,' I said.

'I'll bring your flat white and dessert with his next course, shall I?' She looked again at me.

'Please.'

I watched him shake a generous quantity of salt and pepper over his soup before he started to eat, at first slowly sipping each hot spoonful between taking small deliberate bites of the thick slices of buttered, brown soda bread. He gulped hard as if gagging, nothing went down easily. He poured himself a mug of tea and added three spoons of sugar and a generous splash of milk. The pleasure with which he sipped the first mouthful and licked his lips reminded me of a Flann O'Brien poem which, from my memory, had featured in a Guinness advertisement: *A Pint of Plain is Your Only Man*. When I looked up the words of the poem later that evening, they fitted the dark of Stephen's life and I wished that a pint of plain was the worst of what he had turned to when life turned against him.

The older waitress brought Stephen an enormous portion of fish and chips.

'Sure, it won't keep,' she said, 'ya might 'swell eat it'.

Stephen looked at me after the waitress had left us. 'Would you think me rude if I took some of this out to my mates?' he asked.

'Not at all, Stephen. Typical you, always thinking of others,' I said, trying to think how we might wrap the food up. I didn't want to ask for a tub from the young waitress with the turned-up snout and asking the kindly, older waitress might somehow be offensive, showing that Stephen couldn't finish all that she had taken care to give him.

'We can wrap it the old-fashioned way. I've good newspaper in my backpack, *The Irish Times*!' I smiled.

'Perfect. We can read it afterwards.' He laughed. The laugh was a small thing but it felt good to me and I laughed too, not because using

the newspaper to wrap up a portion of fish and chips and then read it was funny, but because his laugh sounded like the old Stephen.

'That was great,' he said after he finished the last bite of the small portion he'd kept for himself.

'I'm glad to hear it. So, where do you usually get food?'

'Merchants Quay during the day…when I make it…sometimes, I don't get my shit together…even to get to Merchant's Quay.' He sighed. 'Pathetic, isn't it?' He frowned and shook his head with self-disgust.

'I don't think so,' I responded, perhaps too fast to sound genuine, even if I did mean it.

I didn't think it sounded pathetic, I thought it sounded sad but saying it sounded sad would hardly be helpful.

'Do you ever get food from the Simon soup-run?' I added hurriedly, hoping to change the subject.

I remembered my time as a Simon soup-runner back before I had children; I would visit people sleeping rough around Dublin, most of them middle-aged regulars on the soup-run list, people who we knew where to find, in doorways and alleyways and various obscure places. We gave out soup and sandwiches at Heuston Station and Butt Bridge too, to anyone who showed up. Back then, nearly thirty years ago, it was mostly young Irish people waiting for their soup and sandwiches at Heuston Station and Butt Bridge. Booze and glue-sniffing were usually their poisons; but some did neither. Many were on the streets to escape bad homes and on the quieter nights, I got to hear some of their stories.

I imagined it was different now. There were likely more middle-aged people and more immigrants with no homes to go to, and no doubt more drug addicts too, as more people tried to find a way to escape the shit that life had thrown at them. These people were failed by politicians, failed by society, and failed by people like me, who

should have done better. We had all been too busy shovelling and stirring the bits of shit in our own small lives to notice their struggles, let alone help them.

'Yeah,' Stephen said. 'I try to get soup and sandwiches from Simon sometimes, when I don't make it to Merchant's Quay, like.'

'I've heard good things about Merchant's Quay.'

He nodded towards the young waitress standing behind the counter and smiled. 'Yeah, no judgment there or from the Simon, they feed us and chat and whatever...'

So many questions came to me: what do you do for money? Where do you sleep? What do you do during the day? I didn't ask any of them, I let the silence sit between us.

I could see he was getting more jittery; he was moving in his seat like a man in desperate need of the toilet – or a fix. I needed to let him go, but I didn't want that to be it, to just feed him once and see him no more.

'Do you have a phone, Stephen?'

'Sure,' he said, taking one with a smashed screen out of what was a surprisingly intact pocket of his torn tracksuit bottom.

'Would you like to give me your number and I'll give you mine?'

'Yeah. I'll give you my digits and if you call me now, I'll have yours.'

That done, he was up and hopping from foot to foot, anxious to get moving.

'I'd better be getting home,' I said as I stood up to pay.

'Thanks Martha. Thank you for everything. I might see you again,' he said. 'If you're passing, like...'

'I'll be passing here the rest of this week and maybe some of next. I don't know the times until the afternoon itself, but I could text you, maybe meet you by the bench at the bridge...if you like?'

'I'd like that,' he said.

# Chapter 2

## Dinner

'An Affair throws a Grenade into a Relationship' ran the headline in the Health Supplement.

It wasn't entirely by accident that was the part of the newspaper I'd given to Stephen to wrap up the fish and chips.

The journalistic art of understatement – more like a bloody bomb. The average grenade doesn't rock foundations and take out the supporting walls.

I turned the key in the shiny new front door: new house, same man, no longer legally married. My life has had many parts, and this was the after the affair part. Before the affair had not been all good, after the affair was turning out to be some bad, some good. There had been many days I had cursed that Patrick's affair ever happened, but now there were more days when I was grateful for it. Something had to change to stop me falling off the midlife, menopausal cliff, taking with me the demons that had been my lifetime companions.

I'd barely cracked open the porch door before Chuckie was at the inner door, leaping like the half-mad dog that he was, his red head bouncing momentarily into view then disappearing again, then there he was again. It always made me laugh to see him do his now-you-see-me, now-you-don't bounce, sending his floppy ears and his long tongue askew. Who needs to take a deep breath and mindfully get in

the right mood to step inside home when you have a dog to make you smile and better still, one who can be relied upon to smother you with judgment-free affection?

True to form, as soon as I opened the inner door, Chuckie leapt on me; his paws rested on my lower chest and his face pointed towards mine, inviting me to let him lick me. And I did let him lick me, right on my cheek beside my open mouth, something I'd never thought I'd ever let a dog do. Before I knew it, I was down on the hall mat wrestling with him. Without my midlife crisis I would never have let a dog lick my face. I knew that.

Patrick was at the house before me; I heard him calling me from the kitchen. Zara must have let him in. While part of me thought we would eventually end up living under the same roof again, I was in no hurry, and I hadn't seen fit to give him his own key yet. I could hear him and Zara chatting and laughing in the kitchen. He was always the one who could make them laugh; it wasn't something that came easily to me.

I left my backpack in the hall and walked into the kitchen.

'Martha,' he said, 'I was getting worried. Your last text saying you were done for the day was hours ago.'

I bristled. It was early days in this new-old marriage, and in the interlude between the old and the new, I'd grown used to coming and going as I pleased. There had been a time when I felt sad that no one might have noticed if I didn't come home at all, but I turned that into enjoying the liberty of being my own person, not immediately answerable to anyone else.

I checked myself. It was a silly annoyance. I'd been expecting Patrick, he was going to cook dinner. He'd said that he would come straight from work, from a meeting nearby, definitely before half six. I should have actually arranged a way for him to be let in. Luckily,

Zara had done the necessary. That he was cooking dinner had given me the freedom to spend time with Stephen.

Before the affair, Patrick had been mainly open ended with arrangements with me, vague at best about things like when he'd be home, when he'd want dinner, if he'd want dinner. The affair brought about a change, and now he recognised a need for more specifics, more explanations; he expected this not just from himself, but from me as well. But I had tasted freedom, the freedom of not having a partner living with me, combined with the freedom of no longer being tied to the rhythms of my children's now-finished schooldays. I fancied more spontaneity and less accountability – for myself at least.

'Hi Zara. Hi Patrick. Sorry, I decided to walk most of the way home and bumped into someone I hadn't seen in forever. It would have been wrong not to go for coffee.'

'It's alright. I was just worried. Dinner won't be ready for another twenty minutes anyway.' He dipped his finger into a bowl with a yogurt dressing in it and licked it.

Since when was Patrick ever worried about me?

'Indian mint and coriander sauce?' I asked.

'Vegan, no less – soya yogurt.' He looked towards Zara who was laying the table with mats and napkins and the whole nine yards; I could barely get her to put knives and forks on the table when it was just her and me.

'Vegan dinner all the way!' I said, not minding one way or the other. I was a flexitarian by that stage, maybe even a wannabe vegetarian, but that would have restricted me too much.

'I told you Mum, I'll fully convert Dad yet, won't I Dad?' Zara piped up.

Patrick looked over his shoulder and winked at me and rolled his eyes, making a face that said, I don't think so. He faced Zara and said, 'Sure you never know, stranger things have happened.'

'See what I mean? He's way ahead of you Mum. He makes the best vegan saag aloo and dahl ever. Wait until you taste them.'

It was on the tip of my tongue to point out that I had given him the recipes along with my notes of how to tweak them to get the best flavours. But I kept my powder dry because Zara was her father's princess and he, her king. Only in recent times had I learnt to say nothing that would pitch me against that pairing; if I did, I came out of it feeling like a wicked stepmother, not her real mother. When Patrick had the affair and I'd eventually asked him to leave the house we'd subsequently had to sell, I was the evil one – Zara had taken his side all the way. In her eyes I had wronged him, he had not wronged me; the hormonal, exhausted wreck that I had been had had it coming. But that was in the past, or at least we were working on putting it in the past. We had a bit more work to do.

'So, who was it you met for coffee?' Patrick asked.

'I'll fill you in later. Good boy Chuckie.' I gave the dog a few playful rubs on his head and got him to jump up for more. 'Sorry, I need to go to the loo.'

*And change*, I thought but didn't say, because why would I need to change having walked home from jury duty on a lovely spring day with its cool sunshine. When there's been an affair, all words are open to question; I need to change because I can smell Stephen on my clothes didn't sound like the best choice of words. I would have to remind Patrick who Stephen was, then explain, not for the first time, his whole sorry history from middle-class, successful student on a football scholarship to homeless drug addict and after all that, explain how I had come to hug and hold him to the point that I smelt like I was sleeping rough and maintaining bad hygiene myself.

In the bathroom, I stripped off and threw my clothes into the empty laundry basket. Patrick must have changed in my room after work and decided to be helpful by putting on a wash.

*For feck's sake,* I thought, *Zara's trying to save the planet and you're washing her efforts down the drain, putting half-filled loads in my machine.*

I wanted to say something about it but how would I do it in a way that wouldn't sound like criticism: all criticism and judgement were out. The counsellor had suggested that I pause before I speak. I had taken up philosophy and mindfulness on her suggestion but there would be a long road travelled before I might master biting my too-quick tongue. The trick is the pause – in the pause you find wisdom – grand in theory and in a perfect world but bloody difficult in the heat of the moment. If Patrick had been beside me when I saw the laundry basket, he would have got an unedited earful from me, not least because it was just after a typical Princess Zara dig in my direction, as usual in favour of her beloved father, King Patrick! There would have been no pleasure in the rant though because Patrick would simply have said sorry, stayed perfectly calm and worn his best poker or contrite face. I'd have been in the wrong on the double.

I stood in the shower and decided that in the grand scheme of our situation, the half-filled washing machine was a non-event – *let it go Martha, let it go.* Chuckie appeared at the bedroom door as I was drying myself and I nodded at him. He understood and jumped straight onto my bed and curled up against my pillow.

'Oh Chuckie, you'd better not be dirty.'

He gave me that knowing look, knowing I'd love him anyway, dirty or not.

As I put on my PJs, I heard Patrick call 'Dinner's ready.'

'Down in a minute,' I yelled back, resolving to be grateful for this unusual role reversal, and to show gratitude. Gratitude, that was another one of those things I was trying to practice.

When I got downstairs, I discovered that although Patrick had cooked a vegan dinner in deference to Zara, she wouldn't be joining

us; she had gone to some save the planet meeting or other, as was her wont. Matt, who also still lived with me too, was not due home as he was going straight from work to training and then on to a friend's. Zara's well-laid table was just for Patrick and me, and someone had even added and lit two large, red candles. I took a slow deep breath. I gave myself a metaphorical pat on the back. I was getting better at this pausing-and-taking-a-breath business.

'Wow, I am impressed. Great spicy smells and a posh table setting!'

'You deserve it, after a tough day at the courts,' Patrick said, in a nod to the past when I used to spoil him after he'd had a tough day at the courts, doing what he did best, being a thorough, professional and supportive solicitor to some client or other.

'Oh, the Criminal Courts, they're so much tougher than the others, you know,' I teased, pouring us each a glass of shiraz from the bottle sitting open on the table. Any chance of a good night's sleep was about to disappear. I loved red wine but ever since my hormones had gone south, as with many of my female friends, it no longer liked me. White would have been preferable, but I said nothing.

'That's why I've always tried to avoid them!' He laughed.

I gave him a kiss on the cheek before sitting down. He smiled and put his hand on mine. The fresh memory of my hand on Stephen's thin, scarred and bloodied hand brought a wave of sadness to me.

'You look well, Martha,' Patrick said.

'Do I? I doubt it. Middle-age doesn't become me…Not like you, Patrick.' As I spoke, I tried to shift my tone to sound almost flirtatious, but what came out was more cheerful than I felt. I raised my wine glass to his and we clinked.

'What case did you get in the end so?'

On my second day of jury duty, the first case for which my number was called sounded like the stuff of gangland movies: drugs, guns, knives, petrol bombs, intimidation, police car chase. It had it all,

including five defendants, one of whom had a too-well-known drug clan surname. Each of the accused had the right to challenge – for that legal term 'challenge', read 'reject' – up to seven jurors without any given reason, and that meant most of us lined up in the courtroom would be rejected and, sure enough, I was one. I had decided that I didn't want that case, it was going to be a long one and I feared intimidation was part of how those gangs operated. No thanks. But I was surprised at my internal response when I was 'challenged'. I felt offended and indignant. I found myself wondering, what's wrong with me? Who says I'm not good enough to be a juror to the low-life of society, the gangland drug dealers? I hadn't seen that reaction coming.

I'd told Patrick I would be excluding myself from any rape or sexual assault cases on the grounds that if I thought there was any real chance someone was guilty of sexual assault or rape, I'd want to lock them up and throw away the key. Having met Stephen, I was reminded to be more open-minded and less black and white in my views.

Earlier that day I'd been called for a case, dating back some twenty years: a man accused of sexually assaulting and raping a neighbour when the alleged victim was only nine years old. While standing in court, waiting to see if I'd end up on the jury, I'd looked at the alleged victim; he was a tired looking man of slight build, eyes down, grey hair, old beyond his years. I visualised him as a vulnerable, young boy and my heart went out to him. I looked from him to the accused: a big, burly man in his late sixties, chin-up, eyes fully engaged. I could have sworn he winked at me when he caught me looking his way. I recoiled and shuddered as I considered what he might have done to an innocent child. As a mother, I wondered whether I was morally bound to play my part and be on that jury. But before accepting jury duty, I had decided that after what had happened to my old, much-abused friend Celine at the hands of her husband, I could not bear to hear what might be said. Once heard, it could not be unheard; it would

replay in my head and wounds that I accepted would never be fully healed would be opened wide. I asked the judge to excuse me from that case on personal grounds.

That morning was my third day at the Criminal Courts and, in the juror waiting area, I'd read a few chapters of my book against the backdrop of some dreadful American channel on a large TV screen. Why do they choose to punish jurors with an endless feed of real-live drama shows which take some poor unfortunates and expose them as if they are fools or misfits of their own making? Finally, my number was called again. Up I filed, with the others, again expecting to be rejected or found surplus to requirements. It was a young woman charged with possession of cannabis with intent to supply, an offence she had been arrested for and charged with ten months previously. The gardaí valued the amount found at two thousand euro. I wondered how much in quantity that would be. It sounded like a low-risk case; no gangs directly involved. I could handle it. I could keep an open mind until I'd heard all the facts. The defendant was pregnant, maybe five or six months' pregnant; by accident or design, I wondered. Would that reduce or only delay any custodial sentence? Being impartial in such a short case wasn't going to be so easy after all.

'A short enough case, I think,' I replied to Patrick's question. 'A woman, mid-twenties, possession of cannabis with intent…shouldn't last more than three days, the judge said.'

'Hopefully! They're usually good at estimating the duration of the shorter cases.' Patrick spoke in that knowing way of his, a superior tone that for many years had impressed me until the penny dropped that I might be as intelligent as him, just in a different way. It was something I had honed in on when I'd gone to a series of free psychology lectures and at one, the presenter had spoken about how women underestimate their own intelligence and that of their mothers but overestimate the intelligence of their fathers, their husbands and

basically all the men around them. I'd taken this to mean that we women have allowed men to convince us for generations they are cleverer than us and, in this way, they have hoodwinked us into keeping them in power.

'Today was taken up with the judge, a female judge, explaining the difference between the balance of probabilities and beyond reasonable doubt. Her explanation was clear, concise and illuminating. The barrister for the prosecution, a man, seemed to be overly anxious to drive the message home further – if we couldn't get beyond reasonable doubt, then we should find the defendant not guilty. He drove the point home so much I was actually starting to wonder whose side he was on!'

As I remembered the tedious, long-winded way in which he had reiterated everything the judge had said, I began to see it for what it probably was – mansplaining, for the sake of the five of us jurors who were women.

'They have to do some of that, Martha, to be seen to give the defendant a fair trial.'

'Really, it was starting to sound as if he wasn't convinced she'd a case to answer, or that he thought half the jurors were a bit thick. I guess we'll hear the facts tomorrow…' I wasn't in the mood for banging the unheard drum for women, so I changed tack. 'This food is good…the mint dressing is spot-on with the samosas and bhajis.' I licked my lips. 'I love the dahl too.'

Actually, I thought the saag aloo could have done with lots more ginger, but I didn't comment; ginger can be hard to get right, you never know how fresh and strong it is.

'I'm glad you like it. Of course, I cheated on the samosas and bhajis – I bought those.'

'They're great, and that shiraz is perfect with the Indian flavours. It's lovely to come home and have dinner served up to me. Thank

you.' I heard myself starting to sound like an insincere gushbag. Patrick didn't seem to notice. He lapped it up.

'My pleasure.' Patrick gave me a broad smile, which, I hope, I returned.

'Did Zara tell you about the climate strike this Friday?' I asked.

'Yes, she's all excited about it – again. Her and that fella are drumming up support at uni as we speak.'

'Of course. I forgot, she's at her Friends of the Earth or Extinction Rebellion thing or whatever tonight. I don't think we'll see her so. No doubt she'll crash at Mr Earth's for the rest of the week.' I sighed.

'Will she?'

'Based on previous, probably. Speaking of…what do you make of him?'

Patrick's elbows came to rest on the table and his mouth disappeared behind his hands – a sign that he wasn't comfortable with what his opinion was.

'Hmm,' he said, 'I don't know what to make of him. I think I like him but…he's a bit quiet most of the time. I don't know. I mean he doesn't say anything at all unless you ask him about the environment or climate change.'

'I know. And even then, he speaks in such a monotone that I struggle not to fall asleep. His tattoos say more than he does! He's a bit one-dimensional, isn't he? Zara must see a side we don't. But there's something else, something I can't put my finger on that I don't like: his superiority, his air of entitlement, his outright rudeness…'

'I don't know…Zara says he's a genius.'

'That's not an excuse for rudeness. A perfect Leaving cert, 625 points, no bother to him. Just a pity there aren't points for kindness and good manners. And half the time he's not on this planet. Once when I came home after a tennis night out, he was looking at me but not registering me and saying nothing. It was weird. Normally, I'd

have let it go but I'd had a few myself and I got the urge to tap the side of his head; he didn't even flinch! I was about to say, knock, knock, anybody home? Luckily, I got distracted or Zara would have killed me.' As I spoke, I had a flicker of light: Zara has always been staunchly anti-drugs. Mr Earth might have different ideas. Was Mr Earth spaced? Cannabis counts as vegan. Obviously. 'I don't know what she sees in him,' I said.

'Aren't you being a bit hard on him?' Patrick took my hand and looked 'lovingly' into my eyes, flickering his own eyelids as he did so in an exaggerated way. 'Love is blind, Martha, you know that.'

'Young love may be blind,' I corrected him. 'Older love has had its eyes and ears checked and found wanting, and probably wears strong glasses or contact lenses and refuses to admit to the need for hearing aids.'

Patrick made to pull his hand away but I tightened my grip on his.

'But it's still love, Patrick. And do you know, maybe in its own way it's a healthier kind of love.' Or just more realistic and less idealistic.

Patrick gave a contemplative nod and I reached across the table and kissed him on the lips. I could tell he was surprised but, in fairness to him, he was quick enough to turn his surprise into pleasure.

'I guess we could take advantage of knowing we have the house to ourselves,' I said, getting up from the table.

Later, I wondered why I had kissed him – what truth was I suppressing, what conversation was I avoiding? Perhaps I had I heard Brené Brown's TED talk voice in my head telling me to embrace vulnerability; she listed initiating sex as a good example. On that front, it had been years since I'd embraced vulnerability.

# Chapter 3

## Hash Brownies

In my bedroom we made love the way I imagined most middle-aged married couples do.

Patrick was enthusiastic; I was indifferent but feigned interest while at the same time making plans for how I might look out for Stephen. I had promised myself I wouldn't do that again – I was working on being more open, honest and present in life and that included our lovemaking. But sometimes the old ways are the easy ways, though not always the most rewarding.

During my time in Sudan, some thirty years ago, I'd come to understand the difference between tantalising lovemaking and sex for sex's sake; a lesson I had, on my return to Ireland, joyfully shared the benefits of with Patrick. We'd lived separately in different parts of Dublin then and sometimes when I was driving home late from work or a night out, my libido would lead me to Patrick's, where I would creep, not too quietly, into bed beside him and press my back into the curl of his body, wiggling into position until he'd respond with a welcoming groan. And when we first lived together, I'd happily ensured we had taken full advantage of the many opportunities for spontaneous, unhurried lovemaking. With each new baby came stitches, tears and tiredness. That too passed and we were back throbbing in each other's arms with a desire I'd believed to be immortal. Then I'd had

my last Merina coil removed and my body crashed into menopausal misery; sex became something I could take or leave – preferably leave. I'd missed it, but the pain in my sexual parts whenever I tried to accommodate Patrick's desires killed my own. Between dryness, tiredness and sweats, I was miserable.

Mum suggested I talk to my doctor about HRT, but after the Merina, I'd decided I wasn't going to give my body again over to artificial hormones. My misery continued. Somewhere in the fog of it, I went to the chiropodist thinking I had a painful verruca. She gently informed me I was too old for a verruca. I had corns; post-menopausal women are susceptible to them because they lose the fat pads on their feet, she said. I told her they weren't lost, I knew where they were; they were hanging around my middle keeping company with my other wobbly bits. As she scraped away at the balls of my feet, I told her about some of my other post-menopausal problems, including the painful dryness. She is that kinda kind lady who you open up to with the most personal stuff. Woman to woman, as opposed to wearing her chiropodist's hat, she suggested that instead of full HRT, I talk to my doctor about trying a pessary of localised oestrogen. And with apologies to Robert Frost, let me say, '…that has made all the difference.' I became a slightly renewed older-but-still-sweaty woman after that.

Recently, I'd decided endless sweats and feck all sleep were bitches to deal with and bad for my natural immunity. It was time to take my renewal to the next level – full HRT. I'd done my research and concluded HRT would reduce my day and night sweats and therefore significantly improve my sleep. Despite any real or perceived risks, I concluded, based, in particular, on the scientific evidence I found on *The Irish Menopause* Facebook group, that HRT would prolong my life. It was early days yet but the flood of sweats did seem to be subsiding and I was expecting the forecasted increase in libido to arrive at any time

in the next month or so. I didn't know what I'd do with it when it came.

Patrick and I were back in the kitchen tidying up after dinner when Zara made an unexpected appearance.

'Mum. Dad. Don't worry, I'm not staying. I'm just picking up some face paint and stuff.' She gave first me, then Patrick, a hug, before shooting quickly out the door.

I looked after her as she disappeared into the night, sad to be unable to savour the rare hug she'd initiated. I wondered if she was more her true self after a few drinks, or less. There had been so many times when I would have loved her to give me a hug, but in recent years she had insisted that she wasn't the hugging type. When she was younger, she had been the most wonderful hugger and we had lovely fun times doing things together, cooking, gardening...anything. Then came her mid-teens and too-easily-provoked little old me became the one she picked a fight with; fights instead of hugs became our norm. The counsellor told me to talk to her about it; say to her that sometimes I'd really like a hug. Ask her if she could agree to give me the occasional one on request, but tell her that I wouldn't presume to take one. I put a lot of thought into how to have that conversation but in the end, I still got it wrong. Her response had been *so* Zara.

'So, were you telling the counsellor how we don't hug anymore? I can hear the violins...So very sad.'

She held up an imaginary violin and mimed playing the bow across the strings. I was thrown yet again into a massive menopausal sweat, followed by a bout of crying that I simply could not control. She stood staring at me, shook herself off like a dog getting rid of excess water, then gave me a hug that started awkwardly and ended with her saying 'I'm sorry Mum, okay? I'll try harder, I will. Honest...But terms and conditions apply.'

After that, we made some progress. I did request – and receive – the occasional hug. But it had been a long time since she'd initiated one.

'Don't give up,' the counsellor said. 'Keep your heart and arms open. You may be surprised…be patient…she's young…she's trying to find her feet…she might be taking her frustrations out on you because she feels safe with you, safe that you will love her regardless…'

'Too safe,' I said, with a long, slow outbreath. I'd learnt that exhaling like this stimulates the parasympathetic system: *relax, Martha*. 'Chill Mum,' I imagined Zara saying.

'Perhaps, Martha,' the counsellor responded, 'there is no compassion without boundaries. We will talk about that another day.'

Breaking my reverie, Patrick asked 'Well, what do you make of that? Nice that she gave us each a hug, wasn't it?'

'Would have been a lot nicer if she'd been sober.' I said, more cuttingly than I meant and wishing that I'd just agreed with him.

Patrick cleared his throat but passed no remark. He was his father's son. Avoiding eye-contact, he looked down at the saucepan he was cleaning and scrubbed a bit harder.

I wiped the entire table down from end to end, not just the half we had used, then polished it thoroughly and vigorously with a tea towel. As I did this, I was trying to find my inner pause button. Patrick would be heading off soon. I didn't want us to part on a bum note.

'Matt seems to be over the worst of his broken ankle and is back doing well at football,' I said.

'Sure is,' Patrick said, smiling. 'I think I'll go to his match this weekend.'

'He'll like that,' I replied. For all Patrick's love of GAA football, for years it had been me, not him, supporting the kids at these games; Patrick had been off playing his beloved and very time-consuming golf. After all the years I'd spent freezing on the sidelines, I still had

only limited knowledge of the finer points of football – just one of the many things they all enjoyed teasing me about.

'I'd best be off,' Patrick said, drying his hands. 'I've an early start tomorrow.'

'Me too, you know. Justice must be seen to be done!'

'No better woman!' Patrick said, giving me a confirming kiss on the lips. 'Au revoir. Sleep well.'

'You too. See you after Matt's match for Sunday dinner – they're all due to be here; Matt and Zara, of course, Fiona and Daniel, and Mum, aka Gran, and Fergal – her bit of elbow candy, as she has taken to affectionately calling him since she got her second hip replacement!'

I went to bed promptly after Patrick left. I thought I might read for a while although I found our book club's current book heavy going and devoid of any intriguing titbits. I'd expected the book to be something like the tales of the Mitford sisters but it read more like an academic thesis on the Lennox sisters. Perhaps the truth was that relative to the Mitford girls, the Lennox girls' lives were pedestrian. Either way, being no page turner, I thought it might encourage sleep to come easily.

My mind had other ideas. The image of Stephen by the canal and sitting in the café beside a vision of Stephen in the old days occupied my head. Less than five years ago, he looked like he had a life full of promise ahead of him. One mega night of excess, followed by more days and nights of goodness knows what, had triggered the end to those promises. What could I do for him? How could I help him? Others had tried. I was sure his family had tried in their way. What did I know about drugs and drug addicts? Very little.

My knowledge of drugs had peaked around the same time as Stephen had disappeared from our lives. Fiona, our eldest, had had a girls' night in at our house with her old school friends. It was a small gang, about ten of them, a reunion of sorts. I anticipated large quantities of

booze, takeaway food and little else. I knew some of her friends smoked, not just cigarettes, weed too. One of our absolute rules was no smoking in the house but I had also told her no smoking of weed in the garden. Sure as hell, the aroma would waft into the neighbours' gardens and best-case scenario, there would be a knock on our door or a phone call; worse case and possible scenario, the cops would be banging on our door. Fiona knew I wasn't exaggerating. Loud music in the garden at 11 p.m. on a previous occasion had resulted in the neighbours calling the guards who banged on the front door and delivered a clear warning. Another party, when we thought the same neighbours were away, we learnt they were home when Matt and his friends got soaked with water from a carefully aimed pressure hose, the nozzle of which appeared over the dividing garden wall.

In all my considerations, ways of consuming weed, other than smoking it, hadn't dawned on me. One of Fiona's friends had brought a homemade batch of hash brownies to the party and they had all been devoured, luckily before I had innocently tried one. As I understood it, Fiona had only ever tried hash in a coffee house in Amsterdam. The first I knew of the hash brownies was when Fiona woke me before dawn on Sunday morning to tell me her best friend, Anna, was having a bad trip, a very bad trip. Fiona was our sensible one, what was she doing talking about a bad trip? It must be serious, my half-asleep and slightly hungover-self told me. It had been a late night for us too and we had definitely had more to drink than was wise. In the bed beside me, Patrick did what Patrick often did during a middle-of-the-night crisis, he snored loudly.

'Anna had some hash brownies and they're not agreeing with her,' Fiona said in an urgent whisper.

'What do you mean not agreeing with her?' I asked, still half-hoping to find a solution that didn't involve me getting out of bed, at the same time as knowing that wasn't going to be the case.

'Mum! It's serious. She's seeing things. She thinks there are people outside…I'm scared.'

Anna was sitting at the end of the stairs, wearing a T-shirt and pyjama bottoms. Her blonde hair, which had been ironed flat earlier, was matted and dishevelled, and her dark eye make-up was smudged across and down her face.

She spoke in breathy whispers that struggled to find enough air to be heard. 'They're out there…I saw them…Don't go near the window…Fiona, don't.'

I stepped gingerly around her and stood facing her. She sat before me drooling like a bulldog in the vicinity of food, not looking my way or showing any signs of registering my presence. Her eyes were open but saw only what was inside her drug distorted brain. She whimpered like a beaten animal. Whatever it was she saw, it tortured her. She was utterly spaced and miserable.

I touched her arm and called her name. 'Anna, there's nobody outside. There's nobody there. Honestly, I looked.'

Her face twisted in further fear; her lips moved but made no sound; her eyes remained stuck on pained startled. Then her breathing became slower and shallower; her body became limp and slithered down the last few stairs. I caught her by putting my arms under hers and moved her gently onto the rug on the floor and into the recovery position; her body gave me no help or resistance. Perhaps she just needed to sleep it all off; perhaps her breathing would get worse or stop altogether; I'd no way of knowing. Right then there was a terrifying stillness to her. I looked at her and I wondered if this is how she might stay for a long time or even for ever. I was scared for her. I was out of my depth.

'Pass me your phone, Fiona, please.'

Fiona's hands were trembling and it took her a number of attempts to punch in her code before passing the phone to me.

I called 999 and asked for an ambulance. I gave our address and as I explained the situation, I wondered how many similar calls they must receive each night. I assured the operator that the patient was still breathing but it was very shallow and she was in the recovery position and as instructed, yes, my daughter had opened our front door so the ambulance people could get in. I don't know how long they kept me on the phone asking for updates of which there was really nothing to update. Apart from shallow breathing, Anna remained perfectly still, but the fear of some unknown never left her face or her wide-opened eyes; it possessed her. Fiona passed me a blanket to put on her, and I told Fiona to get dressed to be ready to go with her in the ambulance. As requested, I hung up from the emergency operator when the ambulance men walked through our front door.

They took Anna's pulse and blood pressure and I thought I saw some new signs of life coming into her as they did so. I could have seen it more in hope than in reality. Fiona told them what she had taken and when; over eight whole hours ago, I thought. Anna eyes were open but she was oblivious when they lifted her onto a stretcher and brought her out to the waiting ambulance. There was no sense of urgency or panic from the ambulance crew and I took solace from that as I closed the front door behind them.

It was still very early, especially for a Sunday morning, but there was no point in going back to bed. I decided to harness my agitation and start the overdue task of turning the compost heaps. I pulled on a tracksuit bottom and went out to the back garden. In one unbroken manic run of it, I turned the entire heap of the older compost from one slot into large bins which I then emptied in piles onto some of my flower and vegetable beds before turning over the newer compost heap into the freshly emptied slot. The power of my fear and frustration got the job done in less than half the time it normally took me. The usual joy that I got from the pleasure of rich, sweet-smelling, homemade

compost passed me by that morning as I waited to hear news from the hospital.

Fiona and Anna had been friends since they were six. I counted Anna's mother amongst my friends. We still met for walks and coffee. I wondered, should I ring Anna's parents and tell them? But Anna was over twenty-one and I felt I'd no right to ring them. But should I? I felt culpable, how had I let this happen to Anna?

When I finished turning the compost, I went into the kitchen where I cooked the porridge I had left steeping the night before, and made myself tea. I sat down at the kitchen table and opened my laptop, breaking my own rule of no technology at the table. I needed to educate myself on the finer details of modern cannabis; bad trips and psychosis didn't feature in my memories of weed back in my young adult, post-school years. Flawed and all as they are, I turned to Google and YouTube. What I learnt was various degrees of terrifying, depending on which websites I explored. I was gobsmacked by my level of ignorance. What I knew about cannabis predated my first mobile phone which had been the size and weight of a brick.

THC is the psychoactive compound found in marijuana; it is supposed to give you a high but as I'd just witnessed with Anna, it can give you something that is anything but a high. CBD is THC's more innocent sister – same chemical ingredients but a different arrangement of atoms therefore it gives a different reaction in the body. CBD doesn't produce the high associated with THC and CBD has been found to be helpful with various medical conditions, including chemotherapy induced nausea and epilepsy. THC, by contrast, has been found to have fewer possible medical uses and significantly more negative side effects and can lead to or play a part in permanent or semi-permanent psychotic disorders such as schizophrenia.

Reading all this gave me no comfort so I kept looking. I found plenty of stories where one or two bad trips lead to repeat psychotic

episodes; often without further ingestion, inhalation or taking of cannabis. I looked at reputable, medical websites and I found confirmation of this. Yes, there were doctors looking for EU drug approval for medicinal CBD for proven good reasons, but this was not to be confused with recreational forms of cannabis. Yes, most people who occasionally used cannabis reported no side effects according to many websites. But regardless, there were more dangers to modern day recreational use of cannabis than I had imagined.

I went back to working on preparing my vegetable beds, worrying that Anna's one psychotic episode would lead to others; worried she might have fried her brain. Would that be the end of her career as an accountant? Thinking back to my early days, also as an accountant, I couldn't remember any of my friends or colleagues who had regularly consumed weed having psychotic episodes. I'd lived in Sudan with two potheads who smoked daily and often washed it down with araki or illicit Ethiopian gin. They had both been in a state of permanent, lethargic indifference but thankfully I had never witnessed even either of them having psychotic episodes. Something had changed and I wondered if it was that the younger generation were drinking more than we had; as well as doing more bang, or green as it seemed to be sometimes called. Or was I missing something?

I paused my gardening and sat down on the bench on the patio and returned to Google. In the days of Woodstock, they must have been a sensitive lot because back then the THC content of cannabis was a mere one to two per cent and that was enough to get them high. Those were the flower power days so maybe there was more to the flowers than I previously appreciated. Or maybe it was the rock and roll. Back when I was in my twenties, according to Google, the THC content was four to five per cent; then they had discovered that the female plant was more potent – no surprise there – and through cross-breeding, the THC content of weed on the street rose rapidly from

then on. In my research I did not discover how these things are measured but according to various websites, the current THC content of cannabis is twenty-two per cent and increasing, with average marijuana extract containing significantly more THC again. After that there are a lot of unknowns but still plenty of evidence that the long-term consequences of using marijuana can be devastating: mental health issues; cognitive impairment; learning difficulties; increased likelihood of using other drugs. The younger you are the greater the likelihood of negative effects. Why, oh why was I only finding all this out now, when it might be too late? I didn't think I'd spent the children's teenage years with my head in the sand but I didn't know any of this.

One website, *Every Brain Matters*, made the point that: *The public is being deceived regarding industrialized marijuana products and their effects, like cannabis use disorder, cannabis-induced psychosis, and cannabinoid hyperemesis syndrome, which has led to a public health crisis.*

They were talking about "a public health crisis" that I'd never heard anything about. From the same website, I learned that as THC content of cannabis had increased, the incidents of cannabis-induced psychosis also increased, with devastating effects for some people. As I understood it, if cannabis-induced psychosis continued after the THC had left the system, then it can be a long road to recovery. Three to five years did not seem uncommon. And those who recovered were the lucky ones.

On all the websites I looked at, the only consolation I could find was that there was a reasonable chance that when the THC left her system, Anna would suffer no further fallout from it. As I returned to my vegetable beds, I couldn't see how this possibility might apply, given the sorry state of her more than eight hours after ingesting those space cakes, baked with cannabis of some unknown source and

strength. I weeded the garden with continued vigour, no doubt removing the seedlings of some perfectly good plants as I did.

Just after 9.30 a.m. Fiona rang to say that after they'd arrived in the ambulance, the hospital had given Anna a full check-up before putting her in a drying out room with all the other…she didn't finish the sentence. At 9 a.m. they had given her another assessment and declared her fit to go home. They were in the taxi as Fiona called.

I didn't see them when they returned as Fiona brought Anna straight up to bed before coming out to me in the garden.

'They say she should be fine, I'm just to keep an eye on her.' Her voice held no conviction.

'Hopefully, she will be,' I replied as I brought the life of a much-maligned dandelion to an end. Zara would not have been impressed at me killing off this bee-friendly, nutrient rich, medically useful plant, otherwise known – for very good reason – as piss-in-the-bed; I was thinking, Anna could find herself unintentionally wetting herself, without resorting to the diuretic properties of the common dandelion.

'Sorry Mum. It was stupid. We shouldn't have had those brownies.'

I heard her say 'we'! She, who had told me she never took drugs except that one time in Amsterdam, had just told me that she had eaten hash brownies that were strong enough to have done *that* to Anna. Inside I said 'Fuck!'. Outside I said nothing.

'Mum?'

'Yes, hopefully she'll be fine.'

*How much did you eat? Where did you get it? Do you know anything about how dangerous it can be? Do you know that if you'd smoked it, it would hit you fast but when you eat it, it can take thirty minutes to two hours for the high, or the psychosis, to kick in? Therefore, you all probably had way too much, by any standards…*

I said none of this. I aimed the trowel to another deep-rooted dandelion but stopped myself.

'It must have been a bad batch,' Fiona said.

'A bad batch! Is there such a thing as a good batch?' I asked, in a tone not befitting of a thoughtful gardener.

'Sorry Mum. I'm very tired. I'm going back to bed.'

Another eight hours later, Anna made an appearance at our kitchen table. She was a jittery shadow of her normal intelligent, articulate self. Fiona, who had to go to her part-time job as a waitress at a local restaurant, was giving her a cup of tea before her brother was due to collect her. She'd told him what had happened. They both still lived at home so if she had another episode he would know. I was comforted by this and temporarily, let myself off the hook of the possible need to tell her mother.

She sat, slouched in her chair, using one hand to scratch the other, reaching aggressively up her lower arm, then switching hands and arms and starting over. I nodded at her and put my hand on hers to ease her scratching. She gave me a sheepish nod back. I offered her bread soda paste to ease the itching but she declined with a silent no thank you. I made small talk with Fiona, offering toast or something else to eat before work. Anna mumbled an apology, looking at her well-scratched hands as she did so.

'It's okay, Anna' I said, still terrified that she'd never be mentally the same again.

It was a fortnight later before Fiona confessed to me that she had had the same fears at the time and that because of the way Anna had been acting since, Fiona still feared for her. The fun was gone out of her, Fiona said, and she seemed jumpy and sad. I asked Fiona if Anna had told her mother, Bernie, what had happened. Fiona said she hadn't and told me not to dare go telling her. I suggested that it might be a good idea if Anna told her herself, just in case. Bernie was my

friend and so much of me wanted to warn her. If Anna was my daughter, I'd prefer to be told. I'm not proud to say, I avoided Bernie for fear I wouldn't be able to stop myself from telling her. I regretted that decision when some months later, I bumped into her in the supermarket. She was very worried about Anna; she'd stopped going to lectures and hadn't sat her exams. Bernie was convinced she was smoking weed and had found traces of it in her pockets.

'I think we should go for coffee,' I blurted and despite having said she was in a hurry, Bernie agreed.

I told her the whole story of the hash brownies and the ambulance and the normally amenable Bernie lost it with me for not telling her as soon as it had happened. She was right. I shouldn't have let Fiona persuade me not to stick to my own judgment. I had no good excuse and my apology sounded pathetic in the scale of how things had unfolded. Bernie didn't really talk to me after that but Fiona managed to stay friends with Anna and she told me her parents went to hell and back with her for more than a year after that before she slowly started to turn the corner after trying various conventional and alternative treatments.

The fallout from Stephen's first known foray with drugs was much longer lasting and far more catastrophic.

The party to end all parties was seemingly like most other parties. Matt had first told me about it when the fallout from it started to hit him hard; he became stressed and anxious and a far cry from his usual self. At that party, he told me that drink had flowed, bags of weed were consumed in various ways, eight-balls of cocaine disappeared up students' noses, and pills were taken.

'Where on earth did kids get the money for all that gear?' I'd asked, aghast.

'I don't know. Parents, jobs…' he replied with a shrug.

Stephen's parents weren't given to handing him money for social-ising and apart from some refereeing for the local club, he hadn't much time for earning money between college, sport and helping out at home minding his younger siblings; all while his parents were working or socialising in what sounded like almost equal measure. But Stephen had been the man of the big match the day of that party and his fellow partygoers had been happy to provide him with whatever drink or drugs he wished to put into his body. Stephen told Matt that all he had was drink and maybe some weed in some brownies, and maybe one little pill, nothing more. All Matt knew was Stephen was 'well gone'; more gone than he'd ever seen him. He probably didn't even know all he'd had. Matt said he wouldn't have abandoned him if he'd copped just how bad Stephen was, but he'd been so locked himself that all he'd seen was Stephen finally making headway with Helen.

I seldom heard Matt coming in late but the night of that party, or more accurately that morning, I had heard the crash of the inner hall door being slammed open against the radiator cover in the hall and closed with another loud bang, followed by the crash of a vase onto the tiled floor. When I got downstairs, I found Matt sitting propped against the radiator, his legs stretched long and wide across the floor, his phone and keys beside him and the pieces of smashed vase spread the length of the hall all the way to the end of the stairs.

'Shit,' Matt said, as he made to stand up and put his hand on a piece of the vase.

'Shit,' I echoed as I saw the blood oozing onto the black and white tiles. 'Stay where you are! Raise your hand above your head!' I spoke emphatically as I went to get the medical kit in the kitchen.

'Don't shoot, Mum. Don't shoot,' Matt slurred.

'I'll get something to clean and bandage that cut.' I was not in the mood to find him funny but I did smile later when I remembered it.

The cut seemed to have sobered Matt up enough for him to be able to get himself up to bed after I'd sorted out his bloodied hand. I kept one ear open for him for the remaining few hours of that night and, unbeknownst to him, I checked on him a few times after I got up later that morning. It was 2 p.m. before he resurfaced, looking the worse for wear and incapable of consuming anything more than two paracetamol and slow sips of ORS in an attempt to rehydrate himself. By that stage, he told me a week later, there were already more than one hundred messages on his school and college WhatsApp group chats, both of which Stephen had been removed from. He told me he had been in no fit state to read them, so ignored them. The only person he messaged was Stephen to find out if he'd finally got with Helen.

All he got back was: 'TTUT', with a smiley face.

Matt took that as a positive and then took himself and his duvet to the TV room to binge-watch some episodes of *The Office*.

# Chapter 4
## Court Case

The day after I met Stephen and had dinner and sex with Patrick, I walked from town along the Liffey to the courthouse and replayed in my head all Matt had told me about the party and the ready availability of drugs at any night out.

'Wake up, Mum, parents are doing it too!' he'd said.

As I neared the courthouse, I wondered if my limited knowledge and experience might influence how I heard the evidence; I wondered what two grand of cannabis resin looked like and how long it might last a few people. I had to rely on the court to answer these questions. We were not to consult Google or any other outside source for information, the judge had said.

When all our jury members had arrived at the waiting area, we were taken up to our appointed room by our designated jury minder. We sat around the table with few words spoken as we waited to be called to court. When we had been working out the appointment of a jury foreman the previous afternoon, I had noted the mix of the twelve members of the jury: six men, five women, and one young person, named Charlie, whom I took to be gender fluid. On the first day I'd spotted Charlie in the jury waiting area, they'd looked distinctly feminine with a skirt, make-up and long hair; the next day I'd done a double take, as they looked masculine, had no make-up and were

wearing jeans and a sweatshirt. Yet I recognised their face and body. I was fascinated by this person and their name was appropriately ambiguous so I remembered it. Remembering names wasn't my strong point, and I often made up names for myself in my head so I might know who was who.

I liked the diversity of the jury in terms of age and personality: four young adults: three male and Charlie; a man and a woman of retirement age; two middle-aged men: one very spiffy Southside Dublin-businessman type, wearing a dark suit with bold, thin purple stripes, a pink shirt and hair slicked black and back. The other middle-aged man, Eamon, was earthy and casual in his appearance, handsome, with slightly messy, dark grey hair, a colourful casual shirt and a modern blue Aran-style jumper open at the neck – Aran Eamon I called him. There were four middle-aged women: two quiet ones who dressed accordingly, another woman who I learnt when we walked by the Liffey after court later that day, was a fellow Northsider, and then me. There was a pleasant variety of accents amongst us, including true Dub, normal Dub, posh Southside Dub and culchie but when it came down to it, all the accents were Irish and none of us were people of colour – hardly representative of the diversity of people I saw walking Dublin's streets or who might come before the courts. After some discussion, we appointed my fellow Northsider, Clare, as foreman; only she or the Southside spiff were willing to take it on and with the MeToo movement very much alive, I proposed that it be her; I simply said that she had been first to say she was happy to do it and that was good enough for me. Eamon said he would like to echo what I had said and we exchanged smiles. He'd a good smile, warm and sincere, made exceptional by a dimple in one cheek, I noticed and found myself repeatedly drawn to look out for when his dimple dimpled. The spiffy man started to protest that he was willing to be foreman too and Eamon gently repeated that he seconded the proposal that Clare be foreman.

After that a ripple of ayes confirmed Clare. It was one small victory for women and a bonus point for the Northside!

When court resumed that morning, the judge reminded us of our duties and then the first witness, the arresting officer, was called. He had stopped the accused outside her local pub and asked to check her bag. He didn't make it clear what had provoked him to stop and search her. In her bag he had found two plastic bags containing what he suspected to be cannabis resin. He had arrested her on suspicion of possession and had taken her to the Garda station. She was holding it for someone, she had said. She had made one phone call and we learnt, as the evidence was presented and various witnesses were called, that it was to her boyfriend, the father of her two small children. A search warrant had been granted; her flat had been searched and another bag found. Total value two grand, the garda expert witness said. The substance contained in two of the bags was high grade cannabis resin, the third bag was of lesser quality, the garda expert stated, holding up each bag for us to see; so now I knew what it looked like – at least from a distance – a greeny-brown lump of hard butter. The witnesses, including the gardaí, were cross-examined by both the lawyers for the defence and the prosecution. I found much of the evidence tedious and on repeat. In the over-warm courtroom, I used sheer determination and pinching my thighs with increasing ferocity to stay awake. My determination was born out of the fear that if I was seen to fall asleep some evidence would have to be reheard or a mistrial could be declared, and not least, I would be mortified.

Court was adjourned just before 4 p.m. before which we were told that the next day, we would hear more evidence, including from the accused. The judge advised us that depending on the duration of our deliberations, we may finish up the following afternoon.

Before we left for the day, I put my jury notepad alongside the others on the jury room table; we were not allowed to take them with

us. I had written some notes but mainly I had written some questions I didn't expect to get answered: was the value placed on the drugs the street value or the dealer value? And the question I'd had earlier, how long might so much resin last a regular user? Going out the door, I enquired of our jury minder what time was the latest we would finish the next day, and he told me 4 p.m. or maybe an hour earlier as it was a Friday. I was asking because I wanted to try to meet Stephen sooner rather than later; I felt I had only one real shot at reaching out to him and if I got it wrong, it could leave him feeling more rejected than ever. I wanted to see if the NA, AA or any other websites might give me information to guide me in how to go about supporting Stephen but for now my hands were tied, I could be in breach of the judge's instructions if I looked up such information before the end of the case my neurotic self decided. In the end, I sent Stephen a text saying I should be able to meet him on Monday afternoon if that suited him. I'd confirm the time nearer the day.

It had felt like a long day in court and as I left the courthouse, I spotted Clare up ahead of me. Being longer legged and a fast walker, I quickly caught up with her and we walked as far as town together. We followed the way of the Luas tracks and as we walked, we were hit in wafts by the distinctive and increasingly familiar aroma of weed.

'It's everywhere, that smell,' Clare said.

'I know, it's got so normal now that I barely notice it, I've come to expect it; the way we grew up expecting to smell cigarettes at every turn.'

'And now cigarettes are often taboo! Who'd have thought they'd be replaced by weed?' She paused before speaking again. 'Can we even have this conversation? Would this count as speaking about the case outside the jury room? It shouldn't, but still…'

Better safe than sorry, we agreed.

I congratulated her on being foreman, telling her she had the right touch, allowing everyone to have their say; she nodded and gave me a quiet smile. After we parted, I chose a long circuitous way home, exploring new and old places as I went. I wandered down an enclave of residential roads that I hadn't walked in years; lovely old roads with redbrick, Victorian and Edwardian houses; houses that had for years been subdivided into grotty flats but were now gentrified with freshly renovated or replaced windows and doors; a disproportionate number of BMWs, Mercedes and Audis were parked outside them and even a number of Range Rovers and Land Rovers – because you'd be needing a large, four-wheel drive for the narrow, tarmacadamed city streets! The houses and cars screamed, MIDDLE-CLASS FAMILIES LIVE HERE. But there amongst this statement of money, stuck, smack centre in many of the large front windows, were some posters:

### RE: 43 ST FRANCIS ROAD
### NO TO DRUG TREATMENT CENTRE

NIMBYism was alive and well and thriving in the gentrified Northside. What were they thinking? No drug addicts here. They wished. Maybe they needed to take a deep sniff before they washed their teenagers' clothes; smell the air as they walked the streets; get out of their cars and look at the people around them. How would they feel if it was their son or daughter who needed treatment and they couldn't get a place? Perhaps they were comfortable that their health insurance would cover private care and get their child the early intervention others are deprived of.

I caught myself in my silent judgmental rant as I saw the same posters not just on Francis Road but on other streets too. I wondered at the one in four houses that didn't have the posters displayed; had they seen at first hand the damage that drugs do? Were their neighbours still talking to them or were they being ostracised for not condemning the possibility of a drug treatment centre in their

neighbourhood? Would their children get stick in school from the children of parents who had proudly put up those posters? Were the people displaying the posters blissfully ignorant of drugs and how widespread the problem of addiction is? As ignorant as I had been. Addiction doesn't discriminate, not between class, creed or colour, one website I'd looked at had declared. It may as well have added, with your family history, Martha, it could have been you. If the Mrs O'Reillys and Máires of my life had not looked out for me, it seemed highly probable that I would have sought connection and acceptance in drink or drugs.

As I walked, I felt increasing frustration and tried to focus my thoughts on something useful I might be brave enough to do, such as typing up some home truths about drug addiction and posting fliers into the letter boxes on those streets with the posters or putting up a post on social media in the hope that it might reach some of them. I concluded I was unlikely to do either, one was too brazen and the latter wasn't my style; I didn't like social media. And many people probably didn't want to hear what I had to say, especially if it ran contrary to their beliefs; I accept that we all get very attached to our beliefs and cling to them particularly tightly when faced with mounting evidence that contradicts them. Hadn't I spent most of my life attached to the belief that I was not good enough?

My mind wandered to a photo I had taken a year previously, it was of a terraced period house, just like the houses with the posters. The house in my photo had Virginia creeper in all its vibrant autumnal glory climbing up the front, around the door frames and windows; a large well-lit pumpkin sat smilingly on the step; a big bold sign in the window read:

## GHOSTS AND ODDBALLS WELCOME

A couple of years ago, as a distraction from my menopausal and marital crises, I'd taken up art classes and recently this had evolved

into a group of us painting together in one of our houses, usually mine. We called it our weekly therapy session because as we painted, we talked about our woes and our joys and what we said in the room stayed in the room.

I had used the photo of the Virginia-creepered house as a basis for a painting I had done, I was happy with the outcome and had called it *Welcome*.

When I got home, after the usual play acting with Chuckie, followed by a dash to the bathroom, I took out a blank canvas, my paints and brushes. I painted a similar painting to the earlier one; same red-brick façade, same bay window, same colour door but in the new painting the creeper grew thickly across the doors and windows, blocking entry and blocking light; in the centre of the bay window, a poster with blood-red writing read:

## NO DRUG ADDICTS WELCOME

The painting was dramatic but most poignant if I hung it beside the earlier one. I took two paintings down from the wall above the couch in the kitchen-living area and carefully hung the two frameless, deep canvasses in their place. They sang bold as brass against the white walls.

With the paintings on the wall, hunger hit me with a rumble of my stomach and the stirring of a headache. I opened the fridge to find plenty of leftovers from the dinner Patrick had cooked the previous night.

'Patrick,' I said. 'The way to my heart is definitely through my stomach!'

The words were barely out when I heard human movement behind me and I jumped.

'First sign of madness, Mum,' Matt said, grinning at me.

I threw him the eye. 'Way past that, Matt.'

'Don't I know. Hope it's not hereditary!'

'I'm sure it is. Look at your Gran, she's been answering herself back for years.'

'Never met a saner person than our Gran,' Matt said with deep affection.

'Me neither. Aren't we lucky?'

'Yep, sure are. I'm starving. Is there any food in it?'

'You and Chuckie, you're both the same, it all comes down to food.'

On hearing his name and food, Chuckie appeared beside us. He wagged his tail and looked from one of us to the other, trying to work out who was his best bet. Matt took a small chunk of bread off a loaf from the breadbin and started messing with him; getting him to reach for some bread by standing on his hind legs; getting him to sit and give first one paw and then the other; getting him to roll over and play dead whenever Matt shot him with his finger; for each trick he was rewarded with a piece of bread. Meanwhile, I filled two plates with leftovers, covered them loosely and put them in the oven.

Over dinner Matt started chatting about work. He had recently started a job as a physiotherapist in the children's hospital and was loving it. He had wanted a job in the nearby adult hospital but that had gone to someone older with more experience. I had told him he might have more fun with children and the stories he had to tell seemed to bear this out.

That day, he'd had a three-year-old girl with a stubbornly dislocated elbow. The doctor had tried to manipulate it but failed. X-rays had shown no breaks. With the toddler held firmly in her mother's arms, facing him, Matt started to gently manipulate the child's arm. Just as he was smiling at having successfully popped her elbow into place, the child kicked out, hitting Matt straight between the legs with force. He yelped like a girl, he said.

Then he'd swallowed hard and mumbled 'Bullseye!', in an effort to make light of it.

'Sorry,' the mother said, not knowing which way to look.

'I. Don't. Like. You!' the child hissed with venom, followed by a wish-you-were-dead look, and sticking out the full length of her tongue. The nurse had to leave the room to hide her laughter.

'Feck it, Mum, if it had happened to anyone else, I'd have laughed too, but it bloody hurt!'

'Are you alright?' I asked, nodding in the appropriate direction while putting my hand up to my mouth to smother my own urge to laugh.

'Stop, Mum. I can see it in your eyes that you're laughing too.' He punched me lightly on my upper arm.

His gentle punch sent me into convulsions. 'Sorry, Matt…Dangerous business, children.'

'Yeah, they are.'

'But still, I'd say adults are worse. Imagine being a doctor working in A & E in an adult hospital. It would be more than a child's kick in the groin you'd have to deal with.'

'No, thank you. All those drunks and druggies.'

'Hey, you were one yourself once. Remember? It was the night you fell with a glass in your hand at a party – at least that was the story you told me – they had to stitch you up without an anaesthetic, you'd that much drink on board.'

'I'd prefer to forget that night, if you don't mind. The A & E was like a war zone.'

'Don't I know? I'd to wade my way through the bloodied bodies to get to you!'

'Drunks and druggies, many worse than me. Scary. Taught me a lesson though, I haven't got anything like as locked since. And as for drugs, no thank you.'

'Well, that's a relief to a mother who seems to see and hear about drugs at every turn in recent days.'

'You got jury duty on a drugs case so?'

'Yes, I did actually…But, more than that,' I paused. 'I met Stephen.' I waited for the name to sink in.

'Stephen, my friend Stephen?'

'Yes. Your friend Stephen.'

'Oh shit, Stephen I've often wondered if he's still alive. I've wondered…How is he?' Matt shook his head a number of times and let out a slow sigh as he put his fork and knife down on his plate and turned to face me more directly. 'Mum, how is Stephen?'

'To be honest, Matt, he's pretty shit. I got a shock when I saw him.' I told Matt the whole story of our encounter the previous day. Matt's obvious upset filled his whole face and being.

'Will you see him again?'

'Yes, I hope to see him on Monday. I sent him a text but I haven't heard back yet, last I looked…' I paused again. 'Would you like to see him sometime?'

'Of course, I would, but will he want to see me? I've been a shit friend. After chasing him for barely a year, I gave up trying.'

'Matt, you did try. And don't forget after that, we'd enough crap going on ourselves…Maybe he wasn't ready to talk to you then. I don't know. Maybe he isn't ready now. All I know is we won't know if we don't try.'

Matt started to recall the Stephen affair – as we had called it until we decided we needed to clearly distinguish it from Patrick's actual affair – now, on the rare occasions that we mentioned it, we referred to it as 'what happened to Stephen.'

In the university canteen that day, away from the others, James had filled Matt in on the stories about what Stephen was supposed to have done after the party crowd had dispersed or crashed out in various

bedrooms around the house. The rumours had been started by Helen's friend, Melissa – a mouthy girl, according to Matt, mouthy in that she regularly got her lips enlarged and mouthy in that she said more than was kind, appropriate or even true. Melissa had made insinuations in messages she'd sent the day after the party, and that Monday morning she had said straight out to anyone who would listen that Helen wasn't in college because Stephen had sexually assaulted and attempted to rape her.

Matt's response to James had been, 'that doesn't sound like Stephen. I've never known him to do anything like that.'

'Yes. Me neither. But, how would we know? He was well fucked and so were we,' James said. 'Were we there when the alleged offence occurred? No, I'm afraid we were not.'

Matt had continued to try to protest his friend's innocence: 'Where was the evidence?'

James had no answer to that other than what Helen was supposed to have told Melissa and according to Melissa, Helen had been very upset.

'Is Helen being upset evidence? Was anyone else there and did they see or hear anything?'

As far as James knew, everyone else had either left or was out cold.

As they were sitting and talking at a table around the corner from where the rest of the group were gathered, Stephen had walked into the canteen. They watched him make his way over to the others; when he got to their tables, Melissa and the three other girls stood up and left. Melissa and one other girl bumped very deliberately into Stephen as they walked past. None of them made eye contact with him. Stephen gazed after them with a what-the-heck expression and then sat down in the seat that James had vacated. The other lads suddenly needed to be somewhere else; to tutorials or lectures that they'd never needed to go to before. Stephen stood up and looked around, spotted

Matt and James and headed over to them. He was clearly baffled by what had just happened. He sat down beside Matt.

'What's up bro?' he said, his eyes darting after the departing posse.

Before Matt could find the words, Stephen's phone pinged. Matt could see it was a message from Melissa. Stephen read it and gasped.

'Fuck. Sick. Oh man. What am I supposed to have done?' he asked, turning his phone for Matt to read.

**How can u show ur shitty face, you RAPIST?? Helen cant face college after what U did to her, U FCKN PRICK. But tink its ok to show up?? We r not going to let U away with it.**

'Fuck!' was all Matt could manage to say.

'I think I'll leave you guys to talk,' James said, standing up from the table.

'What is she saying? Helen hasn't answered any of my messages…Do you think…I mean did I…could I have? I don't bloody well remember anything beyond kissing her. I don't remember.' Stephen's face was filled with terror. 'She was gone before I woke up on the attic floor. Nobody knew when or where.'

'Fuck it, Stephen, I don't know. I wasn't there. What do you think happened?'

'I don't know. I'd a shit load of booze and those so-called space cakes that Melissa made. I didn't take any fucking pills or anything like that mind.' He rubbed his hand down his face and thought for a moment. 'I don't know. For fuck's sake, I was so fucking loaded, there's no way I could get it up. Never mind the other shit.'

'Yeah. You were totally plastered. I was too.' Matt said, trying to reassure Stephen, and himself.

'But could I have?'

'Shit, I don't know. It's not your style.'

'What if I did? Fuck! Fuck! Fuck! I can't fucking remember.'

'Do you remember me saying goodbye to you? I walked out the door of the party with Orla on one arm and holding Jackie up with the other.'

'I think I remember that…Yeah, I do. Did you get with both of them?'

'No, stupid. The three of us were getting a lift home with Orla's Dad. I'm trying to see how much you remember.'

'Well, I remember you leaving. I gave you the thumbs up and said 'All good bro.'

'According to James, after I left, he persuaded you to play foosball with him in the attic and after that he left you and Helen alone there because he was starting to feel like a right spare – to use his words – do you remember that?'

'Yeah. I remember. I didn't really want to play, I just wanted to get with Helen. I lost the game and I'd to drink a large glass of some concoction for my sins.'

'James said that Helen helped you finish it; she drank half of it herself.'

'Oh fuck, Matt, I don't remember much after that!'

'Helen was well fucked herself before that. Orla told me on the way home, she'd tried to persuade her to take a lift with us but she said, no way. She offered Orla a little blue pill to help her lighten up but Orla said, 'no' and Helen took it herself and washed it down with drink from some randomer's glass.'

'Yeah so, we were both out of it, but I'm the one accused of fucking rape. Rape! How's that, eh? Eh? What's Melissa saying? Mouth almighty herself!'

Matt told me he had been reluctant to tell Stephen what he had heard but he reckoned that if he didn't tell him then he would hear bits of it elsewhere or worse be buried alive under rumours that he might never get to hear. 'According to Melissa, Helen says that she

remembered you on top of her, pulling her thong off and she told you to stop but you didn't.'

'Jesus, Matt, who told you that?'

'James did.'

'Who told him?'

'Melissa.'

'So, Helen told Melissa and Melissa told who exactly?'

'I don't know, Stephen. Quite a few, I think. Like, she didn't tell James on his own, she told him when she told that lot who got up and left when you arrived. James told me just before you arrived.'

Stephen sat in front of Matt in silence, his face contorting in pain and horror as he tried to digest what he was being accused of. Matt reached across to put a hand gently on Stephen's shoulder but he shot up out of his chair.

'I've got to go. Talk later. Thanks bro.'

'Wait. I'll go with you.' Matt grabbed his bag and jacket and made after him. But Stephen was gone, out the door and down the path between the faculty buildings, faster than Matt could catch him. Matt took off at speed too but Stephen, always the fastest on the team, quickly disappeared out of his sight.

From that day on, Stephen didn't answer Matt's phone messages and didn't appear in college. Matt called to his house a number of times but either got no answer or was told Stephen had gone out.

# Chapter 5
## Verdict and Family Dinner

Friday morning in the courtroom had me thinking how we are pro-
grammed to want to wrap things up on a Friday; we don't like starting
a new week with the leftovers from the previous week. The defendant
hadn't much to say for herself, by nature or by design, who knows.
She was small and thin apart from her protruding compact bump; she
portrayed a timid demeanour, yet I sensed a steeliness within her. The
lawyer for the prosecution didn't push her too hard with his question-
ing and I again wondered if he was lukewarm on the merits of trying
the case. Yes, she had been in possession of the bags of cannabis; no,
they were not for supplying to others, she and her boyfriend had
bought them for their own use; she didn't know how long they might
last, a number of weeks, depending; depending on what? Depending
on how often they smoked, which depended on what shifts her boy-
friend was working; they only smoked at night when the children were
in bed.

*Was your boyfriend charged with possession? Are you still smoking?*
*Where did you get all the money for the drugs on a minimum wage job*
*and social welfare if you're not dealing? What if one of you suffered can-*
*nabis-induced psychosis? What might that mean for you and your children?*

These were some of the questions I wanted to ask as I looked at her
pregnant belly and thought of her wee ones at home. But the answers
to these questions didn't play any part in the court case and it quickly

moved on to the lawyer for the prosecution and the lawyer for the defendant giving us their very short summings-up, in which they said relatively little and certainly nothing I hadn't already taken in. The judge addressed the jury and reminded us of the charge and our duties and of the importance of understanding that if we were to find the defendant guilty then we must be satisfied *beyond reasonable doubt*, not *on the balance of probabilities*; we must rely only on the evidence we had heard in the court; we needed to come to a unanimous verdict; if we'd any questions we were to address them to the court via the foreman. None of the jury asked any questions but one of the young men, the one with a clean-shaven head and a heavy beard, requested to see the drugs. The judge said they would be brought up to the jury room.

In the jury room, sprinklings of chatter broke out as we got ourselves tea, coffee, water and snacks. The usual social programming determined that we each sat down in the same places, and therefore the same groupings, as the day before: the four young people; the four middle-aged women and the older lady, including myself, together; the two middle-aged men and the older man.

I observed the pockets of chatter taking place around the table. The loudest voice came from Spiffy the Southsider who was wearing a dark shirt with a white collar and a suit with wide grey and thin white stripes.

I cleared my throat. 'I think we are supposed to talk as a group maybe rather than have these side conversations,' I said loud enough for Clare and a few others to hear.

'Yes, absolutely, one voice at a time please,' Clare said.

Mr Spiffy made a face at me, everyone else nodded.

There was a knock on the door and being nearest to it, I got up and opened it. The jury minder took one step into the room, smiled and handed me three sealed plastic bags each containing another plastic bag with a half-pound-of-butter size block of brown-coloured

cannabis resin, more commonly known as hash. I smiled at the jury minder, bemused to find myself standing holding a couple of grands' worth of illegal drugs.

'Thank you, just what we needed,' I said. 'Deliberations may take us a while longer!' I winked.

'I bet.' He winked back and laughed before leaving the room and pulling the door closed.

'Well, that's our weekend sorted,' I said as I put the bags down on the table.

Side conversations started again and Clare gently suggested we speak one at a time.

Mr Spiffy jumped in immediately. 'Well, it's obvious, isn't it? Given the value and quantity of the drugs, there was clearly intent to supply.'

'But are we sure that the value that the guards put on the drugs is reasonable?' I asked.

'The cops are notorious for overvaluing their drug finds,' the young man who had requested to see the bags said as he lifted one off the table and examined it.

I turned to one of the other young men, the one with massive red earrings inset in his earlobes, Masai style. I'd overheard him discussing the quantity and value with the others.

He gave a small laugh. 'Well, I've friends who'd get through this much over a long weekend, no bother,' he said.

'There's no way that's two grands' worth,' the other fellow said and the four young people nodded in knowing agreement.

Clare looked around the table for comments from the rest of us.

'I still say there's enough there to say there was intent to supply,' Mr Spiffy insisted before anyone else got a chance to open their mouths.

'I'm not so sure, I have my doubts,' I said. 'What does anyone else think?' I looked around the table.

Aran Eamon, the down-to-earth, good-looking man beside Mr S. tilted his head in my direction, 'I'm with you there. Nothing I've heard convinces me there was intent to supply. I'm struggling to get beyond reasonable doubt.'

'I can't either,' said the older man.

'Me neither,' said the older lady and the phrase 'me neither' echoed around the room from everyone except Mr S. who shook his head, dismissing the rest of us as some class of dimwits.

'I'm just saying it's an awful lot of money to spend on drugs if one of you is on social welfare, the other is working stacking shelves in a local supermarket and you've two children to support.'

Mr Earring shrugged. 'That's just it. I think it's more like a several hundred worth. I don't think any of it is particularly good quality and I don't know any eejit who'd pay two grand for it. End of.'

The seeds of doubt were well planted and watered. We had strayed outside evidence heard in the courtroom, that I could not deny, but in my head the doubt had grown roots. How could even Mr S. not have doubt? Was his ego getting in the way of him admitting to some? As long as there was any doubt, who would want to risk sending a young mother to prison where drugs were possibly worse than on the outside and her with two young children and another on the way?

Clare went around the table again starting with the four young people on her left.

'Not guilty,' they each said.

'Not guilty,' Aran Eamon and the older man both said.

There was a pause and we all looked at Mr S.

'There remains the possibility and maybe even the probability that the defendant had intent to supply but there is perhaps the grounds for reasonable doubt. Therefore, I have no choice but to say, not

guilty.' The way he looked around the table, he might as well have added, 'happy now, dimwits?'

I suspect I raised my eyebrows and gave him a conspicuous look of disdain as the rest of us all agreed not guilty. We had a unanimous verdict which Clare recorded on a piece of paper ready to give to the judge. We called in the jury minder and after a short delay, we were brought back down to the courtroom where formalities ensued. The defendant stood in the box to hear the verdict. When she was declared not guilty, her face remained impassive. She glanced towards the judge before stepping down out of the box, her hand on the rail, her pregnant belly, somehow more conspicuous than before, ahead of her. She tipped her head in her barrister's direction then at a thin looking man who I assumed was her boyfriend. She walked down the centre aisle and out the door with him following. The door banged behind him and I jumped. We were thanked and dismissed and it was all over before lunch.

As Clare and I left the courthouse, we heard a rip-roaring row coming from across the street. The word 'fuck' featured prominently, making up every fourth or fifth syllable; the defendant and her boyfriend were locked in a vicious argument; not in a hug of shared relief as I might have expected.

'You're un-fucking-believable, you fucker you,' she yelled.

'That's fucking class coming from you, you cunt,' he replied.

'Well, there you go…' I said as Clare and I walked on in the direction of town.

'There you go indeed,' she replied.

'You never know.'

'Another world out there for sure.'

I told her I'd been reading a book of essays before we got called up to court and in one, the author, Emilie Pine, had written about a situation that had arisen where an academic, no more senior or qualified

than her, had spoken to her in a public forum in that patronising way some men have of speaking to women, making it all about their looks or their womanhood, rather than their expertise. She had the stage, from which she could have pointed it out for what it was, but had fallen into the old trap and let him get away with it. She was disgusted with him but more so later, she was furious with herself for not calling him on it, especially when she had the public opportunity to do so; she felt she had missed an opportunity to play her part in breaking the cycle of women being silenced by patronising men. This essay was fresh in my mind when Mr S. had sought to assume the foreman's role and I was dammed if I was going to let him have it when there was a perfectly good woman willing and able to do the job.

Clare laughed. 'Thank you, I must remember not to be so quick to kowtow to men in future. Force of well-established habit, I'm afraid.'

'Sadly. And a hard one to break. I'm working on it. In my family, I could be mid-sentence and my husband will say something and they all turn and listen to him. If I do that to him, nobody even pretends to hear me! I've tested this theory more times than I've meant to!'

Clare thought for a moment. 'Yes. Yes, it's the same in our house. What do we do?'

'I think I might start noisily clearing their plates off the table next time – especially if they're still eating!'

'Good luck with that.'

Sunday family dinner was its noisy self. I catered for all tastes and diets: roast Irish rooster potatoes cooked in olive oil; large organic roast chicken; Irish whiskey-baked ham; vegan Wellington roast made with mashed beans and vegetables in a roll of vegan pastry; roast root vegetables; broccoli steamed with toasted sesame oil; vegan onion stuffing; vegan gravy. Everything was gluten free as well because Mr Earth wasn't just vegan but had declared himself gluten free too without ever

having had any medical problems or diagnosis supporting this choice; unless you counted bad flatulence, which I suspected was more closely related to his high Guinness and bean consumption. He insisted that the gluten in Guinness was different. But still I delivered a gluten free dinner because if I was seen to do otherwise, Zara and Mr Earth, more commonly known as Simon Green, would be out the door faster than you could say plain white flour.

Mr Earth had done the Paleo diet from first year in secondary school, gone vegan in the fourth year and two years later, in Leaving Cert year, declared himself gluten free. As I read it, he was the genius afterthought/late arrival of a family of one older sister and two not-so-young parents who were too overwhelmed by the force of his conviction to argue with him. Fortunately, or unfortunately, whatever Mr Earth said was gospel in their eyes; what he said went. His mother worshipped the ground his vegan Doc Martens walked on and always kept in stock all the necessary ingredients to cater for him, whenever he might deign to visit. I wished natural forces would protect the rest of us from the product of such overindulgent parents. I knew I was being judgmental and told myself '*Stop it, stop sounding like Mother – the woman who reared you but you loved to hate*'. I really could be just as big a bitch as her when I got going and I didn't like myself for it.

Despite it not coming naturally for either of us, I'd deliberately greeted Mr Earth the way I greeted most family or friends, with a big hug. In that moment, there it was, the aroma I'd expected, the strong whiff of weed emanating from his oversized, unwashed vintage fleece. I'd taken a silent, slow deep breath, in and out, and turned to offer Zara a hug. After a brief moment of apparent resistance, she'd capitulated. The same smell lingered on her jumper too; proof of nothing, not beyond reasonable doubt!

It felt like weed was everywhere. I'd have liked a drug-free day myself; a day or two where I didn't think, speak or smell so much as a

whiff of the stuff. But, the previous day, Saturday, Stephen had replied to my text and we were meeting up the next day, Monday, as I had suggested. I needed to prepare and I'd spent hours on Saturday doing just that including watching TED talks and other YouTube videos looking for inspiration, looking for how to reach out to a drug addict. My big question was what helped people in Stephen's situation turn their lives around? For most, it appeared that they had to hit rock bottom, to a point that they were incapable of functioning; for others it was some catastrophic event like the death of a friend through drug abuse or a parent dying in despair because they believed they'd failed their drug-addict child; for some it was one significant person believing in them, connecting with them.

By my reckoning, Stephen hadn't hit rock bottom, he could still function at a certain level. We couldn't wait for a catastrophe; another catastrophic event could be too catastrophic for him. I wanted to be the significant person he needed but I was hardly blessed with the best personality for the job; I wasn't a natural cheerleader; I had no knowledge, skillset or experience that made it likely I could do the job the way it needed to be done. In particular, I wasn't known for my diplomacy or my warm and endearing personality; I might be the last person Stephen wanted or needed in his life. But then again, Stephen wasn't spoiled for choice and self-doubt had held me back too often in the past, I needed to get back in the saddle of possibilities where I embraced what I could do rather than focussed on what I couldn't. Matt could help me help Stephen. He had many of the skills I lacked.

As I ate my dinner, I looked across the table at Matt and his Gran, in deep conversation. Mum, whom even I referred to often as Gran, and her husband, Fergal, also called Pops, had always been a massive part of our children's lives. Mum had known Stephen from seeing him in our house or at matches and I had told her about meeting him that week and reminded her of his whole sorry tale. In typical Mum

fashion, in response, she had orchestrated it that she sat beside Matt for Sunday dinner.

'In hindsight, Gran, I should have insisted on going up to his room when I went to his house, I should have looked for him in the places where I knew some of his local friends hung out, the ones I knew who regularly took weed and stuff.'

'Hindsight, Matt, I'm not sure it's all it's cracked up to be. I think if we'd more hindsight as foresight, we'd do less not more!'

'Maybe you're right, Gran.' Matt said, as usual completely tuned into Mum's turns of phrase.

'When you've a few more miles on your clock, you'll realise there's no point in regret – when you regret one thing, you've got to be prepared to regret or let go of everything that happened after that – because everything changes. Think about it, Matt, are you prepared to regret everything after that time?'

I could see Matt mulling over his Gran's words on regret. I'd been at the receiving end of those words myself on a few occasions.

'You're saying if I'd succeeded in helping Stephen, then I probably wouldn't have gone to Canada for the summer, I wouldn't have worked in that gym there and…'

'…and then you wouldn't have met Sophie.' Gran smiled and put her arm around Matt's lower back and her head against his upper arm. 'And we wouldn't be sitting here now having the chats and a lovely dinner cooked by your lovely mother.'

Gran raised her voice a little for the second part of the sentence, looked over in my direction and gave me a motherly wink.

Matt wrapped his muscular arm around Gran making her look small against the well-worked-out size of him. 'Long distance love isn't all it's cracked up to be either, Gran,' he said.

'You'll have to talk to your Mum about that, it's more her area of experience than mine.' Gran and Matt both turned in my direction.

'Oh, don't worry Mum, I've given Matt plenty of tips in the hope he won't make the same mistakes Patrick and I made.'

'Yeah, back in the day when mail was delivered by pigeon – if you were lucky. Bit different these days…' Matt feigned a long yawn.

When Patrick and I had been in our mid-twenties and going out for about fourteen months, I'd headed off to Africa for a year, strangely expecting our relationship to survive the separation. In the absence of a proper phone service in Sudan and before mobile phones, emails, messaging or Skype were a thing, we had broken up within a few months of my departure. Our problem was more than the lack of a good physical communication system; when we did write we hadn't been very in touch with our feelings and there had been too much we hadn't thought about or said. I hoped Matt was more in touch and expressive with his feelings than we had been at his age.

After Matt had met Sophie, a bright and cheerful Canadian, during a summer working in Vancouver, they had planned she would come to Ireland to visit us the following Christmas. Patrick's affair, and my response to it, had put a cat amongst the pigeons and Matt had worried Sophie would get caught in the crossfire. But after the initial dramatics, there was a ceasefire and peace talks, and Sophie had joined us for New Year. We'd liked her, albeit we found her a bit bossy and demanding. Zara had nicknamed her Princess Sophie, a title she used even in front of Matt, which he either chose to ignore or maybe chose to see as a term of endearment. Princess Sophie had made a number of visits since and Matt had been back to Canada too. I wasn't convinced she was right for him. The word precious came to mind too often; I'd never seen her get her fingers wet to so much as wash a dish or seen her without a thick layer of make-up and perfectly painted and manicured nails. Zara told Matt that if he ever married her, he'd have to build a big fat beauty budget into the household finances. And a cleaner, I thought. I feared they'd settle in Canada and he would find

himself stuck in unhappiness there, always playing to her tune, indulging her in an effort to keep the false peace.

As we finished our deserts of vegan meringue and fruit crumble, Fiona stood up and tapped her spoon gently against her glass. She smiled across the table at Daniel and he smiled and gave her a confirming wink. I held my breath: they were only married six months but still…no, probably not; they could be announcing they were moving abroad so Daniel could get some more valuable international legal experience, most likely somewhere like America; it would further expedite his already rapid rise in the direction of partner. Oh dear.

'Mum, Dad, Gran, Pops, Matt, Zara, Simon, we have some news.' She paused. She did drama in school; she knew how to build tension.

Please not America. With Trump in power, you'd hate it. I'd hate it. It's bad enough having my brothers over there and they swear they're moving straight back if Trump gets a second term.

'Now I know Mum that you might not like to…' She looked directly at me, no doubt seeing my face suspended between hopeful anticipation and pure dread. '…that you might not like to be called Granny when you are still so young…'

'Wagon,' I said as I jumped out of my seat and threw my arms around her. 'You're a wagon,' I repeated as I wiped tears from my eyes with my napkin and made my way over to Daniel to give him a warm hug while Matt wolf-whistled and everyone else cheered and laughed.

Patrick stood up to give Fiona a hug too but was beaten to it by a delighted Zara.

Mr Earth sat in his seat, shaking his head in conspicuous disgust. He didn't believe we should be continuing to populate the planet. Well, he was welcome to decide that for himself, the world doesn't need any more baby Greens, contaminating the air with their bad humour and judging everyone to extinction. I believed we needed to take action to save the planet and I willingly played my part but people like

him who sit on their upcycled, high horse of superiority over ignorance could drive me to overpack non-reusable plastic bags, hop on a carbon emitting jet and fly thousands of miles to a landing strip cleared in the Amazon rainforest.

The extremes of those thoughts did not go through my head when Fiona announced her news; I was too wrapped up in the joy of the moment to pay heed to his bad-tempered judgment. It was later when his expression flashed into my memory and I caught myself on my own high horse sitting in judgment of him and I wondered was it the weed that had turned him that way or had he always been a joyless, spoilt git. I suspected the latter.

It took a few minutes after Fiona and Daniel's big announcement before conversation around the table resumed to its normal level. I overheard Patrick tell Fiona and Daniel about how we had announced my pregnancy with her; how he had taken Gran, Pops and me to a nice restaurant where he'd arranged for a bottle of champagne to be brought to the table before our starters so we could celebrate our great news in a manner befitting of such a great occasion. He told them how surprised and delighted Gran and Pops had been and how they had both said what a great father he would be. He paused at that point waiting for Fiona to confirm how right they had been.

I raised my eyebrows and looked over at Gran who was also listening in on the conversation. She raised her painted-on eyebrows in response and I rolled my eyes discreetly and smiled at her; she wouldn't know that part of my smile was because her eyebrows had been drawn one half an inch higher than the other, giving her a delightful perplexed look, but she would know that I rolled my eyes because we both knew and, somewhere in Patrick's subconscious, he presumably knew, that his story was bullshit. My relationship with Mum was very precious to me, not least because I had only found out about her and met her when I was in my mid-twenties. When I had learned I was

pregnant, I'd insisted on telling Mum alone, without Pops or Patrick; I knew telling her was going to be both wonderful and tinged with sadness. Mum was not married when she got pregnant with me and she had been left with little choice but to give me up soon after my birth. She had believed her sacrifice - she had really wanted to keep me - would give me a better start in life. The woman I had grown up knowing as Mother, was my father's wife and when I was young and oblivious to my origins, she had loved to tell me that the first time the nun held me out to her, she had taken one look at me and said, 'My goodness, she's ugly.' Throughout my childhood, she continued to treat me with utter disdain, leaving mental and physical scars which had faded but were there to stay; it was only in the aftermath of Patrick's affair that I'd come to realise that they were still raw, that I had more to learn from them; Mum knew some of my childhood story but I would never tell her all of it, it would cause her too much pain.

When I told Mum I was pregnant, we were sitting beside each other on the bench in her garden and the buds of the first daffodils were showing hints of yellow; we were as one with our legs resting gently against each other and our hands were lightly entwined. I smiled and cried simultaneously as I uttered the three words, 'Mum, I'm pregnant.' I imagine Mum's face mirrored mine as she smiled and cried too; our heads came together and our tears became tributaries of the same river. We sat wrapped in love and nature joined us in our joy, sending splashes of large raindrops to land on us and beside us as we laughed in unison.

It was far cry from Patrick's version of events. There had been a celebratory dinner but that had been weeks later and early pregnancy exhaustion had brought the night to an early finish. I told Mum about each of my pregnancies on that same bench, each at different times of the year and Mum and I called it the budding baby bench. After Fiona's birth, Mum had happily chosen to be called 'Gran' and so it

became that she was called mostly 'Gran' in our family. The baby bench had become mine when Mum and Pops had moved into an apartment; it had sat in the garden of our last family home and when I'd moved house, I'd given it to Fiona and Daniel for their garden, with Gran's blessing.

The version of events Patrick related to Fiona and Daniel was Patrick being Patrick; he had never let the truth get in the way of a good story, especially if he could give it a twist that cast him in flattering light. I wondered if this ability to twist facts to make them more self-serving was a help or a hindrance for him as a lawyer. On some of my more cynical days, I'd teased him that a career as a fantasy fiction writer was a real possibility for him if he ever chose to give up law. On my sceptical days, I wondered what mistruths I'd been told; I doubted that he had sex with Isabel just that one drunken time as he had told me, there had probably been many sexual interactions over the months of their encounters which I had been aware of in real-time from my monitoring of his phone. On my better sceptical days, I asked myself why was I still with him? What was holding me there? He had rejected me once, why was I leaving myself open for him to reject me again? I'd be better off without him.

# Chapter 6

## A Death and Stephen

Everyone had retired to their respective homes leaving only Matt, Zara and me in the house; I put the last saucepan back in the drawer. I half-smiled as I put the one wooden spoon that I owned into the utensils pot; it was one with a smiley face that Zara had given me as a present years ago because I didn't have one. She didn't know that I didn't have wooden spoons because they reminded me of the beatings I'd received as a child; I've no idea how many wooden spoons Mother broke on me; sometimes she made me bend over a chair and pull down my pants and she broke them across my bare bottom; the shame of those beatings goes deep, I can feel it still despite all the work I've done; but I remind myself that it was not my fault; how twisted she was to do that, not once, but often. My father had not stopped her; worse, at her request, he had taken those broken spoons and sawed and sanded them into short wooden spoons that were kept in the drawer alongside all the other utensils. I loved my father; he was a good man; but he had let me down; he had not protected me; his inaction, his alcoholism and his absence had enabled her; I had had him on a sort of pedestal until recent years when I'd come to terms with his part in my prolonged and repeated trauma; but I had forgiven him and accepted that he was doing his best; he knew no better.

Exhaustion swept over me but I realised I had lasted better than before I'd started HRT. The benefits of less broken sleep was paying off. I would go to bed as soon as I'd sent Fiona a message to reiterate my excitement and joy at her news – not that she would have any doubt about it. On picking up my phone, I saw I'd a missed call and voicemail from Máire, a long-time close friend who had been a good neighbour when I was a child growing up in Sligo. Máire wasn't the sort to ring on a Sunday evening without good reason. I sat down on the couch knowing the message would be about her mother, Mrs O'Reilly who was in her mid-nineties and had failing health. The voicemail started in typical Máire fashion: 'Martha, sorry for bothering you on a Sunday night and no need to call me back. I just wanted to let you know that Mam died earlier today. She went the way she would have liked to go, quietly in her sleep, out like a light in the dark. I'm heading to Sligo now. Feel free to call me tomorrow, if it suits you.'

Sadness washed over me; one of the great people in my life had died, a light had indeed gone out. Mrs O'Reilly had been my first saviour; she had been there for me when I was young and at my most vulnerable. She'd witnessed how the woman who I'd thought was my mother had treated me like a skivvy to be beaten. One day when I was about nine, Mrs O'Reilly had challenged Mother about how she treated me and afterwards she had worried that confronting Mother might have made things worse for me. From that day of the confrontation onwards, Mrs O'Reilly had made it her business to look out for me as best she could. When I was in primary school, she frequently happened to be in just the right place to give me lifts to or from school on wet days or even on dry days; she happened to have extra snacks I might like leftover in her car. After I went to boarding school, I still saw her whenever I went home and she'd slip me a few pounds here or there.

*'Sure, didn't I miss your birthday? Didn't I miss you at Easter...There's a good girl, just take it and don't be embarrassing me...you're a great girl, you remember that...very bright and capable.'*

When I was in my twenties, she had told me, 'Go off and chase your dreams now and don't go letting Sligo hold you back...'

Life had conspired to keep the O'Reillys in my life as Máire's and my paths had crossed when I was a volunteer accountant in Sudan and although Máire was a good many years older than me, we had become and remained close friends. As I sat on the couch that night, I felt her sadness at the loss of her mam, they were two very dear, wonderful people who had always been close to each other. Máire had spent her entire working life abroad with the U.N. and wherever Máire went, Mrs O'Reilly endeavoured to visit and spend some time. I loved them both and for that reason, I wanted to go to the funeral but, and it was a big 'but' for me, the thought of going back to my roots made me shudder and shiver as the chill of its ghosts passed through me, pausing with menace before they moved on.

For thirty years, I had avoided going back to the part of Sligo where I was reared. I'd gone out of my way not to go within a fifty-mile radius of it. The O'Reillys had been neighbours, living three doors down from the house I'd lived and suffered in. Mrs O'Reilly had lived in their house right up to a few months ago when she moved to a nursing home. That same house, down the road from where I was reared was where Máire stayed when she went on her weekly trips to visit her mother in the nursing home. Mrs O'Reilly would be laid out and waked there and all and sundry who knew the family would visit to pay their respects. There would be tea and sandwiches and goodness knows what else, alongside plenty of the hard stuff – as they'd say. After the wake she'd be moved to the local Catholic church for the funeral mass and then buried in the church grounds beside her beloved husband. Mrs O'Reilly had been my friend and ally when I'd been

short on friends and allies. Máire was my friend and had been there for me for many years and I for her, in more recent years. I'd often met Mrs O'Reilly when she visited Dublin, both when Máire was around and without Máire. How could I not go to the wake? How could I not go to the funeral? It had been thirty years. I needed to get over myself. My hands were sweaty, my heart was thumping in my ears and my stomach was in a spasm; I was a child coming home from school again and as I turned the corner onto our road, I had that familiar dread.

I told myself I had to go; it would be wrong not to; the only thing stopping me was fear; I'd got past fear before; fear was usually worse than the reality.

It was nearly midnight. I sent Máire a text:

**Dear Máire, I'm so sorry to hear your news. I know you were expecting it but still it will be hard for you, Seán and Martin. I loved your Mam dearly and think she was a great woman and you were a truly wonderful daughter to her. Thinking of you all with love. I'll call you tomorrow. xx M**

I put my phone down on the coffee table and thought, there it is again; Fiona's baby and the promise of new life juxtaposed beside the end of another. For every ending, a new beginning.

I churned this thought of new beginnings around in my head as I tried to sleep; I tried to turn the thought of going back to my home town of bad memories into a new beginning but whatever way I did it, it felt like stoking hot embers of old terrors; terrors I thought I'd dealt with in the years since I'd lived in Africa and afterwards found my real Mum. In my second year in Africa, when I was in Kenya, Mother had died triggering a posthumous letter from my father to be released to me which explained the circumstances of my birth. It had been strangely comforting to know I hadn't just imagined that the woman who reared me had hated me: she *had* actually hated me. She'd

known I was her husband's love child and that, if she hadn't taken me into her home, my father would have left her and somehow managed to setup home with Mum and me. Looking back on my childhood, I knew that every day of my young life I'd spent in our house, a few doors down from O'Reilly's, Mother had punished me for the personal insult of having been conceived, and worse, conceived in love.

I had told Máire that I had no intention of ever going back; I could see no good coming out of it. But Máire and her mother had put themselves out and been there for me time and again. Going to Mrs O'Reilly's funeral was the least I could do.

I could skip the wake if it was tomorrow night, Monday night; I was meeting Stephen in the afternoon and wouldn't be able to get down on time after that. I wouldn't want to rush my time with Stephen; Mrs O'Reilly would understand.

Only the last time I'd met her at Máire's apartment, she'd said, 'Give priority to looking after the living, the dead will be dead for long enough!'

But what could I do for Stephen? What had I learned from my limited research? The best place to start was to be there for him, to listen, to believe in him and to not let him down.

The next morning was wet and windy and the waves whipped over the sea wall, spraying salt water onto Chuckie and me as we made our way along the promenade. There was something about wild weather and the sea that always brought out Yeats' 'To a Child Dancing in the Wind' in me…what need had I "to care for wind and water's roar?" Yeats had spent a lot of time in Sligo and I'd always envisaged his child dancing in the wind on second beach at Rosses Point, my favourite beach because it was long and unspoiled and because it had been a place to escape to that was within easy cycling distance of the house where I'd grown up.

'All that sea spray was as cleansing and rejuvenating as a good spa,' I joked when I returned home after my walk.

'Mum, if that's you rejuvenated, I'm glad I didn't see you before you went out!' Matt teased as our paths crossed as he went out the door to work.

Before I called Máire, I sat drinking a cup of green tea in our sitting room where the morning light gave the room a warm glow, especially the colourful paintings hanging on the walls. A large painting of the winter sun rising over Dublin Bay hung over the mantelpiece; it was called 'Renaissance'. It had been a present from my friend, Celine, who had moved abroad after the end of her horrendous marriage which had included the full spectrum of abuse, going all the way to violent rape. Celine and I'd stayed in regular contact for a year or so after she'd settled abroad and there'd been plans that I would visit her, maybe even with Patrick. In that first year, she'd sent me paintings to sell; I'd had them stretched and framed and after they were sold through a gallery, I'd transfer the money to her account.

Then I'd told her with great excitement, that the gallery had sold some of my paintings and I got a one-word response: 'GREAT!'

After that, nothing, no contact whatsoever from her, no explanation of what 'GREAT!' meant, no response to any of my texts or emails. It gutted me. For months on end, every time I thought about her, I got the after-pain of a sharp kick in the pit of my stomach; time and again I turned it all over in my head asking myself what had I done wrong? I worried whether she was okay in the wilds of Thailand or Vietnam. I could see the WhatsApp messages were opened but no answers came, and this hurt and worried me some more. Eventually, it dawned on me I couldn't change how things were with her, it was up to me to change my response. My engagements with philosophy and mindfulness had told me this but not how to go about it. The theory was easy, the practice was a whole different challenge. I searched

online and in books for different approaches to letting go of the hurt and the need for an explanation. Letting go sounds so easy; you'd think that all you had to do is decide to let go. It took me a long time to find the tools to help me. I found a guided loving-kindness meditation which, with daily practice, helped me to pull myself out of that dark hole and into the light of acceptance without pain. It was a worthy experience, learning to find light within me, especially for times when darkness or anger chose to visit and overstay their welcome.

For all my mindfulness practice, any feelings of loving kindness briefly deserted me when I'd bumped into Celine's daughter, Karen, and learned that Celine was thriving in Thailand. Karen was just back from visiting her and had brought back numerous paintings to sell for her. My feelings of hurt were reignited; after all we had been and done for each other, Celine thought so little of me that she had left me to stew with worry. It was Máire who had suggested a different perspective. She said that Celine was probably trying to rebuild her self-esteem and self-belief, and put her past behind her; to do this, perhaps, she needed to distance herself from me for a while as I had been so close to this painful part of her life. Máire's thoughts struck a comforting chord with me.

In the height of my pain, I had considered getting rid of the painting: every time I'd looked at it, I'd shivered and felt the kick in my stomach; getting rid of it might have helped me forget and put that part of the past behind me. But getting rid of the painting ran contrary to its essence and why Celine had given it to me; back then we had both been in search of new beginnings and the painting's great, big, bright yellow sun rising out of the darkness, shedding light on a new day, was a symbolic promise of our renaissance; a rebirth I believed Celine had achieved but which I was still working on. I often referred to myself as a work-in-progress. To which Mum would respond with a hug and the words, 'sure, aren't we all!'

I hit Máire's number and jumped when she answered before I was aware the phone had even rung.

'Martha, how are you? I've been thinking of you.'

Her mother had just died and she had been thinking of me, it was so Máire.

'Máire, sorry…that was quick…'

'I'd the phone in my hand, I was just about to call the undertaker to finalise arrangements.'

'Oh Máire, that must be hard on you…It's surreal to think she's gone.'

I found it surreal; I wasn't her daughter but I had known and loved Mrs O'Reilly all my life. Without her, who knows what might have become of me; now she was gone and I felt sad and yet conflicted in my feelings, knowing Mrs O'Reilly would have told us under no circumstances, were we to be sad on her account.

'Do you know Martha, it is, and it isn't. She said to me many times, she'd been around long enough, seen enough, loved enough and been loved plenty too. She was ready to go. In fact, she was getting very cross with your Man up above that he seemed to be in no hurry to take her! Every time she woke up, it was the same question, 'What am I doing still here? For goodness' sake!''

I could hear the bemusement in Máire's voice and I could picture her putting her fingers through her short, thick, grey hair just as her mother had done. I felt comforted at this thought as it reminded me Mrs O'Reilly was not gone; she was very much alive in Máire, her daughter and soulmate, and also in all of us whom she had touched and loved.

'Typical.' I laughed.

'Also typical, we have all been given our instructions in her own barely legible scrawl! God bless us. The only delay in finalising arrangements has been in sorting out Rory, one of Seán's three sons. He had

to organise flights home from Australia but he and his family will be on their way soon.'

'Oh dear, I'm sorry, Máire, the instructions might be partly my fault. Remember I told her about my friend Trish's instructions for a funeral which included the who and what of the service followed by good food and drink...'

'Don't worry, it's all sorted. Casseroles, sandwiches and baked hams from the neighbours have been promised by the lorry-load and good Marlborough sauvignon, Rioja reservé and a selection of beers have been ordered. The best local hotel is booked for the meal; she'd already made enquiries and the manager said to me, rather apologetically, all they needed from us was the date and time; she'd have called herself with that if she could have.'

'She would for sure. She did like to be in charge!'

'You can sing it. The last things she said to me were: make it a good fun send off, won't you Máire? And whatever ye do, don't be making a saint out of me after I'm gone, tell it how it was.'

'Oh Máire, I can hear her saying that. Sure, the only way to do her justice is to tell it as it was – like she always did.'

'Don't I know! With mixed success. Didn't she dig herself into a few holes at times "telling it as it was?"'

'Some things needed to be said, even if someone didn't want to hear them...Can I ask when is the wake and funeral? I hope to go.'

I changed the subject because when Mrs O'Reilly had challenged the woman I knew then as Mother about how she mistreated me, Mother's response had been to give me an extra severe beating that night and for a number of nights after, beatings which I never mentioned to Máire. I never blamed Mrs O'Reilly for those beatings, how could I have, she had been looking out for me as was her way and back then, I saw beatings from Mother as my own fault, they were as much part of my life as eating breakfast.

'Martha, Martha, let me stop you there. You have chosen not to revisit Sligo for very good reason, for some thirty years now. I do not expect you to come to Mam's funeral, and neither would she.'

'I know that Máire. But I want to go. She meant a lot to me.' And you do too…'

'Martha, I know all that but I want you to know, we will not be upset if you do not come. Do you hear me?'

'I hear you.' *You sound like your mother.* 'So, when is it…or will I find it on RIP.ie?'

Máire sighed and no doubt put her fingers through her hair again. 'The wake is tomorrow evening officially from five and the funeral is on Wednesday at 11:00 a.m. But please Martha…'

'Máire, we've been good friends for more than thirty years…I know…'

'You can change your mind at any stage…'

'Thank you, I appreciate that, but I will be there. Is there anything you'd like me to bring?'

I hung up and I went on TripAdvisor to find a hotel on the right side of town for the funeral. I booked it for two nights; it was hotel with a name I didn't know and though it was very close to O'Reilly's and therefore the house I had grown up in, it came with no memories, good or bad.

The sky had cleared from various shades of wet grey to a scattering of fluffy white clouds against an expanse of blue by the time I set off to walk the few kilometres to meet Stephen. I was mentally armed with all the information on drug addiction I'd gathered from multiple searches of the internet and I walked slowly, mulling over what I had learned; compassion, no judgment, connection. I was sitting on the bench, contemplating the mess that was plastic bottles and other

rubbish at the edge of the canal, set against the serenity of two swans sailing by on the stilly water, when I heard Stephen call my name.

'Martha.'

I turned and looked in the direction of his voice. I suspect my eyes widened and my jaw dropped before my face turned to a smile as I took in the thin, handsome, clean-cut Stephen who walked towards me. Gone was the filthy, torn trackies and the manky jacket, replaced by clean blue jeans and a white hoodie. Both were on the big size for his undernourished body but still, he looked great.

There was some pride in his stride but apprehension showed in the way he twisted the peak of his cap from one side of his face to the other and in the half-smile peeking out at me. I stood up and spontaneously threw my arms around him.

'You look great, Stephen. I don't know how you did it, but fair play to you.'

'Easy Martha – robbed a shop, I did. No bother.'

Again, my expression must have spoken for me because he hastily corrected himself.

'My bad. I'm only messin', I got them in Merchant's Quay – honest, I swear.'

'I believe you, Stephen. You're one of the good guys. I know that.' I took his elbow and headed us towards the café. 'Come on, I'm starving and I hope you are too.'

We walked in the door of the café with more confidence than the previous time. I chose to sit outside in the warm sunshine in a sheltered corner away from the smokers; this time we didn't need their smoke cover to smother any bad smells. We sat down and I took off my jacket and Stephen removed his baseball cap revealing shiny curls on top, fading down the sides and nape of his neck, similar in style to how Matt and his friends wore their hair.

'There are volunteers who come and cut our hair if we want at the GPO some days.' He must have seen the question on my face.

'I used to cut one lady's hair back when I did the Simon souprun. I volunteered on a Wednesday and if she wanted her haircut, she'd tell Tuesday night's volunteers and they'd put a note in the book…Yours looks like a proper cut though, not one of my poor attempts!'

'Some volunteers are proper barbers or whatever, they do a good job.'

'Poor Bridie, I didn't even have a sharp scissors!'

I'd enjoyed cutting Bridie's short grey hair; the previous volunteer who'd cut it had moved down the country and a little bit of me felt chuffed that Bridie trusted me enough to do something as intimate as cut her hair. I don't mean trusted me to do a good cut; I doubted Bridie had a mirror in the squalid room she lived in. She was a very private person and conversation was difficult, asking her questions about herself felt intrusive and were batted away often with silence and sealed lips. Before I started cutting her hair, all I knew was she was from the midlands and I only knew that because of her accent. When I cut her hair, I got small insights into the many secrets that hairdressers must collect in a day's work; Bridie told me about growing up one of twelve children, in a two roomed house on a three-acre holding. She spoke of having no shoes and the feeling of grass and cold, hard ground under her feet; she spoke of this as if it hadn't bothered her. I suspected they'd had more pressing issues, such as hunger as she spoke of growing potatoes and cabbage and of her brothers using ferrets to catch rabbits, which they sold on for the few bob they got for them; occasionally, they kept a rabbit for themselves and stripping the rabbits of their skin from the neck down had been Bridie's job; the skins and entrails were sold by her brothers but she got to stew the meat with onions, cabbage and potatoes; and a good meal they had then, she said.

She never told me how or when she ended up in Dublin and I never asked.

The older waitress, who'd given Stephen the extra fish and chips on our last visit, arrived over and with a big 'hello' handed each of us a lunch menu accompanied by a warm smile. Stephen thanked her without quite lifting his head and he started rubbing his hands up and down his thighs as if needing to warm them, despite the ambient heat. We took her recommendations of the all-day breakfast for Stephen and the root vegetable frittata for me and Stephen excused himself and made for the bathroom. From my seat, I watched the same younger waitress behind the food counter giving him a look of approval and I felt tempted to spin her a yarn about Stephen being an actor who, the previous week, had been playing the part of a homeless junkie to experience for himself how drug addicts got treated by others; that might make her think twice, I thought.

Stephen returned and sat down on his seat opposite me, crossed his arms and rubbed his hands up and down his upper arms a number of times, he then set both elbows on the table but his hands were in constant movement around his face and hair.

I looked at him, again concerned that the need of a fix might have him jittery. I wondered if he'd taken anything while he'd gone to the bathroom that might settle him.

'Are you okay Stephen?'

'Fine, fine. Just give me a minute. Sorry, I'm having a bad day.'

'Take your time Stephen. I've no hurry on me.' I was relieved I'd nobody depending on me and nowhere to be until I was due to leave for Sligo the next day.

'I'm not a good guy. You said I'm a good guy. I'm not...' He shook his head as if to shake off the shame before bringing both hands up his face, covering both his mouth and his eyes.

'Stephen,' I said, pausing briefly to choose my words carefully.

Stephen's dark eyes peered out from between his fingers.

'I've known you from when you were five until you were over twenty, all your school years and beyond. That's a lot of years of you coming to our house. I know you are a good guy.'

'That was then. I'm not that person any more. I'm not.' His hands were back in action, moving from his elbows to his face to his legs which were also in perpetual motion.

'I believe that at your essence you still are, Stephen. I can see it in you. I could see it last week. I can see it today. You've been through a lot. I know that too. You've suffered.'

'With respect Martha, that's bullshit. It's more like I've caused a lot of fucking suffering.'

I swallowed a gasp. It was rare that Stephen cursed in front of me.

'Come on Stephen, we all cause suffering. We don't mean to but we do…'

'I've done shit…bad shit Martha. I'm just another fucking scumbag. Yer wan over there, the waitress who stuck up her nose at me, she sees me for what I am…'

I reached across the table and took his hands in mine and his shrunken eyes looked at me.

'Stephen, I'm sure you have done things you are ashamed of doing, things that in your worst nightmares you never thought you'd do. But circumstances conspired against you, hurdling you down a path you never thought you'd experience. But it is not a path of no return. You can come back. You can.'

He held my gaze and I hoped that I saw a little flicker of self-belief in his glassy eyes. He nodded slowly, still looking at me.

'You can come back,' I whispered as I slowly took my hands back across the table, sensing the silent presence of the older waitress at my shoulder, waiting to put our food on the table.

We looked at our plates examining the food in more detail than was warranted, then Stephen lifted up the salt cellar and shook it generously over all his food and then he added a generous twist of pepper. As I ate my frittata and Stephen picked at bits of his fry a strained silence sat between us. I didn't know what to say next, every sentence that came to me seemed to contain implied criticism or sounded patronising. I was relieved when Stephen broke the silence.

'How's Matt?'

'Matt,' I repeated his name as my brain adjusted to the change of subject. 'Matt is fine, working away in Temple Street Hospital.'

I told Stephen the story of the little girl who had told Matt in no uncertain terms that she did not like him. He laughed loudly at the bullseye nature of the kick.

'I told Matt I'd bumped into you and he said he'd really like to meet up with you...but only if you'd like to, he said.'

'Matt's sound. He was a good friend. Feckin' messer though.' He laughed again, probably remembering something Matt had said or done.

'Don't I know! He wrecks my head at times, but he gets away with it because I end up laughing right when I'm fit to kill him! Do you remember when you were all young, the two of you were supposed to keep an eye on Zara while I went to the shops for fifteen minutes? I came back and you'd taken her hostage, tied her to the clothes line pole and stuffed a pair of smelly socks in her mouth.'

'I don't think she ever forgave me for that! She got me back the next time I'd dinner with you, she put castor sugar in the salt cellar and I lashed it all over my dinner.'

'I didn't know she did that! Did you eat it?'

'Sure, what else could I do?' He raised one eyebrow. 'How's she these days?'

'In college studying environmental studies and technology. Vegan, climate activist and inhouse dictator on all things environmental…It's not that I don't agree with a lot of what she says, I just find myself inclined towards rejecting it when it's shoved in my face!'

Stephen laughed again. 'Your house was always such a good place to hang in…I loved it.'

'Hah! I wish…You must have caught us on our good days!'

'Plenty of good days.'

'We've moved…You may not have heard. We'd a few bumpy years – like most people, I suppose - but we're getting there.' I didn't feel in a hurry to tell Stephen about Patrick's affair or our other family troubles, all compounded by my shitty menopause and the financial fallout from post Celtic tiger austerity.

'I didn't hear. Shame, you'd to leave that great gaff. Did yous move far?' I could sense the nostalgia in his voice.

'All of a kilometre, around the corner to Saint Margaret's Close.'

'You must miss the old place though. It was cool. The garden was massive…such parties…'

'It was time to move on and to downsize. My body can't do all that heavy lifting anymore.'

'My folks moved too.'

'Oh?'

'Yeah a few years ago.'

'How'd you hear?' I was hoping he'd tell me that he'd been in touch with his folks but the question was no sooner out of my mouth and Stephen's hands went up again to hide and rub his face, and then, his head came forward and his fingers went on up through his hair, delving hard into the depths of his scalp.

'I was in a spot of bother and I went banging on our door one night. This randomer came out and yelled at me to fuck the hell off or he'd call the guards. I said my family lived there and he said, 'well they

don't fuckin' live here anymore so fuck off now, will ya…' so I fucked off…'

I assumed he had fucked off back on to the streets and I thought to myself that back before all this, Stephen never used the 'F' word in my presence; his language had changed from neutral middle class to more Dublinese, especially when he wasn't talking about the old days, the innocent days.

'I can try to find out where they live now if you like…'

'Fuck, no – sorry – no. They had their fill of me back when I was still hanging there. Sure, they probably had to scarper because of me.'

'Oh…' I nearly asked how so, but I suspected I knew the answer. He chose to confirm my suspicions.

'Yeah, I clocked up a bit of debt and the scumbags told me if I didn't pay, they'd call to our gaff. And they did…they smashed three of the front-room windows; with one rock going straight through into my parents' room, sending glass all over their bed and with them in it! Fuck it, the folks went apeshit. They knew it was related to me but I tried insisting there was a lot of it going on in the neighbourhood. Next time, they squirted petrol through the letter box and threw lit rags in after; my father was just going to bed and got the fire out before it spread beyond the hall carpet. My folks told me I was ruining the family, I was a disgrace to their name, that I'd always been fucking useless but I was taking it to a whole new level…they were right. The last time the lowlife that I brought upon them rang the doorbell, they showed my Ma the barrel of a gun…pay up or…The folks had put a bit aside for a new kitchen and I owed half of that for drugs. My Da came and watched me give it over, otherwise he said, the useless git that I was, I'd just blow it all buying more shit and clocking up more debt…He was probably right.' Stephen shook his head at himself and sighed. His voice was gravelly and he rubbed his nose with the heal of his hand every so often.

I've no idea what expression I had on my face but I was shocked to silence so he continued.

'I handed over the dosh and my Da yelled at me, really loud, loud enough for the scumbags to hear – 'That's it, Stephen. We're done. No more. Yer Ma packed this bag here for you. Don't come home again. Ever. Unless you're totally clean, debt free and ready to earn a living – which will never happen looking on the way you're going.' At first, I thought he was messin', you know putting on an act for those scumbags. But when I looked at his face, I knew…I picked up the bag and legged it, swearing to myself I'd go clean, I would. I'd stop. I would…That never fucking happened…and I've not seen him, me Ma or me sisters since.'

'Oh shit, Stephen. That's rough. Rough for all of you.'

What were his parents supposed to do? What would I do, faced with smashed windows, fire, guns and an unending fear of what it might be next? No easy answers when you've other children to protect.

'What did you do?' I asked.

'I went to me mate's, he'd a free gaff as his folks were away. I tried go cold turkey but I couldn't hack it, the shivers, the puking, the headaches. I thought I was going to die. Me mate takes some himself and he got me a bit of grass and some poppers and whatever you're having yourself. By the time his parents came home, I was back up to my oxters in debt…it's been the streets or Merchant's Quay ever since…going from one thing to another…going nowhere fast.'

What could I say to him? How was I to respond? The look of self-disgust on his face was heart breaking. I put my fork into the last bite of my frittata and brought it up between my lips. I moved it around in my mouth until I could bear to swallow it. I thought of asking Stephen if he wanted to change but that was a stupid question; of course, he wanted to change. He clearly hated his current existence going from one fix to another, living in doorways, on a random bed in a shelter if

he was lucky, or on a rolled-out mat at Merchant's Quay. He probably thought that he couldn't change. How could I convince him otherwise?

'I don't know what to say Stephen. I really don't. I mean, have you sought help? Have you talked to anyone, a counsellor maybe?'

He shook his head. 'Martha, speaking to a counsellor won't fix the shit I've done. It's worse than I've said already.'

'Maybe it is worse but...'

'But nothing. I'm fucked.'

'I don't accept that, Stephen. I just don't. Others with half your brains have got themselves out of worse messes. You can too. That is, if you want to...'

'I might only have half me brains at this stage, that's if I'm lucky, like.'

'Well, half a brain's better than none, especially half *your* brain!'

'Thanks for your vote, Martha but...I'm fucked in more ways than that.'

I realised I was hitting a brick wall so I tried another tack.

'Okay, Stephen, let's say you're fucked but based on our conversations, we accept that you still have a functioning brain. Right?'

He shook his head.

'You think I'm not capable of judging if you have a functioning brain?'

'I didn't say that.'

'Okay so we accept that you have a functioning brain and I have one request to make of you...'

'Yeah.'

'Before we meet next week, I want you to see what help you can get from Merchant's Quay, you know, set up a counselling meeting or talk to a key worker. They know more about what's going on for you than I could ever pretend to know; they can tell you if you're totally

fucked or not. So, set up a session and attend it when it comes up. That's all I'm asking.'

'One session, that's all?'

'One session.'

'Hmm. I might.'

'Stephen…'

'Okay. Okay. I'll do one session.'

'Thank you. I appreciate it.'

'You're one tough lady.'

'I'll take that as a compliment.'

'Yeah, sure.'

We both made a laughing sound. But I saw no laughter in his eyes.

# Chapter 7
## The Wake

**Tuesday**

That night, I ate a light dinner, alone, except for food-obsessed Chuckie. Afterwards, I watched the second part of a documentary on Putin and I wondered what had my expectations of world leaders been reduced to that I was no longer fazed by the Russian leader's blatant disregard for justice or even the pretence of moral scruples: anyone challenging his totalitarian rule was likely to be murdered, video evidence of conspicuous election fraud made no difference, he'd publicly celebrated his electoral success before the count was in, he had plans to rewrite the constitution so he would hold power into his old age. It was like watching a dark comedy, the truth was so far out there. Rumours of Russian interference in the US election in Trump's favour still seemed likely to be true and look what that election had done for America: out with Obamacare, in with increased conspicuous racism; lower taxes for the wealthy; more neglect of the poor and the vulnerable – the very people who voted for Trump and would vote for him again. I didn't dare turn over to the news because that would invariably be wall to wall Brexit and how the Brexiters were still promising to conjure up a magical solution of creating an economic border without breaking the Northern Ireland peace agreement and recreating an actual 'hard' border that would again split our little island into two

distinct parts. Like most people in Ireland, with no working agreement yet reached, I was all Brexited out!

In bed, I read until the weight of my eyelids became too much and the same sentence had flashed before my eyes three times without a single word going to my brain. Turning off the light had the effect of sending my mind into overdrive with an unending whir of questions: how could I help Stephen if others who actually know about drugs hadn't made any progress? How bad an addict is he? What drugs does he take? Does he do heroin? If he does, does he smoke or inject it? Seemingly, many heroin users never inject; there's some sort of hierarchy of users. What had I read about burning heroin on tinfoil or a spoon and chasing the dragon? Has his family ever gone looking for him since that day his mother packed his bag? I imagined that they had or, at the very least, had made enquiries. Should I get in touch with them or had they drawn a line in the sand and said enough already, he's not for changing? Just as, almost thirty years ago, I swore never to have anything to do with Jim, Margaret or Robyn, my half-siblings whom I'd grown up with – my flesh and blood who had trampled on me with Mother's blessing – the memory of their endless bullying and putdowns had tears streaming down my face. I thought I was over it but here I was crying again after thirty years of not seeing them. How could they still get to me? Me, a grown woman, a mother, soon to be grandmother…And Margaret had moved back to Sligo after her marriage broke up, Máire had told me; I hadn't thought of that when I'd said I'd go to the funeral, I'd have to stay out of Sligo town to avoid the chance of meeting her.

I'd been caught in this trap of endless thinking and catastrophising many times before and recently, I'd found an effective solution which I often used; I reached for my tablet, turned it on, tapped audible and selected, *Wherever You Go, There You Are*, I tapped play and set sleep mode for twenty minutes. No need for earphones when you sleep

alone, another perk of separation. Slowly, John Kabat Zinn's dulcet tones lulled me off to sleep.

Between the stresses and strains of austerity, followed by menopause, followed by the trials of post-menopause combined with family turmoil, I'd long since given up expecting an unbroken night's rest. I'd told Máire if I ever again slept through the night, I'd wake up thinking I was dead. That night, I was first woken by the fright of a sudden fall and was surprised not to find myself in mid-air. In my dream, I'd been skiing dressed as a well-worn Christmas fairy and had gone off the edge of the slope. I woke up at the moment where I was surmising whether I'd land on top of a tree or in a pile of snow. As I turned back on John Kabat Zinn, I wondered which would be more becoming, the tree or the pile of snow. Two hours later, I was driving with no lights on and I drove right up a mound which appeared in the middle of the road. Again, I went into mid-air and woke before I could see how I landed. My mind started to try to analyse the two dreams in the context of what lay ahead of me the next day but rather than go down that rabbit hole, I again sought the calming tones of JKZ.

With a pull of the blind, morning sunlight flooded the bedroom and I felt more invigorated than I expected after my night of intermittent sleep; I would get on the road sooner rather than later; the forecast was good, I would watch the sun go down over Sligo Bay and reconnect with some of my happier moments there. I had photos somewhere of spectacular Sligo sunsets which had brought me joy; a great red ball of sun sitting above the bay, shimmering its light over a calm sea, skies of yellows, reds and purples blending into the horizon…If I left early, I'd have time on my side, time to reacquaint myself with the places of my youth, time to process the good and the bad.

The journey was very different to what it had been thirty years ago. There were no motorways heading west then and not much in the way of even dual carriageways. Places like Kinnegad, Mullingar and

Longford were now by-passed; after Longford the road brought me through Newtownforbes, the village of the Sisters of Mercy boarding school where Mother had booked a place for me; if I'd gone, I'd have been the only protestant there, a minority of one. It was the perfect place for me, Mother had insisted. I'd overheard the argument but had not understood the innuendo. It had been more than a school, I'd found out years later; it had been a laundry, a laundry where 'fallen' women were sent to be cleansed of their sins through hard work and no pay – a form of slavery dressed up as penance or kindness. Their babies were taken from them, often for money, and given to the holy nuns. No mention ever made of fallen men who were free to put their sins behind them with the women and children hidden out of sight. Sisters of Mercy, what a misnomer where pregnant women and illegitimate children were concerned!

I drove slowly along the short, straight main street expecting to see the large ominous convent school which had dominated the village for generations; there it was not; gone too were the laundry buildings that had existed behind the school's innocent façade. I stopped the car and took in the blank space, disconcerting in its absences, reduced to a level site ripe for development. Only the sad remains of a billboard were left standing:

**Comin so  - LARG  F ur Be roo  H        .**

Good luck with that, I thought, shivering at the history and the wrongs that had been reduced to this new false promise. Any misplaced appetite to live on the site of a former laundry, in a small village in county Longford had probably died with the Celtic Tiger.

The school I didn't go to was gone. I didn't go because, for once, my father overruled Mother's wishes and had insisted I went to the same private, boarding school in Dublin my half-sisters had gone to. Without this rare intervention by my father, who knows how my life would have turned out. Boarding school in Dublin had been good to

me. It had put me on the other side of the country from Mother; it had taken me out of my role as family dogsbody.

In Rooskey, I stopped by the wide stretch of the Shannon, walked briefly along its shores, ate a couple of homemade flapjacks and drank a cup of coffee from my flask sitting on a bench watching the river flow past before I continued on through Roscommon and over the gentle hills of the Curlew Mountains, laughing to myself at the small blips on the landscape that we Irish called mountains.

A one-way system brought me through Sligo town; many of the old familiar buildings were shuttered; there was a smattering of new shops and cafés on quiet streets. I could see up a hill that a supermarket and other shops had been built on the periphery of the once bustling town, creating the same doughnut effect I'd seen across Ireland. I felt no urge to explore further, not least because I had no desire to meet Margaret.

On the far side of town, I made my way along the old familiar, long, low bridge. The tide was just high enough for the sea to be visible either side of it. I opened the car windows and felt the fresh breeze on my face, I inhaled the salty air and licked my lips and felt gratified; the sea, its presence and its many moods forever my comfort blanket. I knew I would need all the comfort it had to offer and more.

The nearer I got to my home townland, the faster and louder my heart was beating. By the time I turned into the hotel grounds, sweat poured down my face and my hands were glued fast to the steering wheel. Slow it down, Martha, slow it down, I told myself as I pulled into a parking space as far away from other cars as possible. I sat and stared at the empty spaces taking long deep breaths, in for three and out for six, imploring my mind to take control of my sweat glands and stop the flow washing around my eyebrows and down my face.

This wasn't a plain old menopausal sweat; this was post-menopause heavily laced with anxiety. No mascara was a match for it and I knew

my eyes would be reduced to two black splodges. I pulled down the vanity mirror and used a clean tissue to mop my brow, attempting to cut the sweat stream off at source. My menopause may have passed in that useless medical version of the term, which describes it as some magical moment in time when a woman has had no period for one year, but my endless curse of persistent sweats was always at their worst in times of stress and had only recently been curtailed by HRT. I dabbed around my eyes aiming for what I imagined to be that smoky, moody look that Fiona had once said suited me.

I had landed on home territory. What did that mean? It meant it was time to walk tall and look Sligo in the eye; time to pretend I had risen above the burden of the worst of my memories of growing up there. I would do what I often did. I would focus on the hotel décor and other inconsequential things that held no emotional trigger. Part of the façade of the hotel, I realised was familiar, having been the front of a much smaller hotel when I was a child.

I took in the hotel lobby, newly refurbished I decided, with its various shades of grey on the floor and walls providing a sombre backdrop to large bright paintings and a miscellany of loud coloured chairs and tables. It didn't set a relaxing scene in my heightened state, but it was comfortable enough, and a seat by the window offered a more peaceful spot for the falafel wrap I'd chosen for lunch than the bar, where noisy, large-screen TVs were impossible to avoid.

My bedroom had similar décor to the lobby but with less colours screaming in conflict with each other. I slowly unpacked, putting a few things on hangers and sorting my toiletries. I was faffing around, delaying the anticipated joy of seeing the beaches of my memories; I wanted to savour my first sight of them after thirty years, or perhaps, I feared that my fond memories would be at odds with the current reality.

I drove out towards Deadman's Point and parked near what was a new, larger, and fancier yacht club than the one I had known. I wondered what other changes might greet me as I made my way across the grass and down onto the rocks. I smiled with relief to see the much-loved Metal Man still standing, pointing ships in the direction of safe passage, away from the dangers of rocks and currents. Nelson's Pillar, in Dublin, by the same sculptor, had not fared so well! Woe betide any sailor who ignored Metal Man, as many a sailor had discovered when finding themselves pulled onto Deadman's rocks. I walked along what I remembered as a cliff path but what time and nature had rendered cliff-less. I stood on the dunes and looked over first beach, the sea had retired far into the distance and the beach was shorter and fatter than I remembered. Where were the cliffs that had separated first beach from second? An uneven rocky promontory was all that remained. I had not grown physically in my thirty years of absence, but everything before me was smaller and somehow diminished, even the sea itself.

I walked down through the dunes along what was now a short concrete path onto first beach. I remembered my times sitting on the absent cliffs, inhaling the sea air, soaking up the comfort of the sight and sound of the sea, marvelling at how small boats could disappear between the rolling waves. I remembered wishing I could disappear too. I stood on the rocks and looked left, towards Coney Island with its own treacherous currents, and right, towards Lissadell House where I had often imagined Yeats, in the Gore-Booth's dining room, sitting wearing a curmudgeonly demeanour, engrossed in deep political or intellectual discussions with the sisters; '*Two girls in silk kimonos, both / beautiful, one a gazelle.*' Why had I decided Yeats would have had a curmudgeonly demeanour while being entertained by two beautiful girls; perhaps because I believed he must have been permanently unhappy as his love for Maud Gonne had been forever left unrequited.

I stepped down from the cliffs of my memory onto the soft sand and faced the long and welcoming expanse of second beach. As I walked along it, I marvelled again at the ocean, ever present but not innocent or reliable. I wished that the tide was further in, I had planned to paddle at the water's edge, where the cold blue waves turned to soft, shimmering, bubbly white.

Renewed and revitalised by the sea air and the whipping wind by the time I sat back into my car, I decided I would not visit the village for fear of what it might have become since I had left it. Yet when I reached the turn where I might have avoided it, my decision was subconsciously abandoned and I took the high road straight through it. The Celtic Tiger had been and left its scars. I parked at a large, sad looking block of apartments standing where there had once been a friendly, family shop which had been both a meeting place and a grocery store; the restaurant on the ground floor of the apartment block looked abandoned; the hand painted signage, 'The Restaurant' was flaky and the tape holding the faded menu to the door was brown and crisp.

I walked on, seeking out the other, smaller shop and some of the eight or more pubs that had once made up the village. I found the shop remodelled as a home and the same was true of a number of the pubs too. I wasn't much of a pub goer but Austie's was a welcome sight. It was larger and bolder than I remembered it, white and bright on the exterior with an array of well-loved hanging baskets and window boxes, all spilling over with colour. I smiled at the joy and abundance of them and walked through the friendly, battered old door and into a place that had kept its spirit. There was a smattering of customers at the bar and with a nod and a smile, the barman took my order for a glass of Cidona. I chose a table by the window, looking across to Oyster Island and sat and wondered if I'd ever walk or drive across to the island. It was about finding the right timing of the low tides and I

knew tell of many a person who got stuck there waiting for the next low tide, or worse misjudged it so badly that their car got stuck in the incoming tide and had to be towed out after the tide had turned.

The O'Reilly's home was officially open for visitors from 5:00 p.m., though Máire had suggested I could arrive before five if I wished. I wanted to blend into the crowd and feared if I went early, I'd be a conspicuous, awkward outsider, intruding on close family time. If I arrived later, I might have to face not just some of Máire's friends and wonderful, immediate family whom I knew well, but also people who might recognise me and who had known my family.

Known my family. Hah, how could anyone have known my family when those of us in it, barely knew who we were? My half-siblings might still not know that we were not full siblings. I hadn't seen them in over thirty years, and I hadn't heard from them since the year before Mother had died. It was after her death that the posthumous letter to me from my father told me that Mother was not my real mother, news that was confirming of something that at some level, I'd always sensed, or perhaps hoped, because how could a mother treat her own child the way Mother treated me?

As a child, I made up elaborate daydreams in which it turned out that Mother was not my real mother and where my actual mum was off saving other people more in need than me, but she would come back for me, she would accept me as I was, and she would love me. These daydreams were part of my disconnection from my reality, they were part of my self-preservation at work, protecting me from the pain of feeling unwanted and unloved; unfortunately for me, when this disconnection no longer served me, I continued to practice it. I still catch myself observing my life as if I am a disinterested third party.

The hotel I was staying in was no more than a half hour walk from O'Reilly's, out the hotel gate, then right along the same road I'd walked from school on the days that Mrs O'Reilly didn't miraculously

happen to be there to give me a lift. As I walked the much-changed road, I shivered, feeling the pinch of the sea breeze that was threatening to bring rain. I passed a small dense woodland behind which nested a statement house, conspicuous in its sheer scale and its grander and out of proportion porch; I remembered the old white farmhouse that had stood there, pleasing in its perfect portions. Beyond the wooded area, close and openly exposed to the road, I came to a row of six new houses, all on the same modern, square theme of flat roofs, white walls and large picture windows lighting up upstairs living rooms with views over and across the road towards the estuary. Those without blinds provided pleasant snippets of their occupants' lives: a lady cooking dinner in a silken, blue sleeveless-dress with a slit revealing long slender legs truncated by a pair of big, fluffy, pink slippers; a young man, muscles and cheeks bulging as he counted his press-ups before dropping his sweaty body with a splatter onto the exercise mat; a teenager slouched on a chair, her mud-packed, determined face turned towards her phone, both thumbs moving rapidly across the screen. Real scenes, real people, not the version one usually sees posted on social media.

I enjoyed the distraction of these thoughts and observations as I neared the right turn up to O'Reilly's and the house where I'd been reared. It was at this corner that Mrs O'Reilly used to let me out of her car, away from where Mother might see; Mrs O'Reilly, the first person who helped me believe that I might be worth loving; Mrs O'Reilly's death, the reason I had returned to where I had sworn I never would. The narrow turn that had run between two ditches, leading up a grass-lined, dark bóithrín was no longer narrow, but was a proper road, cleanly tarmacadamed with white centre lines and paths either side. Street lighting continued up the incline past new houses on either side. Our houses had been big in their day, but these were of a different scale; like the ones on the main road, these houses were designed to say, 'look at us, we've arrived.' This was the stretch of the

road I'd walked along each day after school. It was at this corner, where I now paused, that the dread had settled into the pit of my stomach: what great wrong might Mother accuse me of that day; what horrible task might she have dreamt up for me.

For years, I'd felt sympathy for my father, trapped as he was in a loveless marriage. But he'd had his escapes, or maybe it was his own well-practised means of disconnecting from reality, by-passing the unpleasant truth through long hours of work, golf and rugby; all washed down with copious quantities of alcohol. It had taken me until middle-age to realise that all Mother had was her much-treasured place in local society, and that was only hers as long as she was married to my father, the local bank manager. If he'd left her for my Mum, as he had wanted to, Mother would have been stigmatised, even ostracised. It would be better for her if he died as he did many years before her, at least then she could enjoy the respectability of widowhood. If he had left her, he would have lost his job in the bank and my wonderful Mum would have lost hers there too. Mother's father as Regional Bank Manager had the power to see to that. Mother told Dad if he stayed, she would 'take me in as one of her own' – words from my father's letter – it didn't quite work out like that.

I had promised myself that I would never allow myself to be them, never would I be trapped in a loveless marriage. Perhaps, if I had not made that promise to myself, not had that fear of repeating history, I'd have had a more measured response to Patrick's affair and not kicked him out without at least giving him the right of reply. Perhaps, I should never have married self-centred Patrick in the first place.

I sighed and felt that old bad feeling settle in the pit of my stomach as I walked up the road. On my left, the row of houses stopped, and I was relieved to see the fairy fort where I'd often sought refuge, still standing in the remains of a green field. The fairies would have made their displeasure known if it was otherwise.

My half-siblings had taken their lead from Mother in how they treated me. My father was rarely around but when he was and Mother wasn't, there were quiet ways he looked out for me; dishes he would wash, meals and chats he would have with me. This was how I remembered him and how I knew he loved me more than he'd ever said. I'd wondered that I'd never blamed him for letting Mother treat me the way that she did. A friend summed it up best when I asked how he felt about how his father, who had regularly beaten him:

'Ah, me Da, he drank too much, too often, he was just my Da.'

Dad didn't know how to do anything other than what he did. Perhaps, the same was true for Mother. Perhaps, she did not know how to treat me other than like a skivvy, to beat me and verbally abuse me, me – her daily reminder that her husband loved another woman, not her. Her hurt and frustration had to land somewhere and I was the ready target. These thoughts, which I guess amounted to a level of loving kindness towards Mother, had come to me in recent times and I felt I was moving closer to forgiveness. As a child, hidden in the fairy fort, my ultimate wish was a variation on my daydreams and had been for the fairies to cast a spell which would make my siblings and Mother disappear, and send me new siblings and a mum who would love me. I had never expected that the fairies would eventually deliver both. I now had a Mum and two brothers who loved me. My 'new' and much younger brothers lived in America, but we talked often on the phone, and they usually came home once a year and it was always a joy to spend time with them and their families. I had much to be grateful for.

Yes, I told myself, it was time to face my past and move closer to complete forgiveness.

The pain in the pit of my stomach eased with these thoughts and I held my head higher as I reached the final right-hand turn into our short road. Trees were bigger, hedges were taller, and the houses

smaller and no longer all painted shades of off-white. All were various hues of fashionable grey; all except for O'Reilly's which was a warm shade of milky green. I propelled myself past O'Reilly's neat front garden, my eyes looking to the end of the road, where our house had stood back from the rest with its extra-long and wide front garden. I stopped and stared; nothing of our house was visible. I moved forward to where the entrance to our driveway would have been, and I came to a stop at a half-shut gate in the unpainted hoarding which now surrounded what had once been our garden and orchard. I pushed the gate open. Our house was gone, all the trees were gone, and all that was there were two acres of freshly turned soil, broken up by five flat slabs of concrete with random pipes and wires pointing skywards: the foundations for five new houses. I closed my eyes and our house was there, half hidden behind two large copper beech trees, first dark and full, and leafy in their summer attire, then turning to yellow and ochre for autumn as they slowly shed their leaves and nuts around them…When I opened my eyes, the trees were gone and there was only the blank hoarding. Why hadn't Máire told me? Perhaps she thought it better not to. It wasn't as if she had expected me to come and see it for myself. My heart was thumping against my ribcage. Slowly, slowly, I told myself. Swoya, swoya, the Arabic words coming to me as they often did, bringing me away from a present moment, back to my time in Sudan. The house of my horrors was no more. What could I do with that thought?

Behind the walls and doors that no longer stood, I'd spent the best part of the first eighteen years of my life. It was there that Mother and my half-siblings had filled me with dread. I rarely said their names. If I heard a whiff of my birth surname, I ran from it. I mostly avoided social media for fear some familiar face from my half-siblings or their families would appear. Occasionally, it crossed my mind that our children's paths might cross in work or in college, but I consoled myself

with the thought that their children would be much older than mine making it less likely. So many words that had been hurled at me in that house came to mind: weirdo, thicko, useless-good-for-nothing, long-nosed witch, and, my favourite, *Cinderella*, – they thought this particularly funny, and secretly, so did I, coming as it did from my not-so-pretty sisters. I half-laughed and then I shuddered as a muddle of memories flooded my head; memories of how I'd been treated in that house, memories of the beatings and the insults that I had for years chosen to pretend never happened. It was the counsellor who called the denial of memories a form of self-preservation, she said that our subconscious minds might choose to forget rather than remembering and repeating the sense of suffering.

The slamming of car doors snapped me back into current day reality. I looked at my phone and it declared it to be 5:05p.m. and that I'd two text messages and some WhatsApp messages. One text was from Stephen, thanking me for lunch the previous day and saying he hoped I didn't think he was rude when he'd rushed off. He also said he hoped to see me next Monday as I'd suggested and that he'd booked an appointment in MQ. I responded that I hadn't thought him at all rude and I was delighted he'd made an appointment and I looked forward to seeing him again. The second text was from Patrick, wondering if I wanted to meet for dinner at the IFI on Friday and then go to a film there afterwards. I told him:

**Sounds good but not one of those dark arthouse movies, I've enough of that in real life at the mo.**

There was a WhatsApp message from Zara in the family group chat:

**I wont b home 2nite. urgent climate issues. plz look after Chuckie, Tnx**

Matt responded:

101

1 more night of climate inaction wont save so much as an ice cube from melting, so Zara, for once, look after the dog that you claim to love, otherwise...there followed an emoji of a dog, that looked remarkably like Chuckie, stretched out on a dinner plate set between a giant size knife and fork.

Patrick responded:

Hmm, presented that way, Chuckie does look good enough to eat but perhaps if I walk him he'll be more digestible. Need keys please and C U Matt at the house later for dinner – there followed a copy of Matt's emoji of Chuckie on a plate.

Matt gave the thumbs up.

I ignored their attempts at rising me and simply posted my thanks to Patrick and Matt and wondered how long it would take before Matt or Zara would – either politely or not so politely, depending on which of them it was – tell me to give my legally-still-husband a set of keys for the house. I'd cross that bridge when I was ready.

The front door to O'Reilly's was wide open and I pushed the inner door and stepped into the wide hall. I'd never been in O'Reilly's house before. I'd never had reason to be, not even before Mrs O'Reilly and Mother had fallen out when Mrs O'Reilly had challenged Mother about how she treated me. Vibrancy, warmth and caring had been at the core of Mrs O'Reilly and it was clear her home reflected this essence. A thick hall carpet in rich, dark green sat calmly beside the muted shade of green on the walls, above the old rosewood hall table hung a large framed print of Millet's *The Gleaners*, and opposite was a faded print of *The Angelus*. The soft light and reverence in both paintings exuded a warmth befitting of the O'Reilly family as I knew and loved them. I felt a strange and unique urge to bless myself, but the protestant in me stopped my right-hand mid-flight, and I laughingly wondered if the urge had come from the Catholicism embedded in my DNA from my Mum's side.

Voices rumbled from the back rooms and sporadic laughter occasionally broke the rhythm of it. One man's guffaw invariably rose above the others, triggering a communal silence in its aftermath. The guffaw was pleasingly familiar. I quietly cleared my throat and waited for the voices to resume before making my way to the back room. My entrance was blocked by a huddle of three women and a man, all more north of middle-age than I was; happily, none of whom I recognised. As I waited for them to notice me and let me through, I could see Máire's head of grey hair bobbing in amongst other heads. An intense conversation continued in front of me until a funny memory of Mrs O'Reilly telling a teacher how he might teach Irish to the uninitiated caused a burst of laughter and the resultant movement gave me an opportunity to mutter 'excuse me' and squeeze by, making myself as small as possible as I went.

'Sorry, sorry,' they chorused and echoed. 'We didn't see you there.'

I nodded and smiled, or grimaced. I'm not sure which. 'Sorry, sorry' I repeated as I moved between other small groupings.

In a corner, across the room, I spotted Máire's two brothers, Martin and Seán, laughing heartily in that comradery way that they had. I'd met them regularly over our adult years, including at Seán's wife's funeral early the previous year and at a more recent sixty-fifth birthday dinner for Máire. It was Martin, the more slender and older of the two whose guffaw I'd recognised. He looked up, smiled warmly in greeting, before stepping forward, throwing his long arms around me, and holding me tight, squeezing my tears to overflowing.

'Martha, Martha, it is so good of you to come. It means so much to Máire, to all of us. Mam would be chuffed.' He pulled back and looked into my face. 'Are you okay? I'm sorry. It's tough on you.'

'I'm sorry for crying. I'm sorry for…for your loss…' I shook my head at how lame I was sounding. I dabbed my eyes and I looked from Martin to Seán. 'I'm sorry. She was a great woman.'

Seán reached his arm around my back and pulled me affectionately into his bear of a body. My face was quickly buried in his woolly sweater.

'Mam always said you're a great woman yourself Martha. And don't you forget that. Sure, we all love you, you're practically one of the family.'

Chuffed and embarrassed, I gently wriggled lose and looked at both of them with a half-smothered sniff.

'Thank you, that means so much to me. You all have her kindness.'

'Martha, you know the rules, don't you? No making a saint out of her now!' Seán said.

'I forgot.' I laughed. 'But she was always a saint to me!'

'You didn't have to live with her. She'd an opinion on everything and if you weren't for her, you were agin her.'

'Don't get us wrong,' Seán added. 'We loved her too but by goodness, you ne'er wanted to get on her wrong side.'

'And you never did Martha, you could do no wrong in her books. You could say things to her the rest of us would get killed for…it was even okay for you to vote for Labour or the Greens – you had your own good reasons – but if we mentioned voting for anyone other than *Her Party*, we'd be banned from being buried in the family plot! Isn't that right Seán?'

'Sure is, if we backed the wrong horse in Mam's righteous opinion, we could be banned not just for life, but for death too. But you were her angel.'

'I'm no angel, and I know it.'

'Can't argue with Mam. She said you're an angel, so you're an angel, end of story!' Seán said.

We laughed and I felt myself brimming with their love. And then I wasn't laughing, I was crying, a deep, overwhelming cry. The more I tried to stop it, the more all-encompassing it became; my whole body

trembled and I felt my knees threaten to give way. I anxiously looked around for a means to escape, even a chair in a corner to sit on. I didn't want to make a scene. Where would I sit? Where could I go? I felt Seán's large woolly arm around my back and he gently steered me through the kitchen and out into the garden, where he sat me down on a bench in the spring sunshine.

'You stay there, Martha, I'll get you a drink. Tea or something stronger?'

'Strong tea with a splash of milk please,' I mumbled.

I sat there contemplating my hands on my lap, wishing I hadn't come to O'Reilly's house and imposed my overwrought response to being back in Sligo on them. I should be there looking out for them, not the other way around. I managed to stop crying and hiccups took over.

Seán appeared holding a tray with two mugs of tea, a glass of water, a plate of sandwiches, some large homemade cookies, and a thoughtful, small box of tissues.

'The neighbours have been busy,' he said as he put the tray down in the middle of the bench and sat down.

I responded with a hiccup and a nod. I picked up the glass of water and drank it in rapid sips without pausing.

'Sorry Seán, I can't cry without hiccupping.'

'That's okay,' he said with a smile.

'I shouldn't have come. I thought with thirty years having passed, I'd be…I don't know…over it…immune to it…or something. I guess I've a bit more processing to do. I should be comforting you guys…'

He stopped me with a gentle but emphatic shake of his head. I felt the tenderness in his eyes touch my heart and my soul in a way I didn't remember ever feeling from him before. He handed me a tissue and I wiped my eyes and nose.

'Martha, whist. Be kind to yourself. Of course, coming back is huge for you. How would it not be? You're very brave to do it. You did it for Mam and for Máire and for us, and we appreciate it.'

'Thank you, Seán.' I swallowed hard.

'We're in this together, Martha. Mam wouldn't have it any other way. You know that, don't you?'

'I do. Thank you for saying that. You've had so much to deal with yourself, what with Jackie passing just over a year ago and now your mum. How are you coping?'

'We're getting there, in our own way. Only myself and Seánín left at home and he's barely there. You could say standards have slipped. Jackie would not be impressed!'

'You always said you married your mother!'

'And turned out like my father...'

'A good match so...Jackie, your Mam and I had some great laughs together.'

'Don't I know – last night we were remembering the time you both took Mam to The Ploughing Championships!'

'Your Mam put us to shame that day, dressed in her hat and heels as if ready for Ladies Day at The Horse Show, and then pulling an umbrella, rain jacket and boots out of her magic bag when the rain and mud came.'

'Ah sure, she was a magician in her last life!'

'That's for sure.'

'I do remember collecting the three of you after the actual Horse Show, it was when Ireland won The Aga Khan.' He was smirking as he spoke.

I blushed at the memory.

'It was a long day...We started with a leisurely lunch, and then, after the Aga Khan, we had to celebrate on the double, because Ireland didn't just win the trophy, they beat Great Britain in the jump off!' I

reddened some more as I remembered the three of us giggling like teenagers at a French horse in the warm up ring, knocking fences with what Jackie politely referred to as his lose arm and Mrs O'Reilly declaring the horse, 'typical French; over sexed and over excited!'

'You were all hilarious in the car that night, between long arms and spare legs…'

'Moving quickly on…' I looked at him, inviting him not to remind me how pissed we'd all been. 'Not every wife gets to have such craic with their mother-in-law like Jackie did with your Mam.'

'I know that's true. Mind you, they clashed at times too – especially over the children.'

'I guess that's bound to happen with two plain-spoken women.' I sipped my mug of tea and waited for his response. His expression was one of thoughtful sadness.

'They were that, for sure…Gone within not much more than a year of each other, can you believe it?'

'Gone but not forgotten.' The phrase had come to me earlier as I'd looked at the site where our house had stood.

'You wouldn't dare forget either of them, sure, they'd haunt you.' He laughed quietly at the possible truth of it and I did too.

'They would you know. They'd hide things on you, like your phone, your wallet or your car keys, and even the coffee.' I was teasing him and I didn't expect him to realise I was.

'Now that you mention it, since Jackie died, my keys and my wallet keep going missing…Jackie always knew where they were.' He smiled at the memory and his eyes watered.

I pictured him still losing his phone, wallet and keys, just like Jackie said he always did, running around the house like a madman, about to be late for wherever he had to be, until Jackie would say, on the hall table, on your desk, on the counter…It had been the same in our

house which is how I'd come to find out about and monitor Patrick's phone and his affair, all unbeknownst to him.

Seán let the silence sit between us and when next I looked up at him, he offered me another tissue. 'Your eyes are a bit smudged…'

'Thank you…I'll have to give up wearing mascara soon if I keep going like this.' I dipped the tissue into the water glass and he held out his hand to take it from me.

'May I?' he said.

He gently dabbed below my eyes. 'That's better.'

'Thanks, Seán.'

'I guess we better wander back in or the neighbours will start talking,' he said with a wink.

'Heaven forbid!'

# Chapter 8
## Sundown

**Wednesday**

I was brimming with love and acceptance and walked with a lightness in my stride back to the hotel sometime later. Máire and I had regaled some of her friends with tales of our experiences with her Mam. There had been a few times when I'd joined Mrs O'Reilly on her trips to visit Máire when Máire lived abroad and there'd been other trips together after Máire's retirement. It was Mrs O'Reilly's aim to always do the most adventurous tourist challenge possible: in my absence, a nervous Máire had been dragged white water rafting on the Zambezi, the three of us had gone off-piste skiing in the Alps, and Mrs O'Reilly had sailed down without a care in the world while Máire and I'd been scared witless as we navigated the many obstacles and finished feeling lucky to survive. Máire had refused to join her Mam and me on Europe's highest swing, set at the top of a tower in Amsterdam; screaming was obligatory, Mrs O'Reilly declared as we swung over the city. As we were regaling the stories, Máire voiced the thought that her mother might have been aiming for her own TV series: *50 Ways to Kill Your Daughter.*

Some of Máire's friends had never met her Mam and expressed their amusement that the wonderfully reticent Máire had had such a vocal and adventurous mother. Máire assured them that she was more

from her father's side of the family, while Martin was more like his mother, and Seán was a mixture of both.

I happily drank only tea at the wake, as I had it in my head to drive out to Rosses Point for a refreshing swim before watching the sun set over the bay. I parked at the carpark at First Beach and I took my phone out of my handbag to bring with me. There were a few texts of no consequence and some random WhatsApp messages, mainly jokes, from some friends, but there were twelve messages on the family WhatsApp. Patrick had arrived at the house to find Chuckie had left a poo and puke trail around the kitchen-living room. He'd posted a message looking for the vet's name and number. Assuming I was at the wake, he'd called Zara but she was still saving ice cubes (sorry, icebergs) and was therefore not answering her phone. He'd called around the local vets until he located ours who gave him instructions to give the dog plenty of liquids and dry food, enough to replace what might have been lost. If Chuckie wasn't better by the morning, someone was to bring him to the vet. By the time he got home after work, Matt reported Chuckie was already improving and yes, Patrick had cleaned up and disinfected the poo and puke trail. Furthermore, the dog had not puked or pooed for an hour and was looking to go for a walk. The dog whom I adored was ill and I was pleasantly surprised to find that, in my absence, everything had got sorted and I didn't feel any need to even call to check on him. I was tempted to pass no remark and make straight for the ocean but they would know I'd seen the messages so I posted a thumbs up and thank you.

Sea swimming had become my sanity after I'd come home from travelling with my friend Celine in Bali where we'd had a couple of weeks' holidays and where she had stayed on as planned. In Dublin Bay, the Irish Sea was not the soothing, warm Indian Ocean and it was the bracing cold of it that had come to appeal to me. I firmly believed it dulled my arthritic aches and pains and shocked my mind

into a better place. I wondered if the Atlantic would feel warmer or colder. When I saw the high tide and breaking waves, I knew immersing myself in the clear salt water would be easy; waves made it more fun and less of a chore to get fully wet. Jumping onto the back of them and riding them to shore brought out the child in me and I was already feeling like a much-loved child. The beaches and the sea were the Sligo I had loved when I was young. Over the years I'd been away, I'd actively suppressed my memories of Sligo and in doing so, I'd forgotten the best of it.

I jumped and skipped out to where the waves were rolling gently and I swam parallel to the shore. The water embraced me in its thrilling coldness and I swam with it. The word sensual came to me and with it the thought that there had been something sensual between Seán and me that afternoon. It was there as we sat chatting on the bench, especially when he'd gently used a tissue to clean-up my mascara and again, when he'd taken my hand and kissed me on the cheek when I was taking my leave. I felt my face go red as I wondered if I was imagining it or if anyone else had noticed. I wondered how I felt about it. Nervous, uncertain, apprehensive, wary, out of sorts…Seán was a sort-of brother to me. I cared about him and all the O'Reillys too much to dream of messing things up with any risky relationship with him but a hint of excitement was there too amongst my feelings.

At the height of being separated from Patrick, I'd felt that rather than just finding myself falling back in with Patrick, I should explore other options, and I'd briefly considered online dating. I'd quickly ruled it out on the grounds that the men on online sites who might actually consider dating me, would inevitably have a massively greater interest in sex than I had – given that my interest was sitting at close to zero. On the other hand, I'd argued with myself, if I was going to find my previously suppressed, authentic self, I needed to venture outside my old, familiar, comfort zones and explore other options. I'd

tried drawing up a half-decent profile, I'd uploaded some photos from Bali that Celine, with her artistic eye for flattering reality, had taken. I'd looked at profiles that came up; everyone was looking for something such as a meaningful relationship, close friendship, intimate relationship, good company, or someone to do interesting things with – which was way too ambiguous for me. In hindsight and with the benefit of listening to both Brené Brown's TED talks more than once, I was not ready to try and fail at dating; I was not ready to choose that vulnerability.

I had concluded I'd enough good friends in my life with whom to explore life's possibilities and there was nearly always at least one of them willing to escape their partners or other shackles for a few hours or a few days to do things that I found interesting and fun; there was nothing I was looking for which I was likely to find on a dating site. I'd never anticipated I'd ever feel so dried up and disinterested when it came to the possibility of sex and I resigned myself to only ever wanting friendships or relationships without sexual demands; I'd discovered that sleeping alone appealed to me.

And then there was Patrick. It bothered me that it seemed to be assumed we would get back together. I wasn't comfortable with that assumption, yet I did nothing to squash it, and more to fuel it. I had rolled with it. It suited me. I had a man in my life pretty much on my terms. But that wasn't going to wash indefinitely. As that article in the Irish Times said, 'An Affair throws a Grenade into a Relationship.' The old relationship was gone and that was not a bad thing. The question was whether I wanted a new and lasting relationship with Patrick. The truth, as indicated by my reluctance to give him the keys, was I was not convinced. I'd lost interest in dreaming of growing old together. I wanted more fun, more laughter, more new experiences, but I wasn't sure if I wanted any particular man in my life as I went down the slippery slope of ageing. I may have been still having occasional sex

with my husband but any urgency for sex had long since passed. Of course, over time HRT might change that but really, what middle-aged woman needs the trouble of a new, sex-hungry man in her life? Not me. No man would arrive pre-trained on my terms. I'd be better off alone with friends and family for company.

I towelled myself dry and looked at the few dusty pink clouds in the sky. The sun would set soon but there was still time for a short phone call to Mum as I stomped along second beach to get the circulation back into my feet.

'Martha, where are you? It sounds like there's a gale blowing. Is that the sea I hear?'

'Yes, it is. Sorry, Máire's Mam died and I'm in Sligo.'

'Did you say Sligo?'

'I did. The funeral is…'

'Good Lord, Martha. You went to Sligo and you didn't tell me. Are you okay?'

'I'm fine. I have my moments but honestly, I'm okay. I couldn't not go to Mrs O'Reilly's funeral.'

'Oh gosh. Yes.' There was a pause. 'Sorry, I didn't expect that. Let me just sit down.'

'Sorry Mum, I should have given you some warning but it was a last-minute decision…a part of me thought it was about time…but I should have told you…'

'It's okay. I understand. You and the O'Reillys are very close. I understand.'

I knew Mum hadn't been back to Sligo town or its environs for nearly sixty years, not since she had been pregnant with me and had been given a transfer within the bank to Dublin, courtesy of Mother's father, a cold man of high authority.

'How is Sligo?' Mum said in a quiet voice.

I described the beaches and the new yacht club, how the cliffs were gone. I said that the wake at O'Reilly's was happy and sad, but at the same time befitting. There was silence at Mum's end of the line.

'Are you there, Mum?'

'I'm here, pet. I'm here…and you're there…'

'I am here and yes, it is weird, very weird. And upsetting at times too. I've cried a few times but…' I could hear some stifled sniffles. I felt guilty I hadn't waited to tell her to her face. 'I'm sorry, Mum.'

She sniffled again. 'I'm okay, if you're okay.'

'I am Mum. I'm okay. I think it's good for me. one last part of the road to acceptance and forgiveness maybe. It helps that the O'Reillys have been amazing to me, even though it's their Mam's wake.'

'Your father always said they were a good family…and you and Máire have been such close friends for years…And Mrs O'Reilly was always so good to you.'

'She was, Mum. How would I not come to her funeral after all she did…'

'How indeed. You were right to go and if it helps you, all the better.'

'Thank you, Mum…You always say the right thing…I love you so much.' I was crying again but I was okay with that. It was just Mum and me, we often laughed and cried together.

'I might go with you another time. I just might.'

'You might indeed, Mum…Do you know what I'm going to do now?'

'What dear?'

'I'm going to sit on the rocks between First and Second Beach and watch the sun go down. It may be a bit watery – like ourselves – but it will be beautiful.'

'You do that and enjoy it. We'll talk in a day or two.'

'We will, Mum. We'll talk and have a big hug very soon.'

'Love you, Martha.'

'Love you too, Mum.'

It was a sunset like I'd never seen before. The sun sat above the sea creating a perfect, pale gold crucifix with a white blazing ball of light at its centre. It shimmered above the twinkling water on which two yachts made their way towards shore, sails filled with well-measured wind…As the sun descended, the upright post of the crucifix slid silently into the blur of the orange horizon, the white sun quickly followed as if in a hurry after it, taking with it the last of the golden cross.

I could interpret it as I wished. There was nobody there to argue with me, only myself.

# Chapter 9

## A Funeral

**Wednesday**

I slept for a solid six hours that night before being woken by an involuntary shudder that hit me as if I'd touched live electricity.

I'd had such sensations before and this time when I went back to sleep the same thing happened. There had been times when I could tie the timing of these repeated 'shocks' with real life events: Patrick's car accident involving hitting a cow on a back road of Mayo, the local farmer had declared the cow the king of the road and demanded that Patrick pay the vet's bill, Patrick said he'd counter sue for the damage to his car and his injured shoulder. Fiona attacked while waiting for a taxi in the city centre, saved by a passer-by who'd waited with her until the gardaí had arrived, her face had received a cut on her chin that needed stitching and she was badly out of sorts for a long time afterwards. Matt's drunk party injury which landed him in A&E.

I checked my phone for bad news. There was only one new message on the family WhatsApp to say that Chuckie had virtually barked his lead off the hook until he'd finally persuaded Matt to bring him for a walk. There followed emojis of lassoes and a happy dog. But still the feeling that something bad had happened lingered.

There was still no word from Zara and I could see she hadn't opened any of the WhatsApp messages. Either she couldn't be

bothered or Mr Earth or Mother Earth had all her attention. I sent her a direct message on WhatsApp and by text asking her if she was okay. I didn't expect a prompt reply based on past experience but I knew I'd feel unsettled until I heard from her.

After a trip to the bathroom, I opened the hotel window wider to cool myself down, lay under the duvet cover, which I'd emptied of the duvet, and turned on Audible to John Kabat Zinn. I had to reset the sleep timer twice to fifteen minutes before JKZ put an end to my catastrophising and I found sleep again. Miraculously, I managed to sleep more on than off all the way through to my alarm at 8:30 a.m.

The bright dining room was quiet by the time I made my way down for breakfast and I had a choice of tables with an uplifting view right across the car park, the road and the trees all the way to the wide estuary. The day was undecided whether it might be grey and wet or blue and dry; by the time I'd eaten a bowl of fresh fruit, overnight oats and a scone, it had changed its mind three times. It was going to be a proper late April day with sun, wind and showers. Layers of clothing, sunglasses, a good mid-length raincoat and a hat would all be required. I was prepared. Mrs O'Reilly would be proud of me.

Máire had offered that I sit at the front of the church beside the family. She had also asked me to do a reading. She'd kindly understood when I declined both on the grounds that I preferred to be in the background where I could sniff quietly away unnoticed.

I wondered what time the coffin had made it to the church the night before. There would have been no fixed time for it. Down the country, each funeral set its own pace, not like in Dublin where time slots were strict to avoid one funeral overlapping with another. Mrs O'Reilly would not have been moved until the family were happy all the mourners had paid their respects. I had chosen not to see her in the coffin, I wanted to remember her as I had known her; lively, warm and kind, not cold and unresponsive.

I arrived early at the church and sat in the back corner, at the end of a pew. It gave me a clear view of the whole church, especially of the mourners as they arrived and walked down the aisle to take their places on the punitive, straight-backed, hard wooden pews. We'd all have our penance done by the time mass was over. At least we had pews, not like the old days when people stood for hours and the weak went to the wall for support.

At ten past eleven, the O'Reilly family arrived. I checked my phone one last time for bad news then turned it off. Seán and Máire walked down the aisle together, tall and strong, and holding hands – a gesture that brought a lump to my throat and tears to my eyes. Then came Martin, holding hands with his wife, Anne, followed by Mrs O'Reilly's grandchildren, all now adults, each of them angels in her eyes. Four young, beautiful great-grandchildren held their parents' hands and Martin's son held a tiny baby, born just weeks earlier. The baby had been named Mary after her great grandmother, Martin had said, stressing that while he wanted the name to live on, he hoped that the child's personality might not entirely match the force of his mother's. I imagined Martin's own wife, Anne, not approving of her grandchild being named after her formidable mother-in-law; the two of them had never got on well and it hadn't entirely surprised me that Anne had been noticeable by her absence from the wake.

The church filled up quickly once the family had arrived, each mourner came down the centre aisle and genuflected towards the altar before taking their seat. My inability to feel comfortable doing an even half-baked genuflect had been another incentive to arrive early.

Mrs O'Reilly had been well-connected in the church and a couple of priests and probably a bishop might have been expected. But the lady herself had requested only one priest, a beloved nephew, the son of her dead sister, a man she had told she could trust to keep the service short and not too sweet. The music consisted of a piano accompanist

and female soloist, who to my untrained ear, sounded as if she had been chosen for the strength of her voice rather than her ability to hit the appropriate notes. Nonetheless, the Ave Maria was familiar and soothing and the words of the second hymn sent me into a mediative visualisation: 'I watch the sunrise/ Shine through the clouds/ Warming the earth below…I watch the sunset fading away/Lighting the clouds…I watch the moonlight guarding the night/Waiting till morning comes…'

My trance was broken by noise and movement in the pew in front of me. People were moving along to make room for a late-comer, a woman whom I took, from her movements and her voice, to be older than me. She took off her hat as she stepped sideways into the space in front of me. My eyes registered something familiar and my heart stopped.

*Margaret!*

I sat down fast and hard. My umbrella fell with a clatter to the floor. Our eyes met, mine cold with shock, hers offering questioning warmth. Margaret, my half-sister. I had not seen her for thirty years yet I knew her, and she knew me. She gave me an uncertain smile and a nod, then turned to face forward. I was left looking at the short grey hair on her head and the back of her red coat; red, the colour of power, a strange choice for a funeral. Nothing subtle about that. I would give her no power. I would take control. I would be the one to say hello, I would shake her hand when the time came.

At the end of The Lord's Prayer, came the words, 'Let us offer each other the sign of peace.' The man next to me turned and we shook hands, but my gaze was on Margaret. She was shaking the hand of the elderly lady beside her, and as soon as her hand was released, the lady turned and offered me her hand. I held it firmly.

'Peace be with you,' I enunciated, one word at a time.

'And also, with you,' she said, following my gaze towards Margaret who was now staring straight at me.

I swallowed and put out my hand to Margaret, praying I could utter the words clearly again. Margaret beat me to it. 'Peace be with you, Martha,' she said, putting her other hand tentatively over both our hands and resting it there. I heard the lump in her throat as she spoke, and saw tears and a quiet fear in her eyes.

'And also, with you,' I said, swallowing the lump in my own throat.

She held my gaze and our eyes glistened as we looked at each other. She swallowed hard and gave a barely discernible nod as she released my hand and turned towards the altar again. I found myself and the lady beside Margaret still standing, looking at each other; everyone else was on their knees. It was my turn to nod and with that I sat down and leaned forward, my hands on the back of the pew behind Margaret, my head bent forward, not touching any part of her, but feeling her disconcerting presence.

In planning to come to Sligo, I had not allowed for the possibility of coming face to face with a member of the family I had grown up with. As far as I understood, none of them liked the O'Reillys, even though they had called upon Mrs O'Reilly for help looking after Mother on a number of occasions when home-helps had let them down after I'd taken a year out to go volunteering in Sudan. Before I left, I had been the one organising care and doing most of the other work looking after Mother. In some twisted thinking, I had decided that while she couldn't be the mother I would have liked, I was going to be a good daughter. I slavishly did everything I could for her on my regular trips to Sligo despite the inevitable abuse that she hurled at me. As serendipity would have it, the opportunity to go to Sudan had come at a tipping point and I had grabbed it. My siblings had been furious with me for leaving them to look after her; they wrote to me

demanding that I return home and resume Mother-duties. I ignored their pleas.

My encounter with Margaret required a ginormous leap of faith. I know people change. I knew I had changed. I might have even mellowed. I wasn't sure. I had emotionally travelled far. I was a long way from where I had been. I had read Edith Eger's *The Choice* and told myself that if she could forgive the perpetrators of what she had experienced in Auschwitz, then I could forgive the source of my much lesser hell. I was more prepared to forgive than I'd ever been. But I hadn't thought to include Margaret, Jim and Robyn in my forgiveness. Only Mother.

The offer of Communion came and it appeared that every member of the congregation lined up to take it. Everyone except Margaret and me. For many years, I'd participated in communion at wedding or funeral masses. But since President McAleese received a backlash from the Catholic hierarchy for taking communion at a protestant service, I no longer felt comfortable receiving communion at mass. That was not the issue that day. I was glued to my seat, weighed down by the thought of facing Margaret. If I'd seen her ten years earlier, I'd have been out of the church faster than the priest could say, 'Peace be with you.'

Before Mrs O'Reilly had given me a reason to return to Sligo, I had been considering the possibility of returning; it was part of the new me, the part that wanted to face the discomfort of my past, process what had happened to me and take the monkeys off my back. But for some emotionally convenient reason, I hadn't thought to include my half-siblings amongst those monkeys. I guess I could only process my past traumas in a piecemeal way.

The priest was saying some nice things about his aunt and I tried to focus on his words. He had treasured her as a friend and a sparring partner. If he'd argued a point with her, he'd felt ready to argue it with

the archbishop himself; the Church needed people like her to keep it honest, on its toes, and relevant to the people it pertained to serve. Yes, he said, it was the Church's job to serve the people, by spreading the good word and by having goodness at its core, just as his aunt, Mary O'Reilly, had had goodness at her core, but on her instructions, he wouldn't say too much more about that.

He said more about Mrs O'Reilly but I got buried in my own thoughts and I slipped in and out of listening when Máire, Martin and Seán each spoke briefly about their mother. They had no doubt about her kindness but they all eventually learned it was best to agree with her and not to get in the way of anything she had planned. Seán said that until the grandchildren came along, there were only two people who could do no wrong in her eyes: one was Martin who having survived meningitis as a child was awarded the status of her Angel, and the second was me, Martha, a treasured friend of the family for as long as any of them could remember. He joked about how Jackie and I had been known to lead his poor mother astray, knowing full well that she had been the primary instigator. I'd nearly missed these mentions of me as a family friend and comrade-in-arms as I was focussed on working out what to say to Margaret. How might I let her know that I was on the road to forgiveness? My stumbling block to saying anything was the fear she would deny how I'd been treated by them, as each of them had before. I wondered if I needed to confront her with the past we had shared, or should I let it go? Perhaps, as far as she was concerned, she had acknowledged it already in offering me the sign of peace.

Máire's few words about her Mam came to an abrupt ending when Mary, the latest addition to the family, started screaming loudly.

'Mum speaks through the mouth of her namesake. I will take heed and end there,' Máire smiled and then invited everyone to join the family for lunch, after the burial, at the hotel where I was staying. The

hotel and the meal had been chosen by her mother, she assured everyone. Nothing had been left to chance.

As soon as the coffin had been carried out of the church by Martin, Seán and other family members, Margaret turned to me.

'Martha, I'm sorry…I came today hoping to see you.' She paused and looked down at her feet, one hand under her chin, strangling her neck between the thumb and fingers of one hand, the other hand rested inside her shoulder bag. She lifted her head and I looked at her troubled face and waited for her to speak.

'I understand if you don't want to see me,' she continued. 'And I know now is not the time, but maybe, sometime, in the future…' She took a white envelope out of her bag and offered it to me with a trembling hand. 'My contact details, in case…'

I stood still as a statue looking at her, feeling strangely sorry for her. She was the Margaret I had grown up with, yet she wasn't. Never before had I thought of her as vulnerable. Her eyes were sincere and wet with tears. My hand floated up and took the envelope from her.

'Thank you,' was all I could say. I hope I gave her at least an uncertain smile but I may have been more abrupt than intended as I felt driven by an urge to move on. I turned and followed the other mourners out of the church.

I don't remember much about the burial. Seán had seen me arrive at the graveyard and had brought me over to stand between him and Máire. When directed to, I threw a handful of soil into the grave. I felt the finality of the burial as the clay hit the coffin and I turned and looked at Máire with her head bent in quiet weeping. I put my arm around the small of her back and she put hers around mine.

'Earth to earth,' the priest said. 'And Mary really was of this earth in her love of nature and all living creatures and we will remember her as we look in awe at the beauty of the natural world around us.'

As I sat into my car after the burial, I was bursting with the urge to tell someone that I had met Margaret and at the same time, I felt in need of internalising it before I did so. I made my way to Second Beach for a short walk before returning to the hotel for the funeral meal. Perhaps nothing bad had happened at home, perhaps my shudders were a premonition of coming face to face with Margaret. I settled on that thought.

# Chapter 10

## Home

### Thursday – Friday

Chuckie was noticeable by his absence when I opened the hall door the next afternoon. My heart sank, imagining I'd find him sprawled out on his bed, half dead. I dropped my bags and called his name. The kitchen door opened and he came bounding out. I allowed him to push me down onto the hall floor, noticing as I landed on the hard surface, that my beautiful, old rug was not there. Shit, I thought, Chuckie's shit. I took a few deep sniffs and was grateful not to smell poo or cleaner.

Zara had not replied to any of my messages and I had been getting increasingly worried about her but had kept telling myself it was not entirely unusual for her – she was signed up to some app that meant that if she kept her phone usage below a certain level, a tree got planted somewhere, sometime, by someone – the connection between tree planting and phone usage was lost on me! That morning, Matt had sent me a text to tell me that she'd lost her phone and was home. From the hall, I called her name, certain it was her in the kitchen.

'I'm here,' a weary, gruff voice answered.

I moved my bags to the side of the hall and walked down to the kitchen. She was standing with her head in the fridge and I waited for some derogatory comment about the lack of decent food in it – decent

food being vegan food – no comment came. She gave a slow sigh and closed the fridge with a resigned wariness.

'You okay?' I asked, hoping that my words and tone would hit the right note for her mood.

'Yes. yes, I'm fine. Don't you start.'

'O – kay. I might go up and put my few things away and come down then and see what we'll have for dinner. I think there are some vegan burgers in the freezer, if you'd like?' I did my best to keep my tone quiet and level as I spoke.

'I don't want dinner, thanks. I'm going for a shower and then to my room.'

She walked past with her back to me. I bit my lip. Going to her room meant don't talk to me and don't disturb me.

A couple of hours later, Matt and I sat eating dinner; lamb chops for him, vegan burger for me. Both served with homemade wedges, carrots and spinach.

He asked me about the funeral and I told him it was difficult, as was to be expected, but it was fine in the scheme of things. He didn't probe any further and I had the feeling his mind was elsewhere. I told myself that whatever was bothering him, he'd tell me when he was ready. I hadn't the mental energy to deal with anyone else's issues as I was struggling to process the emotional roller coaster of my own previous few days. My normal concerned curiosity was overcome by my exhaustion. I asked Matt to suggest something to watch on TV and he said the IT Crowd was old but priceless and Chris O'Dowd was in it. So that was one decision made.

I told Matt I'd tidy up after dinner and I moved at manic speed around the kitchen-living room, clearing and cleaning the draining board and the worktops of things that should have been put away; wiping down the dinner table, and the coffee table which had numerous hot chocolate rings on it; reloading the dishwasher so that the

dishes would actually wash; sweeping the floor; generally bringing everything up to my standard. I had to fight my grumpy frustration that they couldn't just do things the right way in the first place. I longed for the time when I'd come home and everything would be as I had left it but then again, I reminded myself they had looked after Chuckie while I was gone and that really the bit of top-up cleaning was minor and could be done in little to no time. And did I really long for coming home to a sterile unlived-in environment? Was I in danger of undervaluing those unavoidable interactions that happen in a household?

Chuckie followed close at my heels as I cleaned and cleared, looking hopefully at me in a way that told me he hadn't a walk that day.

'Chuckie, walk,' I said, and he broke into a jig of excitement.

It will clear my head, I told myself without much conviction given the crowd of thoughts crashing into each other inside it. Where could I begin? Mrs O'Reilly's death; the affectionate energy from the O'Reillys, especially Seán; the many changes in Sligo and Rosses Point; the house I'd grown up in, gone; seeing Margaret after some thirty years. And then there was Stephen and the promise to see him on Monday. And now, amongst all those thoughts and confusion loomed the sense that Zara was suffering from something more than lack of sleep and a bad hangover and that Matt had something else going on. And neither of them was talking.

In the past, I'd have been that mother who'd marched up to their children's bedrooms, knocked on their doors and without any subtlety, I'd have tried to coax the information out of them. With Zara in recent years, I often didn't get beyond the door before she screamed, 'go away.' When I was allowed in, it had mixed results. There had been times when I'd felt I'd successfully given her the motherly comfort and support she needed. But as she got older, there had been more times, I walked away as the mother who didn't know shit. With Matt, my knock could get a polite 'I'm okay, Mum, I just need some alone time.'

Or else, 'Come in, Mum,' and I would go in and we'd chat about whatever it was and talking had seemed to be enough.

I toyed with these various possibilities as I walked Chuckie around the block, and I concluded I needed a good night's sleep before I faced any possible new traumas.

When I got home, I posted on the At Home WhatsApp:

**Am off to bed. Am wrecked. Talk to you both tomorrow. Xx**

I texted Mum to say:

**Home safely. Am off to bed now. I'll call you tomorrow morning and maybe meet in the afternoon? Xx**

The next day, I was up and out early, walking a very lively Chuckie. I bumped into an older friend along the promenade and we walked and talked, bringing each other up-to-date on our families. She was delighted to hear I was due to become a granny. I'd have to get sturdy slippers and have my hair permed to look the part, she joked. I said that as I understood it, modern grannies needed good walking shoes and were unlikely to have much time to get their hair permed or even dyed. The conversation was a welcome distraction from the intensity of the previous few days, although when I spoke about Zara and Matt, I was distracted by unspoken concern for them. After we parted, I called Mum and assured her I was fine and arranged to meet her for a walk and a cuppa that afternoon. I rushed home to set up for my normally weekly, painting session with a few friends. We'd missed out on it recently due to my jury duty and other things. Matt was heading out for a run as I put my key in the door, he seemed to be in better form as our paths crossed.

'And no, Zara isn't up yet,' he said. He'd checked as he was about to leave – if she wasn't there, he'd have had to set the alarm. I'd hoped she'd gone to college. She had full days on Fridays which I believed

she usually attended, except when Simon – Mr Earth – who had no lectures on a Friday, persuaded her to attend the climate strike protests.

I crept upstairs and quietly let myself into her room. It was its usual messy self, the floor barely visible under the array of clothes. Wardrobes and cupboards were wasted on her, it was a wonder she hadn't freecycled them to a new home. I watched her quiet breathing, curled up in the foetal position, apparently deep asleep. I wasn't convinced, I wondered if she was avoiding me.

I told myself what I often told myself: I'd survived living away from home from when I was barely eighteen; if we didn't live in Dublin, they'd be living away, and I would know less about what was going on for them, I'd worry and interfere less and they would learn sooner rather than later how to stand on their own two feet; which is what adult children are supposed to do after all. Leave her be, Martha, leave her be, she'll be fine.

My three friends, Katherine, Julie and Clodagh who were my fellow painters arrived in predictable, slow succession over the half hour up to 10:30 a.m. We had some random catch-up but I saved my bits of news until they were all settled with paint brushes and cups of tea on the ready. I mentioned Mrs O'Reilly's death and my going to her funeral and I was not perturbed when the conversation quickly turned to Sligo's beautiful scenery, the challenges of ageing parents and the difficulty of getting siblings to pull their weight. My friends did not know much about my youth and that was fine with me. They were more interested in Fiona's news and the prospect of having a new member of the granny gang. We painted and we talked, fixing our own little worlds a bit as we did so. The conversation came back to ageing parents. Julie's sister in America had been home briefly and her primary input into her mother's care had been to tell Julie to stop giving their mother's feet therapeutic soakings and pedicures as putting

nail varnish on her toes was apparently bad for her eighty-six-year-old ailing body. Julie was hurt as it had been something she thought her mother had enjoyed and it had provided a quiet bonding experience with her otherwise difficult mother. But once her sister had her say, that was the end of it. It seemed the siblings who lived furthest away or who had the least involvement in a parent's care, were often the most vociferous in their opinions and were powerful with it. I listened but I didn't see fit to say that when it came to Mum, my two brothers who both lived in America, were nothing but supportive and always acknowledged how much more than either of them, I did for Mum and for Fergal, their dad.

I asked Katherine, Julie and Clodagh their thoughts on my new painting of the NO DRUG ADDICTS WELCOME wisteria-imprisoned house hanging on the wall beside my older, prettier painting declaring GHOSTS AND ODDBALLS WELCOME.

Opinions were divided, not on the paintings themselves, but whether the residents had a valid point for not wanting a drug addiction centre near them.

'When did you become an advocate for drug addicts?' Katherine asked, with a roll of her eyes. 'Was that what jury service on a drugs trial did to you?'

'Watch that space!' Julie said.

'I'm just wondering if the centre was a private centre for private patients rather than allcomers, would there be less of a backlash?'

My question was left hanging as conversation quickly moved on to another subject.

Clodagh declared that my joining the granny gang was cause for celebration and she booked lunch in the local restaurant.

Before I left for lunch, I went upstairs to check on Zara and met her, still in her PJs, towel in hand, heading into the bathroom for a shower.

'You okay?' I asked.

'Yeah, I'm fine. No need to keep asking.'

I had to take a slow breath to stop myself from snapping back at her. I said, 'I'm going down the road for lunch, shall I bring you back a vegan pizza?'

'Grand.' She gave an impatient nod and continued into the bathroom without once looking my direction.

The interaction was not so different from many recent interactions I'd had with Zara in the previous six months or so but it niggled me.

After lunch, I was running late for getting over to Mum's. The alarm wasn't set at home so I assumed Zara was there and I called up to her. There was no reply. I called again.

'Zara do you hear me?'

'Yes, I hear you! You said, my pizza is in the fridge.'

'Yes, and I'm off to see Gran. See you later.' There was again no reply. I didn't comment on her not being in college. She normally went to college every weekday and she'd already missed the previous day. It would be rare for a whole day, never mind two, to be cancelled. I reminded myself to pretend she lived away from home.

Mum looked at me with undisguised concern when she opened her apartment door and we shared a prolonged hug.

'I'll just grab my coat. Fergal, Martha and I are off for a walk and a cuppa now. See you later.'

'Hi Martha,' Fergal called from the sitting room. He'd normally come out or I'd go into him, to say hello, but he no doubt knew Mum was anxious to talk alone with me.

'How are you doing, Pops?'

'Creaking a little, but fine.' he replied with a laugh.

'Nothing a bit of WD40 won't fix,' I joked.

'Or a drop of whiskey...'

'See you later,' Mum called, grabbing my arm, leading me out the door.

When we got out into the fresh air, she looked me straight in the face again and uttered, 'So you went to Sligo.'

'I know, Mum. I went to Sligo and visited some of my old ghosts there. I should have told you first, I know. I know how hard it is for you.'

'Almost sixty years since I was there. Not since I was pregnant with you. A long time…'

'A very long time, A lot has changed…'

I told her about my trip, what was gone, what was still there, what was different, how the O'Reillys had been so caring to me…I glossed over Seán's particular attentive affection towards me. We laughed at Mrs O'Reilly's detailed instructions, including not wanting to be elevated to sainthood. Mum had met Mrs O'Reilly a number of times and regarded her with guarded affection as big-spirited, rather than sainthood material. Mum reminisced about the beaches as her go to place for good, long walks with friends. As her affair with Dad had been beneath board, I suspected with sadness on their behalf, they'd never got to walk the beaches together. I told her about the beautiful sunset and the connection I felt with the hymn at the funeral and it lightened our mood, and we promised each other that we would visit Sligo together sometime, hopefully sooner rather than later.

Mum and I were having coffee in a little café near Mum's place and I swallowed hard before saying to her, 'Margaret turned up at the funeral.'

'Margaret, your sister?'

'Yes, Margaret, my *half*-sister,' I put unnecessary emphasis on the word half, a word I never used in referring to my brothers in America. 'She went to the funeral because she thought I might be there, she said.

She gave me an envelope with her contact details, in case I wanted to see her again.'

I hadn't opened it until that morning and I was still digesting it but I handed it across the table to Mum.

As she read of it, I thought of how it was not what I'd expected; it was much more than an apology. Margaret had fully acknowledged how Mother, she and my other half-siblings had treated me, it was something they had virulently denied before. Mum voiced her curiosity as to whether Margaret knew Mother was not my mother and therefore that we were not full sisters. There was nothing in the letter to enlighten us on this. Margaret apologised for her part in the denial all those years ago when I'd challenged Jim, Robyn and her about the awful way all of them had treated me. It had taken her years to admit to herself what had happened in our house, but it had nagged at the back of her mind as she watched her own two children growing up. Finally, when her marriage was on the rocks – her fault not his – she'd gone for counselling and had started to face her own dysfunctional childhood and in particular, how cruel they'd all been to me. She said she had a lot of work to do but she was trying to be a better person. She wasn't expecting me to forgive her. She was trying to forgive herself. I knew my half-siblings had been taking the lead from Mother. When they were young, they knew no better.

Mum read the letter and added her tears to mine, and I suspect to Margaret's too, given the little bubble marks on the paper when I first looked at the letter. Mum folded the letter carefully along its fold lines and put it back in the envelope. I doubted myself for giving it to her, I should have saved her the anguish as I had in the past. We sat in silence and I could see her face contorted in pain and I felt terrible.

'What do you think?' she said.

'I don't know, Mum. Like I said before, I'm mostly over it, especially since I've had Máire reassure me that I didn't imagine how things

were or that I didn't bring it on myself. Honestly, back when the others all denied that I'd been treated...eh...differently to them, I did think that I was a bit fecked-up but then after Máire and her mam told me what they remembered, I felt validated, lighter in myself even...I've had years to reflect on it...and I know I'm lucky. I've had you...' I reached across the table and took her hand. 'I know I hadn't been to Sligo until this week but...We're good.'

'That's all true and very positive, despite what you went through...I'm sorry you had the childhood you had, so very sorry...'

'I know, Mum. I know. But look at us now. We are the lucky ones.'

'We are that. We have each other and in that we are so lucky, so very lucky...But, what about Margaret?'

'My first reaction was I don't need to go there. I don't know if I have the inclination to revisit it all or even how I feel about building some sort of temporary or lasting relationship with her. I have enough in my life without it.'

'A reasonable reaction,' Mum said, squeezing my hand tightly and looking into my face. 'I'm curious to know your second reaction.'

I was reluctant to speak for fear of what else I might reveal.

'I don't know, Mum. It was what it was and I feel more over it since I started really processing it. I know I learned from it. For example, I've very different relationships with each of my three children but I try equally hard with each of them. Admittedly, with mixed success...What I'm trying to say is because of my upbringing, I'm aware of what it feels like to feel less loved than your siblings and I try my best to make Fiona, Matt and Zara each feel equally loved. And I try to encourage them to look out for each other and accept their differences...Mum, you know what I'm trying to say...'

'I do, and I hear you. You do look out for each of them in a very special way, you really do...But how do you think you will you respond to Margaret?'

'I'm going to kick for touch for now. You know, drop her a note saying, I've had more counselling over the years since they told me I was talking bull and to build a bridge…and all that other crap they told me…I've come to terms with it…I've had a good life, time to move on. I'll tell her I feel as if I have come to forgiveness…Although, I'm probably still working on it…I'll tell her I'm very busy at the moment but I'll be in touch in the future.'

I'd thought about telling Margaret that Mum and I had become very close over the nearly thirty years since we first met and even telling her Mum was my best friend. But as I didn't know if Margaret knew about Mum, this seemed like it could be the wrong thing to say.

'Sounds like a plan,' Mum said. 'Perhaps, you might want to sit on it for a day or two, after the intensity of the last week.' Mum lifted my hand to her lips and kissed it. 'Good for you for getting towards forgiveness. Margaret definitely needs to hear that. Goodness knows what place she's in herself. Emotionally, I mean.'

'You're right, and honestly, Mum, having gone to Sligo, I am a lot closer to forgiveness.'

Mum moved her chair closer to mine and pulled me to her.

'You're the best,' I said. 'I'm lucky to have you.'

'And me you,' she said pulling me tighter.

# Chapter 11

## Zara

Mum and I parted company with a prolonged hug. I was mentally drained and wired at the same time. I needed to get home and have some quiet time.

I walked into the kitchen and Matt was sitting at the table staring into his mug.

'You trying to read your tea leaves, Matt?'

'No. Just thinkin'.'

'Hmm. You're doing a lot of that recently…There's something bothering you, isn't there?'

He coughed into his hand, stood up and pulled out my chair at the table. He walked across the kitchen and listened into the hall, before closing the kitchen door quietly but firmly. Whatever it was he didn't want Zara to hear. On the way back to his chair, he grabbed a second mug out of the cupboard and put it down in front of me.

'I was told not to tell you, Mum. But no matter what way I look at it, I can't find a way to say nothing.'

He lifted the teapot and the milk jug and after a nod from me, poured me a small amount of milk and filled the mug up with tea.

'Something bad happened to Zara, didn't it?' I said, wrapping both hands around my mug.

He gave a few slow nods. 'I'm certain of it, but I don't know what. I've never seen her so upset and such a mess.'

I brought my mug up to my lips and held it there. What had that creep done to her? The thought that Zara might have been raped loomed large in my mind. Matt had mentioned she'd had a long shower before he left for work on Thursday and I'd heard her having two more long showers since I got home. She normally had short showers, at most twice a week, as part of her efforts to save the planet. All that showering raised alarm bells.

'When, Matt? When was she so upset and a mess?'

'On Thursday morning. I was fast asleep and was woken by the doorbell, not a short ring, a long finger on the button ring. What the feck, I thought as I jumped out of bed. I opened the door and Zara nearly fell in on top of me with her finger still pointing at the bell. I've seen her looking messy when she's called me to be rescued from some party or other but this was different. She looked rough, like she'd been at an all-night rave. Her eyes were two black circles and black lines ran down her cheeks, her legs were bare under her skirt…And she looked scared.'

'Oh Matt. Poor Zara.'

'I brought her into the kitchen and sat her down and turned on the electric stove, she didn't even threaten to turn it off, she was that shivery. I made her hot chocolate with almond milk and she sat and sipped it with her head hung low. Underneath her messed up makeup, I thought I saw a bruise.'

'Oh, Matt! What *did* that bollix do to her?' I could feel myself starting to tremble.

'I made myself a hot chocolate too, and I sat and waited for her to talk, to tell me what had happened but she sat and stared at the false, flickering flames of the stove. When I'd finished my hot chocolate, I offered her another one but she pointed to her mug to show me she

was still drinking the first one. What happened, Zara? I asked her. Nothing, she said. Clearly it was not nothing. Nothing you need to know about, she mumbled, without looking at me. I sat with her until she finished her hot chocolate, got up from her chair and bent down and turned off the heater. And Mum, I'm fairly certain she wasn't wearing any underwear - not even what Dad used to call her dental floss. When she stood up, she pulled her skirt down tight to her thighs.'

My hands went up to my mouth and tears spilled down my face.

'You're trembling, Mum.' He took both my hands in his and brought them down onto the table and held them. I stared at our hands but felt disconnected from them. Matt started to speak again.

"Don't dare fucking tell Mum and Dad anything, Matt, do you hear?' she hissed at me as she left the room.'

'Oh God, Matt. Poor Zara, poor, poor Zara. I have to find a way to talk to her. I can't not.'

Matt nodded.

'Have you spoken to her since?'

'Only through her bedroom door.'

'Is she up there now?'

'Yes, I think so.'

'Okay. I need to think before I talk to her. I'll have to text your dad to cancel tonight, tell him something came up with Zara and I need to spend some time with her…even if she won't talk to me.'

'Don't worry Mum. I'll text him for you. Actually, I'll call him. He has an inkling that something's amiss. I'll fill him in.'

'Thanks, Matt.'

Matt got up from the table. 'I'll make you some fresh tea and toast, Mum.'

'Thanks. You're right to tell me. You had no choice.' Those shudders hadn't been about Margaret, something bad had happened to Zara, something to do with that bollix of a boyfriend of hers.

I knocked on Zara's bedroom door but I didn't wait for a response before I walked in, followed by Chuckie. I tiptoed my way through the array of clothes on the floor. I could see the very still shape of her curled up under the duvet and my heart skipped a beat at a dark possibility. I gently sat down on the nearside of her double bed and put my hand firmly on her shoulder. I exhaled when I felt her breathing.

'Zara dearest, I'm worried about you. It's not like you to miss college or to spend even one day in bed.'

She wiggled a little, stretched her legs down the bed and then brought her knees back up towards her chest. But she didn't try to shake my hand away. I sat in silence for a few minutes.

'I know something happened to you. I just know. But I don't know what.' I sat with my hand firmly on her shoulder. Chuckie sat at my feet, watching everything. 'Bad things happen to us all, Zara. And they're not our fault. People can do bad things to us and…and it makes us feel like shit.'

I paused again, wondering what to say next. My arm that was resting on her shoulder was starting to go dead. Again, she wiggled but it felt like a wiggle to encourage me to stay there. I sat still until my arm could take it no longer. I took the clothes off her chair and lifted it around to the other side of the bed so I could look at her face. Her eyes and cheeks were peeping out above the top of the duvet, there was a purple bruise visible on her right cheek. I stroked her hair the way she used to love me to do when she was little, back when I used to tell her silly made-up stories as I cuddled her. Tears were running from the corners of her eyes and I could feel tears wetting my own cheeks. I wiped away her tears gently with my thumb and I kissed above the eyes that made them.

'You feel shit?' I said gently.

She nodded, barely lifting her head off the pillow.

'Somebody did something to you and you think it's your fault...you're hurting and you want to wash it all away.'

She opened her eyes, looked at me and nodded again slowly. 'How do you know?' she asked. 'Matt?'

'I knew something was wrong with you, Zara, and I asked him. He didn't want to break your trust but he was...He is worried about you. He cares about you, pet. We all care about you. Whatever it is has happened, we want to be here for you...We're not here to judge, honestly, we're not.'

*We will however judge the effing creep who's done something to you.*

'You were right about him.'

'About Simon?'

'Yes. Him.'

'I never said anything to you about him.'

'No. But I knew you didn't like him.'

'Oh?'

'You tried too hard with him.'

'Did I?'

'Yes.'

'He is...was your boyfriend. I wanted to see if I could like him because you seemed to like him.'

I didn't add that I had been determined to make an effort because to do otherwise, I believed would have caused her to cling tighter to him in an effort to justify to herself her choice of going out with him. For her to see Simon as the killjoy I believed him to be, I thought it was best if she saw for herself how he fitted in, or didn't, amongst her family.

'You never tried like that with Daniel.'

I smiled thinking of Daniel. 'I don't think many people have to try with Daniel, do you? I mean he is pretty nonconfrontational and kinda hard not to get along with…'

'Not like Simon, you mean?'

'Not everyone can be like Daniel. And much and all as I love him, I wouldn't want everyone to be like him. I love a mix of people.'

'But you never liked Simon, did you?'

I stopped to think before answering and settled on telling the truth. 'No, I'm afraid, I tried but I didn't. I'm sorry.'

'He's a bastard. A fucking bastard.'

'Oh!'

With that, she sat up in bed and moved across to the other side of it, patting the warm space she had vacated, telling me to sit on it. Chuckie who had been sitting quietly on a discarded sweatshirt on the floor looked up at us with anticipation and with a nod of her head, he jumped onto the bed and lay beside her with his head in her lap. Zara and I sat against the pillows staring at the sodden garden through rivulets of rain running down her large bedroom window.

'You know the way I never wanted to take artificial hormones, the pill, the implant or anything. I told him that all along. And at the start, he was okay with it. We used condoms. Then he decided he didn't want anything artificial between us. The condoms weren't natural, he said. But…but, I said we have to do something. I can't get pregnant…'

I looked at the tears streaming down her face and I ached for her. I put my arm around her shoulder and pulled her towards me and she lay her head on my lap, her face towards the window. Chuckie wiggled and rested his head on her hip.

'You won't get pregnant, he said. You say you know your body; you know when you're ovulating. But, I said…Zara, for fuck's sake, we'll be fine – That's what he said, for fuck's sake, we'll be fine. But…'

I squeezed her shoulder and she looked at me. I brought my hand across and gently touched her bruised cheek.

'But?' I said.

'But it was never fine. Because I was always scared I'd get pregnant and he still wouldn't wear a condom. *Sex is better for me without them.* Better for him. It's all about him. It's always all about him. Fucking him. The fucking bastard. I hate him.' She burst out crying, uncontrollable sobbing, broken by the half-spoken words, 'I hate him.'

I pulled her tighter into my arms and held her until the sobbing stopped and hiccups started.

'Why do I have to get all your bad traits?' She said rushing to get the words out before another hiccup took control. 'I can't even have a good cry without getting the bloody hiccups.'

'I'm sorry,' I said. 'I'm really sorry.' I held her tight, squeezing the air almost out of her, but the hiccups persisted. 'We could see who can hold their breath the longest?' I suggested.

She half smiled. 'Sure, you'd only win, you haven't even got hiccups! Isn't that right, Chuckie? She'd just win, wouldn't she?' She rubbed his head hard, fluffing up his hair and flapping his ears.

'Chuckie, tell her it's worked before…Come on one, two, three, hold.'

Despite her best efforts, hiccups broke through on the first few attempts, but finally they stopped.

'Thanks, Mum,' she said in a way that brought a lump to my throat.

'As much as you may be an adult, you're still my girl, still my pet.' I squeezed her into me.

'I know, Mum. I know.' she rubbed tears away with the back of her hand.

'Don't you ever forget it. We have our differences, but I will always love you and I'll always have your back.'

'I think I forgot sometimes, especially when that bastard was around.'

'That's okay. I understand and perhaps I need to get better at reminding you how much I love you.'

'When I came home the other night, I wished you were here, Mum. I was angry with you for not being home. Matt was very kind and all that, but I wanted you. If you'd been at home, I'd have borrowed the security guard's phone and got you to come and collect me. As I walked home after it happened, I was cursing you for being in Sligo. Your ears must have been burning.'

I shuddered, remembering the shuddering sensation I'd felt that had woken me that same night. I tightened my arm around her and repeated her words. 'After it happened…'

'After the meeting, we went back to his place in the student accommodation as we often did. I think security think I live there because they never pay any heed to me. Anyway, we had some vodka and a bit of weed. When it started to wear off, he decided he wanted…he wanted sex. I'd already told him I was ovulating and we couldn't have sex without a condom. I sipped my drink and said it again, no condom, no sex. 'How do you know you're fucking ovulating? It's not even a month since the last time you thought you were fucking ovulating', he yelled at me. I'm sure this time, I told him. I'll pull out so, he said, if that's what you want. No condom, no sex, I tried to say…But…' She stopped and gulped down a sob and took some deep breaths. 'Before I could stop him, he pulled my tights and thong off me.'

I held my breath, dreading what she might say next. What violence had Simon fecking Green done to her? Had he raped her? How would she cope? Had she missed the opportunity for the morning after pill?

''No', I screamed. 'No condom, no sex…' Conor yelled across from his room asking if everything was okay over there. The bastard put a

hand over my mouth and yelled back, 'Fine. We're all perfectly fine. Aren't we, Zara?' I couldn't speak under the weight of his hand on my mouth. When he lifted his hand, I mouthed, no condom, no sex. And with that he hit me across the face. 'Fuck you,' I said and I grabbed my boots and ran out the door leaving my phone, tights and even my fucking thong behind me. The security guard asked me if I was okay as I walked past him.'

He hadn't raped her; he'd come close; but he hadn't. That was something. 'Thank God,' I said. The words coming out of my mouth as fast as I thought them. Zara looked at me confused. 'Thank God you got away, Zara. Thank God you were strong...Oh Zara.'

'He still has my phone and he knows the passcode and I only thought of blocking it yesterday so I don't know what he's done with it. He could've done anything. Texted my friends, anyone. I don't fucking trust him.'

'Did you track your phone since? I mean, do you know if it's still in DCU?'

'Yeah, I think so. It was there an hour ago.'

'Don't worry we'll get it back from...' I clenched my teeth and stopped myself from saying, from the fucker. 'I've his number on my phone. I'll WhatsApp him and say Matt or I will go over and collect it from him. If he doesn't agree to hand it over, I'll tell him I'll send the police to get it.'

'Mum!'

'Fuck him, Zara. He deserves worse, the bastard.'

'Mum!' she laughed and gave me the biggest hug ever. I would have preferred if it had arisen in better circumstances but still, I felt the warmth and sincerity of it.

# Chapter 12

## Ultrasound

### Monday

**ULTRASOUND – FULL BLADDER 9:15 MONDAY** read the reminder that popped up on my phone on Sunday morning, just as I received a text from Stephen confirming lunch on Monday. Feck it, I forgot, fuck, was my spontaneous reaction which only Chuckie might have heard.

Sweating, bloating, persistent urge to pee, flatulence and fatigue had threatened my sanity since my so-called peri-menopause all the way to my now five-year-old post-menopause – the threat of one periodic curse had ended and a queue of more permanent curses had lined up. I had mindfully practiced trying to accept each of these new curses but try as I did, I couldn't bring myself to sign up for PMT, four weeks of every month. On a practical level, I'd taken to wearing loose clothing and frequently thanked the inventor of elastane which allowed waistbands to expand and contract with my stomach during the course of a day; a higher elasticity would have been even more appreciated.

On a visit to my doctor, for review and renewal of my Eltroxin and HRT prescription, he asked me how I was feeling, had I any concerns? Glad of the opportunity to rant, I gave him the full, uncensored list.

'Hmm,' he said. 'It's early days for you on HRT and those symptoms are probably post-menopausal changes that should settle down but best to have it checked out, given your age and so on.'

I grimaced, there seemed to be too many reminders these days of my age etc.

'It's unlikely to be anything to worry about,' the doctor continued, 'but bloating and persistent urge to pee in post-menopausal women are best investigated. Ovarian cancer can be a silent killer and is best caught early so, just in case, I think I'll send you for an ultrasound.'

I had not told Mum, Patrick or anyone about the ultrasound which had allowed me to mentally park the whole thing, especially the mention of ovarian cancer. Of course, I'd googled it. I'd read something about the higher number of ovulations being a factor. I'd started my period at eleven and finished at fifty-one which amounted to a long time ovulating except when you took out the years that the Merina coil had been my contraceptive of choice. I wondered what risk category this put me in and whether the Merina might be a positive or negative factor. I decided big pharma wasn't likely to tell me the answer unless they could dress it up in their favour. Too many unanswered questions and no absolutes. Hard not to think about it. I couldn't decide if the flutters and aches in my stomach and my flatulence were increased anxiety and IBS or not so silent ovarian cancer.

For years I'd sworn if I got cancer, I wasn't going the chemo route. I'd seen what it had done to my best friend Trish and I'd wondered whether cancer or chemo had killed her in the end. I remembered Trish toying with the idea of alternative treatments after she'd learned chemo had been derived from mustard gas which had been an effective incapacitating weapon in World War I. Trish, being Trish, had jokingly produced an old gas mask at the first chemo session I'd brought her to. A family heirloom, she claimed. She produced it just as the nurse was setting up the canula, the nurse jumped in fright.

'What's that?'

'It's for the mustard gas, I don't want to be incapacitated,' Trish said, deadpan behind the mask.

I'd snorted trying to hide my own laughter and the nurse looked at Trish and me as if we were in a different league to any previous nut cases she'd had to deal with. The same nurse came to appreciate Trish's dark humour and was known to emit the odd snort herself when she tried to play the serious professional. Trish remained determined to laugh in the face of death right up to her last morphine-distorted breath. I wish I'd half her capacity for laughter.

I wiggled on the edge of the seat in the ultrasound waiting area, trying to take the pressure off my full bladder. My thoughts went: symptom: persistent urge to pee. Instruction: come with a full bladder i.e., don't pee. Cruel!

A lady sat down beside me holding two plastic cups of water.

'Rejected. Bladder not full enough,' she said, loud enough for the ears of the four of us sitting near her.

I crossed and uncrossed my legs, telling myself, over and over again that I didn't need to go to the toilet. It is psychosomatic: you can't go, so you think you must go, and anyway, you put in a pad just in case; you're not going to leave a puddle.

A young lady in a white uniform trimmed with navy called my name. She introduced herself as Christine and ushered me into a room. I was thinking that she was probably in her late twenties, about Fiona's age, as she politely explained the procedure before asking me to take my jeans off but leave my smallies on.

*Smallies*, I thought, wait until she sees the size of them! She discreetly left the room and knocked before entering a few moments later. She spread the translucent gel on my lower belly below my midlife flab line and while looking closely at the monitor beside us, she worked the probe with a firm hand around and down towards my pelvic bone. I

feared the pressure would cause a leakage but my regular pelvic floor muscle exercises seemed to be proving effective. Memories of ultrasounds when I was pregnant with each of the children filled me with a warm glow; wonderful images of large heads attached to small bodies, thin limbs stretching as far as the confines of my womb would allow.

'Okay, Martha, I'd like to get a better look if that's alright with you.' She held up what reminded me of the toy lightsabers Matt had waved at imaginary enemies when he was little. 'Would you be okay if I gently inserted this in your vagina? It would give me a better picture.'

I was taken aback, not because Christine wanted to insert a plastic stick up my vagina, but because I remembered that Trish had told me that when a mammogram had found a possible tumour, they hadn't mentioned the possible tumour, they had said they needed to take a closer look, a better picture…I blinked away the thought.

'No problem, I've had three children. What's a little probe?'

Christine smiled assuringly. 'You might want to slip on your jeans and use the bathroom first.'

Christine covered the probe with gel, inserted it carefully and moved it around inside me, again peering closely at the monitor. I'd never tried a dildo for what I argued was the same reason I didn't bark; why keep a dog and bark yourself? But I wondered how a dildo and the probe would compare and I might not always have a metaphorical dog. I was obviously not in the frame of mind to get turned on and anyway we women can disguise these things, the same could not be said for men. Only a few days before my lightsaber experience, I'd heard a man talking on the radio about his mother persuading him to be the live model at a masseuse training course she was attending. He'd got visibly excited as the strong, young masseuse worked on his upper legs.

From how he told the story, instead of dying of mortification, he'd joked that he 'hadn't expected that kind of Thai thigh massage'; as he told it, it was the young lady who ended up purple with mortification.

'All done,' Christine said. 'The result will go to your GP in the next day or two, following review.'

'Thank you,' I said with a forced smile, batting down the words bouncing around in my brain:

*Closer look.*

*Following review.*

*Silent killer.*

Later, Stephen and I met at the bench by the canal with the rain still pouring down. I was dressed for the weather but he wasn't. The flimsy, lightweight jacket he wore hardly qualified as a wind-cheater, never mind a rain-cheater.

'Oh Stephen. You're soaked. I should have said to wait in the café if you were early.'

He responded with an expression I read as, no chance I'd go in there without you, but he looked miserable.

'Let's get out of this rain fast.' I started heading towards the café, then stopped. 'Sorry, no. Let's go to the pub across the road instead. I hear they do proper plates of food and there's a fire down the back. It's a gas fire but it's warm.'

I took off across the road and quickly found I had to slow my pace down to allow Stephen to catch up; he was still shivering and was dragging one foot after the other. I felt a twinge of deep despair. The stride of the former confident athlete was nowhere to be seen in the man beside me.

We were lucky. Two besuited men vacated a table by the fire as we entered the back section of the pub and a waiter pointed us towards it. Stephen made no eye contact with either the waiter or me as he pulled

a chair up beside the stove, as near to it as was just about safe. He pulled his cap down over his eyes and picked up the three-sided menu from the middle of the table. He turned it round and round without looking at what it had to offer. The waiter handed me a second menu.

'I hear the shepherd's pie's good here,' I said. 'I might have that with chips – feels like a day for comfort food. What do you think, Stephen?' I heard myself sounding overly chirpy as I failed to lift his mood.

He looked at the menu in his hand, still without reading it and said, 'I'll have the same. Thanks.'

'Had you a bad week?' I asked softly.

'It was alright…Martha, I don't know why you're bothering with me. I'm a mess…a waste of space…one step up from a scumbag.'

His voice was rough as an old smoker's and he stopped mid-sentence often as if there was a delay in finding the words. He seemed worse than the other days I'd met him, slower and more agitated.

'I'm sorry you feel like that Stephen. I could never think of you as a waste of space. I know you better than that. You know that don't you?'

'Your problem Martha, is, you think I'm the same Stephen you knew…I'm not. I'm a total scumbag.'

In a matter of seconds, he'd moved from one step up from a scumbag to a *total* scumbag. It was unsettling.

'Why do you say that, Stephen?' I said after a short pause.

'Cos I'm an addict, a low-life. And worse…much worse…you don't need me in your life…not with your lovely happy family.'

'Ah Stephen, maybe we want you in our lives. You'll have to let me be the judge of that I think.' I looked at him directly, trying to convey my concern and my belief in him.

He shook his head. 'You've got a perfect family. Ye love each other…Yer good people. Really good people. You don't want to go wastin' your energy on me. I'm not worth it.'

I was wondering if he'd gone for counselling, like he said he would, and if this was what counselling had done for him. I reached across the table and put my hand on his wrist and looked at him until he lifted his head and made eye contact with me.

'Very little is as it seems, Stephen, and that applies to my family as much as any.'

He rolled his eyes at me, a gesture out of character with the old Stephen.

'I'm sorry, Stephen I don't mean to disillusion you but people's lives are rarely as they seem, and ours is no different.'

I went on to tell him a recent history of our family: my hormonal midlife crisis, Patrick's affair and that he no longer lived with us and that we'd come close to financial ruin and to get back on a secure financial footing, had to, rather than had chosen in free will, sell our house. Stephen's mouth hung open as I spoke and he only closed it as the waiter put our food down on the table. I saw added sadness in his eyes and his downturned mouth. In telling him about our family woes, I felt I'd burst his favourite balloon.

'That's shit. Martha, I'm sorry, I didn't know any of that. Yours was a great gaff. I loved being there. I'm sorry you'd to sell it.'

'We're doing fine, for the most part, now…I think.' The 'I think' referred to Zara. I was worried about her. Based on her mood swings over the weekend, it was going to be a bumpy ride. But Matt had managed to collect her phone on Friday night. After getting my message, Simon had left it with security which was just as well because Matt said that if he'd set eyes on him, he could not have trusted himself…The bulk of Matt against the puny Simon would have been no contest. I was on balance relieved it hadn't come to that as given the

angry state he was in, Matt might have ended up charged with serious assault. Zara had gone to college before I headed off to meet Stephen and better still, one of her pals had called around at the weekend and I'd overheard Zara telling her what the bastard had done.

'That's good. I'm glad you're doing okay,' Stephen said, interrupting my thoughts.

'Thanks. I believe we're getting there…My point is, if we can come back from where we were, I believe you can too.'

Again, there was that look of dismissal on his face as he rubbed his hands at speed up and down his thighs.

'Now, I've given you some insights into my life – and I know it's nothing like yours – I'd really like to hear more about you.'

He put a small bite of shepherd's pie in to his mouth and he took a long time to swallow that one small bite. His eyes darted around the room, looking at everything and nothing. Finally, he cleared his throat.

'It's not good,' he said mashing his shepherd's pie around the edges.

'Trust me, the finer details of my story are pretty shit too, Stephen.'

He looked at me to acknowledge the possible truth of that. 'What do you want to know?'

'I'm aware of how little I know about drugs or addiction. My one previous insight was a bad incident with a friend of Fiona's. I don't pretend to know how shit life must be but I do imagine you think it's all your fault but Stephen, weirdly, I don't believe fault always comes into it.'

I'd been watching various YouTube videos from the addiction and trauma specialist, Gabor Maté. He believes addiction is founded in trauma, mainly childhood trauma, and it needs to be acknowledged and processed through compassionate enquiry and other work. He looks for the source of the trauma but talks of responsibility rather than fault. I was intrigued by what I learned from him that applied to

my own history of childhood trauma and the more I learnt, the more grateful I felt towards Máire and Mrs O'Reilly and others who had helped me in more ways than they could ever know. Gabor Maté's thinking also made me feel more compassionate towards Mother and my half-siblings – flawed and all as things between them and me had been, they were all doing their messed-up best with what they'd got – I guessed that we all had our trauma and I was lucky to be able to acknowledge and address mine in my own imperfect, better-late-than-never way.

Stephen's eyes flickered again and he pulled the sleeves of his jacket down over his hands.

'Sometimes, Stephen, things happen and then more things happen, and together they conspire to create a tragic situation. It is not always someone's fault.'

He looked at me with big blue eyes full of tears. 'You're being too kind to me, Martha. I know you are being too kind.'

'Tell me your story and then we'll see if I'm being too kind. Start at the beginning.'

Stephen gave a laugh that was packed with self-doubt before he started to speak in a slow, stop-start manner.

'In the beginning…there was an ordinary teenager who had two great passions…sport and his friends. He lived at home with his parents and younger sisters. His parents worked hard and went out to the pub a few nights a week. They trusted him to be responsible, to be a good example to his younger siblings.' He stopped at that point and looked up at me as if wondering what I was thinking.

I've no idea what my facial expressions told him. So far, he had only said what I already knew. I was fascinated that in telling his story, he spoke in the third person. I smiled and nodded at him, indicating for him to go on. I said nothing even when he paused between sentences.

'When they went out, they left him to mind his siblings. Which was okay. Most of the time. Sometimes his parents came home after a few or more drinks and Stephen wouldn't have everyone in bed and the place all clean and tidied because he'd homework to do, or whatever. On these occasions, his parents used to get thick with him and tell him if he couldn't have things right by the time they got home, they would have to think about letting him continue to play football. Football was his passion and the one thing that he thought he was good at. He learned to always have things sorted and to get his sisters to help and also to go to bed before their parents might come in. His parents seemed happier then and told him they were glad he was learning to be more reliable and set a good example for his sisters. Then he fell for a beautiful girl and no matter how much he thought about it, and he thought about it a lot, he couldn't think of any way that he might talk to her, never mind get with her. She was way out of his league. One night, after he was made man-of-the-match, a big match, everyone was all over him and kept giving him drinks and he drank way too much and maybe had a few tablets too. Between the match and the drink and everything, he thought it was going to be his lucky night. The next morning, he was sick as hell. He couldn't remember much but he was sure he'd got with Helen. That made it all worth it. But it was the beginning of hell. Melissa told everyone that he…he did something awful to Helen…he didn't think he'd ever do a thing like that…not to Helen…not to any girl…Fuck, he hated guys who did shit like that. But everyone said he did…Everyone believed he did…So, he must have…The fucker. He let everyone down: his parents; his sisters; his friends; himself…'

Half way through talking, he'd started mashing his shepherd's pie again with his fork and by the time he'd finished speaking, he had it mashed to a pancake spread the width of his plate. Some landed on the table with the force he used as he called himself 'The fucker'.

I was thinking how best to respond to him when the waiter appeared.

'Excuse me, is your shepherd's pie okay?'

'Fine. Fine. We were just talking too much. A fresh pot of tea would be lovely though, please,' I said.

Stephen looked at his plate as I ate my cold shepherd's pie in silence. He tapped his fork against the mashed potato but ate nothing.

I wanted to reassure him that neither Matt nor I had ever been convinced that whatever happened, had happened in the way Melissa told it. If Stephen had assaulted Helen, then it was truly horrible for her. We believed it was totally out of character for him and whatever it was that had happened, it was the result of all the drink and drugs consumed. Not an excuse that would or should stand up morally or in law, but sadly, from what I'd read, all too common. Given how drunk Helen had been according to Matt and later, James, we wondered how Helen could remember what had actually happened. But perhaps she did remember because trauma can be strange, it can be the only thing you remember, or the only thing you forget. We would never know. Matt had never spoken to Helen about it; Melissa and Helen never hung out with James or Matt again. One of Matt and Helen's other friends, Orla, had told Matt that she'd tried to persuade Helen to go to the sexual assault unit at the Rotunda Hospital the day after it was supposed to have happened, but Helen had refused. Orla had phoned the Rape Crisis Centre herself to find out how to support Helen and she then suggested to Helen that she speak to them and maybe get some counselling. With or without Helen's blessing, Melissa had told Orla to 'Fuck off out of Helen's business and leave her alone'. From then on, Orla had kept her distance from both of them. I often wondered how Helen was doing. There was no denying it but she was a victim in any version of the sorry story and I wasn't sure if Melissa was the best person to have as a friend. I was glad when Matt had told me

Helen had gone off to Australia with another friend, away from Melissa.

The fresh tea arrived and I realised I needed to pee. But I was worried if I went to the loo, Stephen might choose to disappear as he was probably finding the conversation distressing. I needed something to keep him there.

'Stephen, I need to go to the loo, if I leave my backpack here will you keep an eye on it for me, please?'

Stephen without lifting his head more than an inch or two, gave a small nod. I could feel the continuous jittery bounce of his feet on the floor being transmitted via his arms to the table.

'Be back in a minute.'

As I made my way to the toilet, I wondered if I was being naïve. Addicts are known to be so desperate for a fix, they steal from the hand that feeds. Stephen could still do a runner and he could take my bag with him. I patted my small shoulder bag and assured myself that everything of value was in it, other than my keys, which were in the pocket of my backpack. This is stupid, Martha, I told myself. But the doubt lingered. I let out a long breath of relief when I saw Stephen still sitting in his seat, jigging his legs, staring at the gas fire and scratching his arms through his sweatshirt. I sat down and sniffed, pretending to need a tissue. I rummaged in my backpack, checking that my keys were still where I had left them. When I found them, I felt guilty for my thoughts but I took out a tissue and blew my nose.

'Sorry, Stephen.'

'No worries. Need to go myself. Back in a few.'

'Do you want to tell me more?' I asked when he'd settled back in his seat some minutes later.

'I think you know what happened next – I went to college on the Monday and the gang were sitting around the usual tables in the canteen. As soon as they saw me, they left. All except Matt and James who

looked at me with total horror. They told me what Melissa had said about me. I didn't know what they were talking about. I still don't know what I did…but if I did anything to Helen, I'm a fucking scumbag.'

'Stephen, Stephen please, you're not a scumbag. You know Matt and I still believe in you, don't you? You'll probably never know what happened that night. And if you did assault Helen, it is not something you would do sober. And it is a big 'IF'. Somehow Stephen, you have to forgive yourself for what *might* have happened. You've got to find a way to stop hating yourself…'

'Forgive myself? Will ya look at me? I'm pathetic. I'm a useless good for nothing, just like my parents always said I was. I let everyone down. How can I face any of them?' His hands were in his hair as he spoke, scratching some real or imaginary itch.

Thoughts were screaming in my head: what about everyone who fed you the drink and the drugs, Melissa who supplied the space cakes and Helen who was seen giving you some poppers or blueys or whatever? Are they not culpable too?

'Stephen, a lesser person might have continued life as normal, pretended nothing happened, too arrogant or too in denial of what might have happened. Some men may even have boasted about some version of it. But you're not built like that. You care that you might have done something to hurt someone…' I picked up the newly arrived teapot and pointed it towards Stephen's mug.

'Please,' he said with a slow nod.

'The MQ keyworker said something similar. He said I'm not a bad person. I'm a person who has done some bad things. But seemingly, I am more than those bad things, he says.'

He had spoken to someone, that was good.

'I believe you are much more than those things.'

'I couldn't deal with it, Martha. Easier to run away…Easier to stay away from Matt and James and go drinking with lads on the green near home. They gave me weed. It was cheap. But sometimes it makes me go ballistic. You know, psychotic like. I wish I could just have done weed. But when I took weed, I often needed to take something else to kill the psychosis and even the anger. I broke two fellas' noses and had my own broke twice – I guess that makes it quits! Hah…Not funny, not funny at all…' He sighed and rubbed his nose and I saw a distinct bump on it I didn't remember from before.

'Wasn't like you hadn't had it broken before.'

'Yeah, but a football war wound is nothing beside a Ballymun speedbump from a drug-fuelled git.'

'A Ballymun speedbump?'

He sliced the air with his forehead. 'A headbutt with proper force, Martha. You don't want to be at the receiving end of one of them.'

'I see,' I said, grimacing. 'So, do you think weed made the person who did that to you violent? Does it make you violent?'

'Weed can make lots of us violent! But it's hard to know how much so, 'cos we take other shit too. Most people are grand with a wee bit of weed, you know, all chilled and that, but for some people, like me, it makes us mental.'

'I didn't know it made people violent…'

'Psychosis throws paranoia into the mix and then throw in a bit of agro and it can be lethal.'

'Literally?'

'Yeah. Fucking dangerous. I've tried it with poppers and blueys and I'm not as bad then…But I can still end up like a madman.'

'Poppers?'

'You inhale them and it gives this rush and then a feelin' of being spaced – I'm not crazy on 'em. The high's too short.'

'And blueys, they're like Xanax and Valium, aren't they?'

'Yeah.'

'Mother's little helper!'

'What?'

'That's what Valium used to be called back when I was a kid. Doctors prescribed them to women to help them cope and loads of women became addicted to them.'

Mother used to take Valium but I didn't remember it doing her much good. I didn't remember her ever being chilled or cheerful.

'Where do you get them?' I asked.

'Anywhere you want them: where there's demand, there's supply; think rich and poor: Clontarf, Summerhill, Sheriff Street, off Marlborough Street, even Ballsbridge…depends where I am. I've got them all over. You ring a source and…' He trailed off, and shrugged.

'It's a whole other world, Stephen.'

'You could say that. All drugs are shit. All they give is temporary relief. Life's still pissing on you when the high wears off.' He scratched his face and his head and moved his hands down to scratch his lower arms.

'I hope you don't mind talking to me about it.'

'Nah. It's grand. Weird though.'

'You spoke to someone in MQ. That's good.'

'Yeah. I'm supposed to go again next week. He's a recovering addict himself. So, he ain't preaching from on high or anything.'

'God, I hope I don't sound like I'm preaching…'

'Nah, you're just trying to get a handle on all my endless crap.'

'Sorry. I guess that's how it feels to you? Endless crap, I mean.'

'Yeah, on and on it goes. I'm a hobo on a burning treadmill, running from the flames only to find they're right in front of me.'

'Stop the wheel, you want to get off?'

'Putting out the fire would be a good fucking start! Most of my mates are on the same treadmill. If I succeed in escaping, what will I

do? How will I cope? I need drugs. Without them, I'm fucked. With them, I'm fucked.'

# Chapter 13

## Tuesday

I felt glum and spent as I walked home. Stephen had been so wound up with negativity and agitation that I worried what he might do. I still wondered if he was doing heroin, and if he was, was he smoking it – chasing the golden-brown dragon coming off the burning liquid – *Never a frown with golden brown...*I reminded myself that three quarters of homeless people on the streets of Dublin do drugs but most homeless didn't do heroin. Whatever way I looked at it, the odds seemed stacked against Stephen but I kept trying to argue with myself for the positive possibilities: he was probably addicted to weed and pharmaceuticals before he'd ever landed on the streets but maybe if he was doing heroin, he wasn't injecting; many heroin users never inject, not as long as they can get the hit they want chasing the dragon; a needle, or even a dirty needle phobia might surpass their need for a bigger hit, perhaps that was Stephen, there was still a sensible side to him. I hadn't seen Stephen's arms and he kept scratching them and pulling down his sleeves. Maybe he was shooting, leaving himself with irritated, even infected, puncture marks. I told myself to stop catastrophising and focus on the fact that he was talking to me and more importantly, to a someone in MQ. There was hope.

I said all of this to Matt as we were cooking dinner together the following evening.

'Fuck it, Mum. You're starting to sound like an amateur drug expert.' He rolled his eyes. "Next thing, you'll be trying weed or poppers or whatever to get a proper insight into what you're dealing with…So to speak.'

'Ha-ha, Matt. No chance. A bit of light weed in a joint or two is all I ever tried.'

'You smoked weed? You never told me.' He brought his hand up to his mouth and became goggle eyed, feigning horror. 'I suppose you're going to say next that you never inhaled!'

'Very funny. I did inhale on at least one occasion…There may have been other times but I was way too drunk to remember them.' I laughed.

'Mum, the piss-artist. What a thought. There must be a good emoji for that!'

'I was messing about being too drunk to remember! That one night, I'd had a few drinks alright. The problem was I never could smoke anything without having a few drinks to dampen my natural aversion to smoking. Also, I was always too scared of losing control.'

'And?'

'And nothing. We had a chilled-out night, danced to some good music, waved our bicycle lights around in the dark room and thought we were all dead cool.' I smiled at the memory.

'Quite the eighties rave so,' he said with a laugh. 'It's a wonder you didn't make a habit of it after such a night.'

'No chance. I'd the worst hangover of my life the next day – all of the next day!'

'Ah there's a whole other dark side to you you've never told us about!' Matt gave me a friendly tap on my upper arm. 'I'll have to open the confessional just for you!!'

With that the doorbell went.

'Saved by the bell,' I said pointing towards the hall.

Matt went to answer it with Chuckie hot on his heels. As expected, it was Patrick who I'd invited over for dinner after I told him, at Zara's request, about much of what had happened between her and her now ex-boyfriend.

I finished putting the mash potatoes on top of the fishless pie I'd made for her and I put it and the fish pie for the rest of us into the oven and set the timer. Patrick and Matt were in full blown football conversation as they came through the kitchen door. I gave a loud, groaning yawn of boredom which went completely unnoticed. Patrick said hello and gave me a peck on the cheek without missing a beat in the football conversation. I offered Matt and him each a drink of water, beer or wine, but I'd have been better off talking to the dog.

'Matt, Patrick will you lay the table, please?' I said loudly before I picked up my chai tea and newspaper and left them to it.

I'd long ago given up trying to understand the foreign language of soccer. They rarely noticed they were excluding me from their conversations which was okay except when it went on and on at mealtimes and my attempts to change the subject to something inclusive went unnoticed. Occasionally, I'd give up and pick up my dinner and take it elsewhere to enjoy which had been known to get their attention, but not always. I hadn't yet succeeded in clearing their own unfinished plates while they were mid-conversation, but it was going to happen someday.

I returned to the kitchen when I heard the oven timer beeping. By this point, they were discussing how long the current manager of Chelsea might last. I coughed as loudly as possible, only to be ignored again. I put plates in the oven with a clatter and I laid the table, banging each piece of cutlery down onto it until they finally saw fit to look my direction. I wasn't feeling angry, I was conducting an experiment that was amusing to me; how loud did I need to get before I got heard?

'If you wanted me to lay the table, you should have said,' Matt protested.

'Ahem, I did say I wanted you to lay the table before I left the room 30 minutes ago but...'

'Oh. Sorry, Mum,' said Matt, the family peacekeeper.

The doorbell rang again. I looked at my watch.

'Patrick, why don't you get the door? It's Zara, she's forgotten her keys. You know, give her a hug and all that?' Chuckie barked with excitement, confirming it was her.

'Yes, yes. Good idea.' Patrick put down his beer and headed for the front door. Chuckie scarpered ahead of him and I heard him jumping at the inner door demanding it to be opened.

I turned the heat on under the broccoli and gently steamed it in some toasted sesame oil and a little water, listening hard to the exchanges in the hall. Patrick would have to wait his turn while Chuckie and Zara exchanged greetings.

'I saw him today in the student bar but I didn't talk to him,' I heard Zara say. 'Later, I met Conor, his roommate, and he let me into their rooms and I got all my things I'd left there.'

'That's good, did he say anything?' Patrick asked.

'Just that he's sorry.'

'Sorry?'

'Yeah, Conor's sorry that he didn't get up to see if I was okay the other night. Alison, his girlfriend, ate him for not checking on me that night.'

Quite right, Alison, I thought.

'You're better off without him. Without Simon I mean.'

'I know. I've had half the members of DCU's Save the Earth Society telling me that today. I'd no idea so many of them hated him. They

said his sort give the green message a bad rap. They never said shit about him to me all the time we were going out.'

'Ah princess, that's how it's always been. I remember…'

Here goes, Patrick's off on one of his fictional tours down memory lane.

'Come on, Dad. I need to go to the bathroom and we'd better get in for dinner or Mum will be cleaning up before we've even sat down.'

Too right! Is that some of the old Zara I'm hearing? I hoped so. We had history of being thick as thieves when she was young. We started sparking off each other when I was in the worst of my menopausal mess and she was in her late teens and on we sparked through to the height of Patrick and my marriage crisis. She and I'd started to turn that corner with the help of our mutual love of Chuckie and we were starting to get on quite well with each other, going for walks and chats together, until Simon, the toxic, green monster had come along.

It was a Tuesday evening and I generally don't drink on Mondays or Tuesdays, but with the day that was in it, I poured myself a small glass of 14% proof, full-bodied Chablis. I knew it would be good because Patrick had brought it. Also, I was feeling annoyed with said Patrick. During dinner, Chuckie liked to sit at my feet and I was quite happy to have him there and pass him the occasional titbits for which he would sit and give me his paws, first one and then the other. Patrick disliked this arrangement and believed Chuckie should stay in his bed during mealtimes. Normally, I just rolled with it when Patrick sent him to bed at the start of dinner and he would look my way and with a nod from me, he would sulk off to his bed with his bushy tail between his legs. That evening, Patrick hadn't sent him to bed before dinner and Chuckie had taken up position beside me, looking up at me with those eyes that said, poor me, you're all eating and I'm not. I had just nodded at him to say, I know, and had taken a piece of potato

off my plate to give to him, when Patrick's voice boomed from the other end of the table.

'Bed, Chuckie. Bed now.' Patrick gave a you're-dead stare and pointed towards Chuckie's bed.

Chuckie looked at me with a confused what now? I was furious with Patrick and I opened my mouth to say 'my house, my rules.' But I stopped myself at 'my'; dinner that night was for Zara, Zara was his princess and he her king. Save your breath to cool your porridge, I told myself. Choose your fights…

I gave Chuckie the piece of potato and forced my gritted teeth open and said, 'Bed Chuckie, bed.' I swallowed hard and mustered up the best smile I could. 'Ahem. Would anyone like more pie?'

I passed the fish pie to Matt who passed it on to Patrick and there followed a leisurely, exchange of views and news, but despite football not being mentioned, I struggled to engage.

As Patrick and Zara were cleaning up, I checked my phone. There was a call from an unknown number and a voicemail. With a sickly flutter in my stomach, I wondered if it might be the results of my ultrasound. But no, that seemed unlikely given the hour of the evening. I put the phone to my ear and listened to the message:

'Hi Martha, Seán O'Reilly here. I hope you don't mind that Máire gave me your number. I hope you're keeping well since your visit to Sligo. I wanted to touch base with you as I'm going to do some work on my new garden and I know you're a bit of a green fingers. It would be great if you could give me some guidance. Maybe call around for lunch or something. No pressure. Ring me back whenever suits. All the best. Talk soon, I hope.'

I hadn't seen that coming; all said with the utmost diplomacy. How was I going to respond to that?

I looked over at Patrick sharing a laugh with Zara and felt my annoyance towards him re-emerge.

# Chapter 14
## Wednesday

I spent Wednesday morning with Zara. We walked the few kilometres along the promenade to our local café by the beach and ordered oat flat whites and vegan treats. We sat on rocks looking out to sea and Zara talked enthusiastically about her college course and expressed surprise that there was so little in it that didn't interest her; she'd expected that anything other than the pure environmental end of the course would bore her but even the technology end of it had her hooked, so much so she'd signed up to focus more on it. Her fear was that she might prove to be no good at it. I reminded her that from when she was little, she had a natural aptitude for computers and had at one stage been the family go-to person when technology problems arose.

'That was until you decided you weren't going to play that role anymore. You declared you wanted to spend less time on screens and more time outdoors.'

'That's just it, Mum. I still want more time in nature but universities seem to think you can solve the environmental crisis from a desk.'

'All I'm saying is you have the ability…And sure, you've signed up for some summer field trips that are coming up soon. That will get you away from screens.'

'Yeah. You're right. They'll get me out of Dublin and away from *him* for a while. That'll be good…Should we start walking back now?'

She stood up, put our reusable cups in her backpack and called Chuckie back from the rocks at the edge of the sea.

'A change of scenery will do you good.' I said as I stood up to join her.

We walked in pensive silence until she stopped to watch some seabirds pick their pickings from the wet sand before the tide came back in. 'Did the change of scenery do you good last week, Mum?' She said, still watching.

'Pardon?'

'You went to Sligo for Mrs O'Reilly's funeral, didn't you?'

'I did…I can't believe that was only last week. So much—'

'How was it for you?'

'Gosh…yeah, okay. I don't know. Strange. Difficult at times. I'm still processing it, I guess.'

'Mum, tell me about it…I'd like to hear what it felt like to go back after all those years.'

I heard the role reversal happen in those words, tell me about it, my words, words usually followed by something like you know how talking about something usually helps clarify your thoughts…helps you process it…

I gave Zara a similar version of the events in Sligo to the one I'd given Mum, again with barely a mention of Seán, other than his kindness with the tea in the garden. I told her about my shock at the cliffs and the house being gone, the changed beaches, the beautiful sunsets and lastly about meeting Margaret and her note to me.

'Mum, you haven't seen her in over thirty years, you have to meet her. You can't not.'

'I don't know. Maybe you're right…I'm thinking about it.'

'If it was Fiona and me who'd fallen out, you'd tell us to meet up and make up.'

'I would, but that would be different. Margaret and I didn't fall out. We never fell in. It's complicated.'

'All relationships are complicated.'

'Where have I heard that before?' I said and we both laughed.

'Well, will you meet her? I could go with you, you know. For moral support. I might even meet some new cousins.'

'Thank you. I appreciate the offer.' I hadn't thought of their cousins, that was another aspect. I reached to put my arm around her and she surprised me by taking me into a hug. Chuckie joined in, standing on his hindlegs with one front paw resting on each of us. I smiled all the way to my toes; a few uninvited hugs from Zara in a few days; hope springs eternal.

'I'd love to see where you grew up, especially Rosses Point, even if it has changed.'

'You never know.' I hadn't the heart to tell her it was probably one of those trips best done alone and that Mum had first refusal. Then again, if Mum did decide to revisit Sligo, Zara might be a welcome companion, just what was needed to take the sting out of the likely pain for Mum.

Zara headed off to college for her afternoon practicals, and I sent Stephen a text. He often took a while to respond and I thought, with the house to myself, I'd use the time, to ring Seán. I'd thought long and hard about what I would and wouldn't say to avoid any misunderstandings. He answered on the second ring before I'd settled on how I would greet him.

'Martha, good to hear from you. How are you?'

'Fine. Fine. Usual family and other distractions. And you?'

'I'm good, all things considered. Rory and his family have gone back to Australia and I miss them already. But I'm lucky, all the others are nearby since I moved.'

'Remind me, was it Dalkey you said you'd moved to.'

'Yes, a small terraced house a short walk from the village and the Dart station and more importantly, from Micheál, Rosemary and their children. Jackie insisted we buy the house, if it was the last thing she got to boss me into doing…You'll thank me when I'm gone, she said…She was right, as usual.'

'Lucky you.' I laughed. 'No flies on Jackie. She knew you well…I bet it was hard to leave your old place though.'

'It took me a while alright, very hard to leave all our family memories behind. This house sat empty for four months until Rosemary walked me through it with her plans. She's an architect, you know. A good one.'

'I remember, she helped Máire with her place and it turned out great.'

'Well,' he cleared his throat. 'She said gardens aren't her thing, and Máire said you did an amazing job with your old garden and with your new one.'

'Seán, I'm no expert. I work within the limits of some basic knowledge acquired over the years. I'm no more than a dedicated dabbler. Trial and error has served me well and nature has been kind: I've always had gardens with a good sunny aspect. These days I aim for some home grown veg and fruit and a bit of rewilding – natural untidiness – keeping the hours of maintenance as low as possible!'

'Sounds just what I need. How about you come for lunch on Friday – the forecast is good. I can walk down and meet you off the Dart.'

No beating about the bush from Seán! There had been some vague talk of Patrick and I rescheduling our dinner and film date to that Friday but…

'Lunch would be lovely. I'll text you my Dart arrival time,' I said. Then I wondered what I was at, what new mess might I be starting. Seán was a close friend. Máire, his sister, was one of my closest friends.

An hour later, a WhatsApp message, with the words 'Friday films' in it, came through from Patrick. I let it sit unopened as I tried to suppress a certain girlish anticipation I was feeling about lunch with Seán. I put my phone on silent and went upstairs to get changed into my tennis gear and pack a bag for a post-match swim.

The doubles match delivered a welcome distraction, competitive yet friendly and fun. Friendly slagging was as much part of the game as the tennis. Afterwards, as I swam, I tried to clarify my thoughts on the Seán and Patrick issues but the choppy sea forced me to focus on not taking in mouthfuls of the dubious Dublin Bay water and I wished I was back in the clean, clear waters of Rosses Point. I had my minor eureka moment as I stepped out of the sea. I didn't have to tell Patrick why I couldn't make dinner on Friday; I could just say Saturday night would suit me better and see what he came back with.

Thursday evening came and went and I still hadn't heard from Stephen. I sent him another text. We had made no specific plans as to when we would next meet but Monday seemed like a good idea and I'd suggested it. I wondered if he might have run out of credit but felt certain he'd have access to WIFI somewhere and would at least get the messages I'd sent on WhatsApp.

On Friday morning, I painted a massive painting of tulips with their heads turned in different directions and their petals opened wide, showing off their bright yellow and black centres. I almost sang as I painted.

'You're in good humour today, Martha. Going on a hot date or something?' Katherine asked.

'Pardon?' I said, pausing to think of an answer I was willing to give.

'You going on a hot date, or something?'

I focussed on adding depth and dimension to one of the tulips but I could feel all eyes on me and I'm certain I was the colour of the reddest tulip.

'No. Not at all. It's just I've had a good week and I'm feeling happy…But…but I am meeting a friend for lunch so I'm afraid I'll have to kick you all out promptly today.'

'Lunch with a friend…' Julie repeated. 'Anyone we know?'

'Just a brother of a friend of mine who wants help with his garden. Nothing major…I think these tulips are starting to take shape. What do you think?' I turned my painting around and held it up for the others to see.

'I love the tulips,' Clodagh said. 'Wild and colourful, like yourself.'

'Me too,' said Katherine. 'I like the tulips…I'm not sure about the background though. Too dark, in my opinion.'

On the Dart to Dalkey, I checked my WhatsApp messages to Stephen and they still hadn't been opened; maybe his already broken phone had finally died, or maybe he'd lost it. If he had, then how would I get in touch with him? How would he get in touch with me? Even if he borrowed another phone, he'd no way of getting my number. Nothing to be done about it for now. I sighed and gazed out the window as the Dart made its way past grand, old houses, stopping at stations where well-dressed people embarked and disembarked; everyone carefully keeping their distance from four men of ages ranging from forty to twenty slouching in a corner of the carriage, in their not-so-clean clothes, passing two beer cans between them and slurring words through mouths that hung beneath bleary eyes. How did these men come to be there together? Were they bonded by homelessness and alcohol and by the scorn of the rest of us? They surely had dreamt of better. Their mothers hadn't wiped their noses and send them to school for them to be lost in some out-of-it world. If it can happen to Stephen, it can happen to anyone. I'd be a fool to think it can't happen to one of mine, particularly after all that happened to Zara with Simon.

These thoughts made me feel melancholy and no doubt my face reflected this as I stepped out of the Dart station to see Seán standing just outside the door waiting. He was fresh faced and beaming in my direction as he stepped towards me. He took me in a tight bear hug that felt so natural that I half-expected him to take my hand as he led me out of the way of the other passengers, along the narrow path towards Dalkey village.

'You look wonderful,' he said. 'How are you keeping?'

All the better for seeing you, were the words that came to mind and made me blush.

'Well, thank you. And you?' were the words I chose to say.

'Very well. And all the more delighted to see you.'

I felt a warmth run through my body. I looked up at him and took in the depth of his genuine joy, reflected in his cheerful red rain jacket worn over a rich dark blue sweatshirt and jeans.

'Thank you, Seán,' I said struggling to resist the temptation to flirt back, wondering, if Seán wasn't Máire's brother, if I'd be more than happy to immerse myself in the rare and wonderful experience of a flirtatious exchange. Gosh, I thought, HRT seems to be starting to have some interesting effects.

We came to a terrace of period, redbrick houses, set a perfect, long car's length back from the path all cleanly presented with cream painted sash windows. No gate posts to worry about hitting, I thought, remembering a couple of menopausal encounters I'd had with the gate posts of my last house.

'You must like red,' I said as he put the key his red door.

'Yes, it cheers me up on dull days. You must like it too,' he said with a chuckle.

I looked down at my red raincoat and realised that we were dressed like odd-sized twins; my dark navy jumper was similar in style to his sweatshirt and was worn over a red casual shirt and jeans. I laughed.

'I can hardly deny it!'

The solid door opened into an inner porch and on into a narrow hall. All the visible walls that greeted us were white with splashes of colour provided here and there by some striking artwork. In the hall, opposite the large, over-table mirror was an equally large Gerard Dillon painting of two Italian women gossiping as they stood over their laundry, their broad backs were to the artist with their large bottoms prominent but their faces visible, turned in amused engagement. It was a painting I'd seen before on loan to the National gallery and I loved it for its bold and solid forms. It was wonderfully cheerful relative to some of Dillon's other work.

Seán led me past the sitting room into the kitchen-living room which was white and bright with four skylights above a dining table and couch. Both had full views of the small garden through massive sliding doors that ran almost the width of the house. I noted everything was in its place, to a fault in my opinion and I had the desire to scatter a few cushions, rugs and half-read newspapers around the place so I might feel inclined to relax and flop on the comfy looking couch. In the house I was reared in, everything always had to be clean and in the exact right place and after years of working on my own inclination towards perfection, I found extreme neatness unsettling, even triggering, the opposite of comforting.

'The cleaner was here yesterday, I'm not usually this tidy!'

'Phew! That's a relief. Our house rarely lasts tidy for more than a few hours after I clean it.'

'There's only me here these days. Seánín, our youngest, has abandoned me for new found love in a place nearer college.'

'Lucky you. I never thought I'd say it but I'm feeling ready for them all to move out!'

'It can be lonely all the same, you know. I find I miss all the comings and goings. And I've taken to talking to the cat.'

'I'm sorry. That was insensitive of me. Of course, it can be lonely…I didn't know you had a cat.'

'See, over there…typical cat, never answers back, maintains an air of complete indifference no matter what I say.' He pointed at a painting of a sprawling black and grey-brown cat.

I laughed. 'Someone's a Gerard Dillon fan,' I said, spotting the bold Dillon signature in the corner.

'That would be me. Jackie was more a Norah McGuinness fan. What about you?'

'I can like both but I find some of Dillon's too grim and dare I say, too crudely executed. I love *The Washer Women* in your hall though. It's full of personality.'

'It's my favourite, catches my eye every time.'

We fell into a conversation about our favourite Irish artists and Seán took me on a tour of the house and his not insignificant art collection. There were Harry Kernoff's, Eamon Colman's, Estella Solomons', some more wonderful Dillon's and equally striking Norah McGuinness's. Without the paintings, the house would have been stark and austere; there was too much white for my tastes and too little in the way of cushions, rugs and curtains to soften the sounds and the lines; even the duvet cover on the king-size bed was white. It struck me as out of sync with Seán himself whom I saw as a woolly jumper and sweatshirts kind of guy. I wondered if the décor had been chosen by Rosemary, who may have favoured the more minimalist look; in my experience, architects rarely chose cosy clutter. Seán popped a bottle of champagne as I stood outside the patio doors looking at the blank canvas that was his garden. The compass on my phone declared the aspect a perfect southwest.

'It will be easy to choose plants that will thrive here,' I said. 'The challenge will be not to choose ones that will quickly become too big. Is the soil quality good, do you know?'

'All new, good quality top soil wisely organised by Rosemary for delivery when the house was still a builder's site. No rear entrance, I'm afraid,' he said, clinking his champagne glass off mine.

I stepped out the dimensions and drew up some rough plans as Seán put the finishing touches to lunch and laid the table.

'The frittata's very good, did you make it?'

'I did,' he said with pride. 'I got a few late, crash courses in cooking when Jackie started getting ill. It proved initially stressful and then surprisingly therapeutic – made me feel useful – though half the time, she didn't eat much.'

'And it left you better prepared for living without her – another part of Jackie's plan, maybe?'

'Ha, no doubt! But I don't get many opportunities to test my skills on others. Consider yourself one of my guinea pigs and hope you survive the experience! I was excited to be cooking for someone other than myself for a change.'

'I'm a bit the opposite as yet. I'm delighted when I only have to cater for myself. And often, I wish I didn't have to tidy the kitchen or wash a few pots before I can start. I believe living alone would suit me fine.'

'Be careful what you wish for, Martha…You've only one left in college. It will happen soon enough.'

I looked at him and nodded. 'You're right, of course…sure when they all leave home, who will I have to argue with. Our dog may look like he has some deep thoughts but so far, he struggles to find the words to express them…'

'Ah, you've a dog. I'm not much of an animal person, too much trouble and mess for me, but if I had to have one, I'd prefer a dog to a cat. Better for cuddles.'

'Definitely. Especially, relative to your cat!'

'No competition.'

We laughed and Seán refilled our glasses.

# Chapter 15

## Shopping with Fiona; Film with Patrick

**Saturday**

It was one of those rare times when two Nurofen, plus a long shower and strong coffee were a must. Fiona would not be impressed if she got a sniff of a hangover when I met her to go shopping for maternity wear in the heart of Dublin. The object of the exercise, she had explained, was to get expandable clothes as much like her normal attire as possible. She didn't want all the students in school knowing she was pregnant until it was impossible to hide. I laughed to myself at this thought as three of my good friends had grandchildren in her classes and at least two older sisters of her own friends also had children in her class. Dublin is a small city; Clontarf is a village.

As we entered the maternity shop, a fellow teacher from school was leaving, and inside, rummaging through a rail, was an old classmate of Fiona's from secondary school. When they'd gone on their merry pregnant ways without actually mentioning that any of them were pregnant, I turned to Fiona.

'Well, we're obviously not in here on my behalf, what's the great taboo about mentioning the baby in the womb?'

'Mum, shush.'

'Fiona, we're in a maternity shop.'

'Mum, you can't assume they're pregnant. They could be looking for a friend.'

'Oh, I get you, they're both carrying those bumps for friends.'

'Mum!'

'Okay. Okay. I'll shut up. No more baby talk for the rest of our time in town...' I looked away and rolled my eyes high to the god of common sense, mumbling to myself, no talk of babies while shopping for maternity clothes, remember the PC police are in charge.

'Thank you, Mum. That would be great.'

I browsed around the shop and selected some cheerful tops to brighten up the plain dark trousers and skirts Fiona had chosen for trying on. Most of my choices were rejected outright and only two were a reluctant maybe.

Thank goodness for the occasional ibuprofen and codeine, I thought as I remained reasonably patient and good humoured. I sat down and shut up when I was told to do so while Fiona went to one of the changing rooms with a small pile of conservative clothes carefully selected with the assistance of the owner-manager.

I sipped ORS from my water bottle and took out my phone. Two texts from Seán, checking to see how I was and how I was surviving shopping. I felt my colour rising to a hot red. At his insistence and expense, I'd got a taxi home and after I'd snuck quietly up to my bedroom, I remembered sending him a text to say I was home safely and thank you for the lovely afternoon and evening. I flicked back through the text history to check I hadn't written anything I wouldn't have said sober. I had planned to have only two glasses of champagne and stop there but between the main course and dessert, when I'd already had more than was wise, I'd gone to the bathroom and read a text from my GP to say my ultrasound was all clear. It was hard not to have another glass or two to celebrate that news. Of course, I gave Seán no immediate idea why I was suddenly in celebratory mood. But

somehow as the afternoon moved gleefully on into evening, I had come straight out with it. Oh feck! Now he was the only person I'd told about the ultrasound…a bit intimate for what wasn't even a first date.

'Mum, what do you think of this outfit?'

The word 'boring' came to mind. 'Perfect for you for work,' I said. 'Black long-sleeved top and black trousers; a very safe ensemble, I'd say.'

'Mum, have you nothing positive to say?'

'Sorry, but you did ask for my opinion. And that was me being positive.'

It was Fiona's turn to roll her eyes skywards but she made no effort to hide it. 'I don't know what's wrong with you today…'

'Fiona, there's nothing wrong with me today. I'd just like to see you choose a bit more colour. It is coming into summer and when you're pregnant, you might get pale and drawn…black might not be the most flattering and it can be very hot in black when the sun is out, even more so when you're pregnant…'

'But I like black.'

'I know you do but have you considered that it might make the inevitable black rings around your eyes pop out like target marks? I'm just saying maybe it would be a good idea to add a cheerful top or two to your mix.'

I was starting to remember why Fiona and I hadn't gone clothes shopping together in years; we were poles apart in taste leading to in-evitable friction as she tried to dampen down my colourful choices while I tried to encourage her to brighten up.

She bought two of everything that was black that she liked and reluctantly allowed me to pay for a gorgeous turquoise top that I prom-ised her would be flattering as it would reflect a welcome warm glow into her face when she most needed it.

'Have you seen the price of it?'

'Yes, and it looks stunning with your dark hair and the little silver detail on it is lovely.' The owner-manager agreed profusely with me and I didn't mind if it was because it would give her a big fat profit margin.

'You're impossible to take clothes shopping,' Fiona told me over lunch.

'I know. I never liked it. I only came because I love getting some alone time with you.'

'I mostly like spending time with you too Mum but...'

'But maybe not for shopping. Best we leave that pleasure to your friends in future!'

'Exactly.'

'And when that which cannot be mentioned arrives, you can drop he, she or they off with me while you go buying some post-pregnancy clothes. I'll be delighted to oblige as long as you promise to stop for a cup of tea and a chat afterwards.'

She let out an audible sigh.

'Agreed...Mum. But what's got into you today? I'm not saying you're bad-humoured. In fact, more good-humoured, I'd say...I can't put my finger on it. What is it?'

'Oh, I don't know. Let me see: lots of things...HRT, Sligo maybe...Zara and I getting on surprisingly well what with green and nasty off the scene...you know, all that sort of stuff.'

Two Neurofen plus, a few lovely days with Zara, good news on the ovaries and a very pleasant afternoon and evening with a kind, caring, huggable man was the more honest answer but not one I was ready to give or that she might ever be ready to hear.

'I never could warm to Simon.'

'Me neither. Too up his own—'

'Mum!' Fiona shook her head emphatically.

'Well, he is. And worse. Did you talk to Zara recently?'

'Only by text. She's coming over tomorrow and cooking us a late vegan brunch. It'll be her first time in our new house. I think she'll be impressed with all the eco features that give it an A2 rating.'

'She might want to talk about more than your house's A rating, Fiona. Do make time for some one-on-one girl chat. That fella had too much control over her. He's a shit really. We've had some good chats recently, Zara and I. She talks and I mostly bite my lip to stop myself saying too much about what I thought of him from the get-go.'

'What? You biting your lip? I'd love to witness that!'

'Haha. Watch closely. I do it more often than you might think.'

I had a much-needed nap that afternoon and woke up thinking how much I wanted to see the French movie, *Amanda,* that Patrick I were planning to go to. It sounded like my kind of movie, a warm take on a tragic story focussing, not on politics, but on the personal fallouts from a terrorist attack in Paris. I had considered different things I might say to Patrick to avoid the pre-cinema dinner but none seemed worthy of trying; dinner with my almost-ex/almost-husband seemed unavoidable and I settled on telling him a version of the truth as to why I'd postponed.

'Sorry about postponing,' I said after he gave me a kiss on my cheek that would have landed on my lips if I hadn't turned quickly away pretending something had distracted me. 'Seán asked me if I'd go to Dalkey to look at his new garden yesterday afternoon and give him some advice on what to do with it. It would have been too much of a rush to get back in time, and I surely would have fallen asleep at the movie.'

Patrick nodded but said nothing, so I prattled on.

'Seemingly, Máire told him I was good at gardening because I'd helped her with hers and had done a decent job on my own. Seán's has nothing in it to give it any established character.' Realizing I was

talking too much to sound credible, I stopped abruptly and opened the short menu.

'Not to worry. I had a client meeting that ran on, and in the end, I didn't leave the office until after ten.'

'Just as well so,' I said, feeling a faint sense of that old doubt as to the truth of his "late in the office" line, but happy to ignore it given my own circumstances.

I steered the conversation over dinner to safe ground: our children and the movie, and I stood up with a sense of relief when it was time to walk into the cinema. The movie was all the reviews had promised: a French tragedy with a warm glow. Patrick walked me to my bus stop, and he might have expected me to suggest he join me on the bus and come home for the night, but I made small talk to avoid any hint at that possibility.

'It wasn't easy to keep kicking for touch, especially when, at a mention of the pleasure of Mr. Green being no longer on the scene,' Patrick responded. 'So, who's Zara off gallivanting with tonight? She told me she wouldn't be home.'

'She's gone over to her friend's and then straight to Fiona's in the morning.'

'Oh, will Matt be home?'

'He's out with his mates, but he'll be home late morning. I've promised him brunch.'

That was my cue to say, "we've a free house, why don't you come home with me?" But I coughed and blew my nose while I thought about what to say.

'I'm glad they both have something fun to do this weekend. I'm looking forward to waking up tomorrow morning and having the house to myself. It's been a while since I had that luxury. All that's been going on these last few weeks has me exhausted.' I gave a small stretch and a yawn.

It was his turn to cough.

'Of course, you need some time to yourself. I get plenty of it, living alone. I'll give you a shout in a few days and see how you are.'

'Great. Thanks for the lovely evening,' I said, watching the doors of the bus open, ready to allow passengers to embark. I gave him a kiss on the cheek and stepped into the thick of the queue.

I sat on the bus and imagined Patrick and Fiona exchanging notes on my strange humour. I couldn't tell either of them that I wasn't sure if I wanted any full-time partner in my life, and I certainly couldn't tell them I wasn't sure if I wanted Patrick as my life partner, even on the current quasi-part-time basis. And then there was the sense of excitement I had felt with Seán the previous night versus the plodding affection and borderline annoyance I felt towards Patrick. The thought of a relationship with Seán gave me both a warm feeling and a sense of trepidation, not least because Seán was Máire's brother. In addition, the prospect of the children's reactions loomed large in my head. I'd been far from cheered on by them when I'd kicked Patrick out after his affair. I didn't fancy maintaining the half-hearted non-committed status quo and giving up on life's other possibilities. As Seán had said, the children would be fleeing the nest sooner rather than later.

For the first time in years, I felt I had energy, I had choices, I had possibilities. A marriage breakup and HRT, who knew what might follow.

# Chapter 16
## Brunch: Where's Stephen?

I cooked a carnivore's dream brunch for Matt late on Sunday morning, glad that he could enjoy it without having to listen to Zara reminding him of the poor little pigs and cows that had been slaughtered to create the sausages, rashers and pudding for his pleasure. A part of me felt guilty because the more I knew, the less comfortable I felt about buying or consuming a lot of meat. I hadn't been able to eat pork or bacon since I'd learned how surprisingly close human and pig DNA are to each other, not to mention that consuming bacon regularly increases cancer risk. I'd gone from enjoying the occasional fry-up to the stage that the very thought of pork passing my lips made me nauseous. But Matt still loved it. I allowed him the pleasure knowing that any vegan or other commentary from me would give rise to accusations of disloyalty to carnivorism which would be delivered with Shakespearian aplomb: *Et tu, Brute*! I stuck to my own vegan choices of porridge followed by mushrooms on toast. We munched and chatted at our leisure and when we'd finished eating, Matt ground a carefully weighed portion of coffee beans and made a large pot of French press, a sure sign that he was in no hurry out the door.

'How's Stephen since? Did you hear from him yet?'

'Not a dickie bird,' I said, picking up my phone to check for the umpteenth time. 'I've texted him multiple times since Wednesday.

Not a word since I saw him on Monday, and he hasn't opened my WhatsApp messages. I've visions of him dead under a box on one of those derelict building sites developers are hoarding as they hold out for property prices to rise to some new high….by which time I imagine Stephen's body will be reduced to bones, ready to be dug quietly into the foundations.'

'What should we do? What can we do? Maybe he's lost his phone or sold it for a fix.' Matt rubbed his face with worry.

'It has a smashed screen. It's hardly worth selling.'

'Probably broken beyond repair by now so…' Matt sighed. I shrugged, sharing his frustration and concern.

'Did I tell you one of the last things he said to me?'

'No. What?'

'He said his life was shit and that he is stuck on a burning treadmill. He can't escape the flames, and he doesn't believe there's anything better for him off the burning treadmill…That's what he said, and now I'm scared he's done something to stop the pain—'

'We can't think like that, Mum. We just can't. His phone's probably the problem. We'll have to go looking for him.'

'I've been thinking that tomorrow I should walk the streets where he sometimes hangs out…And I can ask around and see what I can find out.'

'Will it be safe? If you wait 'til after work, I could go with you.'

'I'll only go to places where I feel safe. I promise.'

The next day, I took the bus into town to the area where I had met Stephen. Everything about the morning was grey: the clouds, the rain, the canal, the paths at the side of the canal, the murky water that the raindrops bounced off…It wasn't the sort of day you'd expect to find anyone hanging out, drinking or getting a desperately needed fix – it was too miserable for hope to find a place. I met a scattering of people, all with their hoods up and their heads down as I wandered the canal

bank walkways and the narrow streets, wondering where homeless people might be found on such a day. I remembered Stephen had told me he sometimes went to the MQ centre where you get a meal, a shower and a smile; no judgement, everyone welcome.

The nearer I got to the MQ building, the more small gatherings of depleted people I saw; thin men and women with vacant eyes, broken voices, slow shuffling feet…There was no sense of aggro between them, more a mutual acknowledgement that they were all similarly homeless, half-stoned and wretched. On the steps up to a doorway where maybe eight people had gathered, I noticed that some held crude metal pipes which they were trying to light and suck on. I'd always thought heroin was burned on a metal spoon or foil and that a glass straw was used to inhale the smoke. I wondered what drugs these pipes were used for smoking. I'd read that crack cocaine was taking over from heroin on and off the streets. There were so-called crack houses or crack dens in many parts of Dublin and whatever potentially lethal behaviour heroin addicts might do for a fix, seemingly crack took things to a whole new violent level; the high being so short but sweet that the user wanted more and more, building up to an insatiable, demented appetite for it.

Two wisps of undernourished young women stuck out their hands as I passed. 'Spare a euro or two for the hostel, please, Miss. Anything 'tall, Miss, will ya, please?'

My wallet was buried deep in my backpack and not for the first time, I felt frustrated at my own inability to feel safe enough to stop and dig out a few euros when need was staring me in the face. I cursed myself for not having the foresight to bring at least some food or cigarettes with me, knowing that I wouldn't feel comfortable giving out money, rightly or wrongly assuming it would only be spent on drink or drugs. I reminded myself food could always be had from the MQ and other homeless centres and that I still could make a small diversion

to a shop to pick up cigarettes or coffees as a means for some positive interaction. To my shame I kept going, stopping only momentarily at the door of the homeless centre, feeling conspicuous in my own glowing, good health and new clothes. A welcome background hum greeted me as I walked inside.

'Hi, I'm Tom, can I help you?' the young man behind the reception desk chirped as I approached.

'I hope so,' I said in a quiet voice. 'I'm looking for someone, a family member.'

I don't like lying but I thought if I didn't claim kinship, I'd get nowhere. I explained I was due to meet Stephen, as I had done a number of times recently, but I hadn't been able to get in touch with him, maybe his phone is completely broken…It was already broken the last time I'd seen him. I described Stephen and asked the man if he'd seen him recently.

'I can't say that I have,' he said. 'We do take a name for everyone we see, but it is up to them whether they give us their real name or not.'

'I understand. I know you probably can't tell me anything about him, one way or the other, but can I give you my number just in case you do see him.'

'I can't guarantee anything, but I can make a note of it in the book.'

He took my name and number and noted it in a book. I resolved to keep coming back every few days until I found out something. I told myself no news was good news.

Two days later, back I went. It was Cora, a middle-aged woman, behind the counter. As I showed her an old photo of Stephen, I thought I might relate better to her and her to me.

'I can't say I've seen him,' Cora said just as Tom had.

'But…' I said and I proceeded to give her a more emotive version of the story than I'd given Tom.

'I'm sorry, Martha. I can only say we'll do what we can. We have your name and number and we will look out for Stephen. We can do no more than that. But not everyone gives us their real names to be honest. You'd be surprised how many Mickey Mouses we have on our list.'

'Thank you, Cora, I live in hope.'

As I left, I again resolved to keep looking, to scan the newspapers each day for any possible word, to call the hospitals…In the meantime, I headed to Mr Middleton's Garden shop for prompts on what plants might provide some ready interest in Seán's garden as soon as the Liscannor stone circular patio I'd planned was laid. I decided that a couple of Skimmias, some lovely scented Sarcococca – often called Christmas Box or Sweet Box – and a nice holly bush or two would all be worth considering for Seán. I bought plants and seeds for my own garden, including some easily grown vegetables that had been a failsafe for me for years: kale, perpetual spinach, mangetout and runner beans.

Seán and I had exchanged texts or talked, or both, every day since Friday's lunch. I used the plans for his garden as the pretext for my communications. To admit to myself that I was feeling like a young one in the throes of that will-he-won't-he – will-I-won't-I dilemma would have driven me to call STOP. Over the course of those days, I enjoyed some sensual dreams; I found myself waking up with a broad smile, intrigued that the vague prospect of new romance combined with HRT were having such a desirable effect. These feelings were always quickly replaced by the voice of reason reminding me of the likely consequences if Seán and I did take things to a new level: my current good relationship with Zara would crumble; the tired and hormonal Fiona would disapprove of me abandoning the sort-of reunion with Patrick; Matt could judge me harshly too, especially as he was lonely for his Canadian girlfriend; add to that the complication of my very close friendship with Máire…who was I kidding? It was ridiculous to

have these endless circular conversations with myself. Weeks were ticking by and I was delaying meeting up with Seán again much and all as I'd loved our time together that Friday afternoon. I was heading towards sixty, not sixteen. I had responsibilities and a multiplicity of strings attached. I wasn't free to follow my heart – maybe it wasn't my heart, but good old, too long suppressed, passion for new adventures, freshly-fuelled by HRT. If romance wasn't to be, I could find other new adventures; I could play the devoted granny after the baby arrived and then take some time out, travel again, visit my brothers in America, go back to Kenya maybe…Much safer than embarking on a new relationship and threatening my currently good relationships with the important people in my life.

'What do you think, Chuckie? Would you miss me if I went off travelling and left Zara to look after you?' Chuckie looked up at me, assuming I was talking about something important, like food.

'And where do you have in mind to travel to?'

'Jesus, Matt! For a minute there, I thought the dog had found his voice!'

Matt picked Chuckie up in his arms and had a mock conversation with him. The dog fixed his eyes on Matt's face, giving him his full attention as if he was being asked what he'd like for dinner. 'So, where do you think Martha might be off to?' Matt asked.

'I don't know, you'll have to ask her,' Matt replied to himself in a voice that might have been Chuckie's.

I laughed and Matt put Chuckie down on the couch and rubbed his head and belly and then turned to look at me.

'Where is it to be?' He asked.

I coughed, trying to think of an appropriate answer. 'Nowhere planned unfortunately. Just dreaming…'

'Sligo a possibility? I know it's none of my business but I've been wondering what your thoughts are.'

I shook my head. 'You and Zara both. I'm thinking about it. I wrote to Margaret and told her that her note meant a lot to me. I said I've too much on at the moment but I'll be back in touch.'

'Good one, Mum. Keeping your options open. No harm there.'

'It was a shock seeing her, we were never close and we didn't part on good terms – it will take time to get my head around it. And then there's Mum, if I decided to go, she says she might come with me, and I fear it will be harder on her than she thinks. It's been nearly sixty years since she was there. Do I really want to trigger her by having her face her horrendous past? She's a woman who lives well in the present.'

'She does and she does it well. But as you would say, she has her own mind...she's well able to decide for herself if she wants to go back.'

'True,' I said, exhaling slowly to release the tension I felt brought on by the weight of the consequences of every big decision I faced.

The smoke alarm screamed shrill across the room.

'Shit!' I pulled the over-grilled burgers and wedges out of the oven. 'I was trying to get them to brown a bit.'

'They're black as charcoal, I'm not eating them.' Matt watched with undisguised disgust as I shovelled the cinder-tinged food onto two plates.

'You won't taste the lack of meat when they're that colour!' I said.

'Thanks, but, no thanks, I'll get a takeaway.' He was already punching his fingers on his phone.

'Think of the homeless and all the starving people.'

Matt shook his head. 'Think carcinogenic. And thinking of homeless – any news of Stephen?'

'No. Nothing. I'm worried. I went back to the centre today and walked around the usual areas and nothing. It's been weeks since I've heard from him. I'm going to have to ring around the hospitals to-morrow and pretend to be his mother.'

'Mum!'

'It's not really a lie, we used to joke he was like part of the family so...'

'It's a lie, Mum. Dress it up all you like but it's still a lie, and you never encouraged lies.'

'Well, do you have a better suggestion? Do you? What if he's lying in a hospital with no one to be discharged to? Nowhere to go? I've sent him texts and WhatsApp messages every day in case one might get through to him, in case, he might be in a position to answer one at that moment...'

'I hear you. Look, maybe I can make some enquiries through the doctors I know in the hospital, many of them work in other hospitals too.'

'Thanks Matt. You'll do that now, won't you? You're not just saying.'

'Of course, I will. He was my mate, Mum. I should have done more for him.'

'Should have, could have, would have; all past tense...let's do what we can now.'

# Chapter 17
## Finding Stephen

Another two and a half weeks passed and still there was no sign of Stephen.

Zara had offered to go looking for him with me, but I said she'd enough to keep her busy with end of year exams and assignments. She was mostly in reasonable form with the occasional flare-up in my direction but the time between flare-up and apology was shortening and sometimes came with a bonus hug.

I was desperate to see Stephen again, just to know he was doing all right, and so, in my plight to find him, I looked up more about drugs and homeless services in Dublin. I found an article that said that the volunteers and staff in MQ made it their business, as far as their clients were willing, to get to know them by name, to talk to them, and to connect with them.

It gave me hope that someone might have connected with Stephen; I knew he was a regular there. So, back I went to the MQ Centre to tell them what I'd read and to ask them again about him. Tom, the same man I'd met my first day there, was at reception. 'I hear what you are saying, Martha. But honestly, there is no update. As I said before, we endeavour to pass on messages such as yours.'

'So, have you given him my messages?' I asked, looking for any hint of a reaction from him, any tell-tale sign that might give me hope.

Tom's voice and face were impassive. 'As I said, if we do see him, we will pass on the message.'

'We've tried all the adult hospitals. And I text him every day in case he lost his phone and eventually gets a new one...' I said with desperation.

Tom put his hand on my shoulder and gave me a gentle smile and nodded an I-know-you-have nod. There was nothing more to be said here. My shoulders slumped and I walked away with my metaphorical tail between my legs.

I plodded along the boardwalk towards O'Connell Bridge. A man and a woman were sitting on a bench there; they had that look I was becoming too familiar with: overthin, pale grey pallor, small pinhole pupils and the general demeanour of being not quite connected to the world as I saw it. It was not yet 11:00 a.m. and they were sipping from cans of what I assumed to be some cheap beer. I had come prepared this time and I plonked myself down at the far end of their bench. I took a couple of sandwiches from my backpack and offered them to them.

'Thanks,' the woman said, taking both sandwiches, reading the labels before handing one to the man.

'Yeah, thanks,' the man said.

I took out a box of cigarettes and held the open box toward them. They looked at me with narrow-eyed suspicion, but one after the other, they reached across and took a cigarette.

'Thanks,' the woman said again. The man just nodded.

'You're welcome. Take a couple more.' I held up the box again as they helped themselves.

Their faces and the sideways way they looked at me made it clear that they were wary of my generosity.

'I don't know how to put this but...'

They turned and looked at each other as if to say, "we were right, we can't trust yer wan."

I started again. 'I'm looking for my son's best friend, and maybe you can help me. Stephen's his name, and I know he sleeps rough, and all that. But he's a good lad, and he was like one of the family until…you know…'

'Yeah,' they said, both nodding, so I went on.

'Anyway, I started meeting up with him, but now he's not responding to my messages, and it's not like him. I'm just wondering if you've seen him or anything.'

I took the photo of him from the day of the big match out of my back pocket and showed it to them. Stephen looked gorgeous in the well-fitting team gear, with his grin from ear to ear, his big blue eyes, healthy outdoor complexion, and well-built athletic physique.

'He's a lot thinner now,' I added.

'Yeah, I knows him. A decent skin like. Haven't seen him for a while, though, have we?' He turned toward the woman to confirm what he was saying.

'Yeah. No, we didn't see him in a long number of weeks like. Could be longer.'

'Oh, pity. I was hoping…But if you do see him, please tell him Martha's looking for him, and I've left a message at MQ for him in case he's lost my number.'

'Yeah,' they said together.

'We'll tell him…no problem like. You wouldn't have any spare change for the hostel like?' said the man.

I'd had a shift in my principle of not giving out money in case it was used on drugs or drink; the more I knew, the more I asked myself, who was I to judge? Perhaps a bed for the night in a hostel was all they wanted the money for, perhaps not. I dug out my purse and took out a €10 note and handed it to them with the remaining cigarettes.

'Thanks. Thanks a million, Missus,' the woman said.

'Sure. No problem. I hope you get a bed.'

I wondered how much a homeless bed might cost. I assumed they hoped to get one to share, one that was meant for a couple. Did such beds exist? €10 and a packet of cigarettes, it wasn't much to give them, I should have given them more.

The following week, I was on the phone to Seán, confirming I'd meet him the next day in Dalkey for a walk and a review of the garden plans over a late lunch when my phone pinged. A WhatsApp message from Stephen appeared on my screen and I paused midsentence.

'Sorry Seán, I just got a message from Stephen. I'll call you back later.'

**So sry 4 not txting U B4. Been real sick. & hd no phone. K now. H2CUS**

So, Stephen had been sick. What did that mean? Sick? Sick, wanting drugs sick or cold turkey sick or what?

Best not to ask.

**Hi Stephen, good 2 hear from u. Took me a while to interpret your text but I got there with the help of google! R u sure you're ok and up to meeting? If so when suits? M**

Thankfully Stephen was thoughtful enough to use closer to plain English in his response.

**Don't worry. I'm better each day. A terrible sickness. Was worried myself TBH. Cld mt tmrw.**

Seán would understand, I'd told him about Stephen and he knew how worried I'd been when I hadn't heard from him. I texted Stephen straight back.

**12:30 at the canal bench?**

Stephen responded with a thumb's up emoji.

The following morning, as planned, Mum popped over to me for coffee at 9:30 a.m. When I told her, I wasn't rushing off to Dalkey, there was no hanging around.

'The sun is shining, we'll walk to that café I like, get a coffee there and walk back,' she declared.

'Mum, whenever I feel like I'm getting old, I think of you and decide I've years left on me yet!'

She laughed. 'Two new hips, Martha and there's nothing going to hold me back.'

'How're Seán's garden plans going?' Mum asked as we sat sipping our coffees at a table outside the café.

'Getting there. The proof will be in the planting. We were supposed to discuss the plans today.'

'Hmm.' Mum said and left it sit there.

'Hmm what, Mum?'

For years Mum had been the sort of mother who was careful not to interfere. That was the case, at least, until Patrick's affair. When it all came to a head, I had to tell her the truth: that I'd known about it for months and hadn't told her, or anyone for that matter. I waited until I was ready and had a plan, and then kicked Patrick out, with no conversation and no notice. It was unfortunate that Mum was over visiting my brothers in America at the time, but it's how the cards fell.

'I don't know. Just a feeling. Anything I should know?'

I shifted uncomfortably in my seat, racking my brains for a change of subject. I was about to start talking about how well my own garden was doing.

'Just a feeling,' Mum repeated.

I wasn't going to get away with it but I wasn't going to make it easy for her either.

'And what feeling might that be, Mum?'

'You tell me.'

'It's *your* feeling,' I said, knowing I was close to smiling.

She burst out laughing. 'I don't like to interfere, you know that. But saying nothing doesn't always turn out for the best either…'

I couldn't help but laugh too. Mum was a highly intuitive romantic despite how her first big romance, with my father, had worked out.

'Tell me your feeling, and I promise I won't consider it interfering. I might even tell you whether your feeling is right or wrong.'

'Let's say I've noticed you've hardly mentioned Patrick in the last couple of weeks but you seem to be putting a lot of time and effort into this garden of Seán's…'

'And?'

She raised a knowing, painted eyebrow and looked at me through smiling eyes. 'I feel more than a garden might be blossoming.'

I smiled at her from behind my hand and she reached across the table and squeezed my other one. I felt her love. I knew there would be no judgment, she would be my rock whatever I decided. A hot flush rose in my cheeks, not a full-blown menopausal flush, more a glow. I poured myself a glass of water, pausing for thought before I took a long sip.

'How should I put this? Well…there may be a seed planted that could, in time, grow into a beautiful lasting evergreen, or maybe will be no more than a short blossoming annual. I don't know. My gut says if I feed and water it, it will be more than an annual. My reality says there are some very good plants on that patch already and if I encourage this new promising plant to get established, however briefly, other treasured plants will suffer…Symbiosis is unlikely. For the time being, I'm nurturing the plant to keep it as a seedling. But I know there's a limit as to how long that will be possible.'

She hmm'd once more, gave a gentle nod and patted my hand, acknowledging that while I was using playful gardening metaphors, I was not taking the situation lightly.

'I don't envy the gardener their dilemma,' she said. 'I think they're right not to rush and I hope circumstances won't force an early decision on whether to uproot or let blossom.'

'I hope so too. It feels like there's a lot at stake. My good relationship with Zara is in its early days. She still favours her father and we have the odd clash, but mostly, we're good. And there is Fiona becoming a mother and Matt missing Sophie...'

'I know you'll do your best to do the right thing by everyone, Martha, but don't forget to include yourself in your considerations... You know what I mean, don't you, pet?'

I squeezed Mum's hand tight and our eyes said that we both knew Mum spoke from the sad experience of how things had worked out when she had put everyone ahead of herself and had given up first, my father, and then me.

he Stephen that stood waiting for me holding onto the bench that afternoon reminded me of the phrase, sure, you wouldn't see him if he turned sideways. I didn't think it was possible but he looked paler, thinner and weaker than when I'd first met him early the previous month, but here he was. Sunlight bounced off his white blotchy face as he pulled hard on the end of a cigarette and with a shaking hand, squashed it out against the back of the bench and put it in the bin beside him.

'These are the next things that have to go,' he said in a pained, husky voice. 'Soon, but not yet.'

I reached up and squeezed his skinny upper arms and gave him a motherly kiss on the cheek. He brought his hand up to his face and held it where my kiss had landed. My heart bled a little for him as I sat down on the bench and lifted my face to him and the warm sunshine.

'Good on you, Stephen. It's fierce hard to give them up but I bet you will.' I patted the bench beside me and he sat down. I gently placed my hand on his trembling knee. 'How've you been? A rough few weeks, eh?'

'Bad, real bad. The sickness, I mean. Hell hath no fury like your body being deprived of the crap it's come to love.'

'Oh?'

'Yeah, turns out if you want to get into any of the available rehab programs and you're taking all the crap I was taking, you have to detox first. Fucking mad stuff. But the detox centres have long waiting lists, really long ones. I couldn't wait half that long…so I had to try it without them. You know like, before I changed my mind. Over the last six weeks or so, I've being purging the fucking benzos out of my system. It near killed me. It did. I nearly gave up so many times…You even have to get your methadone level down real low to go on some of them rehab programs.'

'You were on methadone?' The question was out before I knew it. My mind had been whirring as he spoke and methadone was what it honed in on. But my real question was, were you on heroin, but if he was on methadone, then he must have been on heroin. But I'd no right to ask.

'No. I wasn't on methadone. A cocktail of every other shit though. My mate, Dave, he's a bit younger than you, he told me don't do it. He says every fucker, thick or intelligent, thinks they can dabble in heroin; take it for a random big hit and…But, you get such a bleedin' hit from it, you'll want more cos with it, all your worries disappear. Then you need more and more to get the same fucking hit – sorry, his words. You'll swear you'll never inject but you will because you'll chase that big hit and smoking will stop giving it to you…Next step, if you're lucky, methadone and that's one of the biggest bitches of all to kick after crack cocaine and fentanyl of course…that's what Dave kept

telling me. But sure, I knew better…I was only going to dabble with heroin but Dave was having none of it.'

'So, because of what Dave said, you didn't do heroin, crack cocaine or fentanyl? That's impressive.'

He looked at me with his mouth moving but no words came out. His eyes were bloodshot but the pupils were larger than before. His hands were in a state of perpetual motion, scratching his wrists, rubbing his thighs, rubbing each other, moving through his untidy hair.

'I…I only did heroin…No, I did heroin only recently, a couple of months back. The weed and the benzos weren't doing it for me. I was getting fierce fucking agitated and angry, getting into fights and shit. I tried taking more benzos but nothing good was happening for me. What the hell, I thought, I've nothing to lose, I'm fucked anyway. Like every other eejit, I told myself it was just going to be the occasional dabble. But that first hit felt so fucking great, not a care in the world, and the feeling lasted. I was so chilled, I was invincible. When I was riding its wave; I was without a drop of shame…and I loved the feeling.' The last four words were said with a shake of his head that said he wished he hadn't loved it but he had.

As he spoke, he looked down at his hands and thighs. When he stopped talking, he lifted his head and looked straight at me, prompting me to lift my lowered jaw and shut my mouth. I moved my hand on top of his hand on his thigh, hoping he felt my heart go out to him, the way I had felt Mum's for me that morning.

'The reality that faced me was worse than ever and…and anyways, I had just bought me some more Horse one day and who do I bump into, fucking Dave, right on O'Connell Bridge. I was grinning like a dog with a bone. I was going to get my high. What you got, Dave said. Nothin', I told him. I know you've got somethin', he insisted. The fecker leant his left elbow on his crutch and quick as a light, patted me down and found the H in my tracky pocket. Should've been in the

guards, should Dave. 'I told you not to do this shit, didn't I? I told you it near killed me. Fuck it, Stephen, you've brains and two good legs.' And with that he sent it flying into the Liffey. I nearly went for him. Someday, I hope you'll thank me, he said as he hobbled off. I kicked the wall; I was that fucking furious I nearly broke my toe.'

I gave a muffled snigger. I was thinking I'd like to meet this Dave guy. With a half-smile and a raise of his eyebrows, Stephen acknowledged my smothered laugh.

'Next day, I was hanging with my drinking buddies. As soon as the drink was gone, I was going to ring a dealer and get me some more H and this time, Dave wasn't going to get his paws on it.' Stephen stopped and rubbed his hands hard up and down his thighs, again and again.

'And did you?' I couldn't help myself. I had to know.

'Probably a stupid question, Martha, but have you any cigs?'

I opened the backpack on my knee and pulled out a packet. Stephen, one of the best athletes I'd ever known, and I was handing him a box of cigarettes and I felt glad to. Life is so unpredictable.

'You're full of surprises, Martha,' he said ripping the cellophane off the box and offering me a cigarette from the open box.

I smiled. 'I don't smoke. I keep them for friends.'

'Fair play.'

'Sorry Stephen, and I know it's none of my business, but did you get your fix that day?'

'Nah, I didn't. Cos that was the day you came along. Me and my mates were nicely on and I was nearly out of booze. You took me for food and by the time we parted, I'd lost my appetite for getting gear, hadn't I? Then, like you told me to, I went to see someone, and he asked if I thought I might be at an important crossroads and if drugs were working for me. I said they were better than the bleedin' alternative. He said, how do you know that, when was the last time you tried

202

the alternative? I had a choice to make. Perhaps, he said, Martha and Dave coming along at the right-wrong time was telling you some-thing…are you ready to hear that something? Choice, I didn't feel like I had a fucking choice. I tried to cut down and it was shit. Then when I met you again, I got thinking, maybe I did have a choice. But I didn't think I could do it…It's not as easy as it sounds…'

'No, not easy at all…' I squeezed his hand reassuringly and he con-tinued.

I noticed that while I was feeling really warm sitting in the sun, he was still shivering. Logic was telling me that I should bring him some-where for food to warm him up, but he was talking, and he seemed to want to talk.

'I texted Dave and met him to get the load down on how to get clean. He'd always said he'd help me. 'It's a slow burn,' he said, 'you've got to do it real slow, come off those benzos too fast and you'll have a seizure and bye bye those brains of yours.' So, I started trying to slowly cut back, you know like, delaying taking the pills until I was really desperate. The fuckin crazy thing is I kept feeling like I wanted one more heroin hit to help me give up the benzos. Stupid or what? I was meeting you when I was starting to cut back but it was so hard and I was making fuck all progress. I couldn't do it in the hostel with drugs everywhere in there. And my drug mates were everywhere too. It was torture. I was ready to give up giving up but Dave had other ideas. I got myself a tent: €15 in Penney's, paid for it with the social, I did. Dave told me where to pitch it, further out from here, along the canal, near where he lives. He said he'd keep an eye on me. And he did. He spent hours with me every day. He took my money and bought me food and soft drinks. He was slowly weaning me off the benzos. He was in charge. He caught me texting a dealer one day and the fucker took my phone and threw it in the canal. He's a thing with water, Dave has. After that, he took even tighter control of my tabs. I thought

I was going to die, dying seemed a better option. I thought I'd burst my guts and puke my insides out. The worst was my head, it didn't feel like my head. It was on fire. It hurt like hell. It still hurts at times. I wanted to die. 'Fuck it, Stephen,' Dave said, 'I'd twice as much shit in my system plus heroin, plus methadone and I didn't die, did I? A young fella like you'll be fine.' He's one tough nut, is Dave.'

When I had been walking around looking for Stephen, I'd wandered further up the canal and passed a tent. It never crossed my mind that Stephen might be in there. I'd heard someone getting violently sick and the smell of it and toxic human excrement had made me turn and quicken my pace towards home.

'Wow! I like the sound of Dave,' I said. 'He must have one hell of a constitution.'

'You'd like him. He's a really good mate. He'd pretend to think you're too posh for his liking but he'd like you, cos you're a decent skin like him.' Stephen's voice was thick with tears as he spoke.

'Ah, thanks, that's nice to hear. You're a decent skin yourself.' I tried to hold back my own tears but down my face they ran. I took a packet of tissues out of my backpack and handed one to Stephen. We wiped our eyes and blew our noses.

'I was meant to meet Dave that day on O'Connell Bridge and I was meant to meet you here that other day,' Stephen said between sniffles. 'Serendipity, isn't that what they call it?'

'Yes. Yes, it is. The stars were aligned for you and you deserved them to be. You'll get there, Stephen, you will. You were always brave and determined when it came to setting targets and aiming for them. Matt always said no one knew better than you how to stay focused on the end result. That will stand to you.'

'I hear the worst is yet to come. I've a long road.'

# Chapter 18

## Matt Meets Stephen

Stephen finally stopped shivering when he'd finished a large bowl of soup. His initial talkative energy faded into heavy tiredness and tears escaped down his face between quiet sniffles.

'I got a new phone with the money I saved when I wasn't handing it all over for a hostel or for all my usual poisons. Dave still has me saving. Imagine! He's a bit of a dictator- evangelical, like a man who's found fucking religion and wants everyone to join…If I keep going this way, I'll not just be drug-free, but debt-free too.'

'That's amazing. So much progress in a short space of time.' I meant what I said, but I worried that it was too much, too fast.

'Scary, to be honest. One never-ending day at a time. It's hard staying clean on the streets…there's fuck all to do. I can't hang with me mates because they're using. Dave's all I've got. I see him every day, and I stay in my tent or with him. It's worse than boring.'

'Oh Stephen, if I can help, you will call or text me, won't you? Promise you will.' I touched his hand with mine, noticing my aging, thinning skin against his young, scarred hand with its prominent knuckles and tendons.

'Yer man in MQ says they might get me a place in rehab soon, but I have to stay clean. I've just got to.' He sniffed and snuffled and wiped the back of his hand across his nose.

'I'm still struggling to get my head around you having to get clean before you can get help to stay clean…'

'Well, he says many places don't have staff to supervise detoxing from benzos and the other shit. You know like, trying to make sure you stay alive and all that. Detox is like passing through hell, and when you're going through hell, it feels like you ain't ever coming out the other side. Without Dave, I couldn't have done it. And I'm fucking scared I'll relapse before…Every day I wake up, and all I want is to get a fix. I have to remind myself over and over again what getting fuckin' clean was like.'

'Hard to forget, I'd have thought…Feck it. Let's hope you will get a place soon.'

'Yeah, hopefully, because after rehab, MQ has a step-up facility where I can try normal living, even get a job. I'll take any job, the worst is having nothing to do all day, every bloody day.'

'On that, I know it's not much in the scheme of all the days ahead, but Matt asked if you'd like to meet up with him. He'd love to see you, and he says his next day off is Saturday, if that suits you.'

A flicker of joy came into Stephen's face. He picked up his phone and tapped into it. 'I'll have to consult my calendar. Let me see. Ah, Matt's in luck, I've had a late cancellation on Saturday!'

'Great. I'll give him your number, and his secretary will be in touch to arrange a time and a place.'

'Matt's secretary – how passé!' He sighed dramatically and rolled his eyes in mock horror.

Our shared silliness brought laughter and hope. The old Stephen was alive and well. As I walked home through the park, the birds acknowledged my joy and I realised I'd forgotten I was on a promise to go swimming with Zara that afternoon.

'Late again, Mother,' she said as I pulled the front door behind me to join her at our gate where she had both our bikes ready.

'Zara, the birds in the park distracted me!'

She let me off with a teasing side swipe of the back of her hand.

After our swim in the questionable waters of Dublin Bay, I suggested we get fish and chips. She didn't pooh pooh me or mention the micro plastics that I'd be ingesting with each bite of fish.

She simply said, 'Onion rings and chips for me so.'

We ate sitting on the seawall watching the sun set in a blaze of reds, oranges and yellows with the promise of a bright new dawn and I told her about the time I'd gone home to look after Mother in Sligo and I'd woken early and headed out to watch the sunrise as I had done so many times over Dublin Bay. I was in the car heading to the beach before it dawned on me that Rosses Point facing west was good for sunsets over Sligo Bay but not so good for sunrises. I had continued going and to my great joy, my early morning walk on second beach was rewarded by a slowly building show of light and colour rising up to show the striking silhouette of Benbulben in new glory.

'There is no other mountain anywhere like Benbulben,' I said, 'it rises clean into the sky, providing a dramatic backdrop, no matter what angle you see it from.'

'So, Mum, when are we going to see it together?' she said.

'When indeed?' I replied.

The next morning as Chuckie and I walked along the seafront, I phoned Máire. I'd been avoiding her and perhaps she me, because of the possibility of something maybe happening between Seán and me. After some small talk which was stilted by our norm, it was Máire who brought it up.

'Martha, forgive me if I'm speaking out of turn here, but there is something I feel I should say...'

'Please, Máire, say whatever it is…' I spoke quietly.

'Seán and you, I love and treasure you both and…Blast, how should I say it? Well, you may become more than friends…Who knows?! All I'm trying to say is that whatever happens, I hope we won't let it come between us as friends. But…at the same time, I don't want our friendship getting in the way of what might happen; you're two good people and…And that's all I want to say. And I hope to goodness it came out right, but there, I've said it.'

The 'there' was expelled as a sigh.

I had to swallow a lump in my throat before I could respond. Máire's kindness and support had meant so much to me so many times in my life and here she was again. How did I deserve her?

'Máire, thank you. Thank you for saying that. I'd hate to lose our friendship. I am fond of Seán and…who knows? I don't know…But…and I'm being honest here…life feels very complicated at the moment, and I don't feel ready for any big decisions or commitments…Whatever happens, I definitely don't want to cause Seán any hurt or risk our friendship.'

'I know you Martha, I know you don't want to hurt anyone, but I know people can get hurt in relationships for reasons that are nobody's fault. I'll try to be there for both of you…but you and I don't have to bring this up again unless we feel we need to.'

'Máire, Máire, how do you always know how to say the right thing?' My words were thick with grateful tears.

Despite receiving Máire's blessing, I left my planned meet-up with Seán sit until the end of the next week. I needed more breathing space. Patrick texted me to say that he was too busy and tired with work to meet up and I felt only relief. A weekend of no pressure, time to think, time to process; I needed it. I spent it pottering in the garden: weeding and tidying the vegetable beds, lightly pruning the espalier apple trees,

harvesting some overwintered perpetual beat and rhubarb. And when all that was done, I did some more weeding.

Some of my best decisions in life have been made pottering in the garden. Weeding in particular, it demands little thinking in its own right and is best done slowly or good plants, such as the seedlings of random sunflowers created from scattered birdseed, might be brought to a sudden end. I considered the important people in my life: my children, Mum, Máire, possibly Seán, Stephen, my not quite ex-husband, my other friends…As father to our children, Patrick was sure of a place but was it time for that to be the extent of his role for me; was it time to cut the more intimate ties with him; I observed that I hadn't been particularly missing him over the weeks I hadn't seen him. Next time I saw him, I would tell him, we should take a break. It sounded silly, a break from what?

I treasured my friendship with Máire, she understood me better than most people I knew. Seán was wonderful in lots of ways, he could be a treasured and fun friend to have. I felt happy and comfortable in his company, the problem was I couldn't decide if I fancied him or how I felt about the thought of kissing him deeply in that sexual way and as for the thought of making love with him, that notion felt way outside my comfort zone – I guess thirty years with the same man can do that to a woman. Best to see him as a good friend, be measured about it, focus my attention on my immediate family and on Stephen who was starting to feel like my prodigal son. Yes, I decided, now is not the time to start a relationship, best not to complicate life unnecessarily, best to focus on my children and other people who matter in the long term. I had survived without any committed male partner in my life. I could thrive alone; I liked my own company as long as I had my family and friends too. I already had more than enough people in my life; it was more me time I needed; that was my decision made.

Sunday started with breakfast and the papers on the patio bench in warming sunshine. I had my clippers in my hands, ready to start trimming the rosemary bushes and bay trees when Matt came out carrying a large tray with a pot of coffee, a plate of hot croissants and two mugs. Chuckie was glued to his heel with his tongue hanging out.

'Time for a break, Mum. Croissants are fresh out of the oven.'

I put down the clippers, drawn by the promise of Matt's good company and the smell of coffee and buttery croissants.

'How's a woman supposed to get any work done?'

'You know what you should do, Mum? You should get yourself a good man to do those jobs. He'd have it done in no time.'

'Done half as well in twice the time! Stop trying to press my buttons.'

'And the feminist is off...But is tripping at the first fence...' He used his best racing commentator voice.

I rolled my eyes heavenwards and gave a sorry face. 'Oh Matt, I'm sorry. I must have misinterpreted what you meant. You're offering your services, you're the good man volunteering to do the gardening jobs...'

Matt rolled his eyes right back at me and passed me a plate with half an almond croissant and half a pain au chocolat.

'I'll stick to the baking, thanks,' he said emphatically as he poured me a mug of black coffee.

I bit into a warm croissant and its almond paste squirted onto my plate. I dipped my fingers into the sticky substance and licked my fingers with the pleasure of a child eating an ice cream. I sipped my coffee and smiled.

'Good croissant. Good coffee. You've got the touch.'

'Thanks. And you're good with the clippers so I guess that's the division of labour decided!'

I laughed and gave Chuckie a tiny bit of croissant. 'Forever the artful dodger of all gardening tasks, isn't he Chuckie?'

'I had an unusual day yesterday.' Matt said.

'With Stephen?'

'Yeah, with Stephen. I met him at Mary Jane's in the park for a coffee and snack in the afternoon. Afterwards, we went kicking ball over on the pitch we used to play some of our matches on...He's rusty but he hasn't lost the touch. He's bloody scrawny though. I was shocked.'

'I warned you.'

'And I was still shocked...We'll have to get him to bulk up if he's to go back playing.'

'I'm with you there. I've been trying my best to get food into him every time I see him.'

'Yeah, well, after footy, we went to the Indian, and I bought us a takeaway which we ate on a bench on the promenade. My turn to pay next time, he insisted. 'I'll have more cash when I quit these,' he said, taking a long drag of the butt of his cigarette. Then, he went over and handed the rest of his packet to a smoker sitting near us. 'That's that, time to get fit again. Give me a couple of months and I bet I'll outrun you,' he said with that determined smile of his. 'You're on,' I told him.'

I shook my head. 'He's certainly determined, always was. But really, Matt, how much can a body give up in the space of a couple of months? I mean, is he expecting too much of himself.'

'He says he's going to start eating more and better and get properly fit; can't do that on cigarettes. Statistically, he told me, the chances are he'll fall off the wagon – relapse, go back on drugs – but never mind the stats, he wants to focus on the possible. He says if he gets back playing sport, he'll stay clean. And I say, if anyone can do it, he can.'

'I hope you're right. I really do. No better man...He could turn into a sports addict, I suppose. Could do worse.'

'He could…We're meeting later today…' Matt stood up and started to kick an imaginary ball around, kicking it firmly in the direction of one of my vegetable beds. He brought his hands up to his head as if he'd just demolished some of my precious plants, then sat down again. 'Stephen was well wiped last night when I dropped him off near his tent…but give him a few months…'

'I'll look forward to seeing him on the pitch again so.'

'Yeah.' Matt smiled. 'It was good to see him. He may be a skinny fecker, but he's still Stephen.' Matt popped half a croissant into his mouth, drank the last of his coffee, lay back on his chair, and stretched his long legs out in front of him. 'Yeah, it really was nice to see him,' he said as he closed his eyes and turned his face towards the sun.

I clipped the rosemary and inhaled its herby scent. I wondered at the wisdom of my decision from the day before. Was I giving myself enough consideration? Was I forgetting the children had their own lives which were moving on at a pace? Maybe I was using them as a convenient excuse not to embark on a new romantic adventure, forgetting to feel the fear and do it anyway? I would talk to Patrick and tell him I treasured him as a friend and as a father to our children but I wasn't sure what else I wanted from our relationship. I'd set him free to see other women, to do as he wished.

In the midst of all my decisions and revisions, the gardening got done and I finished the weekend tired and creaking.

# Chapter 19
## Lunch with Stephen, Patrick and Seán – Escape

I arranged to meet Patrick for lunch on Tuesday and Seán for a walk, garden chat and lunch on Thursday. Seán was adamant he wanted to show me around Dalkey.

I had decided I was going to tell them both variations of the same thing: I didn't know what I wanted for the next stage of my life, I felt swamped emotionally and wanted to put my energy into our children, my Mum, becoming a grandmother and maybe even into meeting Margaret. I'd tell them I didn't feel in the right place to have a relationship, old or new, and that I wanted to fly solo for a while but stay friends – if that was okay with them, of course.

On Monday, Stephen was full of the joys of his time with Matt over the weekend.

'Matt's a great guy,' he said numerous times.

'He drives me crackers, always fecking winding me up!' I said with a smile. 'But I love him anyway cos he's a good soul and makes me laugh.'

'I'm only sorry I won't see either of you for a while.'

'Ha! Stephen, you don't look sorry!'

'I've got a place on a drug rehab program. I'm going next Monday.' He beamed.

'That's great. Only seven more sleeps!' I said using the expression I would have said to the children when they were counting the days until Santa, a birthday or some other much-anticipated event.

'Only seven more endless days and nights struggling to stay clean. Then, I'll be gone for maybe three months – to some farm or other – they didn't tell me where. No mobile phones – Dave's going to mind mine – I hope he doesn't throw it in the canal or something.'

'Hopefully not.'

'Seemingly, we can make the occasional call from a landline or something…proper old-fashioned; I wonder if it will be one you need to wind up like they had when you were young…I might call you just to see what a landline is like.' He was beaming at the prospect of it all.

I smiled. 'Thanks a bunch, and all that but I'm not from the era of windup phones!'

He laughed. 'Sure, I know that!'

I rubbed his shoulder. 'I'm pleased you've got a place in rehab. It's all happening quickly in the end, isn't it?'

'Doesn't feel quick, I can tell you…I'll get by. I'm going to come back fit and ready for moving on with my life. I have to. It's past time.'

'Good on you, Stephen. Matt and I will be right here, we believe in you.'

'Thanks. I know that. But…' His voice went quieter. 'Could I ask you guys to do me two favours, please?'

'Sure.'

'Can I put your names down as the persons to be contacted if I get ill or something?'

I was touched and sad too. Sad that he didn't feel it right to use a family member.

'Of course, you can, Stephen,' I said.

'Thanks. Hopefully, they'll only need to ring you to tell you I've won a medal for running or something!'

'No doubt.'

'And do you mind seeing if you can get some contact details for my family, my sisters in particular, please?'

I must have looked taken aback because before I had time to answer, Stephen explained. 'Don't worry, I don't want to contact them right now or anything. But I might need to as part of rehab or something. I don't know…It depends. I think I might prefer to be out and up and running though before I talk to them – look healthy and you know, on the right path. I don't want to build up their hopes and mess things up again.'

'We'll find a way to contact them. Zara and Matt will find your sisters on social media or through younger sisters of school friends of theirs or something.'

'Martha, I don't want my sisters knowing much yet. I know I look like shit. and I have a long road.'

'But when you're ready, I'm sure your parents and your sisters would love to hear from you…'

'I'm not sure.' He rubbed tears away with his fingers and shook his head emphatically. 'My parents told me that I wrecked their lives. And I did. I know that. They even had to move house because of me.'

Lunch with Patrick went better than I might have planned. If I was a betting person, I'd have bet he was relieved to be set free of me and on terms that included him in family life. He suggested I tell Fiona, Matt and Zara it had been a mutual decision and that we both thought that it would do us good to have a clean break and see how we felt about the future.

The problem with Patrick's quick response was it felt dangerously like it gave each of us an immediate free pass to go out sowing wild

oats with an attitude of devil-may-care. I wasn't sure if I was ready for a free pass but he sure seemed ready.

Seán and I walked around Dalkey on Thursday and I couldn't but agree with him that Dalkey was a special place, a pretty village set between sea and hills, what more could you want?

'Only one or two problems,' I said.

'What might they be?'

'It's on the Southside and full of Southsiders; a breed in themselves, Southsiders!' I was smiling as I spoke.

'And what about Northsiders? Are they not a breed in their own right too?'

'Yeah, but unlike Southsiders, Northsiders are very balanced, they've a chip on both shoulders!'

'Ha ha. So, what's wrong with Southsiders?'

'They're chippy, without the balance. They can't laugh at themselves, the way Northsiders can.'

'Martha, are you being funny?'

'Maybe. Aren't we both neither? We're culchies from way outside the pale…Still, Dalkey is lovely but the Northside's better.'

'And why might that be?'

'We kept the airport and the port…even long after Lord Leinster led the so-called gentry to the Southside. Beat that!' I said.

'Understandable, I'd say, that they gave the Northside some extra means of escape!' He winked.

I laughed. 'That's certainly true for some of the big drug names living not a million miles from us. One of those family names came up as defendant in a case I could have ended up on the jury for…but they rejected me; the cheek of them!' I wiped my eyes in mock upset.

We laughed and continued on our merry way through the area around the village with its eclectic mix of houses ranging from redbrick

216

Victorian to stunning old/modern, all with pristine gardens. As we walked past some of the larger older houses, I vociferously imagined being the demanding lady of the house, bossing staff around and demanding everything be done just so, in keeping with what Victorian or modern south side society might expect.

'Oh my gosh, you can't sit Lucinda next to Harold, don't you know Harold and she were rumoured to have had a thing…'

'Oh, we must get a new dinner service, we can't possibly use that dinner service again…'

Seán playfully took the part of the benevolent, browbeaten husband, acquiescing to demands, agreeing to pay the bills, continuously trying to keep the peace and please his lady.

People passing by gave us second and third looks as if assessing whether we were loopers, or were high on something other than each other's company. The dropped-jaw looks we got sent us into giggles, no doubt reinforcing the passersby's suspicions. When we got as far as Vico Road and Sorrento Terrace, where the best of the rich and famous hang their Christmas stockings, we listed off some current and past residents, some of whom had fallen, one way or another, from their giddy heights, reminding us that wealth and success can come at a high cost.

Along the seafront, the wind was bracing and I was ill-prepared for it in my more stylish than practical lightweight jacket. Mrs O'Reilly would not have been impressed! Without thinking, I found I had linked Seán's arm and tucked myself in beside him, using him as a welcome shelter from the worst of the wind's bite.

How could I possibly have my planned conversation with him after such a presumptive move?

The term mixed messages came to mind. Being close to him felt so natural, but was it affection of a brotherly nature or something else? A small voice in my head told me now was not the time. Breathing

space was what I needed; my head and my body were giving me mixed messages and I was passing them on.

But after a hearty bowl of chowder, flavoured as it should be with good chunks of smoked fish, I knew I had to have the conversation. Over coffee, I poured out my thoughts with more honesty than I intended, all the way from my lunch with Patrick to my struggle with those mixed messages. His eyes never left me as I spilled it out at speed.

'I hear you Martha,' Seán said, taking my hand. 'And I appreciate your openness and honesty. It's one of those things I love about you. And I understand why you need breathing space and you should take all the time you need. And believe me, I don't want to ever come between you and the people you love, of course I don't.'

'Thank you, Seán. I'm sorry but I'm feeling too overwhelmed at the moment to think straight, to even consider whether I want a relationship. Don't get me wrong, I thoroughly enjoy our times together…I—' I stopped myself.

There I was again, saying one thing that was pushing him gently away, but bloody well feeling like I wanted him near me. It felt ridiculous to be hedging my bets. And did he just sneak the word love into a sentence?

'I enjoy our times together too. Very much so, Martha…I'm not going anywhere, I will wait…I'll respect your decision whatever it is…But I won't pretend to you; I do hope that in time we will be more than friends.'

Feck it. The more he said, the harder he was to resist. His hand was still on mine sending signals up my arm…and it was just as well we were sitting across a table from each other in a pub or I might have thrown my arms around him and hugged him.

'Thank you, Seán. Thank you for understanding.'

I heard myself speak in that breathy voice you hear in intensive love scenes in movies. I felt my cheeks redden, and wondered what a proper

kiss or more with Seán might be like. I couldn't stretch my imagination to go there. It had been too long since such thoughts had entered my head with a man other than Patrick. Perhaps it would take time to allow them to develop further.

'I will wait,' Seán said without breaking the spell.

On the way home on the Dart, I sat glued to the window, I saw nothing, I heard little, I felt a certain joy and a certain sadness. I wanted to share my mixed feelings with someone who understood me, someone I could trust would give me sound advice. Apart from Máire and Mum, the only person I had ever known who I'd felt free to fully open up to, was Trish, my beautiful, blunt, best friend who had died just when the boom times ended and the recession hit us with devastating force.

How I missed her.

Nobody could ever replace her.

I could pick up the phone to her at any time of the day or night. No explanation or apology needed. We were always there for each other. Only in recent years had I cried for the loss of her and the wasted years following her death, years spent working endlessly to keep us from bankruptcy, leaving no time for grief; years when I should have been enjoying our children growing up. I had cried for the loss of the united family we had been before the proverbial financial and menopausal shit had hit the fan. I had cried for the dis-united family I had grown-up in. On the Dart, I cried again for all these things.

Through my tears, came knowledge: I was right, I was not ready. I needed to sit some more with all these things. I needed more time; I needed alone time. I would book somewhere by the sea for Chuckie and me, somewhere near a beach where I could swim. I might write my thoughts and memories down, explore my feelings, unlock the rest of the pain and release it, let it go. Writing had helped me when I was young. I should try it again. There was nothing stopping me, nobody

needed me: Stephen would be safely in rehab; Mum and Fergal were well; Zara was heading off on a field trip; Matt would be happy to have the place to himself; Fiona's pregnancy was in the second and easier trimester. Now was the time to go, before the schools were out.

'Won't you be scared on your own in a house in the middle of no-where, Mum?' Zara asked.

'It's not in the middle of nowhere. It's a ten-minute walk from a small stony beach and there are neighbours across the field. And I have Chuckie to protect me. He's ferocious if he doesn't know you, aren't you Chuckie?' I rubbed his head and ears and I could see from his enthusiastic response that he agreed with me.

'Only if you find being licked ferocious…' Zara reached across to pat him and he rolled over for a proper rub of his belly. She shook her head with an air of exasperation, not with Chuckie, with me.

Glengarra Woods, where I stopped for a picnic and a walk, was as beautiful as I remembered it from when I'd gone there with the children enroute to a family holiday in Clonakilty years previously. The river meandered clean and clear over green hued rocks, through the green woods. I remembered them paddling in it and sitting on rocks with the water around them as they ate their lunches.

Matt had cried when he'd dropped his sandwich into the water but had recovered quickly when I said I'd share mine with him as long as he sat on the rug beside me eating it.

*'I'll do it to help you, Mum. If I eat it, your jeans won't be so tight.'*

After a quizzical moment, I'd laughed as I realised he must have overheard me tell Patrick I needed to eat less if I was to fit into my tight-fitting, summer jeans. I laughed again at the memory.

Patrick had followed us down to Clonakilty the next day after some important game of golf or other. For the next three days, it rained almost non-stop but still the rest of us managed to play games of

football, rounders and even to swim in the sea. The cold water never failed to soften my anger and frustration at Patrick's lack of engagement and general bad mood.

'Nice weather in Dublin, little wind or rain, perfect for a game of…' Patrick said more than once, swinging his imaginary golf club and watching his ball soar straight and high.

After each dream shot, he sighed as if to remind me what he was sacrificing to be with us all on holidays.

Low and behold, something came up in work and he needed to go back a few days early. As I remember it, the sun came out that day and stayed out for the rest of the week; the kids and I got up when we chose, ate what and when we wanted, played more silly games and headed to the beach when the crowds were leaving and the parking was easy. We were often the last people there and we left wearing sand and smiles.

That was the time, all those years ago, that I went from being a cold-water wuss to being a believer that cold water quenched one's woes. I loved to drive the children mad with embarrassment as I screamed as my body hit the cold water. I never told them my screams were as much a release of anger or frustration as a response to the cold water. I wished I'd kept up swimming through all the rough and sweaty years; it might have helped. Now, I was grateful to Zara for dragging me back into the habit of it.

The walk on the narrow road from the cottage to the turn for the beach was under a canopy of leafy trees, creating an arched green gateway to another world. A cacophony of birdsong filled the air as I turned down the winding lane. I recognised finches and robins as they flittered between the willows, blackthorns and flower-adorned hawthorns. The gorse brought happy memories of holidays when I'd lathered myself and the children with coconut-scented sun protection. I skipped as

much as walked along. It had been too long since I'd taken the time to notice the unspoilt beauty of nature. A sheltered stony beach and a turquoise sea came into sight and my heart filled with the joy of being alone and alive in the quiet peace of it all. A whisper of a chilling breeze touched my skin as I tiptoed through the seaweed; the cold water met a few more inches of my body as I edged forward; step, gasp, pause, repeat until the water was lapping against my waist and I launched myself forward with a loud, liberating scream, happily heard only by Chuckie and the birds and the bees. I took slow deep breaths with each stroke until my senses were at one with the sea. The soft heat of the ebbing sun warmed my face and I felt I could swim to freedom, on out to the open water, beyond the point of return where there were no more decisions or dilemmas and sea merged into sky. Everyone would wonder was it deliberate or planned; in the absence of a note, they would never know…

A loud bark broke my thoughts and I looked to see that Chuckie had climbed out along the shore, scrambling on the high tide line, keeping as near to me as possible without getting into the water. I kept swimming towards the horizon. Chuckie barked again, more urgently this time.

I turned and swam back, calling him, 'Come on Chuckie, come on.'

He put one foot tentatively on to the surface of the water, as if testing if it would take his weight. He tried again. The water gave way and he was launched into the ocean with an ear-raising startle which propelled him to doggy paddle at speed over towards me.

I laughed, splashed him and turned to swim to shore. I felt something touch one of my feet, then the other. That had never happened before. Seals never came so close. I swam a little faster. Nothing. I floated with my arms out front and my legs behind me. Again, something touched my foot. I looked nervously over my shoulder and

laughed; it was Chuckie nudging me to shore. The sun sprinkled its sparkle on the sea, the sky was the purest shade of blue, the stony beach smiled back at me. I was beholden only to myself and to Chuckie.

For the next week it would be just me and him and I was going to enjoy it. I was going to rediscover the joy of swimming alone as I had first experienced it when I'd lived in Sudan thirty years previously. There I had quietly taken sneaky swims at the Sudan Club pool in the dark of night before curfew. Nobody had seen me as the pool which was officially closed at sunset, was separated from the rest of the club by a thick hedge. It had been just me and the starry sky and I'd been soothed and exhilarated by it. I might manage a night swim that week. Anna, the owner of the beautiful cottage I was renting, had told me this was a safe, sheltered cove. Very few people knew about it. I could swim here under the light of the stars and the moon; a full moon was due, if the night was clear, anything was possible, the fairy magic of phosphorescence was possible.

# Chapter 20

## Cottage and Sea Escape

Glass of Chablis in hand, I sat at the small, white table in the cottage, and in between writing my version of the stories behind my thoughts and feelings, I gazed at the dramatic evening sky. The pony-tailed, pot-bellied, sleeping giant that was Mount Gabriel stretched out dark and serene in front of a blaze of white and yellow light which merged upwards into shades of orange and red which blended into clouds of fluffy purple. Slowly the brighter colours were extinguished, but the length of the dark silhouette of the mountain remained. I sat and wondered at the long, lazy lie of it as a contrast to the upright majesty of Sligo's Benbulben. I meditated on Mount Gabriel's permanence, intoxicated by the pureness and quiet extravagance of nature as I had ingested it in the hours since I had thrown my bag on the noisy, antique bed that day.

I followed the sun's lead and went to bed under a white cotton sheet and colourful bedspread. The metal bed creaked with every turn and I expected it to cause a night of broken sleep but the first sound I heard was well after dawn and it was a conversation of cows mooing for attention. For years I'd joked that if I slept through the night, I'd wake up thinking I was dead. I pinched myself and found I felt more alive and less uncertain than in forever. I pulled back the cheerful, flowery curtains and a bright yellow sun greeted me from behind a

hawthorn hedge. In front of the window rose a barely audible buzz from a crowd of tall, purple echinacea with bees dancing on their flowers. I rolled out my yoga mat on the bedroom floor and I stepped and breathed my way through the sun salutation, finishing with my head held high facing the glow of the morning sun. Then I picked up my mat and made my way to the small back patio, Chuckie at my heels. With my eyes softly closed, I moved my way through the five Tibetan rites, finishing resting in the child's pose; I opened my eyes and Chuckie was beside me, his face resting on his front paws, his eyes staring sideways at me, wondering where in this shared ritual breakfast might appear.

I was too busy hillwalking, swimming in the sea and feasting on the peace and beauty of it all, to spend as much time writing as I had planned. As my head cleared with the breadth of the expansive scenery, writing it all down seemed less relevant. Walks up bog tracks to the top of hills provided such panoramic views that it was impossible to feel overwhelmed by decisions and dilemmas; I felt my mind expand with possibilities. How could I feel otherwise when I could turn on the one spot at the top of a hill and take in the three sister bays of Bantry, Dunmanus and Roaring Water, separated from each other by the gentle sweep of hills and rolling countryside? I was spoiled for choice. I perched on various viewing thrones and ate my picnics, wondering at all I'd been missing while spinning around on my own hamster wheel, spinning from one problem to another. I felt the desire to make up for lost time, to spend more time in the wilds of nature, walking, swimming, sitting, *being*…I imagined a cottage by the sea from where I could hear the "waves make towards the pebbl'd shore", shifting small stones with those which went before. I could be lulled asleep to the uneven rhythm of their sound and wake to the sea still there, a little nearer, or a little further out; louder or quieter depending on the

tide and the weather. I fell in love with the idea of my dream place by the sea.

I started a list of 'Things to Do' while I am still fit and able:

Number one: stay in a place in Ireland where I can see, smell and hear the sea.

Number two: stay in a place in Europe where I can see, smell and hear the sea.

Number three: stay in a place in Africa, maybe back in Kenya, where I can see, smell and hear the sea…the sea, the sea, the sea.

In my mind, I made plans but I couldn't decide if I would want to go it alone or would I travel with a good friend, especially to countries where I couldn't speak the language. I didn't have to decide that now, I could see what works for me by trying different places in Ireland. I patted Chuckie's head to confirm his approval. Different places, different companions, maybe. I laughed to myself. Who knows? Right then, just me and the dog felt right. He never told me what to think or do, except when he wanted to be let out, cuddled or fed.

As I marched back down one gentle hill, I thought of Trish. I missed her sound advice and good friendship. We hadn't been ideal travelling companions; she'd argued that she didn't pay to go to the sun to come home without a deep tan, while I argued that I hadn't paid to go somewhere different just to sit by a pool or on a beach. Hiking up a hill wasn't her thing unless there was a pub or a worthy man at the top of it. She wanted food just like home. I wanted local cuisine, preferably involving fresh vegetables and fresh fish. Compromises had to be reached which involved some rip-roaring arguments, usually resulting in me giving in.

I wondered, if she had lived for longer, would she have changed. It seemed unlikely given how little she'd changed over all the years we had known each other, from when I was nineteen and she was twenty-one to when she died at thirty-five. In all that time, had there been

compromises? Holidays involved me alternating between going sight-seeing on my own with spending hours getting scorched and bored by the pool while trying to find out from a guidebook or other people what local restaurants catered for a plain meat and potatoes eater and someone with more adventurous tastes - TripAdvisor didn't exist back then, back in those pre-Wi-Fi days.

It wasn't for our shared holiday adventures together, that I had loved Trish. It was for our everyday exchanges, her endless support, her acceptance, our fun and serious chats, our shared laughs right down to when we planned in minute detail her pre-funeral party. And I loved her for how she egged me on, how she told me her equivalent of *Feel the Fear and Do it Anyway* long before there was a book with the title.

*'For fuck's sake Martha, what are you pissing yourself over? Just effing do it…As my Nana used to say, you'll rarely regret what you did, but you'll often regret what you fucking didn't do!'*

When I got home from my walk, I wrote Trish's and her Nana's expressions on a piece of paper, complete with expletives. I stuck the page up on the fridge with two plasters for want of some blu tack. I toasted Trish's spirit with a glass of Rioja, knowing she would have demanded it be a glass of Guinness.

'It's your turn to compromise now, Trish!' I said, raising my wine glass.

After dinner, I stretched out on the couch reading Nick Hornby's *People Like Us.* It took me a while to settle into it. I surprised myself with how disconcerting I found a forty-something-year-old mother of two dating a man in his early twenties, not too many years older than her own children. The colour of his skin sat comfortably with me but not his age. Nick Hornby's writing gently sucked me into the credibility and authenticity of the relationship as it revealed different characters' opinions on whether the UK should remain or leave the EU in

the build up to the vote for Brexit. I was reading it with the benefit of hindsight and the bias of an Irish person who was sick of the Northern Ireland protocol bullshit endlessly spewed out by pro-Brexit politicians; they neither knew nor cared about the implications of a hard border between the six counties of wee Northern Ireland and our twenty-six county Republic. We'd had thirty years of troubles and only since the 1998 Good Friday Agreement, had the North enjoyed relative peace, a peace that needed to last beyond thirty years for it to span generations and expect to become more permanent. But Brexit was opening new and old wounds and was in danger of stirring up new and violent troubles.

I made the mistake of glancing at my phone as I was going to bed: four missed calls from Patrick, one missed call from an unknown landline number with a Sligo prefix, two voicemails.

Shit.

Voicemail from Patrick: 'Hi Martha, hope you're enjoying your peace and quiet. Nothing urgent, just want to talk to you about something when you get a chance. Ring me tomorrow when suits.'

Second voicemail: 'Hi Martha, it's Stephen. I hope you don't mind me calling you. I'm here at the farm near Sligo and they suggested we might get someone who knows us to come to a chat session on Sunday afternoon. No pressure. Honest. You've probably got something planned, I know. Could you ring this number back please to let them know one way or the other? Thanks. Cheers.'

Note to self: do you not look at your phone before going to bed. There is no good to be had from it.

The optimist in me told me I could still read myself to sleep but four chapters later and I remained wide-awake. I turned off the light and shut my eyes. What unearth could Patrick have to tell me that lead to four missed calls from him? I had told him I'd touch base with

him sometime after I got back from west Cork, no need to ring me in between times unless it was life or death. Balls. What could it be?

The suggested visit to Stephen on Sunday was a different matter, obviously I wouldn't dream of not going. I was due to leave west Cork on Sunday anyway. But what would I do about Chuckie? I didn't want to leave Cork a day early to go home to drop him off and I didn't know how long it would take to get to Sligo or what exact time I needed to be there at.

I got up and looked up Google Maps to see a likely journey time; five hours, I could do it if I left early on Sunday morning; traffic would be light. Stephen's message said Sunday afternoon, so it was doable. I could stay somewhere in Sligo that night if I could find an Airbnb that accepted dogs - maybe tick off one of those items on my new bucket list. Sunday nights are often easier to get availability. I searched through Airbnb and found a number of possibilities one right on a beach was available for the minimum stay of three nights. It had two bedrooms and two bathrooms but feck it, it wasn't too dear and dogs were allowed, subject to pre-approval. I messaged the host to confirm.

I had a plan.

I went back to bed and played John Kabat Zinn on Audible and was asleep before twenty minutes of his soothing voice became silent on my tablet.

The next morning, I phoned Patrick back.

That was bloody fast, I thought when he had finished telling me the mysterious 'something' he'd referred to in his message the previous evening.

'Why are you telling me now?' I asked.

He gave a meaningless half cough, a pause to let him think what to say next.

'Martha, I just thought it would be best if I let you know sooner rather than later.'

'Hah,' I said, smelling a rat. 'I don't know what to say. I guess I feel I'm down here on my own and I can't understand why it couldn't have waited. I mean how serious can it be given we only agreed last week that we were both free to pursue—'

'I know, Martha. But I didn't want you it hearing from someone else.'

My lie-detector antennae went up a bit further. He'd been back working unusually *late* long before we made an agreement to have a clean break.

'I'm going to ask you two questions, Patrick. All I ask is for short honest answers. Okay?'

There was a pause and I imagined him swallowing his exasperation. 'Okay,' he said.

'Firstly, who did you think might tell me?'

'Well, maybe someone might have seen us together.'

'My question was who might have seen you?'

'Well, we bumped into Zara on Monday night in town. We were coming out of Reilly's restaurant and…'

'And?'

'And we bumped into Zara.'

'I see, and you thought Zara might tell me?'

*Zara, your princess and supreme defender…*

'Yes, she told me…I mean suggested to me that I should tell you.'

'I see.' I wondered how that conversation had gone; would I ever know? 'Second question.'

'Yes.'

'Truthfully, when did you start seeing this other person?'

Another couple of coughs. 'Richard in the office introduced me to her a few weeks ago.'

'So, you started seeing each other a few weeks ago?'

I was pushing the boundaries of what I was entitled to ask but feck it, there was a part of me enjoying myself. I realised I was pleased that he had effectively set me free, properly this time. Even Zara couldn't argue with that. And the other interesting thing I noticed was I didn't feel in the least bit jealous.

'Yes. Yes, a couple of weeks ago.'

'Just as well we had that conversation last Tuesday so, isn't it?'

'Honestly, Martha, if you hadn't started that conversation last week, I would have brought it up. I would have told you.'

'I'm glad to hear it, Patrick. Two more questions please.'

He gave a massive sigh. 'If you must.'

'Which Monday did Zara bump into you and your new lady?'

'Does it matter? What difference does it make?'

'Tell me, which?'

'Monday, Monday before last,' he said in a quieter voice.

'That would be the Monday before the Tuesday when, at my suggestion, we agreed that we would take a clean break so?'

'Yes. And your last question? I'm sorry but I have meetings to get to.'

'Do I know her? What's her name?'

'That's two questions! I believe you do not know her. Her name is Louisa. She lives in Blackrock.'

'That's all my questions, your honour…The witness can be excused!' I laughed. I couldn't help myself.

And Louisa a Southsider to boot! I bet she was blonde, wore perfectly applied makeup and clothes that were conspicuously designer.

Patrick laughed too. 'You missed your calling, Martha. You should have been a bloody barrister.'

'You never know, Patrick. I might be one yet! Life is full of possibilities.'

I hung up the phone and looked at the tide clock and saw it was nearly full tide; I headed off for a celebratory swim, laughing to myself as I walked to the beach. Trish would have been impressed. She'd have told me I was fucking brilliant!

While I was on the phone to the centre, confirming I would visit Stephen for the session on Sunday and getting the details of how to get there, Zara rang and left a message:

'Hi Mum, just checking in with you, seeing if you're okay. Hope all is well. Ring me later if you like. I've a tutorial soon but I'm free this afternoon.'

Zara never phoned. She messaged. And I'd been putting photos and messages on the family WhatsApp group. She'd been looking at them. She knew I was fine. She was checking to see if her dad had been in touch and if he had told me. If I hadn't already interrogated Patrick, I'd have been wondering what her message meant. I sent her a text:

**All beautiful here still. Thanks for asking. Spoke to your dad. Good honest conversation. Call you this afternoon.** 😃 **xx**

# Chapter 21
## Stephen and Sligo Again

On Sunday, I treated myself to a swim at dawn before I headed off. I attempted to focus on the flat stillness of the water broken only by my hands pushing through it, water, hands, breath – simple! My thoughts of the day ahead were never silenced for long and I accepted that my mediocre attempts at meditation would never bring me to Nirvana. I decided that I wasn't seeking Nirvana. Such deep seeking wasn't within me, I was happy to build on the moments of presence which I felt were bringing me to a more joyful place.

Quietening my mind was not something I was ever likely to master, I thought again as I drove the five hundred plus kilometres to Sligo. I was destined to think too much, to analyse too much and secretly, I enjoyed my inner conversations too much to want to give them up. I noticed I was feeling nervous anticipation at the thought of meeting Stephen and attending the session; what insights had I to offer? I had not lived with him, I had not suffered as a result of his drug abuse, it was easy for me to be compassionate towards him when I had nothing to forgive him for. I had to forgive myself for not being there for him. If only I'd dealt with my shit sooner, things would have been different. But then again, it wasn't until the proverbial shit hit the midlife, menopausal fan, that I realised what past shit I had yet to deal with.

His family had suffered the hell of it all: his dropping out of his normal home life, dropping out of college, dropping out of sport. They had lived with the fear of a drug dealer's next threat or attack on them or on their home. Therapists might tell them they need to show Stephen compassion – compassion with clear boundaries – to help him recover but how might they put aside all he had put them through and accept him back into their fold? Would family group sessions help them to understand and forgive? Maybe. Maybe not. Therapy might help them understand Stephen better and accept him. How could they not accept and love him, their own beautiful child?

Sadly, in all I knew of Stephen's family and how they treated him before he ever turned to drugs, compassion was something they seemed lacking. I wondered the part their treatment of him had played in him turning to drugs and not them. From what Stephen had told Matt in the one interaction they had after their conversation in the canteen, his parents knew nothing about what he was accused of doing to Helen. He had never felt able to confide in them; he was always more comfortable in our house than his own. I could relate to not being able to confide in the people who reared you for fear of triggering more putdowns and harsh judgments. I could relate to being uncomfortable in one's own home. My heart went out to him. We loved him and I thought it would be hard for us not to. For now, Stephen's focus would have to be on his recovery, not on how his family might react; he had no control over that, only they could decide how they would respond to him. We would be there for him this time. His priority would have to be to try to understand and accept himself and all he had done. The more I sought to learn about addiction, the more overwhelmed I became by the desire to do something for him combined with the fear of not being up for the task.

In all the years I'd known him, I'd met either of his parents in total only a handful of times and those times were when he was a child and

I occasionally dropped him home. In primary school, when he came to our house on play dates, I collected him from school and mostly left him off afterwards directly to training. I never met his parents at a single match and when Stephen was still a child, he mastered organising lifts for himself as needed; we, and sometimes others, were happy to oblige. Matt and he were best friends right from the first day of junior infants and Stephen was always easy to have around, obliging and grateful, fun too. In secondary school, cycling became their chosen means of transport and so it continued to be on into their college years. It frustrated Matt that Stephen sometimes missed training or an occasional match because his parents insisted they needed him at home to mind his younger sisters or for other reasons best known to them. Matt said Stephen's parents were nearly always out, either together or separately. When they were home, they were okay towards Matt and nice enough. But, he said, there was a vibe in the house, it never felt like a home, everything had its precise place; everything had to be seen to be perfect and Stephen was held responsible for maintaining that image of perfection.

'Even at the height of our various family's crises, our house still felt more like a family home than theirs ever did,' Matt had said in a recent conversation.

'That's a pretty damming comparison – all things considered…' I had answered, remembering the inglorious days of our financial crisis and later, my menopause hell coupled with Patrick's affair and the resultant fallout.

'And another thing I never got was, for all the training Stephen missed to mind his sisters or to do other things for his parents, they never said so much as thank you. But they never missed a chance to tell him when he'd done something wrong by their perfect measure!' Matt got quite worked up as he spoke.

'I remember you saying something like that years ago,' I had said in response. 'And also, that Stephen never complained; if things weren't to *their* liking, he took it as his fault…Football must have been his one big escape from the rejection he felt at home.

The house I had rented was in a part of Sligo I wasn't familiar with. It was tucked away down a small, grass-lined road which served only the farm property on which it stood: a quaint, converted two-story out-building perched no more than forty feet from the everchanging sea. *Teach Beag cois Farraige*, Little House beside the Sea. Bliss, I thought.

It was a short walk from the large main house, *Teach Mór cois Farraige*, a Georgian building of perfect portions, with freshly painted, sash windows, a moss strewn roof and walls with flaky, once-white paint. I pulled the old bell and waited, and waited. I heard a dog barking behind the door. I was looking at my watch, calculating how much time I had, wondering if I should go back to the car and grab my lunch, when a voice behind me called my name. I turned to see a figure in a blue Aran sweater, a sweater I'd seen before.

'Martha! Martha, it's Eamon, remember me?' He laughed. 'You're the only Martha I've ever met and when I got your enquiry, I wondered…But I thought, don't be silly…And here you are. Imagine!' He threw his arms out in welcome and a broad smile spread across his face.

'Imagine indeed. It's a wonder anyone ever gets away with anything in this country – six degrees of separation, my ass!' I laughed too and allowed him to kiss me on the cheek, half-European style.

He smiled the same way he had back when, between us, we'd made sure that Clare got to be foreman of the jury and not Mr Spiffy. I smiled at that memory and at the sexy dimple in his left cheek which I also remembered.

'I know you're in a hurry. So let me get you sorted, and maybe you'll come over for a drink later.' He opened the front door to the main house and a golden retriever bounced out and danced around me. I rubbed its warm, soft head and admired its good looks.

'Later sounds good. I need to get a quick bite of lunch and let my own mutt stretch his legs before I head off or he might be a bit hyper in my absence and God knows what might happen!'

'Sure, leave him lose if you like, there are no animals around here apart from Harry here.'

'That would be great, except Chuckie's a city dog and if I abandon him in a new place, he's sure to disappear.'

'Have your lunch so and leave him and his lead with me? I've to walk Harry afterwards anyway. He's very easy-going, gets on with everyone.'

I caught myself contemplating Eamon's easy ways and handsome face: like owner, like dog.

I recited the directions to myself as I turned off the main Sligo-Collooney Road and drove up a gentle hill, left at a small cross roads and all the way to the end, through an open gateway, over a cattle grid, on past three polytunnels, an orchard and a chicken run and in front of me a large ninety-seventies characterless, dormer bungalow sat against a backdrop of a broadleaf woodland. No signs to confirm this was the drug treatment centre. I pulled up parallel to one of the eight cars parked randomly on the unadorned tarmacadam and made my way to the open door of the house. Someone moving in the front room caught my eye and I was relieved to recognise the silhouette as Stephen's. He raised his hand in a small uncertain gesture before slowly and tentatively walking out to greet me, his head and shoulders sagging under the weight of his worries.

'Hi Stephen, good to see you. You're looking well,' I said taking in a healthier glow on his face than when I'd last seen him.

'Hmm. I guess fresh air, good food and no bad drugs can do that,' he muttered.

'Good for you,' I said, catching myself feeling overcome with emotion and opening my arms to hug him.

As he came towards me, I saw dark sorrow in his eyes. I hugged him long and tight, my head to his chest. I felt him crying and I cried too as I had before but somehow, this time, Stephen's tears felt heavier.

'I'm a wet sap these days,' he said apologetically.

'That makes two of us.' I sniffled. 'Could be worse…'

He introduced me to Tracey, who would be sitting in with us, and she suggested he leave us to chat alone for a while. She told me Stephen was really trying, doing everything they asked of him, always keen to please, to not let them down, but, like many addicts, she feared that his recovery would be hampered by guilt and shame and that endless fear of letting others down; the same negative emotions that had driven him to drugs.

'Stephen's sense of shame and inadequacy seems more deeply rooted than the alleged incident with the young woman,' she explained. 'He has a lot to process, to work through, to acknowledge and accept. It will take time. He needs compassion from others for him to develop self-compassion and self-belief…I'm not suggesting that others are expected to ignore what has happened or to move on in haste – all these things must be fully acknowledged – I'm suggesting that he needs people he values to show they believe in him and are there for him…Providing, of course, he is willing to play his part.'

'I do believe in him. I do believe he can come out the other side of this. I've known him for a long time and I know the goodness in him. Matt, my son, who has been his best friend since their first day at school, believes in him too…We should have done more for him back when…We had our own stuff going on, I'm afraid…it seems a poor excuse…'

'Martha, most people do the best they can with what they've got at the time. Don't blame yourselves. Look to the present and the future. I'm glad Stephen has good friends like you, who believe in him and are willing to look out for him. That can make all the difference to his chance of success. But it is important for you to know that it is his own personal responsibility to do what he has to do to stay clean and to use the supports that are there for him as he goes on his journey. He seems to be taking full ownership of the suffering he caused others…his family included. But these things are not straight forward…'

'I do understand that his upbringing might have played its part in him becoming an addict. To be honest, Tracey, I've been thinking about his family life and talking to Matt about it, and Stephen did not have it easy. It was amazing what he achieved, until the incident with Helen, despite how he was treated at home.'

'Do you think it would be useful if you told me more about that? I'm afraid all Stephen says on that front is how he let everyone down.'

We sat and chatted for a half an hour or more and I gave her what insights I had into Stephen's deep-rooted sense of shame and inadequacy, and why he might have turned to drugs rather than his parents when things blew up. Obviously, I didn't know the full story, only what Matt and I had seen and heard over the years.

The room was warm when Stephen joined us, and he took off his sweatshirt revealing a faded, short-sleeved, plain T-shirt. I saw deep scratch marks on his arms where I assumed he'd dug his nails into his own flesh in an effort to feel a pain he could control that might distract him from the pain he couldn't. I saw no obvious needle marks.

We sat around a circular table which held three glasses of water and a large, open box of tissues. Tracey explained to Stephen that we were not here to judge him but to listen and to hear what he had to say, how he felt now, how he'd felt in the past…

Stephen opened his mouth a number of times and we waited for him to speak. But no words came out and he shut it again.

'Why don't you start by telling us how you felt when you first met Martha a few months ago?' Tracey suggested.

He looked at me and held my gaze. Words and tears spilled out of him.

'When I first saw you at the canal, I wanted to run away, to pretend I hadn't seen you or you me. I was ashamed of who I was, of what I had become...You didn't turn your back on me...You hugged me. I thought I must have dreamt those hugs you gave me but today you hugged me again and I knew they were real. I was dirty. I was smelly. I was drunk. And you hugged me and took me with you into the café for food. You wanted to spend time with me...The state of me...And you accepted me and I don't think I've ever felt more accepted in all my life. And I didn't deserve it. I don't deserve it.'

He rubbed the back of his hand across the end of his nose a few times as he spoke and when he stopped speaking, he reached and took two man-sized tissues out of the box. As he blew his nose, the weight of shame brought his chin tight to his chest. He twisted and untwisted the tissues between his fingers until they were crumbs in his hands and on his lap.

'Stephen,' I said.

His head shot up and he glanced in my direction, then he shook his head, turned away and talked to the skirting board opposite him.

'You don't know me, Martha. You think you do, but you don't. It's not just the Helen thing. I've done worse since...I've stolen hand-bags from old ladies, I've stood back and done nothing when my drug addict mates held a knife to the throats of other old ladies, women older than my nanny. We demanded money or phones from them. We didn't want to hurt them...at least I don't think I did, but I was in no state to stop myself or my mates – a shitty excuse for doing shit.

We terrified the bejaysus out of them – one of them beat me with her stick – told me she kept it to deal with fucking scum like me. I told you, Martha, I'm scum. I am worse than fucking scum.' His voice rose with self-disgust as he spoke.

I didn't know what to say. I wasn't entirely shocked based on all I'd read. I couldn't imagine how anyone, a tough nut or otherwise, might survive as an addict on the streets, never mind how Stephen might survive. But drug addiction ruled your mind and your behaviours. I looked to Tracey for guidance. She nodded at me, telling me to speak, but what could I say that wouldn't sound like bullshit, patronising, naive bullshit.

'Stephen, you're right I didn't know any of that…How could I? What you did to those people was awful. There's no denying it…But the Stephen who didn't take drugs, who wasn't addicted to drugs, could not have done any of that. It was not the true you. You're better than that. I know you are.'

Stephen glanced my way and shook his head dismissing my words.

'Stephen,' I continued. 'You did not choose to be a drug addict. It happened to you for lots of reasons. Now you have a choice. I bet many drug addicts who have passed through these doors have done what you have done and worse…they, and you, have to choose to put the guilt that goes with that behind you in order to move on. I know it's hard but I believe you can go forward as who you really are.'

Stephen didn't acknowledge my plea-full words; he stayed looking at the skirting board. I looked again to Tracey for support.

'Stephen,' Tracey said, looking directly at him. 'It's true, there is no end to what drug addicts in need of a fix might do, their brains and bodies demand a fix, that takes the controls, all sense of right and wrong is lost. When you break that cycle, as you have done Stephen, you can reprogram your brain, you can stimulate it to want other

things. It takes time and huge effort. But, Stephen, I too believe you have what it takes.'

'Matt and I have seen you in action Stephen,' I added. 'We know how determined you can be once you've set a goal for yourself. You can do it.'

Stephen lifted his head towards me and his face was distorted with frustrated anguish.

'My mate Peter, he did it. He got clean, went back to his family and all. But he couldn't hack it. His mother kept telling him he was a waste of space, that they had sacrificed so much for him, sold one of their cars to pay his drug debt, put up with so much of his shit…He came looking for me. Said it was a waste of fucking time getting clean. They still hated him, *he* still hated him.' Stephen dug his nails deep into an old wound in the soft flesh of his forearm. Dark blood oozed onto his fingertips. Agony was written on his face. 'He asked me to get him some gear and I did, and we had it together. I never had H before. I smoked it and it was amazing. It was the first time in forever I felt great, no pain, no shame…fucking bliss it was. Peter injected it. I couldn't watch. 'You get used to it', he said, 'I'll teach you'. I fell asleep and when I woke up, he was there beside me, cold as fucking ice. I killed him. I told Dave I killed Peter. I got him the gear. I killed him. 'The fucking drugs killed him, Stephen,' Dave said. But I got him the drugs. 'Yeah, but if you didn't get him the drugs, he'd have got them somewhere else.' But I got them, didn't I? See what I mean, Martha. I'm a bad person, a really bad person. A total scumbag, just like I told you.'

I waited for Tracey to speak but she let the silence sit. I scratched my own arms, thinking about what I should say. Compassion was what Stephen needed, that was clear. Was he telling me all these horrible things he had done or experienced because he didn't believe I could still love and accept him if I knew the worst of it? If he had

caused my family or my family's home to be threatened or attacked…if my own mum was one of those ladies that they'd held a knife to in an addict's sick efforts to get drug money, he would still need my compassion…I visualised a faceless addict holding a knife to Mum, the small frame of her shivering, begging not to be hurt; I didn't know how much compassion I could have for that person.

'Stephen, I can't imagine how traumatic it was for you and for Peter's family. But I'm with Dave. It's not your fault Peter died. If you had not been a drug addict yourself and you had known the consequences, then maybe…But you didn't get Peter drugs for your own gain, you got them in some distorted but genuine faith that you were helping a friend. Peter was responsible for Peter. I am sure when he got clean, he was warned that if he took heroin again it could kill him because his tolerance of it would be on the floor. He chose to use it. He injected it, for god's sake. Chances are he accidentally overdosed. You didn't kill him. He accidentally killed himself. You did not kill him. Do you hear me?'

When I stopped speaking, I wondered at how desperate I was sounding, how desperate I was to lessen what Stephen had done to those old ladies, to lessen what had happened to Peter, how desperate I was to believe that he could process it all and forgive himself, move on, build a new life. His starting point was lower than I'd imagined.

In the car, I put my elbows on the steering wheel and held my head in my hands. Stephen said they'd threatened old ladies, with a knife; he didn't want to hurt them. Had he actually hurt them? If not physically then surely mentally. Had he left them too scared to leave their homes, to go to their previously favourite places, jumping every time a strange person approached, checking in front of them, checking behind them; waiting for the next scumbag to pounce on them…

Too much information. Too much for me to process.

It was for me to accept what he had done and still love and believe in him. Could I do that?

I felt the tension trapped to bursting in my skull and I stuck my fingertips deep into my hair and massaged hard into my scalp to release it. A horn blared and I jumped. It was my horn. Time to get out of there. But to where? Somewhere to decompress. What beach was on my way back? I felt the weight of darkness, yet the sky was bright. It was early evening; most families would have gone home to get ready for school the next day. Streedagh Beach might be quiet. I bet on it being less popular than other local beaches. Google Maps led the way, interrupting my bleak thoughts with its pseudo-cheerful instructions.

# Chapter 22
## A Much-Wanted Swim

There were few cars in the car park. I had chosen well.

I reached the top of the dunes and a strong wind whipped my face as I looked at the curve of the beach with only a few people on the length of it stretching towards Classiebawn Castle in Mullaghmore and its tragic history. The full expanse of the sea was mine apart from an instructor and a few teenage surfers dressed from neck to toe in wetsuits and booties, catching the waves before they broke white towards the shore. I was going to avoid that rougher stretch and headed away from it. Then I saw the reason for the absence of swimmers glistening on the sand: jellyfish littered the beach; large brown Lion's Mane jellyfish with long tentacles, two, three and maybe four feet long tentacles, stretched as neatly as the outgoing tide had left them; further in, small and not so small purple-blue jellyfish sat as pretty as Murano glass paperweights, like jewels on the flat sand – innocent looking and more sinister for it. I didn't know the proper name for the purple jellyfish but I did know that the sting of a Lion's Mane could be serious. I gave a shiver. If they were on the beach, they were in the ocean, I couldn't swim there. I looked across towards Mullaghmore wondering if its beaches had been similarly commandeered.

Disappointed, I sat back into the car. I remembered that I'd promised Zara that I'd ring her after I'd seen Stephen. I didn't expect her

to answer her phone as she usually had it on silent or turned off but she did.

'Mum, how are you? How's Sligo? How's Stephen?'

'Fine, fine and not so fine…in that order.'

'Poor Stephen. What's the matter?'

'He's a long tough road ahead of him and he's forever beating himself up with guilt and shame…I sure hope he can move on from that, I really do.'

'I'm sure he will. You'll help him, Mum. You know about that stuff. Gran says you beat yourself up with guilt and shame for years.'

'I guess I did. But, Zara, I didn't know I was doing it. I couldn't even have told you that what I was feeling was guilt and shame until I came to understand myself and what I had experienced.'

'Well, you can help Stephen with that understanding of himself.'

'It's early days yet for him.'

'Exactly, it's not that bad. The Stephen we know will get there.'

'It's bad enough but I hear you and I'm sure he's in the right place…Enough for now, okay? I need to process it all before I say more. I was about to go for a swim to clear my head but the beach is littered with nasty jellyfish…' I let out a long sigh. 'Do me a favour, Zara, and tell me something positive.'

'Well. My placement's going well. I'm outdoors mostly reviewing the impact of different organic sprays on different plants – not sure it's work totally relevant to the next stage of my course but they're a nice bunch, and good craic.'

'Thank you, pet, that's positive.'

'And I've been in touch with Stephen's sisters…'

'Oh good. Go on…'

When Zara said she had to go and our phone call ended, words I'd read on the internet came back to me: it's hard to love an addict; they most need our love and belief in them when we feel least able to give

it. Stephen didn't need to be told to own his mistakes, he already held them as his and his alone. He was going to struggle to forgive himself. I thought of him at the match that day. His last match. He had offered his hand to each member of the opposition, praised them for their play; he had singled out the player who had scored their only goal and commented on the strength of his left boot. After the cup was awarded and team photos were taken, he'd come over and hugged me and lifted me up in the air.

'Martha, we did it,' he'd said.

That Stephen was still there. I did believe in him. He had become an addict, an addict who had done terrible things. He was willing to atone for them. He would find a way through the guilt and shame; I knew he would.

When the door of the Georgian house opened to my pull of the bell, I was enveloped in a warm and excited welcome from Chuckie, Harry and Eamon. With two dogs jumping and barking for my affection and a good-looking man there behind them smiling at me, my much-wanted swim became less necessary and I chortled.

'I hope you eat Thai green vegan curry,' Eamon said.

'I love it,' I said delighted and suddenly feeling starving. 'That would be great especially as I've a bottle a Gewürzt' in the fridge!'

'Perfect.' Eamon said with a dimply smile.

Eamon's kitchen was a higgledy-piggledy mix of modern cup-boards and old furniture – much of it salvaged from skips or donated by friends who were modernising, Eamon explained. I had used a sec-ond-hand kitchen when I'd renovated our previous house and I'd been so pleased with the result that I'd gone out of my way to do the same in the kitchen of my current house. Eamon's reuse of kitchen furniture was successful too; no two chairs were the same but together they sat happily around the table, a ready invitation for some eclectic, relaxed

gatherings.

As I sat on one of the larger bentwood chairs, Eamon took the dishes of curry and rice out of the electric oven and caught me eying the old Aga.

'That's my autumn project,' he said. 'I had it installed to replace the one the owners had taken out. It needs further work. There's a back-boiler on it, I'll need for heating come winter.' he sighed. 'The big challenge will be working out how to use it...I've a shed full of dry wood so...'

'I grew up with one just like that, same creamy colour, same make...it had a back boiler too. If I scratch the right part of my head, I might remember how to use it. You haven't tried it yet?'

'Gosh, no. I'm newly domesticated and have only been here since the start of the year...all guidance gratefully received.'

I laughed. 'And there was me thinking that this house was where you were born and bred...'

'Well, I am from near here...but I spent the last thirty odd years in Dublin.'

'And you kept the accent!'

'It seems I did! Can't place yours though. Dublin with a hint of culchie I'm guessing...'

'Haha. Good start – that would cover more than half the Dubs...what culchie county would you say?'

'Midlands, maybe?'

'My accents not that flat!'

'Hmm, probably not. Where so?'

'Formative years: Sligo, twenty or so kilometres from here.'

'Really?'

'Yes, near Rosses Point actually. Boarding school in Dublin and I haven't lived here since. I hadn't been within an ass's roar of Sligo for

thirty plus years until a few weeks ago when the funeral of an exceptional friend brought me back.'

'Oh…Sorry. Sorry for your loss, I mean.'

I shrugged, remembering Mrs O'Reilly and how she'd brought me back to Sligo.

'No love of Sligo so?' he added.

'No love of some of the memories, I'm afraid…'

And so, I came to give Eamon a snapshot version of some stages of my life: being reared by a woman who hated me, which she had expressed loud and clear, both physically and verbally, a mostly absent father – a functioning alcoholic, boarding school saving me and leading to me becoming an accountant, finding out in my mid-twenties about my real and wonderful Mum, believing, with surprise, that Patrick loved me – faults and all, marrying him, having children we loved but neglecting them when the financial crash threatened everything we'd built, my mad menopause, Patrick's affair causing me to kick him out.

What I didn't mention was that in telling my story, I had new doubts. I was starting to doubt that Patrick had ever loved me; I was beginning to think that Partrick had only ever loved Patrick.

We talked as we ate. For each stage of my life for which I gave him a brief synopsis, I insisted he gave me the same for his.

His went like this: reared on a farm at the foot of Benbulben, father a sometimes-functioning alcoholic – sometimes tolerable, sometimes obnoxious, mother a perfectionist. We agreed that an alcoholic father and a perfectionist mother often went hand-in-hand – a form of denial or self-preservation or both – an attempt to control what they could control. His mother reared them to go easy on their father, to dance on eggshells around him, all in a useless effort to keep the peace which amounted to nothing more than enabling his father in his obnoxious traits. Understanding and naming his mother's enabling had only

come to Eamon in recent years. After school, he had done a degree in agricultural science, hoping to inherit the farm, but his father passed it to his older brother under a farm-retirement tax scheme four years before his father died; brother sold it as soon as he could, literally from around his mother, barely leaving her a strip of grass to call her own. Before this, while still hoping to inherit, Eamon had become an accountant with Ernst and Young. He didn't much like it but stuck it out…

'Snap,' I said. 'I wanted to be a psychologist but Mother insisted there was no way university was on the cards for me, so I became a reluctant accountant.'

I didn't mention to him that Mother had told me that if I became a psychologist, that there would be an increase in the number of suicides. Nor that a part of me had believed her.

We considered with sadness how many people of our generation were reared with alcoholism mixed with added perfectionism, both there to deny and hide the dysfunctional reality. Then, we laughed at the thought of all the well-paid, reluctant accountants there must be in the world; his ex-wife, Therese, a Corkonian, was another good example. She complained endlessly about being an accountant but still she stuck at it; she complained about Dublin when she was there and about Cork when she went home; she was another perfectionist – like his mother, but not like his mother.  They separated a few years ago and she moved back to Cork, and in with an old flame. As a partner in Ernst & Young, he took a year's sabbatical that he was overdue and discovered that he fancied a change of life, he took up woodwork, retired, and bought this place – much done, more to do. He was happy – the sea, the fields, the woods, the hills and a pub within easy walking or cycling distance. He enjoyed relaxed time with his now adult children; simple things that he never before knew were all he needed.

'What more could I want?' he said gazing out the kitchen window with a happy smile.

'What more indeed?' I followed his gaze and took stock of a moon floating large over the land.

'A big bright moon tonight,' he said.

'It must be on steroids!' I exclaimed.

'Perfect for a swim. Would you fancy it?'

'Is the Pope a catholic?' I said, jumping up from my chair. 'I'll go put on my swimsuit.'

As I changed in the bedroom of my temporary abode, I wondered if he had expected me to go skinny-dipping. It was a secluded, stony, private beach, I doubted if he normally wore a swimsuit there. I wouldn't either if I knew I had it to myself.

We swam in our own space, listening to nature having its say. The breeze rustled through the trees, cows mooed in the distance, horses responded telling the cows to be quiet, and eventually the cows became quieter and the horses' neighs became less insistent.

The water was the right side of not too cold and I moved mindfully through it. Occasionally, Chuckie tapped my feet reminding me he was watching me, his touch had none of the urgency of the night I'd felt tempted to swim to eternity.

Chuckie had the whole beach to choose a spot, but true to form, he shook his shaggy wet hair all over my towel. Throughout it all, Eamon's dog, Harry, sat quietly on the beach, holding the pose of a king who was above the shenanigans of the rest of us.

As I sat on a rock putting on my socks and shoes by the moonlight, Eamon sat down beside me to do his and then pulled two flasks from his backpack.

'Tea or a hot whiskey?'

'Eamon, you're full of surprises…It'll have to be hot whiskey please.'

It would have been easy to cuddle into him on that rock. Too easy.

I had told Eamon that Patrick and I were operating in some post break-up version of marriage. I didn't tell him we had recently agreed to set each other free to explore new possibilities. I didn't tell him about Seán or about Patrick's latest interest, Louisa. I told him I was at a confused and somewhat overwhelmed phase of life. He put his arm around me.

'I've been there, Martha. Give yourself time…No rash moves. I tried that with near disastrous consequences. Only saved by the wisdom and outspoken nature of my daughter.'

# Chapter 23

## Eamon

The thrill of waking up to the intimate sound, sight and smell of the sea was intoxicating.

I skipped my morning yoga ritual, put on my still-wet swimsuit, donned my much-loved Kenyan kikoi and scruffy sandals and made for the little stony beach with Chuckie dancing beside me and bird-song filling the air. The tide was halfway between being in and out, creating a deep, stony cove enlivened by seaweeds of various hues of brown and green. Gentle waves lapped the shore and the sun sparkled on the turquoise water; who needs the sunny Mediterranean when you have a private beach in Ireland on a clear day. The sun shone warm on my face as I sat taking off my sandals on the same rock Eamon and I had sat together on the night before. I walked into the cool water, my feet feeling light as I tiptoed on the flat stones and watched the pinkeens dart away from me. When the water reached my waist, I launched myself with my usual inelegant splash and gasp…water, hands, feet, light, sea, joy…

Perhaps this was my Nirvana.

I turned onto my back and gently kicked my legs and flapped my arms beneath the surface. Up from the shoreline grassy fields rolled into gentle green hills above which sat Benbulben in all its powerful glory. If there ever was a mountain made to be visualised in a mountain

meditation, Benbulben had to be it. It commanded the landscape no matter what angle I saw it from. The crumbling Rock of Cashel may have been designed and built to oversee its surrounding territory but Benbulben did it naturally and into perpetuity.

As I walked the grassy track towards my Teach Beag, I heard the sound of a saw coming from an outbuilding near the main house. I considered saying good morning to Eamon but decided against it. I like my own space and I suspected he did too.

I'd called Mum after I'd decided to go to visit Stephen in Sligo.

'After years of avoiding it, forces outside of my control are drawing me there,' I'd said.

'Destiny,' she said. 'Drawn back to your roots…In my ageing memory, I see it as a beautiful place, the beaches, the green hills, Benbulben, Queen Maeve's grave on Knocknarea, I walked them all. Perhaps I remember it with the rose tint of the excitement of first love…'

'Difficult and all as that was…you and Dad didn't have it easy…but I get what you say about the rose tint of first love – I forever think of Sudan with fondness and I know my relationship with Stefan there adds warm colour to my memories.'

'Isn't it a pity that the joy of first love only happens once? After that our innocence is gone and the newness and unexpected nature of it can never be experienced again…' There was a sadness in her voice, a nostalgia for what she had lost.

'I know…and I don't know, Mum. It's not all bad, is it? Look at you and Fergal. Maybe we can experience the first love of youth, of near middle-age, of not so middle-age…I live in hope!' I gave a half-laugh.

She laughed too. 'Keep those fires of hope burning, Martha. Now that Patrick has set you free, embrace the possibilities.'

'I will, Mum. In time, I will.'

That was a few days ago, and I had promised Mum that I would give her an update when I had one. As Eamon was laying the table for dinner the previous night, I'd sent a text to say:

**All good, call you in the morning. xx**

It was now mid-morning, I put in my earphones, put Chuckie on the lead and took the bóithrín towards the village. In favourites, I tapped *Mummo* on my phone and waited for her to answer.

'Sorry, I was in the bathroom,' she said breathlessly.

'No hurry, Mum. No hurry at all.'

'What news? How are things? How long are you planning to stay in Sligo this time?'

'Overall, things are good. The place I'm staying is wonderful. It's right by the sea, I can see it up close and personal from the little house I'm staying in. And, you won't believe it, but the man who owns it was on jury duty with me. He has a dog himself and he minded Chuckie yesterday afternoon while I went to see Stephen.'

'Ah that's great. It's a small world for sure.'

We talked about Eamon's house and some of his family history. She wondered if she could have known his father through the bank. The name, Mattie Brennan, rang a bell.

'Tell me about Stephen, how is he?'

'As they say…it's complicated. He has a long road ahead of him, a lot to come to terms with. Yesterday…yesterday was difficult. It was hard to hear some of what he had to say, particularly some of the things he did at the height of his addiction…But it's good…he's talking and getting support from people who have no doubt heard it all before and can give him the tools to come out the other side…'

'Deary me, I can't imagine…Every time, I see a young addict out on the streets begging, I think of him. I want to stop and give them money but…I don't know…Should I buy them coffee? Should I buy them food?'

'Mum, whatever you do, don't end up near an addict or addicts on your own. Please be careful…don't take out your purse or your phone. You never know what an addict in need of a fix will do. You just don't…'

'Gosh, Martha, I was only wondering. Don't worry I am not an old fool yet and I rarely go anywhere in town alone. You know me, I usually drag Fergal along…so I can give him something to complain about.'

'And you reward him with a pint in a pub and maybe even dinner at Chez Max afterwards…if he's been good! The right way to go, Mum!'

'Works for us…On another subject, Martha, dare I ask, but will you see Margaret?'

'Hmm…I've asked myself that question a number of times and…and I don't know yet. I'm waiting for the feeling to hit me…'

When I arrived at the village, we ended our conversation, promising to stay in touch. I followed signs for the village café and I bought myself an oat flat white and a vegetarian sandwich of roast vegetables and pesto. I found a secluded spot by the river, under a weeping willow where I sat to eat it, feeding Chuckie the crusts, not because I didn't like crusts but because I found it hard to eat and not give him something. I told myself that sharing with him meant less calories for me.

I'd been keeping Seán up to date on my movements every few days with short texts and I wondered if he might be expecting a call from me after I'd met Stephen. He'd been nothing but supportive of my wish for plenty of space and still I worried that I was taking advantage of his understanding. In the end I sent him a text saying that the meeting with Stephen had been challenging and upsetting and I would fill him in when I saw him.

As I walked towards my Teach Beag, the barn doors were open and I saw Eamon poured over a wooden lathe, turning a spindle or

something. He wore a sawdust sprinkled fedora on his head and a visor pulled down over his face. Beside him, Harry started to bark excitedly. Eamon lifted his head from his work, smiled and waved and I waved back. He pulled up his visor and off his hat and walked towards me, putting his fingers through his thick, curly, grey hair as he did so. His build, his hair and his movement brought back memories of Stefan – not the youthful, slightly awkward Stefan with whom I had shared intense secrets and passion – a mature and more certain version of the Stefan who had opened my heart to love and some of its many possibilities.

'Penny for your thoughts,' Eamon said.

'Sorry. Sorry, I was lost in some youthful memories.'

'Happy ones by the look on your face.'

'Mostly happy, definitely cathartic. Volunteer accountant in Sudan memories, back when I was blissfully ignorant that in some ways, I was more an idealist than a cynic! After that Kenya…'

'A contradiction in terms somehow…'

'Huh?'

'A *volunteer accountant*, always sounded like a contradiction in terms to me!'

'That's funny. That's exactly what I used to say!'

'You mentioned Sudan last night. I'd love to hear more. South America, I know a small bit from when I lived there. Africa, not at all. It's on my list to visit when I next travel.'

'It's a big continent and it's thirty years since I was there but some-day, I hope to return to Kenya, soon, I hope. I'm sure much will have changed but somethings will have stayed the same. The poor will be poorer, the slums bigger and the big five will still be the big five but there may be less of them.'

'Indeed, the gap between rich and poor is widening in most developing countries which makes me wonder where all the development aid goes…'

'Yes, and then there's China effectively contriving to take control of their poor economies through giving them large loans they will never be able to repay…But, and on a positive note, I think the self-help approach and more emphasis on empowering and funding women might be making a difference…however small.'

'I hope so. I really do…' He put his fingers through his hair again and it was as if the gesture triggered a smile. 'And tell me, the big five, did you get to see them all?'

'I did. I actually did.'

In my head, I relived the joy I'd felt when a herd of elephants had crossed the track in front of us in Kenya. They moved in a line, one after the other, the baby elephants walking behind their mothers, holding their tails with their little trunks – the elephant equivalent of a mother holding her small children's hand – memories of the sensation of holding my own children's hands tickled me; one or two of my children's hands in mine always completed me.

'When I lived in Kenya I spent many weekends on safari. It was wonderful. Before I went to Kenya, I'd seen lions, elephants and buffalo in safari parks in Zimbabwe…a rhino and its baby stopped and blocked the track in front of us in Matobo…you don't argue with a rhino, especially when its horn is pointing at the bonnet of your little car and it's between you and its young…'

'Oh wow. So, which did you prefer, Kenya or Zimbabwe?'

'It's been a long time – thirty years – but, I can tell you what I remember. How about I cook tonight?'

The invitation slipped out unchecked. What was wrong with me? I should have been planning to sit in alone, contemplate life and all its complications – not add new ones.

'That would be lovely, I'll bring the wine.'

South America, in particular Argentina, had been to Eamon what Africa, in particular Sudan, had been to me.

Just as I had done, Eamon had taken a career break to spend time abroad. Before becoming a manager in Ernst & Young, he had gone to Argentina to teach English and learn Spanish and also like me, he had fallen in love for the first time on a foreign continent. The love of his life had been a Spanish girl. He had started making enquiries through E & Y to see if he could move to Madrid to be with her. He was gutted when she told him nonchalantly that she and her friend were on their last trip of freedom before they were going home to get married to men that they had known for most of their lives.

'First love, it just happens when you're not thinking about it. Not wondering, will it, won't it…suddenly, there it is!'

'And then there it isn't…Mum and I were just talking about it. The joy of ignorance and innocence. And the pain of lost love too. Especially when we were young and trying to find our true selves, still weighed down by the baggage of our childhood…'

The conversation went on into the night, another night-time swim was suggested but we were too engrossed to get up from our seats. We got to the point of talking about being parents of adult children.

'It is our job to give them the tools to be independent and the wherewithal to know to ask for help when they need it. A balance, my wife and I struggled with,' Eamon said.

'It's a tough one and we struggled too. I still feel responsible for their well-being, now as much as ever, which is something I need to work on. They're all adults now.'

'Never more so than when they're struggling. Be it with boyfriends, girlfriends, anxiety, drink or, in our eldest daughter's case, drugs…'

'Oh no, Eamon. What a nightmare. How bad was it?'

'Bad, very bad! In her final year in college, Shirley went completely wild. Got addicted primarily to cocaine…You could say she was mostly a functioning drug addict until…' Eamon's demeanour had changed as soon as he brought up his daughter. His voice became slower and less animated, his hands fidgeted with his cutlery. 'We hadn't a clue what was going on…She became an antichrist to live with…hated us all, hated the house, hated her life…was angry all the time…and whenever she left the house, the rest of us heaved a massive sigh of relief.'

'Oh, I'm so sorry. How did you cope? What did you do?'

He shook his head, then tapped his hands off his thighs. 'I didn't cope…I ran for cover. I escaped to the office – and worked all the hours…Previously, I rarely went to the office at weekends, I used to do what work needed to be done from home. But with Shirley picking fights with everyone and everything, I'm ashamed to say, I bailed. It was a race out the door between my wife and me; Therese hightailed it home to Cork – which may have been when she started seeing that old flame of hers whom she's still with.'

'Feck!' I brought my hand up to my mouth.

Both hands went over his face and up through his hair. 'I know. I know. I'm not proud of how I reacted. Our second daughter had to take control. Therese and I thought it was just Shirley going off the rails in some delayed growing-up way. She'd always been so thoroughly good, too good. But she didn't get her expected first in her third-year exams – she always got first. Then her boyfriend broke it off with her – nobody ever broke it off with her. Her old, local friends stopped calling for her…And in all that, it never dawned on us that what was wrecking her life and tearing her apart was low self-esteem and drugs…'

'Holy shit! How did you find out?'

'I was sitting in my office in work one afternoon, having a meeting with a client, discussing a proposal to do some big job or other. In burst our second daughter, Shauna. 'Dad, it's way past time that you and mum did something about Shirley's drug problem,' she said. I jumped up and ushered her quickly out of the room, apologising to my client as I went. As Shauna later pointed out to me, my primary concern in that moment was not that Shirley had a drug problem – which was news to me – my primary concern then and there was what would the client think…I have thought about this many times since and I remain shocked at how skewed my values had become. Shauna wondered out loud when I had become such a dick or if I had always been one…Can't beat your children for giving you a wake-up call…'

Eamon stopped there and froze with the heels of both hands pushed deep into his cheeks. His eyes were watery and his shame was palpable. I reached across the table and put my hand on his upper arm gently but I said nothing. I'd told Eamon some of my story. I'd told him what had brought me back to Sligo this time and how we felt we had let Stephen down. I'd been that person, I'd shutdown and disconnected from the family troubles at the height of my menopause woes. I was in awe of Eamon's raw, unadorned honesty and I had noticed the previous night that the more he told me about himself, the more honest and open I'd become. In telling his story, he didn't paint himself as any sort of hero, more as a man who had done a journey and learned to become more comfortable with his own shame and vulnerability. I liked that about him. It was a journey I could relate to.

'That was my wake-up call,' he continued. 'Shauna was four steps ahead of me. She'd been to a counsellor in college to find out what needed to be done. When I confronted Shirley with what Shauna had told me and I told her we had managed to get her a place in the Rutland centre, she cried and hugged me. Somewhere in that drug addled head of hers, she knew she needed help. I didn't deserve that hug. Fuck

it, but we'd abandoned her. Imagine, we had abandoned our own child…'

Eamon sniffed loudly his head bent low. I wanted to hold him, comfort him. Tears flowed down his chin and he sniffed again and felt in his pockets for a tissue. I pulled a handkerchief from my pocket and handed it to him. I'd changed into a pair of cropped trousers before he arrived for dinner and I'd put a clean hanky in the pocket. I could have done with a box of tissues though as tears were welling up in my eyes too.

'Thank you.' He wiped his eyes, gently blew his nose and then looked at the handkerchief in his hand. 'You always carry a man-sized hankie?' he asked with a smile.

'Mostly. Women's handkerchiefs are often more affectatious than useful especially when it comes to the river of tears I've been known to shed.'

'I only told Shirley's story to one other person and that was to a woman I got involved with after Therese left – it didn't work out well. That woman used it against me when I was ending the relationship – she threatened to expose us and our neglect of Shirley on social media. Shauna put her on notice of what she would do to her if she did any such thing!'

'What a bitch! What was going on for her?'

'She was very dangerous. I chose badly on the rebound and I let my daughters down all over again. I really have made so many mistakes as a parent.'

'We all get things wrong more often than we like. Don't I know? I've come to slowly accept that. I did perfection for years but now I'm a recovering perfectionist – which means that I can revert to form whenever I'm feeling at my most exposed! And I could tell you more about how I neglected our children during the financial crisis and how our son, Matt called us to order for it. I could tell you about the

irrational wagon that I was at the height of my menopause horrors – all the time convincing myself I was being reasonable and rational and that it was the rest of them who were in the wrong…The list is long…And the night shorter than when we started…'

Eamon looked at his watch and started to get up out of his chair. 'Gosh, Martha, I didn't mean to hog the whole evening. We were supposed to talk more about Africa!'

I grabbed his hand and said, 'Sit down. You're grand. I didn't mean it like that at all. I'll make a pot of tea and we can talk of lighter things. Like Africa and how you came by this piece of heaven?'

At the door as we said good night, he kissed me on the cheek. I held my breath as I felt his lips linger against my skin, the sensation sparked an intense urge to turn my lips to his. But I didn't. I listened to my heart thump in my ears. I savoured the pleasant tingling ping in those parts of my body which had until recently become unaccustomed to pleasant tingles, more intense than in many long years. I knew I wasn't imagining it. As his lips left my cheek, I let out my breath and looked into his dark eyes looking into mine creating a beam of connected energy. We both swallowed.

'I should get home to Harry…'

'Yes…'

'Thank you, Martha, for your lovely company…' His lips sparked off my other cheek and while I was still processing the sensation he added, 'Think about staying a few extra nights maybe, no charge of course. Let me hear your story and tell me more about how you came to have such an on-off relationship with Sligo…'

'Hmm, tempting indeed…I avoided it for thirty plus years. Now here I am, twice in a matter of weeks.' I smiled. 'Who'd have thought?'

He touched the tip of my nose lightly with his finger – something I usually hated anyone to do. 'Perhaps Sligo is your destiny. We begin

at the end and end at the beginning. Perhaps this is the beginning of a new relationship with this beautiful county, the end of the old…'

And on that note, he turned and walked off, back to his own beautiful home, a tall figure moving through the dark, unaware of the power his sensuality was having on me.

I looked after him and nodded as Chuckie nudged my lower leg. 'Yes Chuckie,' I said. 'Yes indeed.'

# Chapter 24

## Margaret

Something in the evening with Eamon fired in me an urge to text Margaret. It was past midnight, very late to send a text, yet I felt compelled to do it before morning doubt stepped in.

**Hi Margaret, hope all is well with you. Unexpected circumstances have me back in Sligo for a few days. Would you be free to meet up? Sorry for such late notice, Martha.**

I didn't expect a reply until morning at the earliest but having brushed my teeth, I checked my phone – breaking my new rule I'd only made the previous week.

**Hi Martha, what a surprise to get your text. I can be free tomorrow or the next day – whichever is best for you. Let me know when and where and I'll be there, Margaret.**

Feck. Now what? I texted Eamon for guidance…

**Where would you suggest for me to meet my sister tomorrow morning for a coffee - outside of town preferably? Please bear in mind that it's 30 years since we talked, other than briefly at Mrs O'Reilly's funeral! I will explain tomorrow night – if I'm not too shellshocked from the experience!**

Ten minutes later he sent a list of six cafés, including two in Mullaghmore and two in Bundoran…

...My gut says Mullaghmore harbour; good coffee and food, great German apple pie. Bigger and usually easy to find a quiet table. It has outdoor options too and also the possibility of walks by the sea afterwards if you need to clear your head. I'll mind Chuckie while you're gone.

Thank you and thank you.

No worries 🌲 Good luck.

Margaret, how about 11am tomorrow at the Café in at Mullaghmore Harbour? I don't know it but a friend says it's good.

Martha, I don't know it either but I've heard it's good too. See you there at 11 tomorrow.

I cleared the draining board and became aware of a nervous excitement running through my body, gurgling its way around my stomach, bubbling up into the centre of my chest. Now what?! A swim would be a bad idea. Too late and it would wake me up even more.

I pulled on a tracksuit over my T-shirt and pyjama shorts went out the door with Chuckie following me. I stood on the doorstep and let my eyes adjust to the night light before walking down to the seashore. The sea had never let me down. I sat down on...my rock/Eamon's rock/our rock? I smiled to myself as I wondered which was more appropriate – the cheek of me getting proprietorial about a rock I'd only just met a couple of days ago and what was that 'our' about, that was more than a bit rich!

And oh, my goodness, the sea, the moon, the twinkling light...if I had all this on my doorstep would I ever want to be anywhere else? I stood up and threw my arms out to embrace it, to take it all in, turning slowly to include the powerful silhouette of Benbulben in my embrace. A moving silhouette came between me and Benbulben. Pale, bare skin caught the light. He'd a towel in his hand and his focus was forward towards the water. I paused with my arms stretched wide, holding my

breath, wondering if I should speak first. A small cough escaped from my throat and he jumped.

'Sorry,' I said. 'I couldn't sleep…'

He paused a few feet away from me. 'Beautiful, isn't it? Every time I see it, I'm in awe of it anew.'

'Yes,' I said. 'Tantalisingly beautiful…'

As I said the words, I blinked twice, wondering if I was referring to the seascape or the body within an arm's reach of me, its solid flesh fully exposed, save for a pair of lose, brightly coloured swimming shorts. An image came into my mind of me standing facing out to sea, savouring the shimmering light sprinkled across the water, my body naked, leaning back against Eamon's rock-solid chest, his arms and mine entwined resting on my waist…I felt my face grow warm with colour and I thanked the twilight for its cover. I heard a change in the intensity of his breathing, and mine.

'What more could we ever want?' he said quietly.

I could have given him the answer that came to mind. I sensed that his face was as flushed as mine. I'd forgotten the power of sexual energy that can reach through the air and generate an intimacy as sensual as the naked touch…

Eamon cleared his throat as quietly as it was manly possible. 'I'm sorry. I didn't mean to disturb you,' he said. 'You have a big day to-morrow. I should leave you be.'

I swallowed. 'Yes, I guess I do. Let me leave you to enjoy your swim…I have a date with John Kabat Zinn…'

'Ah him, JKZ. I know him well – *Wherever You Go, There You Are!*'

'That's the one!'

I moved to walk back towards my Teach, careful not to step too close or too far from him…wanting him to take my hand, pull me to him and say, here we are…not wanting him to because life was too complicated already.

'Good night, Martha,' he said. 'Good luck tomorrow.'

'Thank you.'

# Chapter 25

## Meeting Margaret

The salty, seaweedy smell of the sea wafted into my bedroom and I could taste it on my lips. Through the open window I could see the moonlit water twinkling a pale yellow. I closed my eyes and listened to the gentle sound of the tide lapping at the shore. Mingled with all these sensations, inseparable from them, bubbled my newly re-invigorated sensuality. The temptation to savour it in all its luscious glory was there for the taking. But no. Bad idea. Tomorrow promised to be an emotionally demanding day, I needed straightforward sleep and that meant turning to one man only; I tapped audible on my phone and selected twenty minutes of John Kabat Zinn and wondered at the irony of using mindfulness to help me fall asleep when its very practice was supposed to make me more awake.

From the moment I woke early the next morning, butterflies were dancing in my stomach and tickling the back of my throat. They didn't leave me as I swam in the choppy sea or as I dropped Chuckie and his lead to Eamon. We grunted good morning and nodded at each other the way I imagined a couple might on the morning after the night before when too much drink had been consumed with unplanned consequences. Daylight can be like that, make me feel exposed and uncomfortable.

For all my fear of exposure and of meeting people from my past life in Sligo, I arrived early at the harbour café and allowed the unexpected sunshine to entice me to choose a table outside where I could engage in my favourite pastime of people watching. There were plenty of people to watch: mothers with quiet and not so quiet young children, older couples sitting opposite each other reading their phones or their papers, matching women cackling and chattering animatedly.

Three blonde women strode towards the café, they wore black, zippy sweatshirts, leggings with a stripe of pink and Asics runners – what is it about some groups of women who walk together that they resort to group uniform? The chief blonde chose a table, told the other two to sit down and she would order the usual; the sitting blondes acquiesced in unison. I wondered how many times this scenario had played out before…The roars of a mother giving out to her daughter startled me. I had earlier enjoyed watching her two children play on the grassy patch across the road from the café as she had been getting a takeaway coffee.

'Maeve, what are you doing taking Saoirse's toy…? All I ever ask is that you are nice to your little sister…that's not much to ask…When we get home, you'll go straight to your room…'

Maeve's lip and chin quivered, she lowered her head and scuffed the grass with her, already dirty, runner.

'Look at me when I'm talking to you. Why can't you do as you're told? *Why?*'

The little girl looked bewildered. Why wouldn't she be? While her mother was getting a takeaway coffee, she and her toddler sister had been playing a game. It started when the toddler, Saoirse, who was strapped into her buggy, dropped her soft, pink bunny onto the grass and then pointed at it and emitted a piercing squeal. Her older sister picked up bunny and tickled her little sister in the face with it bringing on joyous giggling and shaking of her head of blonde curls. It was a

delightful, untrammelled toddler's giggle. I felt nostalgic for the joy and blissful ignorance of a small child; as soon as Saoirse's giggling eased, her sister pushed bunny gently back into her little hands and Saoirse dropped it and squealed again. This giggling-squealing ritual continued on repeat until their mother returned with her coffee and found Maeve, the older child, holding the toy.

Saoirse started to cry and the mother turned again to the still trembling Maeve.

'Look what you've done...I hope you're happy now you've made your little sister cry.'

I could take no more and I stood up to go over to the scene of the alleged crime. As I got up, I saw Margaret coming towards me. I stopped and she continued.

'Sorry, Margaret, just a minute. I'm at that table over there.' I pointed to where my backpack was on a chair. 'Back in a minute.'

I stopped at the bench where the mother sat drinking her coffee, looking at her phone and occasionally turning to tut-tut at her older child.

'Do you mind if I sit down?' I said.

'Be my guest,' she said giving me an if-you-must look. I saw a memory of myself, a stressed mother struggling to deal with what life was throwing at her.

'I'm terribly sorry but I couldn't help but watch your beautiful children playing together earlier.'

'What?'

'Yes, your gorgeous older daughter is so patient with her little sister, isn't she? Every time she dropped her toy and squealed, she would bend down and pick it up, tickle her with it and then give it to her.'

'That...that's not what happened. That's not it at all.' Her words were certain but her tone and face expressed doubt.

'I can only say what I saw while you were getting your coffee…Perhaps you might have thought your older daughter took her sister's toy because the little one was squealing and the older one was holding her toy…but…'

The mother looked at me and shook her head. 'You don't know her, she can be so bold sometimes, you know.'

'I'm sure she can…I read somewhere children can be bold just to get attention. How are we mothers supposed to work that out?! The same article said it's best to ignore bad behaviour as far as possible and praise good; positive reinforcement or something like that…I'm sorry I don't mean to interfere. I remember how stressful it was when my own children were young…I often wish I had it all to do again so I might do a better job.'

'You wish you could do it all again?!'

It struck me looking at her that at this point she was thinking I was at best, an interfering oddball but I persisted.

'Yes, I really do. It went by too fast and I was too distracted too often to appreciate my young children to the extent they deserved. I certainly would have hugged them more for starters. I could make excuses, and I'm not short on possible excuses but…you know.' I shrugged and stood up. 'It's tough being a mother but it's worth it, isn't it?'

She nodded at me and then reached out her hand to her older daughter and pulled her up onto her knee.

As I walked away, I heard her tear-soaked voice say, 'Maeve, I'm sorry, pet. Mummy was a bold girl, not you. You're a good girl.'

The little girl giggled and I imagined her mother might have been tickling her, but I didn't look back.

Margaret was sitting at the table I had vacated, watching me as I walked towards her. I took in her outfit of pale blue trousers, white long-sleeved T-shirt and turquoise cotton jumper wrapped across her

272

shoulders. I noticed the turquoise reflected a warm glow onto her face which was in stark contrast to my memory of the red coat image from the funeral. I could see a certain resemblance between her and Fiona. Turquoise was definitely Fiona's colour but she persisted with wearing dark colours.

As I retook my seat she said, 'Do you know that lady?'

'No, I don't know her but I've been there…There was a bit of a misunderstanding between her and her daughter so I thought I might clarify things maybe…'

'Oh!'

'All good now, I think.'

'Very brave of you…Most of us would say nothing – fearing a nasty backlash or something…'

'Oh, I knew that fear too…but I realised the longer-lasting fear is of the consequences of not saying anything…Sometimes it backfires on me…not too often, thankfully.'

'I wish I'd been more like that when you were young and Mummy treated you the way she did…We should have stopped her…Instead, we followed her lead…I'm sorry Martha. Truly I am. I think about it often and I am so ashamed of how we all were to you.'

My thoughts were knocked off their tracks. I hadn't expected the conversation would go from 0 to 100 in less than a minute. I suspect my mouth hung open offering only silence in response. Thankfully a waitress appeared to take our order. I blurted out a request for an oat flat white and a slice of the German apple pie which Eamon had said it was good. Margaret ordered a cappuccino and the apple pie.

'So…' Margaret said quietly into the prolonged silence that sat between us after the waitress walked away.

'Margaret, I've had years to think about it all and…and…families are complicated, aren't they? Children look to their parents for guidance and…I guess Mother treated me like shit and like you say, the

rest of you followed. Perhaps in the interest of your own self-preservation…'

'Yes, but…but as we got older, we should have known better. We should have…We could have…I feel guilty every time I think about when you were in your 20s and we were in or around our 30s, and you asked Jim, Robyn and me to talk to you about how you had been treated within the family. I remember that we each separately denied that you had been treated any differently to the rest of us and went so far as to tell you to build a bridge and get over it…'

'Yes, I remember…That was a difficult time for me…It was probably the spark that led me to go to Sudan – once I got that chance, I couldn't get away fast enough!'

'And God, we were so angry with you! The way we looked at it, you had no ties, you should have moved to Sligo to look after Mummy after her stroke and leave us to get on with living our lives as we wished. After you left, Robert, my husband, pointed out how we'd totally underestimated just how much you did for Mummy and while holding down a proper fulltime job in Dublin…Jim was furious. He wrote to you and demanded you come home from Sudan…'

'Yes, and assume Mother-duties and spare the rest of you, her children, the hassle. I remember the letter he sent me – with all your names on it – it made me want to run a mile in the opposite direction, it reinforced for me the need to spend as much time away as possible – not less!' There was anger in my voice as I spoke. I checked myself to change my tone.

'I'm so sorry. I didn't feel right about that letter and Robert told me to ask Jim not to put my name on it…but I was scared of Jim, we all were, and I said nothing…and that was that. Robyn said she didn't agree with it either…but she only told me that a few years ago…after her marriage broke up and she came to realise that the problem with her husband was he was a bitter bully…just like our big brother.'

A vision of Jim came to mind. I pictured him with a thin topping of wispy, white hair, an old, wrinkled face, a pair of outdated heavy glasses that came free on the government scheme and which accentuated his large, red, drinker's nose – all culminating in a permanently set facial expression of miserable displeasure. Robyn, I imagined, in stiff white blouses and sharp suits, a severe haircut sharpening her high cheekbones, narrow-pointed nose and thin, pursed lips. I wondered if either had mellowed and I asked myself if I wanted to know how they were getting on. I assumed they were alive. I must have been curious enough. I'd come to meet Margaret, hadn't I.

'Tell me, Margaret, tell me about your life since…'

'Since you headed off to Africa?'

'Yes, over the last thirty years…'

'Well, as you no doubt remember, I married Robert, a good man and the first who'd have me and who ticked the requisite boxes of protestant, good family, hard worker, etcetera. Our two children, Jonathan and Rachel, have families of their own now…Rachel remembers you still. She remembers having fun with you when you minded them as little children…you took them to the beach and made sandcastles, collected shells and did all that stuff I was never any good at.'

'I remember them too. I had fun with them…' I said, feeling a sadness that I'd missed the time between their sandcastle building and their family building. The hugs they gave me had given me a sense of being loved, a sense of hope that I was not entirely unlovable.

'We moved to Wicklow when they were still in primary school and I gave up work to stay at home. I'm not sure it was a wise move for all concerned…we weren't exactly reared with the best example of how to be stay-at-home mums, were we? Robert got stuck into growing his family business there. He worked long hours but, unlike our father, he always made time for the children; he had that easy way of cajoling them into being good whereas I always had to make a fight out of it.

Rachel adored him but met me head-on, there was lots of shouting and things said…Robert was forever trying to make peace between us. He may as well have waved a red flag at me…Jonathan let it all go over his head and for the most part did his own thing. Rachel once told me I was worse than Grumpy Gran, as she always called Mummy…'

I put my hand over my mouth to hide my smile at Rachel calling Mother 'Grumpy Gran,' but Margaret barely looked my way as she spoke, mostly she played with the stainless-steel strap on her wrist watch, clicking it open, taking it off, putting it on.

'I was angry at everything and everyone, horribly so. Robert suggested I get some help, you know, counselling. I refused point blank and when he suggested we went to a marriage counsellor – I told him, 'Go yourself…and let me know how you get on.' Net result: he asked for a trial separation. He left the house, and Rachel and Jonathan followed and they both soon headed up to Dublin to uni. I'd a lasting meltdown and they stopped coming home to me too often. Rachel told me to get help or else you'll see no more of me…'

The waitress appeared beside us with a tray. 'Sorry for the delay…we were suddenly overrun…' She put our coffees and German apple pies on the table.

'No problem, we hardly noticed…Thank you,' I said and Margaret nodded in agreement.

The waitress smiled and turned back to the business of clearing tables.

'Did you get help?' I asked, looking at Margaret's tearful face.

'Yes, I did. I went to an out-of-town GP and she put me on anti-depressants but insisted that they were not the long-term solution and that I needed counselling…Have you had counselling since that time, all those years ago when your counsellor suggested you speak to us about your childhood?'

'Yes, after I came back from Africa…'

'Did it help?'

'I saw someone again recently. It helped…'

'Somewhere in the midst of my long months of counselling, Rachel dug out all the birthday cards and bits and pieces you'd sent her…right up until she was eighteen – I didn't know she'd kept them – what's the story with Aunt Martha, she said, how come Grumpy Gran and the rest of you always talk about her as if she's the family loser or worse?'

The word 'loser' hit an old familiar note, and I gulped it down so hard it made my throat feel sore and raw which made me half gag. As I suppressed the gag, all the words that came to me got trapped at the back of my dry throat. I tried to swallow to release them but that turned into a splutter-cough and my eyes watered. I tried clearing my throat but it had its own ideas and the coughing won out and pushed tears into my eyes. I grabbed my backpack from the ground, took out my water bottle and forced myself to take slow sips. I took a hankie from my jeans pocket and dapped my eyes. Margaret looked at me with horror.

'I'm sorry…I didn't mean to upset you. I'm so sorry. You're not a loser…Obviously you're not. That was the narrative we had created to avoid the truth…When Rachel asked me what did you ever do against me, she got me thinking…I'd been talking to the counsellor about our family, how Mummy had always been vicious, miserable and bitter towards all of us but, I realised, especially towards you and Daddy, and I had this slow dawning that I *was* becoming just like her. In Rachel, I'd found someone to pick on, to take my anger out on, just like Mummy took so much of her anger out on you. Robert and Jonathan quietly stood up to me or humoured me. Jonathan was my pet. But poor Rachel, she was always beautiful and lovable too…but she was vulnerable and I played on that. I could rely on her to react…be it with anger or tears…that was the cycle…I attacked her, she reacted. I

think I was jealous of how bright and lovable she was. On and on that horrible cycle went…things only started to change after she moved out of the house and in with her dad, putting distance between me and her. She found the means to set the boundaries with me that she needed…and, as it turned out, that I needed too.'

As I was listening to what Margaret was saying, I realised something I'd never considered before: the bitterness and dysfunction I had grown up with, had taken its toll on Margaret, Jim and Robyn too. It had shaped us all, and not for the better. I almost reached across to put my hand on hers, to tell her I understood some of her struggles with Rachel and some of what had made her who she was. My hand twitched in my lap but didn't reach to touch hers. Affection between us was alien.

'I'm sorry, Margaret. Our start in life didn't prepare us well for being mothers. I hope things are better for you now.'

'Robyn was having marital difficulties too and we started talking about it all, how unpleasant Mummy was – except when she was with her golf or altar cronies – how Dad was rarely around, and how he drank too much when he was, and how he and Mummy seemed to resent rather than love each other…there was something sad in that. It was a poor lesson on how to be a parent or a wife.'

I nodded in response; I was listening hard for a sign that she knew the truth about me and I heard none.

'It was so wrong of me to treat Rachel differently to Jonathan, and I asked Robyn why we all treated you so badly. She thought long and hard about it and neither of us could say that you were any more irritating than the rest of us and you weren't a bad person…Mind you, you were too pretty by far and too much loved by teachers and neighbours.' Margaret smiled across the table at me. 'And you're still very good-looking…' She paused there and looked expectantly at me. 'I'm sorry, I'm talking too much.' She lifted her flat cappuccino to her lips.

'Your coffee must be horribly cold; shall we get some fresh ones?' I asked, glad to take a breather before responding to some of what she had said.

'I'm sorry, Martha. I hope I'm not opening too painful wounds for you.'

'A bit, but I think I'm okay so far. It may be good for us...' I caught the waitress's eye as she cleared the just-vacated table beside us, and we ordered fresh coffees.

'The other thing Robyn and I realised was that all the way to the bitter end, Mum showed no remorse about how she'd treated you. She left you nothing in her will and never ever acknowledged all you did for her after her stroke. How would a mother do that to her child, I asked myself. And I asked myself if I was capable of treating Rachel like that. And I was scared that I would have been if she had not left home and restarted communications with me purely on her terms. She saved me from myself. Her father saved us both. But nobody saved you from the abuse Mummy inflicted on you...with us in supporting roles...nobody. None of us. My counsellor said that you were the family scapegoat; the more Mummy picked on you, the less she picked on us. It suited us. I'm so sorry...'

I looked at her trembling upper lip as she bit her teeth into her lower one and the floodgates opened and tears streamed down her cheeks.

I pulled my chair up beside hers and put my arm around her and pulled her into me. Between the sniffles and gulps, she repeated, 'I'm sorry. I'm so sorry.'

'You don't know...do you?'

'Don't know what?'

'Margaret, there was a reason Mother hated me... I was the natural scapegoat of the family! I thought before she died, she would have told

you, or that the Sligo rumour machine might have provided at least one of you with an inkling…But, I guess not…I'm sorry.'

Margaret pulled away from me and every wrinkle and crease on her face intensified as she looked at me.

'I am not Mother's daughter. I am Dad's but not hers.' Tears sat in the corners of my eyes as I spoke.

Her face stayed creased and frozen. 'Sorry, Martha, could you repeat that?'

I took a paper serviette from under my side plate and wiped my eyes.

'Dad fell in love with another woman whom he worked with at the bank. She got pregnant and he wanted to leave Mother and set up home with my mum. But back then, both of them would have lost their jobs and ended up penniless and he would not have been able to provide for any of us. Dad told Mother he planned to leave her, negotiations ensued and he stayed and she agreed to fake a pregnancy and rear me as her own.'

'Holy Moses!' Margaret's thin, wrinkled hand went up to her face and her elbow toppled her fresh cappuccino.

I reached across the table and steadied it before it all spilled. Margaret watched the coffee trickle from the table to the ground and I put a couple of napkins down to stop the flow.

'Lucky you chose an outside table,' she said.

The waitress was over in a flash. I'd had a sense of her watching us a few times, sensing the drama unfolding between us.

'Don't worry, I'll get you a fresh one. These things happen.'

She touched Margaret gently on the shoulder with a reassuring kindness and I was reminded of the waitress in the café where I'd brought Stephen.

'Margaret, I am so sorry. I've been living with all this for so long that it stupidly never dawned on me that it would be disconcerting news for you.'

'Except she didn't, did she?' Margaret said.

'Sorry?'

'She didn't rear you as her own. She treated you like shit. She abused you endlessly. She…she…' Margaret shook her head.

'Yes, she did.'

'And worse…Robyn and I talked about some of what she used to say about you. The way she always referred to you as the—' Margaret stopped herself.

'The ugly and stupid one,' I said finishing for her.

'And worse! But you were never ugly, and you're clearly anything but stupid and still we let her say it. We even believed it and said it too. We were horrible. It's a wonder you're half sane at all.'

I looked at Margaret looking at me but I said nothing. I had the feeling she was assessing if I was actually half sane. Her hands were on her cheeks and her fingers moved up and down her face, the way a man might check if he'd given himself a clean shave.

The waitress put the fresh cappuccino and two menus on the table. 'In case you're hungry,' she said.

'So, you're my half-sister…and somewhere out there, is another woman who is your mother.'

'Yes, we are half-sisters and the other woman, my real mother, Cathy, lives less than five kilometres away from me in Dublin.' Tears swelled up again in my eyes as I mentioned Mum. 'She's amazing and is my closest friend and a much-adored granny to my three children – not grumpy at all!' As soon as I'd uttered the implied comparison, I felt a pang of guilt.

Margaret bit again on her lower lip and more tears sprang from her eyes. 'I'm glad, Martha. You deserve her after all we did to you.'

# Chapter 26

## Confused Feelings

I ordered a vegan buddha bowl, wondering aloud to Margaret whether Buddha himself might be amused by a bowl of food being named after him, and whether he may have questioned whether the optional addition of rashers or a chicken breast might render the entire dish buddha-less!

Margaret said that was all too complicated for her and she'd have a chicken and stuffing sandwich, with lettuce included as a token gesture to healthy eating. Her daughter Rachel, a committed vegan given to mentioning the CO2 omissions created by the dairy and beef industry, would not entirely disapprove, she said.

'Our youngest, Zara, is the same. Hence my shift towards less meat and dairy and more vegetables. First, I did it for a more peaceful life. Now she has me more convinced of its merits, for my health and for the climate.'

'Rachel has a lot more work to do on me…'

We continued to make small talk in between bites, both of us too spent to dig any deeper into the scars of our dysfunctional upbringing. We hugged each other as we parted and it felt strangely natural although nowhere in my memory could I find a time when we had hugged before.

I made slow, deliberate foot prints in the sand as I walked Mullaghmore beach. A deep-buried recollection raised its head: there had been days when Margaret had tied up my hair before school and spared me from Mother's usual, violent creations. I put my fingers to my hair and scalp as I remembered the contrast of the two sensations: Mother dragging the hairbrush hard and blood-drawing deep into my scalp, making tight, skin-pulling plaits, compared to the touch of the same hairbrush in Margaret's hands which felt soft – almost tender – as she made two neat, relaxed plaits in my hair.

Another memory floated to the surface: Margaret had taken me shopping when I was in boarding school and bought me a top and jeans to kit me out for the school discos, discos that I never mentioned in front of Mother. As I walked at the water's edge, in my head I wrote a text to Margaret:

**I've been remembering and thinking. Things were never all bad between you and me. We had our moments. Perhaps we will make more.**

But I wasn't ready to send it.

There were no visible signs of jelly fish on the beach. Away from the humdrum of other walkers and swimmers, I changed into my swimsuit and charged into the water, hitting the white waves with force and a liberating roar. Beyond the breaking waves, I swam parallel to the shore with determination, my overstuffed mind driving me forward with more speed than style.

When my head no longer felt like a balloon ready to burst, I took long, deep breaths, slowing myself down and letting my thoughts and body float. I asked myself if I felt better for meeting Margaret, concluding that I did, and observing that we had embarked on a difficult, emotional conversational journey through our past and into its ripple effects on our present, it was an enlightening journey with further potential to follow, perhaps. What we might do with that potential

would depend on both of us. I could not predict how she would internalise the new knowledge of our not being full-sisters. Time would tell. In the meantime, I would send a text to Mum saying that my meeting with Margaret went well, better than expected, I'd fill her in further when I saw her.

Seán had given me all the space I'd asked for and I owed him at least a text to offer an explanation as to why I hadn't been in touch since meeting Stephen. I composed it as I swam and sent it, after my one to Mum, from my perch on the beach:

**Hi Seán, hope all well with you. Still processing my meeting with Stephen but I know he's in the right place. Decided to stay on in Sligo a couple more days. Met up with Margaret today. I know. A big move. Went well, I think. Lots to mull over. I'll be in touch again soon. I plan to be back at the weekend. Xx M**

I re-read the text before I sent it. I knew it was a holding text, just as my other texts to him had been. I wondered if I was being fair to him. It was early days yet and I needed to stick to my resolution to make no rash moves until I'd the time and emotional energy to know what I wanted. A voice in my head, that sounded like Mum's, warned me that good opportunities might pass while I kept possibilities of a love life on hold; you're not getting any younger, it said, many a separated woman of your age and younger gets left on the side-lines; is that what you want? The side-lines had a certain but perhaps limited appeal…

My phone vibrated in my pocket, twice in quick succession.

**Martha, mo leanbh, I am so pleased to hear your meeting with Margaret went well. I hope you're looking after yourself and enjoying good food and safe swims. I'll see you at the weekend, or early next week, for sure. All well here, love you always, xx Mum**

She had called me her child as Gaeilge, a term she used rarely and only at deeply emotional times.

When I first met her, she had said, 'Martha, mo leanbh, mo chéad leanbh,' and tears had swollen in the corners of our eyes and flowed down our cheeks.

With her words and her tears, I had felt her love and her holding me as I did throughout all the years since then. I was the lucky one. I had a loving, understanding mother who supported and gently guided me when I needed it. Margaret, Robyn and Jim had not been so lucky.

**Hi Martha, good to hear from you. I still can't begin to imagine what Stephen might have told you. I hope rehab goes well for him. Very brave of you to meet Margaret. Must feel overwhelming for you and I understand why you're not ready to talk. Look after yourself, xx S**

I felt lousy reading Seán's text. He was too bloody nice and far too understanding. At some stage, would he tell me to piss or get off the pot? No, he wouldn't. He was too good and I wasn't even sure how I felt about him or if I wanted a relationship with him that was more than platonic. What if we did have a relationship and it all went horribly wrong? Then again what if we didn't...

Eamon opened the door to me and without uttering a word took me in a deep hug that I didn't know I needed until that moment. The pressure of his arms around me bringing me tight to his chest squeezed a stream of tears down my cheeks. They were good tears and being in Eamon's arms made them even better. It was a feeling I didn't want to end. Chuckie and Harry danced around us and right when things might have become awkward, Chuckie's front paws landed on my thighs and Eamon was nudged aside. I held his front paws and together we did a slow jig around the hall.

'Thanks, for looking after him,' I said to Eamon, touching my hot, flushed face with my fingers.

'He's no bother. Come on into the kitchen. I'm cooking dinner. I picked some early veg from the tunnel, perpetual beet and the like and

I need to use up some other veg. More than plenty for two or more… Tea first maybe?'

'Sounds good.' I nodded.

'Normal, green or fresh mint?' He said, holding up two boxes of tea and pointing at freshly picked mint in a glass.

'Green with fresh mint maybe?'

'I'll make a pot for two.'

While Eamon chopped onions and garlic, I sat at the table sipping my tea, grating carrots and chopping dried apricots. He had a recipe for carrot and apricot patties he'd been meaning to try and he threw in some chopped cashew nuts for a bit of added texture.

'I hope you like cumin and fresh coriander, I tend to be quite heavy handed with both,' he said, adding more of each than the recipe suggested.

'Love them.'

'Good,' he said, as he stirred the mixture.

Together we pressed it into patties which we floured, ready for shallow frying in a pan on the hob beside the unused aga. He then sliced some colourful heirloom potatoes as thin as possible.

'I'm going to try get these to crisp in the oven and then we can dip them in the houmous and the garlic mayo.'

And the evening rolled in and we sipped Aldi's organic prosecco as we nibbled on olives and homemade crisps and dips. By the time we got to the carrot patties served with roast spicy wedges and steamed perpetual beet, we were sipping a French shiraz which was pleasantly light by new world standards and sat comfortably beside the coriander, cumin and cayenne spices in the very tasty carrot patties.

When I remember that evening, I realise that I was focussing my attention on the food and talking too much trying to distract myself from the sexual attraction I felt towards Eamon. I told him about how Mrs O'Reilly's funeral had brought me back to Sligo and all she had

meant to me. I spoke of Máire as a very close friend and the other O'Reillys too but I guiltily made no specific mention of Seán. I got on to talking about Stephen and how I had previously joked that I'd two sons: Matt and Stephen; but for all that, we had let Stephen down when he needed us most. We had failed to go that extra mile for him, too wrapped up in our own troubles and trials. He talked some more about his daughter and how awful he'd felt for letting her down but somewhere in the thick of it all, he'd realised that the energy he expended feeling guilty would be better spent giving his family time and support in the present.

'I was that person who spent too much time in the office, too much energy on work, always busy, always scared to stop for fear of what I might have to face. It caught up on me and…while I wouldn't wish Shirley's situation on anyone, it saved me, it really did. I think I'm a better father now, a better person hopefully…I'm working on it.'

'A work-in-progress like myself so…may we never be finished goods!'

He laughed and clinked his glass to mine.

I hadn't intended to tell him about my last couple of conversations with Patrick, including how I had found out that he had jumped the starting gun and was seeing another woman, before the race had even been called. He roared laughing when I told him how I'd interrogated him about the details of this latest crime. I explained how it was a far cry from my reaction to Patrick's previous affair with Isabel, the high point, or low point – depending on your perspective – being when I'd told them over an elaborate dinner party in our house that I knew about the affair with Isabel and I had asked him to leave. Isabel and her husband were there as our invited guests, eating the food I'd so carefully prepared; *Babette's Feast*, it was not. It hadn't been funny back then but telling Eamon about it, I could see it had the makings of comedy. We both ended up with tears streaming down our faces

287

when I described Isabel's oompa loompa coloured arms bursting out of her designer, white blouse which I had accidentally on purpose, stained with the pollen from some sickly smelling pink lilies she had been trying to force on me. It felt liberating to feel tears of laughter for a change.

There was a pause.

He looked at me with a question in his eyes. I nodded a yes. Then he leaned over and kissed me. On the lips. And wow. It felt like a happy wand had touched me. As his lips left mine, my hand rose to my face, wishing to capture the sensation.

'Sorry, Martha. I shouldn't have done that. I didn't mean to...'

'Oh?'

'I mean I wanted to, of course I did...but it's not fair on you. It's too soon.'

I looked at him and felt my mouth stuck at 'oh,' but slowly the smile in my eyes spread to my cheeks and down to my lips.

'You're probably right,' I said with a barely perceptible nod, followed by an emphatic shake of my head. 'But, fecking hell, it felt good!'

His face beamed with relief and an uncertain laugh escaped. I surprised myself and threw my arms around him and we stood up together in a tight embrace packed with warmth and lust. Our hands travelled around each other's backs, holding our bodies tighter together. I felt his arousal growing against my hip and I felt my body respond happily to it with a wetness I hadn't felt in a very long time. From the top of my head to the tips of my toes, my body felt alive and excited. My hands found their way up under his T-shirt and felt his naked back. His fingertips travelled under my T-shirt creating a trail of excitement as they wandered up past where my bra strap would have been if I had not given up wearing one a short time after that famous dinner party. I wanted him to wander further, to touch my breasts, to

play with my nipples which were ripe with pleasure and…but for all the right reasons, he didn't.

He held me close leaving barely room for sexual tension to squeeze between us. Perhaps, I didn't want it to go any further. How much better could further feel? In our embrace and touch, I felt a depth of connection and honesty that ran deeper than any I remembered feeling in my whole life up to that point. If I believed in heaven, I would have said I'd died and gone there. Was it drink? Was it HRT? Was it real?

Eamon brought his hands up to my face and swept the hair back off my cheeks. He kissed me again on the lips and a fresh joyful response fired around my body.

'Martha, Martha, I like you far too much to want to rush this. I feel there is something special building between us and I don't want to spoil it…'

There was no denying it, his words rang true. But they burst my bubble. I nodded.

'I know. Swoya, swoya. Slowly, slowly. You're right. I know you're right.' I consciously took a deep breath and emitted it slowly, desperately fighting my frustration.

'Swoya, swoya, it is so.' He smiled, a sexy, sideways smile and I could have, would have, melted back into his arms.

'I think I need a swim…' I said.

'I do too. Although, I'm not sure if it will be safe…what with you in your swimsuit on such a bright night…things might happen to a man.'

'Haha! You flirting with me?'

'Absolutely. All day and all night since you got here. And maybe around the jury table too…Didn't you notice?'

'I may have pretended not to!'

# Chapter 27

## Home

The house felt empty when Chuckie and I got home on Friday evening. Zara was still on placement, and Matt had gone to Galway with the lads for the weekend with a plan to divert to Sligo on Sunday to visit Stephen and fill him in on Zara's recent communications with his eldest sister, Sadie.

Through a younger sister of a friend of hers, Zara had made contact with Sadie, they had exchanged numerous messages, followed by an awkward chat on the phone. Sadie and her sister, Susie, were bursting with relief to hear Stephen was alive and in recovery; they feared that he had been murdered for a drug debt and was buried at the bottom of the Royal Canal or the Liffey, never to be seen or heard of again. Their parents refused to have his name mentioned, and when they moved house, they dumped all reminders of him. Sadie and Susie had secretly kept his football medals and other mementos. Susie had found religion and said a prayer for him every night. They were dying to see him. They loved him. They missed him. The fact that he was alive would be their secret. They didn't want their parents to tell them that they couldn't see him. As a parent, I was uncomfortable with this but from what they'd said, I suspected their decision was well-founded.

The family house had been sold because drink had finally killed their Grandad, and their Granny Bridget wasn't well and needed some

minding, so she asked them to move in. Granny Bridget had always adored Stephen and still asked where he was, but the girls wouldn't tell her that they knew he was alive and in rehab; she had lost her filter and sure as anything, she would let it slip to their parents. Sadie wanted to know all that Zara knew about Stephen. Zara said that she only knew that Stephen planned to be in touch with them when he was out the other side of rehab and back in real life, so to speak. Zara was nervous of breaking any confidences or saying anything she shouldn't so she suggested she would talk to me and get back to them. We agreed that I would draft a message for Zara to forward on and during the week, I had taken great time and care to write one:

Hi Sadie and Susie, I first bumped into Stephen a few months ago and since then he has made huge strides. He is currently in rehab in a house down the country and will be there for quite a number of weeks more. During this time, I'm afraid he will not have his phone and visiting is very limited. In all my conversations with him, it is clear that he loves you both and is deeply sorry for the pain he has caused. He is very keen to make contact with you when the time is right. I saw him last Sunday and I believe that his goodness and strength of character will get him through this and he will be very happy to see you after he is out of rehab and when you are happy to see him. I'm sorry but there is little more to say at the moment. When there is more, we will be in touch. In the meantime, please know that he loves and cares about you. All the best to you both, Martha

Zara's response when I sent it to her was:

**What happened to short and sweet? I don't think they were expecting a novel! 😄 Don't worry I've sent it on – unedited!**

I unpacked and ate lonely leftovers that Eamon had sent me home with. Afterwards, I busied myself wiping down already clean worktops and sweeping already clean floors. I flicked through the TV channels

and rejected everything. I flicked through prompts on Netflix and did the same thing.

What now? I thought. After the excitement of the last week, what indeed?

While I was away, Fiona and I had been texting each other in that sporadic way we had developed since she got married. I'd tried calling her on the way home but hadn't got her; it was too late to try her again, she had become an early bird since pregnancy and I'd told her to embrace it while she could. It was too late to ring Mum too, as she would want to hear everything in as much detail as I was willing to give. I hadn't given her an inkling that there had been so much as a spark between Eamon and me, and I wasn't sure how much I wanted to tell.

Now that I was home in my own clean, ordered kitchen, I wondered if it was little more than a holiday attraction, romanticised by the magic of the location and my heightened emotions. But sitting on the couch with Chuckie by my side, there was no denying it, thinking about Eamon gave me a warm and sensual glow. I felt like he understood me in a way that nobody else did. It came naturally to me to be open and honest with him. I savoured these thoughts for a few moments of glorious joy.

I was dying to talk to Máire about meeting up with Margaret but given where things were at with Seán and me, I couldn't bring myself to ring her. And I wasn't ready to ring Seán either. I was struggling to know what to tell him; should I say I was still confused about whether I wanted a relationship with him or what I wanted? I'd have to think about that.

I spent the evening writing and rewriting texts, starting with the easy ones:

**Hi Mum, home safely. How about a walk and lunch tomorrow? Meet you mid-morning here if that suits you? Xx**

Her reply came fast.

**Relieved to hear. See you there between 10:30 and 11. Xx Mum**

Next, I texted Fiona:

**Hi Fiona, would you like to come for brunch or lunch on Sunday? Or whatever suits? Would be lovely to see you. Xx**

I'd composed a few texts to Margaret in my head since meeting her but had been too distracted and undecided on the wording to actually send one. I sat and wrote and rewrote a text to her before finally settling on:

**Hi Margaret, thank you for meeting me this week, especially at such short notice. It meant a lot to me. It was brave of you to reach out to me at the funeral and I admire and thank you for that. Meeting up with you has prompted me to remember more – in a good way. I remember times when you looked out for me – like sometimes doing my hair before school. You always did it nicely and with care. What I'm saying is that we had our good moments. I'm happy to meet up again if you'd like. All the best, M**

Margaret's reply came in minutes just as I was composing a text to Seán:

**Hi Martha, how lovely to hear from you. Thank you for your kind words but it was not me who was brave to meet up but you. After how we treated you, I wasn't sure if you ever would agree to meet and would have understood if you hadn't. I'd be delighted to meet again. I've very few fixed ties at the moment so am happy to meet at short notice. Rachel was so excited to hear we met up that she announced that she was coming to visit and is here with me now, relaxing after both of us eating my attempt at a buddha bowl! I look forward to seeing you soon, Mgt**

I imagined Rachel and Margaret sitting on the couch together looking at my last message and sharing the good feeling. If I hadn't gone to Mrs O'Reilly's funeral…If…If…and more ifs. If I had already

been doing a line with…dating…seeing…meeting…sleeping with…Seán…

I realised I'd no idea what the current appropriate expression was and every possibility I came up with sounded out of date or over the top. Bottom line, if Seán and I were already an item before I went to Sligo, would I have kept a firm distance from Eamon? Definitely, even if I had felt drawn to him! If I'd to choose now, which of them would I choose? *Neither*, I concluded was the safe answer.

Women in their fifties weren't supposed to have these ridiculous dilemmas. Such decisions and revisions were supposed to be worked out with the ignorance and innocence of youth and the opinions of various girlfriends thrown into the mix. But that only worked when you were young. Life was more complicated the older you got. If I chose Eamon, there would be no more friendship with Seán and I'd miss Seán and I'd know I'd hurt him. If I chose Seán, that would be that and there would be no further possibility of a stimulating, sensual, soulmate relationship with Eamon, which ultimately might go nowhere outside of his little piece of heaven in Sligo, and then where would I be? I knew Seán, his family and through my friendship with Jackie, some of his foibles. I was comfortable with them. I knew what I'd be getting into. Seán was safe. Eamon was unknown. I sent a short and simple text to Seán:

**Hi Seán, I got home safely this evening. One hell of a week. Hope all well with you. Are you free to meet up early this week coming? Would be lovely to see you. Xx M**

As I waited to hear from Seán, I got a short text from Fiona:

**Brunch at your place followed by a walk would be good. I will be there for 12:00. Xx**

I responded with:

Next. I heard from Seán:

**Hi Martha, good to hear from you. Happy to meet for lunch on Monday. Town maybe? Forecast is currently good so could have picnic in Merrion Sqre if you like? Xx S**

**Great idea. I'll pick up something tasty for each of us in Tiller & Grain. 1pm? Xx**

And last but not least, I turned my nervous attention to sending a text to Eamon:

**Greetings from Dublin, Eamon, what can I say but thank you for everything and most especially for sharing your little bit of heaven with me. It was a very special time for me for lots of reasons. I hope all is good there. Say hi to Harry. Chuckie here wagging his tail at the mention of him! Back to reality now. There is only the now...xx M**

I sent the message and set my phone to airplane mode, left it in a kitchen drawer and went up to bed.

# Chapter 28

## Seán, Fiona

'Widowers who had good marriages seek to find similar surprisingly quickly after their wives die. Jackie was a good person and Seán knows you're a good person. You could have been happy together maybe if somebody more exciting had not come along. Think about it Martha, which option feels more you? The thought of which person makes your heart sing?'

'Ah Mum, Eamon obviously. But he could be little more than a brief illusion. Seán is safe. Seán is secure. Seán would be for life, not just for holidays…'

'Eamon could be for life too. What did you say was the gist of his response to your text was?'

I took my phone out of my bag and read the text out to her:

**Greetings Martha from a man and his dog who are both feeling a bit sad and lonely since your departure. Strange and all as it might seem, I have not felt lonely here before, but after such a wonderful few days with you, all is not as it was. I loved getting to know you, our chats, our swims and our meals together and I hope it will not be too long before I see you here again. I know you are going through a challenging time emotionally and I want you to know that I do not want to put you under any pressure and I am happy to take things together slowly. Please know that you are welcome to bring your mum, your daughter and yourself here any time as my invited guests. If the cottage is let, rest assured, there are**

**plenty of rooms in this rambling, old house. All I'd say is, pack woolly jumpers and hot water bottles! Hopefully talk soon, xx**

'Ah Martha, that's even better than how you said…And you never mentioned that there is an open invite for me too. Now that puts a different slant on it!'

'Mum, I've only known the man less than a week, will you stop?'

'I'm thinking you don't have to choose one or the other with any haste, you know…maybe we should make a little visit to Sligo while you're deciding between Safe Seán and Erotic Eamon…I think it's important I check out the competition Seán is up against…'

'Mum!'

'Sorry. Sorry. I shouldn't have said that…Those descriptions just came to mind given the way you talk about each of them!'

I heard the gentle lack of sincerity in her apology and saw the twinkle in her eyes as she spoke. The romantic in her was having fun. In such moments, I felt I got a glimpse of my Mum as the woman my father had fallen in love with.

'I never described Eamon as erotic, that was the HRT talking!' I said, sensing a twinkle in my own eyes.

'Well, maybe not in so many words but…all I'm saying is don't put all your eggs in the one basket just because that basket seems safe!'

'Point taken. And let's not forget that I'm not convinced I want to give up the pleasures of being answerable only to myself and sleeping mostly alone.'

'You're spoiled for choice, but whatever you do, don't let too much time prevaricating take the decision out of your hands! And remember, when Matt and Zara move out, you might feel differently…'

'I'll have Chuckie. He gives me no grief…But, you're right, I do like human company some of the time but then I think maybe I'll have enough with you guys, my art, my tennis and my other friends, topped

with being a granny…hard to know how that will work out until I've tried it.'

'As Eamon says, you don't have to hurry. You don't have to decide now, tomorrow or even the next day. Meet up with Seán and see how you feel. Then let it sit for a while.'

'I can take time to see how things unfold…I'm not always good at that, am I?'

'Decide in haste, repent at leisure…Wait and see what Monday brings.'

And now it was Monday and the sun was shining. Children were screaming for joy as they chased around on the freshly cut grass and in between the tall trees in Merrion Square, and adults were chatting, breaking off to take a bite of food or to seek out their energetic children, or both. Four women stood up and left a picnic table free under the trees. I took a seat at it, facing in the direction I expected Seán to appear from. I spotted his red jacket first as he lumbered along, in no hurry, not looking up but at the ground in front of him. When he reached the centre of the park, he stopped and took out his phone and I assumed read my message telling him where I was sitting. He looked in my direction and we smiled and waved at each other. I felt warmth but no flame.

I half stood up as he came up behind me and put his big hands on my shoulders and kissed me on my cheek.

'Martha, it's good to see you.'

'Good to see you too, Seán,' I said, checking and feeling comfortable with the depth of my sincerity.

We sat opposite each other and I handed him his cardboard box of a picnic lunch and the coffee that I'd bought for him. He opened the box and took in the tasty selection of salads topped with a still warm grilled chicken fillet.

'Looks and smells delicious,' he said. 'What did you choose for yourself?'

'The same salads, no chicken.'

We each took a number of bites and declared our pleasure. I sat up straight, looking around me and at the food in my box, glancing across at Seán intermittently and taking in his large chest bent over his food. Sitting up straight wasn't his way, looking comfortable was. I had the feeling that we were both using the distraction of food to postpone the real conversation. When our boxes were getting empty, Seán spoke.

'So, firstly, how was Cork? And secondly, how was Sligo?'

I laughed, a silly twitter of a laugh.

'Goodness, so much happened in Sligo, I almost forgot about Cork…Cork was wonderful. An intimate dalliance with nature, a total escape…'

I described at length the little cottage, the stony beach, the walks, the swims. I thought of my fun interrogation of Patrick but I chose to only say, 'Patrick has a new woman in his life, a Southsider called Louisa seemingly.'

'That sounds quick?'

'I know. It was very quick. He only told me because Zara bumped into the two of them.'

'Oh, and how do you feel about it?'

'I'm surprisingly fine. Bemused and relieved really…Does that sound weird?'

'No, I don't think so. From what Jackie said, he lost you when you caught him having that affair and you've been gradually letting go of him since.'

'Good old Jackie,' I was taken aback by the depth of his understanding and the thought that I was underestimating the possibility of him and me niggled me.

'Forgive me if it's too soon to ask, but where does that leave your thoughts on us?'

'Honestly, after the last few weeks, I'm more confused than ever…I'm not sure what I want. I'm kinda clear that I'm not ready to settle with someone in that fulltime way again. I don't think I ever want to live my life fifty weeks of the year with one person. I like my own space. Maybe I've become too selfish or something…'

I looked up at Seán and he was wearing his well-practiced neutral face. 'Hmm. I don't know what to say really…you're definitely not selfish…'

'Maybe I am because I want to have more me time in future. Possibly lots of me time…I'm sorry. I hadn't planned on saying all this. I haven't worked out what I want other than I'm not ready to completely settle down again – if I ever will be – I may like to travel again. I may not…'

'Do you need more time? Is that what you mean?'

'Maybe. But I don't know. Before I went away, I thought I would give myself six months or so, seeing you regularly and then, I thought I'd be happily ready to take it to the next level, so to speak…but then Sligo happened and turned all those thoughts on their head. And I know I cannot say to you wait for me…I cannot say, let's wait and see how life unfolds…'

'I see. At least I think I do.'

I looked down at my nearly empty salad box and poked at the last bits of red cabbage.

'Seán, I have to tell you, in Sligo, of all places, I tasted a little bit of heaven in a wee house right by the sea. There were so many emotions thrown into last week and…this is hard to say…but I value you too much not to be honest with you…the man who owns the house I rented turned out to be someone I did jury service with, and we connected over shared interests and experiences including family, sea

swimming and dealing with people close to us struggling with drug addiction…We weren't an item or whatever the expression is these days; I'm genuinely not ready for any such commitments.'

I kept poking the cabbage salad as I spoke and when I looked up his face was full of sadness and I wished I'd said less.

'I'm sorry Seán…I'm really sorry. But I'm not the right woman for you now because I'm too unsettled and independent at the moment and maybe indefinitely but for all that, I'd hate to lose you as a friend…'

I rushed the last sentences, desperate to get them out in the open, desperate to end the uncomfortable feelings bursting through me, building me up to a sweat that was the equal of my pre-HRT days.

Seán nodded slowly. I could see pain in his eyes and the wrinkles of his large face. I felt a tenderness towards him rise within me, and I wanted to take my words back and undo the hurt.

'I won't pretend, Martha, I am sorry too. But, over the last couple of weeks, I've built up to expecting this…I love your company. I'd like to think we could still be friends, meet for lunch, walks, even dinner…'

He looked at me as he spoke and I could see his eyes watering and his Adam's apple moving lumpingly in between sentences. I felt racked with guilt for hurting him and with self-doubt at the wisdom of blurting out my half-formed thoughts.

'I hope we will do that, Seán and if you're okay with it, I'd like to see your garden to the finish.'

'I'd like that too. The hard landscaping is finished and the planting is due to happen soon. Perhaps you'll come out and meet the gardener when she's working on it?'

'Let's drink to that,' I said, tapping my coffee cup off his.

After lunch, we sauntered around the square discussing the works of Oscar Wilde, my favourite being a short story of his I'd read as a

young teenager, *The Selfish Giant*. A possibly misremembered line from it had stuck with me: "The Giant loved him the best because he had kissed him."

I wondered aloud what was it in me that I had particularly related to that line. I wondered silently if it was that Mother had never kissed me and that my love of Mrs O'Reilly stemmed from the same beautiful sense of acceptance and love as expressed between the Christ-like child and the Giant. As I pondered these possibilities, we came to the flamboyant, memorial statue of Wilde, cheekily perched in a laid-back pose on a large rock at the corner of the park. Seán had passed it many times but hadn't known that its vibrancy was created from five types of natural stones. Neither did he know that Wilde's facial expression was different depending which angle you looked at it from.

'A combination as exotic as the man himself…' I told him.

On that note, Seán kissed me on the cheek and added: 'You have your different and exotic ways too, Martha. Long may it be so.'

He walked out the park gate and left me thinking it would be one hell of a lucky woman who would get him.

No regrets, Martha. No regrets.

I rang Mum.

'Are you in?'

'Martha! Yes. Why? How did it go?'

'Fine. I'm about a half-hour's walk away. I'll see you soon.'

'I'll put the kettle on.'

There was no sense of relief after having the honest conversation with Seán, only pangs of guilt but my mind replayed an awkward conversation of the previous day.

Fiona had arrived wearing the turquoise top I'd bought her and I'd felt chuffed as even she agreed that it suited her and Daniel had told her that it gave her pale face a lift. It felt like a good start but we had no sooner sat down to brunch when she cleared her throat.

'Mum, there's something I have to say. No interruptions please. Just hear me out. Ok?'

I nodded, feeling trepidation rising in response to her assuming her teacher voice with me. I bit my tongue to silence it and I chewed long and hard at my mushrooms on toast as I waited for what came next.

'Mum, we do want you involved when it comes to the baby…' she paused and rubbed her hand on her swollen belly. 'But we need you to accept, without comment, how we choose to rear them. We know you will have your own opinions but…we can't have you spoiling the child. A baby needs routine, and we will need you to accept this. Boundaries will need to be set and…and it will probably be best if you keep your opinions to yourself.'

That little speech had smacked me to silence as I examined my conscience for the possibility that I was an overly self-opinionated mother, who shoved her opinions down the necks of her children. I wasn't without sin but really, I was starting to think that Fiona was making a habit of chastising me before I'd even misbehaved.

I opened my mouth to protest my innocence but the fear of saying the wrong thing shut it again. I felt tears spilling out of my eyes and I squeezed them closed.

'Okay,' is all I said as I stood up to boil the kettle to make fresh tea to replace the fresh tea already in the pot.

My mum had spoiled all three of my kids, and often done things her way regardless of what my way was. I hadn't felt disrespected or undermined by Mum letting the children choose what they ate for dinner while I had always insisted that they ate what was on their plate, with the occasional side negotiations. Letting children get away with little things was, to me, a grandparent's prerogative – a granny's joy at being only responsible for their grandchildren on a part-time basis.

I couldn't recall Mum criticising me for how I reared the children but she had nudged me along in the right direction through occasional

observations, stories and her own actions. Her spoiling them had done them no harm; it had blessed them with a sense of unconditional love. Fiona had enjoyed Mum's undivided loving attention for more than two years until first Matt, and then Zara came along. Now, Matt and Zara had a close relationship with Gran, they called her regularly and met her for coffee, lunch or a walk, or called into her. Fiona had pulled back from these things a long time ago either by choice or because of work and other demands.

I wondered if she was jealous of the special bond Matt and Zara now had with Gran. Was it a sort of eldest thing? *Hey, I was here first…*

Gran did ring Fiona sometimes, whenever she could invent a good pretence of a reason to do so, but mostly, she said, she didn't like to bother her and wanted to let her get on with her own life. Perhaps I needed to reassure Fiona that Gran loved her as much as she loved the others. Perhaps I should have said more to Fiona yesterday about how I felt about what she was saying, how hurtful it felt to be getting a yellow card before the match had even started.

In response, all I did was say, 'Okay,' and 'I'll do my best.'

How much of all this would I say to Mum? Maybe just the bits about Fiona's firm boundaries and feeling put down and undermined as a granny, before the child had even been born. I knew Fiona would do things differently to me. I accepted that. She was my daughter but she was one ginormous generation removed from me. She was of the generation and personality that did detailed flowcharts for birthing plans. There was no room for the belief that *a certain amount of ignorance is bliss* that we had laboured under. I imagined Fiona had already drawn a second flowchart mapping baby's various expected developmental hurdles – a sure way of setting herself up for panic when baby had other ideas.

She'd missed a few hurdles herself along the way. Some developmental reflexes had lasted way beyond normal expectations and, she

had been teased when she stuck her tongue out when thinking; she went straight from bumming it along the ground to walking, skipping crawling altogether, and at first, when she walked, she fell over more than I might have expected, if I'd known what to expect, but against this she'd had a wide vocabulary and could curse in full sentences by the time she reached about twenty months.

I'd blamed her father for the cursing but I knew the phrases like 'I'm so effing tired,' were mine. And so, it had continued on up through her childhood where she won at board games but lost at ball games. It was the comparison with Matt's development that drove me to take her to an educational psychologist and from there to a paediatric occupational therapist who, following a diagnosis of dyspraxia amongst other things, had prescribed twice daily exercises which she reluctantly did with me.

When I got to Mum's apartment, Fergal opened the door with his jacket on.

'Martha darling, good to see you. I'm just popping out for a walk. Cathy says you might stay for dinner, so I'll see you then…' He gave me a quick hug as was his way.

'Has Mum despatched you off for some fresh air?'

'Ah, you know your Mum and me, I might need to stop off along the way to buy some bananas or such like. See you in a bit.'

I laughed, knowing full well there were no bananas to be had in Ryan's.

As I walked into the kitchen, Mum put a pot of tea on the table alongside some of her homemade banana and walnut cake.

'I hear you sent Fergal out to get more bananas,' I said. 'You used them all up in the cake?'

Mum raised her mismatched eyebrows.

'You know Fergal, he does like to catch the daily gossip in Ryan's. And at this stage of his life, a pint or two does him no harm and I get some peace and quiet.'

She poured a half-centimetre of milk into my mug and then her own and checked to see the tea cosy was pulled down tight on the pot.

'We'll let it sit for a bit.'

I pulled out chairs for each of us.

'Let's sit ourselves. I've the legs walked off me today.'

'Why didn't you get the bus here?'

'I needed time to think. You know how it is, walking helps me process.'

'Nice day for it and for a picnic in the square...How'd it go?'

'Well! We got a nice spot at a picnic table as the working people were leaving just as we arrived. And the food from Tiller & Grain was delicious as always; I had all the vegetable salads including red cabbage and carrot coleslaw with seeds, a mixed greens salad and another salad. I got Seán the same with—'

'Sounds good. I must try there some time.'

'Mum, I'm teasing you. I know you don't want to know what I ate for lunch!'

'Well, maybe not...But I do want to know how seeing Seán went.'

'I can't decide if it was better or worse than I'd hoped. I ended up being totally honest with him because, being the man that he is, anything else would have felt wrong.'

'Completely honest?'

'Mum, you should see your expression! Yes, I was completely honest. Right down to saying that I'd felt a connection of sorts with the man I rented the cottage in Sligo from but I didn't know where, if anywhere, that would go and that the one thing I know is I am not ready to settle...Anyway, we've agreed to stay friends...and I'm strangely optimistic on that front.'

Mum smiled and kissed me on the cheek. 'Goodness. That's more than I expected. You must be relieved.'

'I am sort-of, maybe relieved…on that front…But I had brunch with Fiona yesterday…'

'And?'

'And if I'm to be a participating granny to their baby, terms and conditions apply, and I've to sign a contract saying that I agree to said terms and conditions!'

'A contract to be a granny? Oh Martha, where did she get that from? Did she download it from the internet or something? What does it say?'

'It's not quite a written contract, but it may as well be, if you'd heard her. I'm not allowed comment or criticise their parenting; I'm to keep my opinions to myself – that part is almost reasonable even if having to shut up will be a challenge at times. But worse, as a granny, I have to fully comply with how they wish their baby to be raised – stick strictly to routines, no spoiling the child, and so on, and so on.'

'Interesting…'

'Interesting isn't the word that comes to mind. How can I be a proper granny if I've to do everything according to their parenting rule book? What do you bet that every time I see the baby, it will come with an instruction manual and sheets with boxes to be ticked for every pee and poo it does!'

'Possibly it will.'

'And you think that's okay?' My frustration was increasingly coming out in the tone of my voice, but I couldn't help myself.

Mum gave a short laugh, stopping herself probably because I was wearing my it-is-not-funny expression.

'Sorry for laughing. It's just that you used to give me long written instructions when you first left the children with me—'

'That was different, Mum. They were guidance only. I didn't expect you to follow them to the letter.'

'And I didn't. I only looked at them as I deemed necessary. As Fergal always says, when all else fails, read the instructions.'

'And with each child, the instructions got shorter, because once you've assembled one Ikea flatpack, you've got the gist of what's required and you fully expect to have a screw or two left over!'

'I've never assembled an Ikea flatpack, that's Fergal's department…Fiona's just nervous. That's all. And you were a bit of a super-mum; you were holding down an important job and yet always doing so much with them, not least Fiona, including those twice daily exercises with her that the occupational therapist prescribed.'

'I was just remembering them. Twice daily *arguments* more like, until a friend and fellow mother mentioned that, as parents, we have to choose our fights and thankfully, with the O.T.'s help, I found a less confrontational approach.'

'You learned as you went along…'

'And what you're saying is Fiona will learn too. But in the meantime, I'll have to learn to zip it…' I pulled my thumb and fore-finger across my lips.

'Martha, I've witnessed you bite your lip many times, you'll be fine. Just be patient and let it evolve.'

'I'll try. I will. It is just, I feel hurt that she has so little faith in me. Do you know what she said as she left? 'I'm so glad we had that chat. We do want you to be involved as a granny, but I needed to know that you'd accept our boundaries.' Bloody boundaries, I thought. I mean, who wants all their relationships fenced in by boundaries?'

'Martha, Martha, maybe she's teaching kids about boundaries at school and it's become her thing…I don't want to break any confidence, but when Zara went over to cook brunch for Fiona and Daniel, they may have set a few 'boundaries' for her too.'

'Hmm. I guess Zara won't be able to take the baby out on a climate protest any day soon so! Maybe I should set some boundaries of my own.'

'Absolutely, you should; I did.'

'You did? Like what?'

'I insisted you had a regular night-time babysitter and that we would only be your emergency back-up, apart from for the few weekends when you went away.'

'I'd completely forgotten that. There must have been a lot of emergencies given how often I remember that you minded them I think my memory may be getting more selective...'

'Mine too, but I'm trying to pretend otherwise!' Mum looked at her watch. 'Fergal is cutting it fine. Dinner is at 7 p.m. or its beans on toast for him.'

With that, we heard his key in the door, followed by a jovial, 'Good evening, ladies, I hope I'm not disturbing a good chat.'

'Not at all, Fergal. But I'm afraid I can't stay, as I promised Matt we'd have dinner together so he can fill me in on how he got on with Stephen in Sligo.'

# Chapter 29

## Lion King

When I walked into the kitchen, Matt was standing at the counter munching his way through a leaning tower of slices of toasted sourdough bread smothered in peanut butter. Chuckie sat at his feet, staring upwards in anticipation of the occasional tidbit. He barely glanced my way; food was far more interesting.

'Mother, dearest, what sort of time is this to be coming home? Did we not have a date?' Matt said as he threw a chunk of toast in the air and Chuckie jumped to catch it.

I looked towards the pile of toast.

'Did you not get my text? Gran sent me home with a few helpings of your favourite, homemade, moussaka made the traditional way – and it's still warm…it just needs a boost in the oven.'

'Ah sure, this is only for starters. Got to bulk up and workout to keep my place on the team, especially if Stephen continues getting himself in shape at such a pace…'

'You might consider laying the table, unless you intend to solely feast on that pile of bread and butter.'

'Not any kind of butter, I'll have you know; organic crunchy peanut butter.'

'Which I seem to remember Zara bought before she left and hid from you at the back of the cereal cupboard.'

'Mum, the back of the cereal cupboard hardly qualifies as a hiding place!'

'I don't know, Matt. Half the time you can't find your keys or your phone under your own nose but when it comes to food, you'd sniff it out a mile away.'

Matt stopped short of licking his plate after he wolved his way through a double portion of Gran's moussaka.

'Gran's a great cook, isn't she? Tis a wonder she didn't pass more of it on.'

'Perhaps she did, if you cooked occasionally, you might surprise yourself.'

'As you always say, Mum, why have Chuckie and bark yourself; as long as I've got you, why would I cook? Simple logic really! Anyway, I was only messing. You're the best, you really are.' He tilted his head and flashed his mock, doting, angelic-son smile.

I shook my head. 'One of these days, Matt. One of these days…'

'One of these days, I'll come home to an empty fridge and freezer and all the takeaway joints will be closed.'

'Exactly…And, how were things with Stephen?'

Matt paused and wrinkled his face acknowledging my change of subject. 'Not so bad. We kicked ball for a bit before we sat down with Tracey. He's struggling with what he did, the whole guilt and letting people down thing…how's he going to face the past and all that crap…On and on he went, putting one barrier then another in the way of himself.'

'Well, it is a shitty past to have to face, especially when he doesn't actually know all of what happened…'

'Change is good', I told him. 'But not easy.' I whacked the ball straight at him and hit him right where it hurt. 'What the eff was that for?' he yelped. And I laughed and waited for him to remember…' Matt paused and looked at me.

I smiled. 'Lion King,' I said and in my best Rafiki voice I added, 'It doesn't matter, it's in the past.'

'Yeah, but it still hurts,' Stephen responded, finally remembering.

'Oh yes the past can hurt,' I replied, still trying to sound like Rafiki. 'But from the way I see it, you can either run from it, or learn from it.'

'Just what Stephen said before he whacked the ball straight back into my belly. And I doubled over with the pain of it. 'Bit of fucking learning still required there, Matt,' he said.'

I grinned remembering happily watching *Lion King* with them on more than a few occasions. The children and I had often played out Simba's and Rafiki's exchanges about the past, wrapping it up by singing an out-of-tune rendition of 'Hakuna Matata'. Stephen had been known to witness and participate in some of these exchanges.

'Just like when you were young,' I said. 'But with a bit more colourful language!'

'Yeah. Maybe. Anyway, it was fun and it seemed to register with him. I told him about his grandad dying and that made him sad but he admitted his grandad had always been a grumpy git. He was relieved to hear his folks moved in with his granny when she asked them to – he loves her – and is glad that it wasn't his fault that the family had moved house…He cried like a baby when I told him how his sisters are dying to see him, and that they've long since forgiven him. It was hard to watch him cry, to be honest, Mum.'

'I bet it was, but it's normal and better out than in, as they say.'

"I've turned into a fierce sap,' he said. 'But watch me when I get back on the pitch, there'll be no more sap then!" Matt rubbed his own face with both hands. 'I've never seen him cry before in all the years I knew him…Tracey said not to worry, it will pass when he's ready.'

'He cried with me too. You'd want to hug him tight and squeeze the tears out of him. Will he see his sisters or family while he's there?'

'He said, not yet, it's too soon, not until he's sorted in Dublin, and able to have a proper conversation without blubbering endlessly. But Tracey said it might be good for him, maybe in a few weeks' time, when he has processed a bit more.'

'What did he say to that?'

'He said, yes to his sisters, maybe, but not his parents though as they want nothing more to do with him…And that they're right after all the shite he caused them.'

'From what Susie and Sadie said, he might be right about his folks…for now anyway.'

'Tracey said one step at a time…'Matt and Martha are on your side and they believe in you…you can do it."

'She's seen it all before I suppose and understands his vulnerability…It wasn't easy for him growing up in that house…'

'Don't I remember it well! I never felt comfortable there…I'll say one thing though…'

'What?'

'It made me appreciate our home. The way you were always looking out for us. And Stephen too.'

'Hmm. We were alright, most of the time, until we weren't…'

'Until there was a car crash of events.'

'Yeah, and do you know, Matt? If I'd it all to do again, I'd have taken HRT sooner. And maybe, just maybe, I might have asked your dad to leave sooner too and not waited until that stupid dinner party…'

Matt looked at me and put his hand on mine which was resting on the table. 'Yeah, maybe, but we always knew we were loved, even then. Stephen didn't have that at home, you know? Not ever.'

'So sad for him…You know the way Stephen's parents were often out drinking?'

'Yes, always.'

'Do you think they were alcoholics? You know, functioning alcoholics?'

'Hmm, I never thought about it like that…Maybe. Poor Stephen.'

'We'll look out for him. We will. He deserves to be loved even if he doesn't believe it.'

'He might relapse, go back on drugs, you know…'

'Yes, relapse is a normal part of recovery; it is best we expect it.'

'Mum,' Matt shook his head and laughed. 'I told you they'll be giving you an honorary degree in addiction studies any day soon.'

'Haha. Where would that get anyone? Theory is one thing, dealing with Stephen's reality will be another.'

# Chapter 30

## Sligo Plans

Stephen used his weekly fifteen-minute Wednesday phone time to call me a couple of weeks later.

'Matt had better watch out. I'm working out in the little gym here and running on the sort of track around the perimeter every day too.'

'Fair play, Stephen.' One addiction replacing another, could be worse.

'I'm already running ten kilometres according to the Garmin Matt lent me. At a crap pace but…'

'Good for you. I hope you're eating plenty too.'

'Don't worry. I've a diet plan sorted. Turns out I haven't forgotten everything I learned in college. And as the rest of them here could barely boil an egg when they got here, I'm helping with teaching them the basics, like how to roast a chicken and potatoes.'

'Stephen, I am impressed.'

'Eh Martha?'

'Yes.'

'Before I get kicked off the phone, can I ask you something?'

'Sure, fire ahead.'

'Not this Sunday but the week after that, Tracey suggested I ask if maybe you and Zara could come and visit. Tracey said we might talk about my sisters coming to visit at some later date. Matt was saying

Zara has been talking to Sadie. I know you both may have something on that Sunday but...'

Stephen was speaking at such speed that I couldn't get a word in. What a contrast to the Stephen I'd met months previously.

'Sounds good. I can't think of any reason why I won't be able to make it that Sunday and Zara's due home this weekend and I can find out what her plans are...'

'Thanks Martha, you're the best.'

Now what? I thought. Another reason to go back to Sligo. Do I go up and down in a day or do I plan to stay overnight? If I stay overnight, where will I stay? Eamon and I had exchanged many texts and the thought of seeing him both thrilled and unsettled me. But if Zara was with me that would be too awkward. Best to plan to drive up and down in a day.

Zara responded promptly to my message.

**That would be massive. Let's ask gran to come too and make a weekend of it. Gran is dead keen to go back there so promise you'll ask her.**

Shit. Massive is right. Massive for all of us, not least Mum. Her first time back in nearly sixty years. I couldn't go up and down in a day if Mum was coming too. I'd need to book some rooms in a hotel.

'Mum, there's no pressure now but if you'd like to come...'

Zara, Mum and I were sitting at Mum's kitchen table on Saturday evening eating Zara's favourite vegan dishes from Little Jerusalem. Fergal said he'd let us eat vegetables and he'd eat meat at Ryan's.

On Thursday, I'd told Mum about Stephen's call and Zara's response; I'd suggested she talk to Fergal to get his thoughts.

'Zara and I have a plan,' Mum said with a pleased with herself smile. 'You know it would be a long old journey for me to be sitting

in a car, so I've decided I'll use the free travel and get the train to Sligo with Zara as my free companion.'

'And?'

'And we were thinking…' She glanced Zara's direction. 'You might go down on Friday and collect us off the train on Saturday. Matt said he'll leave us to the station here.'

Mum contriving a plan that left me with a possible opportunity to meet up alone with Eamon wasn't lost on me.

'You have it all planned so…'

Mum beamed. 'Seems like a good plan to me. I was thinking that if your friend Eamon's cottage is available, we could stay until Monday or Tuesday, depending on how things go…'

Heat rose to my face. 'But Mum, I haven't asked Eamon. I thought we'd stay at a hotel. There are plenty available.'

'Oh Martha, hotels are so expensive and at this stage of my life, self-catering suits me much better.'

'Come on, Mum. That cottage by the sea sounds class. At least ask him,' Zara added.

How much had Mum told Zara in order to prompt that comment?

No pressure, Martha, no pressure, I told myself, desperately trying to think of ways to back out of the dilemma they were shoe-horning me into.

I hadn't told Zara about my possible feelings for Eamon, or his for me. Surely Mum hadn't told her either. How would that go down with her? We're not even an item of any sort and it would be madness to throw him straight into the full scrutiny of my protective mum, not to mention a possible unsettling reaction from Zara. And then, when news made it to Dublin, hormonal Fiona.

Oh help!

I reminded myself that I was a well into being a middle-age woman, and Eamon a middle-aged man. We'd both been through plenty. Be

brave, be vulnerable, I told myself, in between thinking of all the reasons to book a hotel.

I had started reading Nancy Mitford's, *Love in a Cold Climate* when I was down in west Cork but had got distracted in Sligo and had made no progress since. That night I picked up the book as a hopeful distraction from my thoughts. Marking my page was the neatly folded A4 sheet I'd stuck on the fridge in the west Cork. I opened it up and read Trish and her nana's succinct advice as I'd written it that day in Cork:

*For fuck's sake Martha, what are you pissing yourself over? Just effing do it. . .*

*You'll rarely regret what you did, but you'll often regret what you fucking didn't do!*

Trish was speaking from the grave, as was her way. I sent a text to Eamon the next morning outlining Mum's plans. I could see his happy face as I read his prompt reply.

**Now that was a text to put a smile on a man's face. I'm delighted to say that the cottage is free from Saturday to the following Saturday. On Friday night, I hope you will feel comfortable staying here. I will make up one of the spare rooms. It will be great to see you, and Chuckie too of course. We might even manage a swim on Friday night, weather permitting.** 😄

That wasn't so bad, I told myself, feeling a smile on my own face. I sent a message to Zara and Gran to say that the cottage was sorted.

I was feeling a bit tongue tied over breakfast the next morning as I tried to work out how to mark Zara's cards about Eamon.

'Meet anyone nice on your placement?' I asked.

'Yes, I told you. They were all nice.'

'I know that. I meant anyone in particular?'

'Possibly. Maybe. Don't go jumping to any conclusions now. There was this really sound guy, Oisín, who was so easy to talk to, but, I don't know…I guess it felt too soon…after…you know.'

Her voice was quiet as she spoke and her eyes dreamy.

'Ah Zara, that's a good start. It will take time to process what Simon did to you.' I hissed his name.

'It's a wonder Oisín didn't run a mile from me. He put his arm gently around me one night when we were hanging together, just chatting like. I jumped and pulled away and Oisín was killed apologising that he hadn't asked before he presumed to put his arm around me. I told him he wasn't the problem; it was me…' She paused and stared into space and then continued with tears in her voice. 'I ended up telling him what had happened…He was so understanding. He said something similar happened to his sister with a so-called friend of hers. He would have throttled the guy if his sister hadn't begged him not to!'

'Oh Zara, it must be more common than we'd like to think. I'm glad you felt comfortable enough to talk about it.'

'It just happened. And it was a relief to say it to him. Before I told him, I felt it was obvious, like I was wearing a sign that said, 'Beware, messed up girl!''

'Ah pet.' I squeezed her hand. 'Is Oisín one of the people you're meeting up with tonight?'

'Yeah. Might come to nothing though.'

'You never know unless you give it a shot…'

'I was asking Gran about this Eamon friend of yours. She said you met him on jury service and then you *happened* to rent the place in Sligo from him…' She watched me for a reaction, with a hint of a smile on her face.

I didn't let her down. My face reddened and I spluttered my words. 'It was nothing like that! It was pure coincidence that I ended up renting his place from him. He was as surprised as I was.'

'Hmm. Is he your *anyone-in-particular?* Gran wouldn't say, but she didn't say he wasn't either.'

I felt the back of my teeth with my tongue and chewed imaginary cud before speaking.

'Maybe. Possibly. Bit like yourself, Zara. It feels too soon. And on top of that, I'm not sure I want to be tied to anyone in particular, yet anyway. We'll see…And he may run a mile when the three of us descend on him!'

'Mum, you've gone beetroot.' Zara laughed.

I brought my hands up to my red-hot face and looked at the ceiling.

'Well, it's very warm in here with the oven on and the sunshine beaming straight down on me through the skylights.' I got up to clear our bowls.

'Very warm,' Zara said with a note of gentle sarcasm and a shake of her head.

'About us visiting Stephen,' I said.

'Yes?'

'Do you think you should talk to Stephen's sisters before we go? Test the water again, so to speak.'

'Way ahead of you, Mum. I'm meeting Sadie in DCU tomorrow. Both she and Susie both play basketball so it will depend, but I think the season is over now.'

She remained sitting at the table and I went up behind her and wrapped my arms around her and kissed the top of her head.

'You're a star, Zara. I love you.'

She crossed her arms on top of mine. 'Thanks, Mum. I love you too.'

On Friday morning, I took Chuckie for a short walk and then headed off to Sligo, stopping in Rooskey as I had on my way to Mrs O'Reilly's funeral. I sat in the sunshine at a picnic table by the river and marvelled at the shift in my trepidation from that earlier trip. This time, I was nervous too but it was a giddy anticipation. I was glad to be travelling alone, except for Chuckie, and not to have to keep in check the ridiculous smile that no doubt spread across my face with every thought I had of seeing Eamon.

As I drove slowly along the grassy track to An Teach Mór Cois Farraige, I had the feeling of arriving home. I told myself I'd no right nor reason for such a feeling.

Getting ahead of yourself again, Martha. Is this what happens when women of a certain age go on HRT and think they may be falling in love or something?

I opened the car windows wide and breathed in the fresh country air: a pleasant hint of fresh cut grass, but no stink of slurry, thank goodness. Harry was on the front door step, sitting in that regal way he had. His ears picked up and he leapt off the step and gave a few deep barks. I had barely pulled up on the gravel near the front door when Chuckie did something he'd never done before, he leapt straight out the back window. Harry and he danced around together, sniffing each other from end to end, nibbling each other's necks and backs. I stepped out of the car laughing at their antics. I heard footsteps on the gravel behind me and turned to see Eamon striding towards us.

'Someone's glad to see someone,' I said looking at the dogs.

Eamon took my hands in his.

'Someone is very glad to see someone,' he said and leant forward and kissed me on the cheek, pausing there long enough to send electric currents to far flung places.

I gave a girly giggle.

'Reciprocated,' I said, closing my eyes to embrace the bliss of the moment.

I felt his lips touch mine with a gentle pressure, and I held my breath as he put his arms around me and lifted my feet off the ground. We chortled like children as he squeezed me tight, and I nuzzled my face into the side of his neck and brought my lips to the soft skin between his neck and shoulder. After a few moments, he lowered me back to the ground and held me at arm's length.

'Martha, have you any idea what you do to me? I feel like a teenager. It's ridiculous. And magical. And heavenly.'

'Feck it, Eamon. I might have more of an idea than you think. It's all those things…Who'd have thought, at this stage of our lives? It's mad!'

He put my weekend bag over his shoulder and grabbed the large fridge bag jammed tight with meals that Mum had cooked. I grabbed the last bag from the boot: Mum's weekend bag.

'That's it really,' I said.

He took my free hand and held it tight.

'Scared I'll run off on you, are you?' I asked.

'I'm not taking any chances.' He winked. 'Welcome to my humble abode. Mi casa es tu casa.'

'Muchas gracias.' I squeezed his hand back.

We split the food between the fridge and the freezer, then sat down on the old couch in the corner of the kitchen; sipping mugs of herbal tea, our legs intertwined and our bodies snuggled into each other.

'Martha, you've had a long day. Do you need a rest or anything?'

'Hmm, let me think…I might need a rest,' I said with a certain giddiness as I disentangled my legs from his. 'But. I've forgotten my hot water bottle, and I'm looking for a good alternative…' I stood up and reached out my hand to him.'

'Are you sure?' he said with loving concern.

'I'm sure,' I said, suppressing the feelings of nervousness taking hold.'

He took my outreached hand and his eyes locked on mine and it was as if we'd created our own power circuit, excitement pinged around my body as I pulled him off the couch and he led me upstairs, stopping along the way to kiss me gently beside my ear, his breath warm and tingly.

It was all I might have hoped for if I had dared to think about how it might be. Afterwards, still in a state of awe at how blissful it had been, I lay with my shoulder tucked in under his arm with my head resting on his chest, the hairs on it tickling my face.

'Was that okay?' he asked quietly.

'Better than okay…much better at every level,' I said with a happy sigh. 'I knew I wanted to but boy, did I dread it.'

'You dreaded it?'

I laughed. 'The last time I was naked in front of a man other than my husband, was well over thirty years ago, and this body is showing a lot of mileage and added flab since then; of course I dreaded it!'

'I think of your body, Martha, as like a classic vintage car, it has beautiful curves and a much nicer shape than any of the current models…Sorry. That's probably a very corny and unflattering comparison, actually.'

'Haha. I'll accept the comparison on the assumption that you like vintage cars?'

'I do. I've one in the coach house out back. Bought as part of my mid-life crisis.'

'Really? What have you got?'

'An MG Morgan. I'll give you a spin in it sometime when the sun is out if you're up for it.'

'Sounds like a plan! And is it red with a soft top?'

'Absolutely.'

'I can relate to that!' I tapped my head.

Eamon laughed. 'I'd say you've the panache and spirit of the Morgan, alright.'

I smiled and my face turned a deeper shade of red. It was a long time since I'd had such sexy compliments, especially a long time since I had ones that I felt were genuine and that I wanted to hear.

'Thank you, I think you bring out my better spirit. It feels easy…natural, almost as if we've known each other before, or something.'

'I was thinking the same thing after you left. I think we were here together before. This house felt almost like home from the moment I saw it, but something was missing. When you're here it feels more complete.'

'Today, when I turned onto the driveway, I felt like I was coming home and I pinched myself for getting ahead of myself.'

'It just feels right, doesn't it?'

'Yes, but when we step off this land, will it still feel like this? Is it like Tír na Nóg and when we leave Cois Farraige, will what we have turn to ash?'

He took my hand, held it firmly and brought it to his lips and kissed it.

'As long as I hold your hand, we will be as we are now, I promise. It is all in my magic powers.'

Later, I wondered at the depth of our connection, was it a reflection of the journeys we'd taken? That we'd faced traumas and learned from them. I could see parallels in our traumas and our responses, that we had grown in depth and understanding from them, that along the way, we acknowledged our own shortcomings and had learned greater compassion and tolerance. Was that why we got each other? I suspected that if we'd met twenty or thirty years previously, we would not have been so compatible.

'When you said your Mum had made Thai vegan curry, I didn't like to say I'd a big pot of it made for tonight and for whoever wants it over the weekend.'

'No pressure, Eamon. No pressure at all.' I laughed. 'Mum prides herself on her authentic Thai green vegan curry and I'm not sure you want to go straight to a cook-off against her!'

'No way. That would be a shaky start.'

'Let's eat yours tonight and freeze the rest for another time. You wouldn't stand a chance. Zara and Mum are like that.' I held up my hand with my index finger and middle finger glued to each other.

'I like them already. Without them, you might have gone and stayed in a hotel.'

'I know. Like I said, together, they're formidable.'

'And your mum is a hopeless romantic…'

'No, the older she's getting, the more she's a hope-FUL romantic – despite the cards she was dealt early in life.'

'My Thai curry tonight, so?'

'And Mum's tomorrow night.'

'No pressure.'

'Our secret.'

'Will we be keeping many other secrets over the weekend,' he said after a long kiss.

When I came up for air, I replied, 'As grandad, on Patrick's side, used to say, 'Let's play it by air!' I bet Mum will spot us from a mile, but with Zara, I think we should pretend we're still at the will-we-won't-we phase. No gazing dreamingly in my direction, and no touching…'

'Now that's proper pressure!'

The spare room he'd made up went unused that night which was fortuitous as we woke to a text from Eamon's daughter, Shauna, to say

that she had got a free train ticket from a friend and was getting the same morning train down as Mum and Zara.

'No pressure,' he said.

'What have you told her?' I asked.

"That I met a wonderful woman and that I'm confident that she will approve. However, I didn't tell her you were coming down for a few days…Whoops! I think I better text her to mention that the same wonderful woman, her mother and daughter will all be here.'

Her response was:

**Ffs Dad. I wish you'd told me and I wouldn't have come! I might take the next bus back to Dublin depending...**

We laughed at the double standards of how our adult children felt we should keep them informed of anything that might possibly affect them, but they didn't see fit to inform us until they were on the way to visit.

We travelled to the train station separately not knowing how things would unfold. We deliberately stood apart but I nodded Eamon's way when I saw Mum get cautiously off the train, careful not to slip on the steep steps.

She was quick to spot me and waved enthusiastically. She glanced back as Zara came behind her, too engaged in conversation with a young woman of similar age to notice us.

'Zara,' I said quietly in the direction of Eamon.

'Shauna,' he replied.

'Oh!' I said as I walked towards Mum.

'Turns out your Eamon's Shauna and our Zara are good friends - fellow eco-warriors, comrades on the fields of environmental strikes and all that.' Mum said by way of greeting.

I laughed. 'That's hilarious.' I gave her a warm hug and a kiss on her cheek.

'I hardly got a word in edgeways. Two delightful girls. What fun! I didn't feel the journey.'

I turned to introduce her to Eamon to find the two girls and him bursting with laughter.

Eamon put out his hand towards Mum. 'Very pleased to meet you, Mrs—'

'Mum hates being called Mrs…She thinks that's for old people!'

'Eamon, call me Cathy. Then I get to pretend I'm no older than the rest of you.' Mum took his hand and held it firmly. 'Good to meet you too. Now, an important question, are we all going to Austie's for lunch on this fine day?'

'I believe you and Zara had that included in your plans…' I said, deliberately not adding that I'd understood their plan was for the three of us to go. I turned to Eamon to see what his response was.

'Really I should go back and finish cleaning the cottage for the next guests.'

'Oh, that can wait, we're not that fussy and these young ladies can surely help later.'

'Hard to say no to lunch at Austie's. What do you think, Shauna?'

Mum was uncharacteristically quiet as we drove through Sligo town, tut- tutting and mumbling about the various shops that she remembered that had disappeared or were boarded up, a few were replaced by the now common proliferation of cafés or foodie stores.

'It feels so dead relative to how I remember it…where is all the life and youth gone?'

'At home, on their phones arranging prinks before they go to the pub?' I suggested.

'Mum,' Zara addressed me, but Gran interjected by raising her hand as we were just passing the bank where she and Dad had met.

I slowed down to a near halt, taking in the sad, grey building.

'Oh, dear. Oh, dear. That's where it all started. Hard to imagine. If it wasn't for that bank, we three wouldn't be here now…' She dabbed at her eyes with a hankie.

I touched Mum on the knee and Zara put her hand on Mum's shoulder and left it there. A motorist behind us beeped.

'It's not the Sligo I remember, it's not it at all…And what's this road doing here, where did it come from? It makes no sense.'

'It's some class of a ring road. I think it was planned by committee and in an effort to please everyone, but it pleased few and achieved less.'

'A committee of men, no doubt! Your dad would not be impressed. His beloved Sligo decimated.'

We were stopped at traffic lights at a convoluted, wide junction. I put my hand on her knee again.

'There's still the sea, Mum. We'll take a walk on First or Second beach after lunch.'

Mum didn't answer. I could see her trying to compose herself, trying to fight her tears.

'I know, Mum. I know. I cried too. It's hard to come back.'

We drove out along a few kilometres of the road to Rosses Point in silence.

'That's the hotel I stayed in for Mrs O'Reilly's funeral. Zara, it used to be a small family hotel. I didn't recognise it from the photos when I booked it. All changed now.'

Mum shook her head in disgust in the direction of the hotel. 'All changed, changed utterly. A terrible eyesore is born.'

'Ah Mum, it's grand actually…But still, Yeats might agree with you.'

Eamon and Shauna were sitting at an outside table when we got to Austie's.

'Will this do?' he asked, standing up to pull out a chair for Mum, giving her a view of the estuary and the islands.

'That will do nicely,' Mum answered. 'One of my favourite views. My friends and I had some great nights here in Rosses Point, back in the days before drink-driving was a thing.'

'Gran, you didn't actually drink and drive, did you?'

'Goodness, no. I didn't have a car then.'

Zara put her arm around her Gran. 'Is there anything else you need to confess? Any stories you'd like to share with us?'

'There might have been the occasional twilight walk on the beach or even a tour of some of the bunkers on the golf course without the benefit of a sand wedge…' Gran winked mischievously.

Zara roared laughing and the rest of us followed with more restraint.

'Gran, I love you. I want to know more.'

Gran tapped her nose. 'Enough for now already. Let's order. I'm having the prawn cocktail if they still do it the old way…and chips too please.'

After lunch, I took Mum and Zara on a tour of Rosses Point: the good, the bad and the ugly. On our short walk on First Beach, Mum took in the shock at how diminished the cliffs were. The three of us sat together on rocks that would have been buried deep at the base of them back when I was still a girl in little dresses. We stared out across the soothing ocean and I wondered if we all saw the horizon the same way.

'Your Dad and I used to sit on the cliffs in the dark and light of night, contemplating life's possibilities and all that might lie beyond what we could see or imagine. Now, he's long gone and so are the cliffs. My goodness, the transience of things we think will last forever…'

Zara and I lent in close to Mum and put our arms around her.

'Martha, Zara, treasure all that is good in your lives. Savour it in the moment. All things pass. Acknowledge the shit - and there *will* be shit – but deal with it and let it go. When I think of your grandad, James, I don't dwell on the horror of losing him, and then losing you, Martha. I think of the good times we have had: the conversations, the intimacies, the laughs, the shared tears too…' She sniffed and started rummaging in her bag.

I pulled a pack of tissues out of my backpack and put a couple in her hand. 'Mum, I came prepared. Plenty for all of us.' I wiped my own eyes and offered the pack to Zara who took one gratefully.

'Shared tears, Gran, are the best kind of tears. Aren't they?'

Gran looked at her and then me through her wet eyes and squeezed us close. 'Aren't we the living proof of it?'

An unrushed silence sat with us, broken by the occasional quiet sniffle.

'Do you think we could visit your dad's grave please, Martha? I've never been, and I'd like to…'

'Of course, Mum. It's been forever since I was there myself and I'd like to go too.'

How will it feel for Mum to see the grave? God, I hope the gravestone won't say 'and his beloved wife.'

The three of us stood looking at the crumbling little Church of Ireland church and I remembered all the slow, painful-on-the-ears hymns sung badly to the accompaniment of a bad excuse for a record player; there had been no one to play the organ amongst the small congregation.

I took Mum's arm and said quietly, 'The gravestone, it's going to have her name on it.'

'I know, Martha. I thought of that. But it will have his too and I'd like to pay my respects to him.'

Zara linked Mum's other arm as we walked to the back of the cemetery where Dad was buried. I expected a sad, forgotten looking grave with more weeds than gravel but all was clean and the gravestone was bright as if freshly polished.

Margaret, I thought, probably Margaret.

I stood and read no extraneous words: two names, James Hyland, Heather Hyland, each followed by their dates of birth and death.

Mum kneeled and blessed herself and I heard her say a speedy Our Father and a few quick Hail Marys.

A decade of the rosary perhaps; you wouldn't hear many of those around here, I thought. I joined in her second Our Father, and Zara looked at me with surprise.

I shrugged.

It was for Mum, and for Dad too. Zara lowered her head and stood still until we were done.

'That's your Grandad buried there,' Mum said as Zara helped her off her knees.

'Yes, Gran. It's strange, isn't it?'

'It is pet. It is. He wasn't perfect, you know. But he was a good man. They were different times, pet. Don't judge us by today's ways.'

'Don't worry, Gran. I won't. I understand better now than when Mum and you first told me.' Zara put one arm around Mum and one around me. 'You guys didn't have it easy, that's for sure.'

She turned and looked at me.

'I'm sorry, Mum, that I judged you so harshly when you told me your family story. I didn't understand.'

The three of us hugged each other close and tears flowed again.

'Your Grandad wouldn't know what to do with us,' Mum said with a sniffle. 'He couldn't handle women crying. He'd want to run a mile.'

'Pity for him,' Zara said. 'There's no escaping us now from where he's lying.'

# Chapter 31
## Everyone Has Their Own Shit

Dinner that night was vegan lasagne, made by Mum with some of Eamon's fresh leafy greens on the side.

A couple of glasses of wine in and Mum had lost all her filters; Eamon and Shauna got a full interrogation. I tried to bat a few questions away, especially when Mum asked Shauna about her mother, but I got ignored. I decided it was because they were enjoying themselves.

Zara wasn't shy about throwing in her tuppence worth either, and the topics ranged from the environment, to politicians' ineptitude, and then to men and their lack of respect for women. I got nervous on Zara's behalf when the latter topic heated up. She spoke fervently and I expected that it would be obvious to the others that there were personal reasons for her passion.

'Hey, go easy,' Shauna said. 'There's only one man here, and he's a good one.'

'Most men are decent,' I said. 'But the gobshites stand out because of their gobshitey behaviour.'

'I've known a few gobshites and seen them in action and as my daughters pointed out to me, I've been guilty of doing nothing about them.' Eamon said.

'You're doing fine, Dad,' Shauna said, giving him a sideways hug.

'Maybe I'm fine now, but I hope the men of your generation won't be as quick to turn a blind eye to what some men do to women. I wish I'd been less of a bystander and spoken up when certain men, managers and partners alike, manhandled women as they queued for a drink in the pub after work or suchlike.'

'I hope so too. It was no different where I was,' I said. 'I tried talking to a female partner about a male partner who was always feeling my legs under the table, but I was silenced by *her*...'

'The likes of Shauna and Zara won't put up with half of what we put up with,' Mum said.

'Too right, Gran.' Zara said. 'Firm boundaries will be set. We will not be silenced.'

'My one big concern for your generation is your drinking and drug use. How do things like consent work when one or other of you is out of it?' Eamon asked, apparently forgetting in that moment, what I'd told him about Stephen, and genuinely oblivious to how sensitive a topic that was for Zara.

'That's where it gets messy,' Shauna said. 'The consent police in the student union would have us text consent every time we engage with each other, if they could. I think that's a bit of a passion killer! Don't you think so, Zara?'

Shauna was sitting beside Zara and she put her arm around Zara's back and pulled Zara to her as she addressed her. The gesture unsettled me. Apart from the sensitivity of the topic, I thought there may have been something sexual in it. Zara wriggled in her seat, looked at me, her face scrunched tight with upset. I felt compelled to speak.

'Passion or lust or whatever you want to call it is no excuse for forcing oneself on anyone, even if that person is your girlfriend, partner or lover. Consent always matters, especially after a few drinks. If someone says 'no', it doesn't mean 'maybe'. And if someone's out of their head on drink or drugs, by definition, *and* in the eyes of the law,

they *cannot* give consent freely. New laws are coming that will make explicit consent more important, to both protect people from unwanted sex and others from false accusations.'

Speech over, I looked across the table at Zara who was sitting with her head bowed tight to her chest. I'd said too much and felt the need to hit pause. I started to stack all the plates near me. Mum looked at me knowingly and stacked a few on her side of the table and passed them towards Eamon. Eamon and I stood up and brought our piles over and put them on top of the dishwasher.

'I'm sorry,' Eamon said quietly, touching me on the elbow.

I looked at him and whispered, 'Touchy subject, I'm afraid.'

But Shauna hadn't got the message and wasn't finished.

'Are you saying that even if you're in a relationship and in the heat of passion, so to speak, that there should be a pause in proceedings to get a clear statement of consent? That seems *waaay* OTT to me.'

She looked again towards Zara whose head was still bowed as she focussed her attention on twiddling her fingers and thumbs.

Mum coughed loudly.

Eamon looked directly at Shauna. 'Consent is a very complex topic, Shauna. The older I get the more I realise that very little is black or white, especially when it comes to sex. And I agree with Martha, passion-killer or not, it's best to seek clear consent and remember 'no' doesn't mean 'maybe.''

Shauna looked up at her father, raised her darkened, dramatically-shaped eyebrows and rolled her heavily mascaraed eyes.

Eamon shook his head at her and she stood up from the table, scrapping her chair loudly on the floor.

'I'm done,' Shauna said, and made towards the door but after opening it she seemed to do a rethink. 'The lasagne was lovely, Cathy. Thank you. Good night.' She disappeared out the door and pounded her way up the stairs.

There were quiet mumblings in response, no doubt unheard my Shauna.

'Would anyone like an after-dinner drink?' Eamon asked. 'Cathy, would you like tea or something stronger?'

'Tea please, Eamon. The wine has gone to my head.'

After drinking her tea with unusual haste, Mum stood up.

'It's been a long day,' she said. 'Thank you, Eamon for hosting us. I think I'll hit the bed while I can still walk.'

'I'll go with you, Gran.' Zara said, jumping up from her seat.

When they left, Eamon looked out the kitchen window. 'It's turning into a beautiful sunset; shall we go for a swim?' he said.

After a quiet swim, we sat on our rock and he made to put his arm around me.

'May I?' he said. There was no sarcasm in his voice.

'Yes, of course. I'm sorry. I'm not as pedantic about it as I probably sounded earlier.'

'I know you're not and I'm sorry how things unfolded. I shouldn't have asked that question about drink and drugs and consent. And I should have stepped in sooner when things heated up.'

'I should have been more measured in how I responded. I know I should. Your Shauna thought I was being totally OTT, but she struck a sensitive nerve.'

'I gathered...I'm sorry. Would you like to talk about it?'

'Not mine to talk about.'

'Zara?'

'Yes. Too recent and painful for me to talk freely yet. Though Zara did suggest that I tell my fellow parents about it, especially those with sons. And I will...in time.'

'I understand. Shauna, she doesn't mean to be, but she can be a bit strident at times and she doesn't always tune in to other people's sensitivities, but she's a good soul. She is really.'

'I don't doubt that. Sometimes the certainty that can go with youth, misses the nuances. Especially after a few drinks...Maybe she'll internalise Zara's and my reactions and realise there was a reason for them, especially given Zara's silence.'

Zara remained quiet the next morning.

My attempts at supportive hugs were shrugged off. Gran also did her best to cheer her up. I knew Zara had talked to Mum about what had happened with Simon Green. Mum had nudged her towards getting counselling from the Rape Crisis Centre and had more success on that front than I'd had. She had been put on a waiting list and, as sod's law would have it, she had been called for counselling while she was off on her placement. A new appointment was set for next week and I felt hopeful.

As she sat at the kitchen table in the cottage, I came up behind her and gently put my hands on her shoulders.

'Zara,' I said.' 'I'd love if you'd join me for a swim before we go to see Stephen. It might get us in a better frame of mind for dealing with whatever comes up...Last time, you know, the visit took the stuffing out of me.'

She turned a pouty face towards me. 'I don't know. I'm not feeling it...And the tide will be out.'

I kept my hands on her shoulders and with my thumbs, I massaged deep below her shoulder blades, the way she used to like.

'I'd love some company, and when the tide's out it's even better, you don't have to wade through the seaweed...' I felt her release some tension and I kept massaging. 'Go on, get your togs on and come down with me...'

'Okay so. I guess you'll not let up unless I go...'

'You know me!'

We swam side-by-side, slipping easily into each other's rhythm, as we had at times before.

'Zara, I could choose not to mention the elephant in the room but…I am sorry about what happened last night. Eamon's sorry too. He caught the vibe that, unfortunately, Shauna missed.'

'Mum, comments like Shauna's are going to happen. I'm going to have to learn to deal with them.'

'I know, and you will learn. In time, I suspect you'll come up with some good, smart retort that will have people think again.'

'But perhaps Shauna has a point. Perhaps, by agreeing to stay over, I implied consent. From where Simon was lying with me beside him, my actions spoke louder than my words.'

'Zara, Zara, that would be to say that every time people get intimate, it amounts to consent to have sex or whatever. That's not right. For goodness' sake, I slept beside your father virtually every night for thirty plus years. That certainly didn't mean that I was consenting to sex every night.'

'I get that but…'

'In a healthy relationship there's much more to being intimate than sex. And respect matters. 'No' means 'no' in any decent relationship. Not whatever you're wanting yourself.'

'Someone should try telling Simon, the green monster, that.'

'You never know, you might tell him yourself someday – it's the sort of thing you can trash out with the counsellor…In the meantime, when you feel angry about what happened, maybe try to direct that anger towards him – where it belongs – not yourself.'

'I was a stupid idiot when it came to him. Alison as good as said that to me last week and she's still disgusted with her Conor, that he didn't get up and defend me when…And where were Conor or Shauna when there's been all the discussions about consent at university?'

'From what Eamon told me, Shauna maybe had other distractions…'

'I did hear…'

'Oh, what?'

'I heard about her sister, Shirley. She lost the plot with drink, drugs, and you name it.'

'Yes, so Eamon said. How'd you hear?'

'Hard not to hear; Shirley made some mega scenes in college after she started taking drugs. Let's say, they're a sort of legend around the place. Her ex-boyfriend got to the point of looking to change unis, until she dropped out and went off to rehab or something…'

'Oh Zara, if she was that bad in public, can you imagine what it was like at home – for everyone – especially Shauna? Shauna was the one who copped what was going on and did something about it.'

'I didn't know that! As you always say, Mum, we all have our own pile of shit – some just hide it better than others.'

# Chapter 32

## Believe Her

After lunch, Zara arrived out to the car showered and looking fresh as a daisy in full sunshine – a welcome contrast to the dark clouds overhead. Her damp hair sat in a loose bundle on top of her head accentuating her clear, bright face. Her eyes were outlined with dark liner and mascara, and her lips were a vibrant red to match a colourful sweatshirt she had rescued from a charity shop. Sea blue trousers hugged her waist and were long and loose – yet again, she carried a charity shop outfit off with striking, relaxed elegance.

'Too much?' she asked as she saw me looking at her.

'Not at all. You look great. You'll bring welcome colour to the place.'

'You'd never think this was a drug rehab place,' Zara said as we stepped out of the car and pulled up the hoods of our raincoats. 'It looks more like a family home with a small farm attached. I could see myself chilling here for a few days, minding the chickens and the polytunnels and all that.'

The outer door was ajar, but the inner one was shut tight, keeping out the driving rain that had started just as we left the cottage. The dull brown porch floor was a puddle deep enough to be best crossed on tippytoes.

'Sligo, just as I remember it,' I said.

I pressed the bell and heard it ring loudly inside. The inner door opened and Stephen appeared. His face looked fuller and healthier than I'd seen him look in forever. I was about to tell him so but Zara jumped in.

'For fuck's sake, Stephen. You're one skinny eejit. You need to get some of Mum's big dinners into you. The state of ye.' She laughed and pulled down the hood of her over-sized, sopping wet jacket and threw her arms around him.

He gave a half-smothered chortle and embraced her back.

'Good to see you too,' Stephen said, stepping back and looking at her. 'The bleeding state of you, yourself. Did you sleep with a giant and steal his jacket, or what?'

'Yeah, something like that – you can still see the blood stains.' She held up the elbow which she'd accidentally dipped into tomato chutney after lunch.

'Older and bolder, but still Zara.'

Tracy, Stephen, Zara and I sat around the same table as at my previous visit, this time with four glasses of water and a box of tissues centre stage.

'I met up with Sadie and she and Susie are only burstin' to see you, Stephen. They say they're happy to come to Sligo.'

'You're not just saying that, Zara? Would they *actually* be happy to see me?'

'Yeah, goodness knows why. But they are. They'd be on the next bus and would hitch the rest of the way if you asked them.'

Stephen's face lit up. 'Really?' He looked from Zara, to me, to Tracy.

We all nodded.

'Fuck it. That's savage. Tracy, when can they come?'

'Would next weekend or the weekend after be possible?' Tracy asked Zara.

'If they can make it happen next weekend, they will. They can tell their parents that they're going to some weekend basketball camp or other.'

I put my hands over my ears. 'What lies children tell their parents, I might be best not knowing!'

'Sadie's twenty and Susie's eighteen – hardly children. And they may well be helping at a basketball camp next weekend. What do I know?!' Zara gave an exaggerated shrug.

'They're still playing basketball? Isn't that great?' Stephen said. 'They were both really good at it…Susie's size might go against her though.'

'She's nearly as tall as me now,' Zara said, wiggling up to her full height. 'And she looks great.'

Stephen's face fell. 'Fuck it. They're all grown up without me.'

Zara linked my arm as we walked towards the car. 'Shit, that was great. It was amazing to see him, the skinny bastard.'

'Zara, he's twice the size of what he was a month or two ago.'

'Really?'

I nodded.

'Jaysus! He's a lot more eating and working out to do yet to get back to the Stephen we knew and loved.'

We sat into the car and clicked on our seat belts and I started the engine. Zara took out her phone.

'Oh, I've a text from Shauna…Ah, that's so sweet of her.' Zara beamed. 'You weren't talking to her, were you?'

'Gosh, no.'

'So, did you tell Eamon about what happened with me and Simon?'

'Truthfully, no. He knew Shauna hit a raw nerve and he was sorry…But I didn't tell him.'

'Not yet anyway...'

'Not yet. I guess I feel you may need more time with it...To process it on your own terms...Or something like that.'

'I've told most of my close girlfriends and some of the lads and like I said, I told Oisín...It's okay with me for you to tell whoever...'

'Thanks. We'll see. Has telling helped?'

'Meh! Sometimes. Some of the girls...They made me feel like I was overreacting, Clare and Anne said that they had similar experiences – but sure, the guys were drunk – what were they to expect? And, they were drunk themselves, so maybe they were giving out mixed messages...' Zara emitted a long self-effacing sigh.

'Zara, you were sober and from what you told me and from what Conor heard, you gave Simon a clear 'no.' And you'd told him previously, no condom meant no sex. No mixed messages there.'

'I guess not. But Mum, isn't there a touch of irony or something that we're here visiting Stephen who ended up on drugs after being accused of attempted rape.'

'That thought did cross my mind...but Stephen and Simon are two very different people. Simon was pretty sober when he attempted to...Stephen doesn't even know what happened, and the evidence Matt and I've heard against him amounts to little more than hearsay from the mouth of Melissa.'

'Say it, Mum. Say it. What did Simon try to do to me?'

I felt my eyes get moist and blurry. I put the indicator on, pulled over on to the side of the road and turned off the engine. I looked at Zara through my tears, chewing the words in my mouth before spitting them out.

'I'm no counsellor or anything but it sounds...it sounds like he attempted to rape you.'

There I've said it, I thought, realising that even in my own head, I hadn't allowed myself to form the phrase. He tried to rape her.

342

Zara's eyes brimmed to overflowing and she bit her lower lip.

'I haven't said that out loud either, Mum. It's hard to admit that a guy I called my boyfriend would do that to me. Fuck him. The bastard. I hate him.' The last three phrases were spat out with venom.

I opened my arms and reached across to her and she crumbled sobbing into my chest. I might have had a hint of relief on my face, relief that she was finally directing some anger in his direction.

'You believe me but what about believing Helen?'

'Yes, I believe you. Of course, I do. You were sober and Alison told you what Conor heard that night…you said, no. And he hit you. There is no ambiguity about it, is there?'

'No. There isn't. Alison could have killed Conor. She said I'd have been better off shouting 'fire', then he might have come to have a look. She said, for an intelligent guy, Conor sure can be thick!'

'I know a few like that!'

'But do you believe Helen?'

'It's not that simple, is it? Amongst all their friends, nobody has ever heard Helen say anything on the subject of what Stephen did or did not do to her. Matt says all accusations have come from Melissa. I'm not saying it didn't happen. I'm saying we'll never know and Stephen, or even Helen, may never know either. And also, let me say something else, from the outset Stephen has shown huge remorse for what *might* have happened—' I stopped myself mid-sentence, realising that what I was going to say was something Zara might not be ready to hear and I changed tack. 'And maybe it's a case of loving the sinner and hating the possible sin.' I said weakly.

'What you were going to say, Mum, is that Simon the shit has shown no remorse whatsoever for what actually happened.'

'Well, yes, that's what I was thinking, but maybe, it's no remorse that we know of…For all that, I'm sick of women excusing men for their bad behaviour, even taking the blame for them. It's bullshit. Our

343

generation were bad but it shocks me that your generation are still doing it.'

'*Hey.* Not all of us.'

'I know, pet. I'm sorry. I guess I thought we would have made more progress in squashing the patriarchy by now.'

Zara's phone pinged again. And she looked at it. 'That first message was Shauna saying that she has cooked some special, vegan almond and pomegranate cake for me to try and now she's wondering if we'll join them for dinner or at least for dessert…I haven't replied yet.'

'Okay. Let's see what Gran says.'

'I'll ring her now.'

Mum was always a peacekeeper. I knew what the answer would be.

'It's all agreed. We're having Gran's vegan curry for dinner followed by Shauna's dessert.'

Back at the cottage, Eamon and Mum were drinking tea at the kitchen table, locked in conversation and laughter. Eamon said he was just bringing Mum up to date on some of the local business people and personal customers she remembered from her Sligo banking days.

'I was asking my mother, and she remembers both your father and mother…' Eamon said to me.

I cleared my throat loudly and stared at him with my eyes deliberately and exaggeratingly wide.

'Sorry. Sorry. Your father and—'

'The woman known unaffectionately as Mother, or Heather the Horrible. Unlike my real and wonderful Mum.' I said, giving Mum a hug and a kiss.

Mum threw Eamon a don't-mind-her look that involved minimal facial movement but that I could spot from a mile. She turned towards Zara with a smile. 'How did you find Stephen?'

'Skinny.'

'And?'

'And fine. In good form. It was lovely to see him.'

'Zara put a smile on his face. He was delighted to see her and he's all excited now at the thought of seeing his sisters.'

Dinner was more relaxed and chattier than I'd dared to hope and afterwards Shauna announced that Zara and she were heading to the pub up the road.

'Maybe we'll join you there,' I said. 'I haven't been yet.'

Mouths wide open and silence were Shauna and Zara's responses.

'I'm joking. I'm ready for a relaxing night in.'

'Best Thai vegan curry ever,' Shauna said. 'Sorry Dad, no competition.'

Mum smiled at her. 'Glad you liked it. I'll send you the recipe on WhatsApp when I get home.'

'Thanks, Cathy, that would be great.'

Shauna and Zara stood up and cleared the dishes off the table and loaded the dishwasher. It was good to see them comfortable together again.

'Girls, girls, when you're done there, would you walk me across the yard to the cottage and then off with you to the pub. I'm going to have an early night. I'm looking forward to some more sightseeing tomorrow.'

'Are you sure, Mum? I can go over with you now,' I said.

'No thank you. I'm going to enjoy some peace for a while. No hurry on you. I've to ring Fergal, assuming he's back from the pub. And then I'm going to read and sleep, a peaceful, snore-free sleep…Bliss.'

Eamon and I had the house to ourselves.

# Chapter 33

## A Home for Stephen

Two months later, Stephen left the centre in Sligo and moved to a step-up facility near Dublin.

The program was designed to step him into an independent life, drug-free and away from people who might lead him astray. He got a job in a franchised grocery shop in the city centre earning minimum wage. Within three months, he had been given managerial duties, for which he got paid one whole euro an hour extra. He was practically running the shop a couple of months later – still on minimum wage plus one miserable euro per hour – living wage it was not.

'Talk about taking advantage.' I said to Matt one night.

'More like taking the piss! I bet they'd give him an increase if he said he was leaving. But he won't. 'I'm lucky to have a job,' he says.'

'There's his self-esteem issues again. Look how grateful he always was for every little thing we did for him. And all we did was include him in the daily ups and downs of our homelife. Do you remember the way he'd insist on doing more than his fair share of post meal clean-up?'

'Yeah. It was great. We loved him all the more for it…Like we were saying before, his folks were always putting him down and not so much as a 'thank you' or a 'well done' for all he did.'

'It came up in one of the sessions with Tracy. At home he was the son who was never good enough. Outside of the house, he was popular with his mates and a hero on the pitch. But he never believed he deserved to be popular…subconsciously, he lived in fear of being found out. Impostor Syndrome with a capital 'I'; I know it well.'

Matt looked at me quizzically. 'You know it well, Mum?'

'Yes, believe it or not, I spent years feeling like an imposter, but I wasn't able to name it. I always felt unworthy, back when Mrs O'Reilly used to look out for me. And Mrs Connolly in boarding school…I lived in fear that someone would tell them what I was really like and that would be the end of that.'

Matt stood up and got himself a fresh glass of water from the fridge, a signal that he was about to change the subject as he sometimes did when I brought up something he wasn't up for talking about.

He stood at the kitchen sink gazing out across the kitchen table to the garden.

'Stephen's time in the stepdown facility is due to finish in a few months. He was hoping to rent a room somewhere, you know. But how will he find anywhere he can afford between town, here and beyond. He'll never find anywhere affordable that's handy enough that he can keep up GAA training and his job.'

'You know yourself, Matt. On your good salary, you can't find a place. It's looking like you'll be stuck living at home with your mammy until you get to choosing a nursing home for me!'

'I might have to put you there sooner rather than later, for your own safety like…Hmm, I've noticed some signs of early onset dementia lately: talking to yourself, forgetting stuff, calling me Chuckie—'

'Careful now or I'll kick you out on your ear and leave everything to the cats' and dogs' home!'

'Seriously though Mum, I'm here saving like mad for the down payment on a house but I'm no closer now than I was six months ago with the way house prices are rising.'

Matt didn't mention that his girlfriend was saving hard too. The sense of urgency to get a place outside of home had increased since he had broken up with Sophie in Canada and taken up with Anne-Marie, who lived less than a ten minutes cycle away from us – ten minutes for Matt – fifteen probably for me.

He had met her on that weekend with his mates in Galway and it had taken a couple of weeks before she was revealed to me, and he had admitted that she had gone with him to Sligo and had a walk on Second Beach in Rosses Point while he visited Stephen. They were young yet. I was surprised that they wanted to be tied down by a mortgage, but Matt wanted out and he hated the thought of handing over rent, especially given how ridiculously high rents were. Patrick's and my finances were back on a strong footing as I held the lease for the building from which he practiced and it was now fully let to three other tenants too. I was willing to help with Matt's deposit but he had to get himself some of the way.

The conversation with Matt got me thinking. There was an unfinished room in our back garden. It was plumbed and wired as a small studio apartment with a minute kitchen and shower room. Zara had got excited when she first saw it, visualising it as her own future home. She had been following some small home sites on Instagram and often showed me various miracles of compact living. But there was a reason that the garden room was unfinished. The previous owners of our house had run into planning problems with the neighbours who had got up in arms at the possibility that the garden room might be used as a mini home.

'You're a granny now, Mum. Maybe we can get planning to make it a home under the granny-flat rules and Stephen can live there?' Zara

said to me when she heard that Stephen's time in the step-up facility was running out. 'They *have* to give planning permission now, what with all the thousands of people homeless in Dublin.'

'Zara, you know from all your environmental campaigning that the county councils or the government don't do joined-up thinking. It's not going to happen. You guys can help me clear it out and I can put in sitting-room furniture, make the bathroom fully functioning and add some basic kitchen appliances too. But there will be no proper bed and no regular all-nighters. No way am I facing into another pro-tracted and expensive planning battle after the cost and hassle with the tiny bike storage unit I put in the front garden of our last house.'

'But Mum, it almost made you famous after the newspapers and RTÉ got wind of it.'

'Yeah, right! Where were your eco-warriors when Dublin City Council were spending millions on a cycle lane at the end of our road and at the same time rejecting my application for planning permission for a small bike storage unit for our terraced house? It wasn't much taller than the grass that grew around it while we waited for the appeal to go through with An Bord Pleanála. Between architect and planning fees that whole fiasco cost us over €3,000? And you can more than double that when you take into account the initial cost of hard land-scaping and the bike storage unit itself. And after all that, An Bord Pleanála still turned us down despite their own inspector recommend-ing otherwise. So, no. We will not be putting Stephen to live in the garden room and then wait for the neighbours to get a planning en-forcement notice against me.'

'Still a touchy subject, so...' Zara teased. 'But we can't have Ste-phen homeless or he'll end up back on drugs, or worse, dead, sure as eggs are eggs.'

'Sure as eggs are potentially baby chickens, from how you see things...Anyway, I was thinking that garden room could be a den for

you all, which means that the TV room you currently use could be a bedroom for him.'

Zara threw her arms around me. 'I knew you'd think of something, Mum.'

'It won't be all plain sailing, Zara. We'll do our best but it is up to him at the end of the day. The words 'relapse is part of recovery' keeps ringing in my ears, and we'd better be prepared...'

'Don't be so negative, Mum, he'll be grand. He has his meetings, and Dave, who knows how to handle him...I believe in him. And Oisín does too.'

I smiled. 'Oisín and he hit it off once they discovered that they both support Liverpool. Poor Matt, left shouting alone for Chelsea. I may have to join him yet!'

I knew from a philosophical perspective, there was no merit in comparison but I couldn't help myself: I enjoyed having Oisín around, whereas I'd always dreaded seeing Simon. Between counselling and having Oisín in her life, Zara was happier than I've ever known her to be. She even forgave Oisín for eating meat, obsessively following Liverpool and being a general sports fiend.

When the lads were here at the dinner table together, there were times when it was back to the days of us women struggling to get a word in edgeways. Zara and I were learning to hold our own better and were even known to call the occasional halt to the endless football dissection and analysis. When Eamon was around, he could subtly change the conversation from sport to food or politics or some other more general interest subject. Zara and I tended to take the more direct approach.

By the time Stephen moved in with us, Chucky and I had taken to spending ten or so days of the month in Sligo, and Eamon and Harry usually stayed in Dublin with me for a week or more a month.

When in Dublin, Eamon had plenty to keep him busy, in particular, meeting Shirley and Shauna and other family and friends. Sometimes I joined him, often, I didn't. We gave each other both intimacy and space, and that worked for both of us. It allowed me time to do my own thing, including some granny duties. When baby Pearl was with Eamon and me, he helped feed, cuddle and burp her and was, generally speaking, a part-time grandad to her the same way Fergal had been a grandad to our children. More times when we were minding her, he cooked dinner and I did all those glorious giggly things with her that included tickling, endless peep-po, Seesaw Margery Daw – which I suspected was no longer PC in Fiona's books – and any other game that allowed me to hold and cuddle her with impunity.

Being a granny, especially when a parent wasn't around, allowed me to indulge my inner child, one that had been well suppressed in my actual childhood and I treasured all the more for that. While I could never relive my own childhood, being a parent of little children had allowed me to feel the sense of childhood innocence that I had missed out on as I child. Being a granny, I treasured this with even deeper presence, free of the shackles of self-doubt that had sometimes held me back when my own children were young. When Pearl fell asleep in my arms, I was reluctant to part with her, reluctant to put her warm, soft, breathing body down in her cot, but Fiona had me on orders, thankfully less strict ones than she'd first mentioned.

Life was good. I felt happy. I knew it wouldn't last but I told myself I'd weather whatever life threw at me.

Shauna and Zara had become good friends and I'd been intrigued to observe Shauna's reaction when she'd met Stephen. I'd sensed a sexual attraction between them but doubted myself because I'd sensed the same with her towards Zara. But then the flirting started in earnest: the touching, the fluttering eyelashes, the teasing…and there was no denying it.

'Is there anything between Stephen and Shauna?' I asked Zara one day.

'Not yet. But if Shauna has her way, there will be!'

'I suspect he's terrified – not of Shauna. Although…I hope it doesn't get messy.'

'Don't worry. It won't.'

'Hmm…Anyway, I thought she fancied women. Is she bisexual?'

'Mum! We don't need to put a label on everyone! She identifies as queer. Does that help?'

I thought for a moment and shook my head. 'No. Not really. Back in the day, 'queer' was a derogatory term. Grandad used to say, them queers this…them queers that…and we'd yell at him for saying it.'

Zara gave me the de rigueur dismissive raised eyebrows.

I responded in kind. 'So, what exactly does 'queer' mean these days?'

More eyebrow exercises followed. 'Not straight – not fitting neatly into the binary heterosexual definitions you were raised with. It covers a multitude, as you would say.'

I can handle that, I thought. I always thought many of us were bisexual but we just had a clear preference for one sex but I'd recently wondered if maybe it was that we were socially programmed that way.

'Maybe we're all a bit queer so.' I said with a small laugh.

Zara's hands went straight up in the air and she threw back her head feigning total exasperation, but I saw the smile on her face as she headed out the door to her afternoon practical.

# Chapter 34

## Fear

I headed to the Dart station to visit Seán and see how his garden was maturing in the months since the gardener had finished planting. Within weeks of our meeting in the park, when I'd told him about Eamon, he'd phoned me to tell me he'd asked another one of Jackie's friends out. I'd met her a couple of times and liked her. I was relieved for me and happy for him and he said he was happy for me too.

Patrick was a different matter.

Louisa was still on the scene and he'd turned up with her when he went to visit Fiona in hospital after Pearl was born. Fiona rang me afterwards.

'What made that woman – a total stranger – think I wanted to see her the day after tearing myself apart giving birth? I don't know what Dad sees in her…'

'How is Pearl doing? Is she feeding well?' I responded.

'She is wonderful. She's so quiet most of the time, I've to keep checking she's alive.'

Patrick had history of hanging out with the occasional cow. Myself excluded, of course. When I first met him, he had recently broken up with Emer whom he had only by chance found out had got pregnant with someone else while still going out with him. And then there was the affair with our so-called friend, Isabel – the affair that triggered the

end of our marriage. Looking back on it, I'd be surprised if there hadn't been other affairs along the way.

I noticed that in all Fiona's rants, she never once mentioned her father's part in Louisa turning up with him at the hospital. There'd been more anti-Louisa ranting when Zara and I went to see her in hospital that evening.

'Can you believe that Foxrock fanny came to visit me in hospital? She gave me a voucher for a massage or treatment or whatever for a place somewhere near where she lives…When does she think I'll have time to go all the way over there for goodness' sake?'

I was standing looking down at the miracle of a beautiful newborn baby. My heart melted looking at her. I didn't want to talk about Louisa when something so divine, as my first grandchild, was lying in a little bassinette under my eyes. I touched her soft face with my freshly washed finger. I quietly cleared my throat.

'Maybe it's somewhere that gives good massages, and she thinks you'll be glad of it when you do get a chance. Maybe Pearl's Granny will happily mind her and you'll head off for a massage…Maybe…She's beautiful, isn't she?' I touched Pearl's cheek again. 'You're a wee pet. Aren't you?'

'She is amazing.' Fiona sighed. 'How did Daniel and I produce something so perfect? He's besotted. He'll be a great dad. He just left to go and get some work done so he'll be free to collect me tomorrow.' Fiona sunk back into the pile of pillows behind her and looked momentarily calm and happy and I smiled to see her that way.

Then she sat up straight again as an afterthought hit her. 'But, Mum, don't you go defending Louisa. Yesterday, she talked non-stop about her pregnancies and went into graphic detail about both births by caesarean section; a classic case of too posh to push, I'd say, she might have burst her Botox face. And poor Dad couldn't get a word in edgeways.'

Giving birth didn't seem to have eased Fiona's hormonal venom as I'd hoped it might. I felt sorry for her having to suffer Louisa instead of enjoying the attention of her father, but I couldn't help smiling. Patrick not getting a word in, that would be something to behold. I gazed lovingly at baby Pearl swaddled in a pretty green and white blanket which Daniel's mum had crocheted for her. She squirmed and wiggled like a caterpillar trying to break out of its cocoon.

'She's awake, the pet. May I hold her?' I asked, my hands twitching. 'Go on so.'

I sat down in the armchair set back against the wall and inhaled the scent of my perfect little grandchild: a head of dark hair, Daniel's blue eyes – aren't all babies born with blue eyes? Will they stay blue? She had Fiona's square face, and little pursed lips which became less pursed as she released tiny bursts of wind. What's not to love about a newborn baby? Most of all, the smell of her head: a scent that invites your heart to fill with love. I hugged her close, marvelling at the size and perfection of her.

Zara sat down on the side of the bed, and I expected Fiona to tell her to get a chair.

'I don't care much for Louisa either,' she said in a conspiratorial tone. 'What is Dad doing bringing her everywhere with him? He did the same when I was meeting him for dinner last week. I'm going to tell him straight: when I want to meet him, I want to meet him alone.'

'Well, you can tell him the same from me. And if he wants to see the baby and me, he's not to always have her tagging along.'

'Hah! I wonder how he'll react to that. I've started to realise that he's used to suiting himself…We mightn't see much of him for a while.'

'I don't think he's like that. He's softer than you think. It's *her*. It's Louisa. She's her sights set on him and she isn't going to let go easily. Women of that age aren't spoiled for choice, you know…'

Fiona glanced my way after she said the last sentence but I pretended to be oblivious and continued to hum the nursery rhyme, *The Wheels on the Bus* to Pearl. An expression of great exertion came over Pearl's little face, *the baby on the bus goes wah, wah wah! Wah, wah, wah...*Pearl's expression switched to one of calm relief. *The mummy on the bus went ssh, ssh, ssh, ssh, ssh, ssh* as I lifted her tiny nappy-clad bum up to my nose and sniffed.

'This little one needs a change,' I said somewhat triumphantly. 'Shall I do it? I can do it at the side of your bed if you want to show me how you like it done?' I added, remembering that when it came to baby, Fiona was boss.

When Daniel was at home on parental leave with Fiona and Pearl, I hightailed it to Sligo. I told Eamon about the Louisa situation and Zara and Fiona's response to her.

'I'd better keep a low profile so,' he said.

'Ah, you're safe enough. She likes you now. She didn't like Louisa when she first met her, and she still doesn't like her!'

'She likes me *now*! You mean she didn't like me before?' Eamon held his hands out with his face set in mock horror.

'You remember the first time you met her?'

'Will I ever forget? I'm still in therapy!'

We had been sitting in perfect harmony one Sunday morning, eating breakfast and reading the papers with both dogs at our feet. Matt was gone training and Zara wasn't due home until lunchtime. In Fiona walked...

'Hi Mum,' she called from the hall as she headed towards the kitchen. 'I had a walk on the prom and I thought I'd see if you – oh! I didn't know *you'd* be here.'

Unusually for Harry, he started barking.

'Stop, Harry, stop. Good boy,' Eamon said patting Harry on the head.

'Eamon, Fiona. Fiona, this is Eamon from Sligo. I told you about him, remember?'

After Mum, Zara and I got back from Sligo, I'd phoned her specifically to tell her about Eamon.

Her responses to what I said were monosyllabic and she finished the call with an abrupt utterance of 'I need to pee.'

I found out later that she then phoned first Zara and then Mum to find out what this Eamon person was like. I'd gathered that she didn't get much change out of either of them other than to say that they both really liked him.

'You're that man Mum met at the Criminal Courts, aren't you?'

'Guilty as charged,' Eamon responded. 'We were on the same jury and then Martha happened to book my place in Sligo and—'

'So I heard,' Fiona said as she waddled over, checked the kettle for water and flicked the switch.

I pulled out a chair at the table. 'Sit down there and I'll make you tea. Do you want anything with it?'

Fiona shook her head and lowered her bottom slowly towards the chair, careful not to land too fast and burst the large, taught bubble that had once been *her* belly but was now fully occupied by a growing baby floating in its amniotic fluid.

'Would you like a stool to put your feet up on, Fiona?' I said, aware of myself clucking like a mother hen.

'I'll get it,' Eamon said, jumping up as if his bottom had just been scorched.

'Thank you,' princess Fiona said, without looking up at him but focussing on taking off her shoes before settling her feet on the footstool.

I put a mug of raspberry tea down on the table in front of her. She moved her eyes in Eamon's direction.

'I won't stay long,' she said.

He shifted in his seat and gave a small cough. 'I think I'll head off now. I've to pick up a few things before I meet Shauna and Shirley for lunch.' He stood up and lifted his breakfast things and mine over to the dishwasher. 'Nice to meet you, Fiona. All the best with things over the next few months or so.'

Fiona nodded. 'Thanks.'

I followed him into the hall.

'So much for a relaxing Sunday morning. She's not normally like this. Honest.' I sighed. 'But ever since she was a few months' pregnant…She's a pet really. Honestly, pregnancy doesn't become her.'

He kissed me on the cheek. 'In fairness, Martha, she didn't expect to see me here and she might have felt in need of some mammy-time.'

'Agh, that's no excuse. I've been dancing around her for months. I should have spoken up sooner…'

'Don't, Martha. Not on my account anyway.'

'I'll see.'

I sat down opposite Fiona at the table and said nothing, thinking I'd wait and see if she'd manage an apology without my prompting. I waited. And waited.

'So, is he going to be here often?'

I opened my mouth and shut it again and imagined steam coming out my ears. 'He might be. And he'll be welcome when he is.'

'I see.'

I ground my teeth hard and resolved to speak calmy. 'Fiona, this is my home and you are welcome here…And I know it might be hard for you to accept but Eamon is important to me and all I ask is that you treat him with normal good manners, especially in my own house.'

Fiona's pout remained unchanged.

'Actually, no. I also ask that unless there is an emergency or something, that you text or ring to say you are calling, or at least, ring the doorbell when you arrive unexpectedly.'

Still no reaction.

'Fiona, I'm trying to be reasonable. We're all adults. I have a key for your house, but I wouldn't dream of walking in unannounced.'

'I get it. I'm welcome as long as I abide by your house rules.'

'You have your rules, or as you call them, boundaries. I realise I need a few boundaries too…so we can all get on better. You know what I mean.'

I made to put my hand on hers but she pulled away. I winched and felt tears building up. I got up from the table and went and looked out the window.

'Maybe, Fiona,' I continued. 'Think about what I am saying, and if you think I'm being unreasonable, let's talk about it…I want you to know that while you may have never lived here, I think of this as the family home and of course, you as my much-loved daughter, are always welcome. But, please, given where we're all at in our lives, let's not presume to walk in on each other. Okay?'

Behind me I heard a half-smothered whimper and I turned to see tears streaming down Fiona's face. 'I'm going to make a terrible mother. I am, you know…I'm always struggling to keep on top of things at work and at home…and that's before I even have a baby to look after.'

I sat down beside her and opened my arms and reached for her, wet sniffles hugged tight to my breast. 'Ah Fiona, we all felt like that when we were pregnant. Believe me, I thought I'd be a terrible mother too. Especially given the role model I'd had. But look at you, you're wonderful and you've a lovely husband – so I can't have been too bad, can I?'

'No, you weren't. You were great,' she said between sniffs.

'Thanks. It means a lot to me to hear you say that.' I hugged her again. 'When you were born, I made up my mind to stop aiming for perfection and I had to remind myself of that every time I looked at the layer of dust on the furniture or the un-hoovered carpets....'

She whimpered some more and wet eyes looked up at me.

'My housekeeping standards slipped with each child...I was saved from complete implosion by something as simple as getting a cleaner...'

'But how will I cope with work, the house and the baby? I'm completely overwhelmed already,' she said through small sobs.

'Lower your standards. I heard a psychologist say that we should aim not to be the *best* but to be *good enough*, especially as a mother! If we strive for perfection, all we're doing is striving, which isn't much fun for anyone, including our children – and of course, aiming for perfection is setting ourselves up for failure – because perfection doesn't exist!'

Fiona's dyslexia and dyspraxia, especially when she was young, meant she had to work much harder than others in order to keep up. She'd found ways around many of her difficulties but she was still trying to prove to herself that she was as good as everyone else and to do this, she was always aiming for perfection. Nothing I ever said seemed to convince her that she was already better than most by a mile.

'What's 'good enough' as a mother? How will I know I'm good enough?' She sniffled.

I laughed. 'Unfortunately, there will be no annual appraisal, reassuring you that you're doing well. You'll have to try not to anticipate a rubber stamp of approval. It won't come. Focus on giving the child food, water, comfort and the sense of being loved and wanted. Hug them. Ignore the un-ironed clothes, the dust, the fingerprints on the glass doors...'

'That doesn't sound at all easy.'

'Easier than you might think when you've a beautiful baby. I was besotted with you, as you will be with your baby. You'll stop noticing the bits of grass on the stairs, the crooked pictures on the wall; I was often too tired to notice! And most importantly, at your gran's insistence, I got *help*, I got a cleaner. Oh, believe me, I still had moments where I'd have a manic urge to put everything right, and I still got those mad urges all the way up until recently, when I worked harder at my self-awareness and started HRT.'

Fiona's face cracked a smile. 'I've seen you in action more times than I want to remember. When that urge hit, you'd go into overdrive and we'd run the other way or you'd be yelling at us to do this or do that…But I'm not you, Mum. I don't think I can do it.'

'Fiona, I didn't think I could either. But I did, most of the time, and with help. And on those days when you think you can't, you can call me, just like I used to ring your gran. And sometimes I will come over and give you a break and take baby for a while. Or I will do a mad burst of housework for you. Other days, I might be in Sligo or elsewhere and I will tell you to feed the baby and go and lie down on the couch or in bed, with or without baby in your arms depending where they will sleep for you.'

'But you hate housework…'

'I do. I prefer to cook. But I will do it for you occasionally…and I will insist that you get a cleaner.'

'The occasional meal would be nice.'

'That too. And Gran has more than a few meals in her freezer which she made for you for when baby is born. I think she's hoping for the title, G. G. What do you think?'

'Ah Great Gran…She's all that already. I should see more of her.' And the sobbing started again but we smiled together knowing that G. G. would embrace her new title with the gusto of a fairy godmother.

# Chapter 35

## GAA and Relationships

Stephen had re-joined the GAA club within a few weeks of moving into the step-up facility. At Stephen's request, Matt had spoken to some of the coaches about Stephen's drug journey and, with one exception, he felt there was strong support for Stephen re-joining and playing. Matt was playing for the Seniors and Stephen joined a pretty decent Junior squad with a clear objective of sharpening up his rusty skills and becoming match fit. His coach, Paul, was a recovering alcoholic himself and while he hadn't known Stephen previously, he told Matt he'd be delighted to try him in his squad and do what he could to support him. He hadn't anticipated Stephen's impressive natural ability and all-round fitness.

'I can't, in all fairness to the competition, justify keeping you on my team for much longer. Much and all as I'd like to…I'll have a word with the Intermediate team coach…' he said to Stephen after a few months.

Matt sighed with exasperation when he heard but wasn't surprised when Mike, the Intermediate team coach, refused to take on a recovering addict, especially one fresh out of rehab. But Paul told Matt that he wouldn't let it go without speaking again to Mike which he'd subsequently told Matt he thought went a bit better:

'Do you know what, Mike? Come next season, Stephen will be good enough for the Seniors and right now, you can choose to take this golden opportunity to have him on your intermediate team. More importantly, you can choose to take the opportunity to play your part in giving a young man a second chance...He could be your son, or with my history, he might be mine! This club gave me a second chance and without it, I'm pretty certain, I'd be back on the booze. He's doing everything he's supposed to do. He's attending all his meetings. He's not looking for a mentor – he has one of those already – all I ask is that you come see him play, talk to him and then, if you still don't want him on your team, that's your prerogative.'

Matt told me that after this conversation, Mike turned up at Stephen's next match and afterwards, with a nod to Paul, he spoke to Stephen and asked him to join the Inters.

'Sorry, Mike and thank you. But I'll have to talk to Paul. I don't want to let him or the team down. He's been amazing to me,' Stephen said was how he had responded to Mike.

Stephen also applied to go back to university and start in third year in Sports Science; he was waiting to hear back. He'd been reading up on the benefits of mindfulness in sports performance and athletes' mental health. Paul had agreed to let him try it with the Juniors the following season and this was another reason for his reluctance to move teams.

'I'm not sure I'm ready for the Inters,' he told Matt. 'My kicking accuracy is way off what it used to be...I'm certain that they don't need me...Their current forwards have what it takes so I'll hardly get any match play unless someone's injured...And I don't know any of them and they all know each other since they started school which means they're well in the habit of passing to each other!'

'Fuck off, Stephen. Stop talking yourself out of it and putting yourself down. I know some of those lads and they're sound, and you'd outplay most of them and they'll recognise that too.'

'That's bull, Matt. You know them, and you know I'm going to struggle.'

'Enough already. Yah, yah, yah. You're getting boring. BIG YAWN, Stephen!' Matt gave an exaggerated yawn. 'Trust me you're up for it. Now, what was that you were saying about the power of mindfulness and positive thinking…'

'Haha. Yeah, I still want to try it with the Juniors, if possible, and Paul says he knows some of the profs and he thinks doing something like that might help my case getting back into college.'

'Well, start practicing positive thinking on yourself already. If Paul says he'll do something, he'll do it. He said he'd ask Mike to take you on to the Inters and he did that, didn't he?'

'Paul or Mike never told me that…'

'Stephen, that's Paul and Mike for you! Play your part.'

I was sitting on the couch half-reading the paper when this conversation took place in between them wolving their way through a dish of lasagne large enough to feed a normal family of six. Stephen turned to me.

'What do you think, Martha?'

'Think of what?'

'Should I move to the Inters?'

'If you don't, you might be a long time waiting for another chance. Mike doesn't sound like the sort to ask twice. But…'

'But?'

'Mind you don't overdo things. You're already chasing your tail: working long hours, attending your meetings, making training, making your matches, eating like a horse, talking to your mentor. Doing

mindfulness or meditation with the team is a great idea, but I agree with Matt, don't forget to leave time to practice it yourself.'

Matt dropped his voice a notch and talked behind his hand. 'Listen to Mum, Stephen. Don't tell her I told you, but she's usually right about these things!' Matt glanced my way and winked.

A week later, there was just Stephen and me sitting at the table after dinner.

'You know the way Shauna seems to want to…you know, go out with me?'

'Yes, I've noticed.'

'She thinks we might be good together…'

I grimaced but tried to hide it. Shauna and Stephen didn't seem like a good idea for Stephen right then, nor possibly for me. Too complicated and potentially too messy.

'I heard wind of something like that,' I said.

'Well, would I be setting myself up for trouble do you think? I mean Shauna's great. I really like her. But I don't want to dig myself into another deep hole. I'm scared I'll mess it up again.'

I thought of Shauna's opinions on consent as expressed that night in Sligo. Passion killer or not, Stephen was going to need clear consent to feel comfortable. Perhaps Shauna's views had shifted somewhat since she'd heard Zara's story, and Stephen's.

'Like I said last week, Stephen, you've a lot going on already. Have you talked to Shauna about that and also about how you feel, given everything?'

'No, do you think I should? Might it not be jumping the gun a bit?'

'She knows your story but I think she needs to know how that makes you feel…and all the things you have going on.'

'Martha, you know, I was never any good at talking to girls. That's what got me into trouble in the first place…'

'Ah Stephen, go easy on yourself. You're better than you think. I've seen you chat to Zara and Shauna plenty. And to your sisters. Stephen, be yourself. Start by telling her straight out that you feel like you're no good at having conversations with girls.'

'Yeah. Maybe since all that counselling and group therapy, I might be better than I used to be.'

'I bet you are…But…I have some other concerns.'

'Sure.'

'Two things really. Firstly, like I said, you already have a very busy life what with work, your meetings, sport, and so on. Do you think maybe you should be careful that you're not taking on too much too soon? It seems like an awful lot to be doing already.'

'Yeah. When you put it like that…'

'How are you coping, as it is? I mean you're doing fine here with us, but have you any spare time? Time that you see yourself sharing with Shauna?'

He rubbed the back of his head with his hand, feeling the tight freshly cut hair. 'Spare time, Martha. What's that?'

'Indeed! Maybe consider that…And…' I paused, knowing I was about to thread on risky ground. 'And I'm nervous on a different front…There is the small matter of Shauna being Eamon's daughter and Eamon being my…' I paused again because I'd so far managed to avoid giving Eamon a title '— partner. Eamon is my partner…and he stays here regularly…and you live here…This is your home for as long as you need it to be…What I'm trying to say, Stephen, is, for all our sakes, take things slowly and have a conversation with Shauna up-front about all the reasons that you need to thread carefully and why, no matter what happens, you don't want to fall out with her…'

Stephen sighed a long and forlorn sigh. 'Matt warned me you'd be painfully honest and that I may not like what you had to say, but he said I should ask anyway…You're right, I'm already flat-out and I

don't want my football or the possibility of college to suffer just when I'm trying to get back into them.'

'Sure, look at Matt and his girlfriend, Ann-Marie. GAA is no ordinary unpaid sport as you know. Ann-Marie's finding it hard to accept all Matt's GAA commitments, especially now he's physio for a couple of the teams. It's not easy. Tennis at my level operates completely differently – Eamon and I play when it suits us and he seems happy to play mixed-doubles with me despite me not being as good as he is...I'm not telling you what to do. A relationship with Shauna might be great for you. I'm just saying be careful you don't end up totally overwhelmed by commitments and promises.'

Feck it, I kept thinking as I spoke, Stephen might give Shauna a version of what I was saying and she might hear it as me saying, whatever you do, don't have a relationship with Shauna.

I felt a backlash coming on no matter what I said.

# Chapter 36

## Helen

Matt's friend, Orla, heard that Helen was coming home from Australia and was going to meet with lawyers to look into taking a case against Stephen.

By the time Orla told Matt, she had traced the rumour back to Mouthy Melissa. Matt didn't know what to do. He didn't want to tell Stephen. He hoped it would never be more than a rumour and that Stephen wouldn't hear about it. Stephen had lost contact with all their old friends so there was good reason to hope that he wouldn't hear.

'He barely has time to wipe his ass,' Matt observed as he stood half-watching me chop up the onions, garlic and vegetables for a spicy mushroom, nuts and greens vegan stir-fry. 'Never mind having time to be online seeing what rumours are circulating…' He walked from the counter to the window and back again, tapping the palm of his hands off his thighs in agitation. 'And how can he defend himself when he doesn't remember anything? Being out of his head is no excuse in the eyes of the law…Mum, he'll be thrown into the Midlands Prison alongside all the paedophiles, rapists and the proper scum…'

I paused my slicing and waved the knife in his direction. 'Slow down Matt, you have him tried, and found guilty when there's every possibility it will never go to trial.'

Matt raised his hands between him and the point of my threatening knife. I put it down on the chopping board and looked at his stricken face.

'Mum, watch that MeToo space. Emotion will get in the way of reason. And people convicted of sex offences *can't* go to mainstream prison, because the other prisoners would eat them for breakfast. I read about a case last week where a young fella got four years for sexual assault and oral rape of a teenage girl a year or two older than him. She was older than him, do you hear me? It happened three years ago, back when he was fifteen – fucking fifteen! There may have been some drink but there was no violence, the judge herself said there was no evidence of violence but still she gave him four years even though he and all his mates said that the so-called victim initiated it. How many fifteen-year-olds who think they're being offered oral sex go seeking explicit consent, for God's sake? She claimed he initiated it. Now he's barely turned eighteen and is in the Midlands Prison with the low life of Ireland – once you're found guilty of being a sex offender, you're a sex offender in the eyes of the law and it's on your record for God knows how long. What jobs could Stephen do if he got found guilty? Nothing. Because he'd never get Garda clearance.'

I stood still, my mouth agog, willing myself to find no truth in what he was saying.

I thought back to an article I'd read about a rape case when our children were teenagers and I was trying to stay tuned in to what might be the new norm. According to my memory, a teenage girl had decided that the time had come for her to give her first blowjob or two and catch up with her friends' experiences on that score. In a posh park on the Southside, where a large, loose group of teenagers were hanging out and drinking, word got out and she had gone down on a number of guys. Somewhere in a bush in the park, a blowjob had led to sex which had ultimately led to a rape case, the result of which I could not

remember. The phrase 'do you gargle, spit or swallow' had stayed with me from that article and I had struggled to imagine how blowjobs seemed to have become more common than French-kissing had been in my day.

'Mum?'

'Sorry, Matt. I was getting my head around what you're telling me. Are you saying that a now eighteen-year-old who had non-violent, oral sex when he was fifteen with a sixteen-year-old, which he says was instigated by her and she says was against her consent has been found guilty by judge and jury and has been put in an adult prison? The same prison that those thugs from the court case last week were sent to, the ones who kidnapped and viciously gang-raped another young woman?'

'I'm saying just that.'

'Holy shit. What state will that eighteen-year-old be in when he comes out? If he comes out. Surely a young person who commits such a crime should be sent to Oberstown and given every chance at rehab, not full exposure to the sexual predators of the country. And I wonder how the young woman is dealing with it too? Wouldn't you think there would be some opportunity for restorative justice for such young people?'

'We can't let it happen to Stephen, Mum. We can't.'

'We won't let it happen to Stephen.'

I picked up my knife and put the sharp edge of it through a peeled onion with force. The knife hit the wooden chopping board repeatedly with violent vigour as I chopped the onion. I turned my attention to the peeled garlic cloves and put the flat of the knife on each one and punched down hard dispersing bits of garlic way beyond the edge of the chopping board.

I cursed silently.

'I'll talk to Patrick and he'll get us a barrister who knows about these things. I'll find out what the real chance is of a case being taken…Why would Helen want to put herself through such a case anyway, particularly given the he said/she said scenario and that they were both out of it circumstances? MeToo or not. I mean why would she?'

'Do ask Dad and soon. Helen can't possibly prove anything wrong happened. But I fear it's getting to the stage that fellas are guilty until proven innocent.'

'The pendulum may be marginally in danger of swinging slightly in the opposite direction to how it swung in the past. For too long, it was horribly anti the victims which mainly meant anti-women! And, yes, emotion can get in the way of people hearing the truth regardless of how obvious it might seem…And, for all that, Matt?'

'Yes.'

'Let's not say anything to Zara or Stephen…not yet anyway. Okay?'

Patrick's well-respected barrister friend, who had acted for the defence and for the prosecution in a number of rape cases, said he'd meet me when his current case was over. He was acting for a defendant in a drugs case that was expected to last for at least three more weeks. The defendant's surname was far better known than the barrister's and I wondered how he could defend the indefensible. But when I thought some more about it, I realised that others might ask the same question if he was to end up defending Stephen: innocent until proven guilty is supposed to apply to everyone, not only to those we care about.

Matt met Orla for a drink and a chat but she knew nothing more than before. He also reached out to his old friend, James – my brother's and father's namesake – whom he hadn't seen in a couple of years, but James had heard nothing.

Matt and I went around the house mostly in states of agitation. We talked in hushed tones, stopping when anyone entered the room. When Stephen told me that he had told Shauna that he would love to have a relationship with her but couldn't because he had too much on his plate, I may have mumbled, 'That's great,' or something like that. I know I didn't register any great relief.

Throughout it all, baby Pearl provided my most welcome distraction and whenever I was around her, I wilfully and happily gave her my undivided attention.

My other welcome diversion was to take off to Eamon's in Sligo where I could better pretend to myself that there was nothing to worry about.

I swam, I walked, I played doubles tennis with Eamon, and singles with Margaret as we had done over recent months. Robyn's name occasionally came up in conversation, but thankfully, Jim's never did. I promised Margaret that I would meet Robyn once an issue with a close friend of mine was sorted, which might not be for a while.

Throughout it all, Eamon was tolerant and understanding of my mixed moods in a way that deepened my sense of oneness with him. He seemed to know when to speak and when to say nothing; when to touch me reassuringly and when to let me be. For me, it had always been, the deeper the mental intimacy, the more sensual the love-making, and in the midst of this time of heightened concern for Stephen, Eamon and I made tender, passionate love that brought surprising comfort and joy to the very core of my being.

I loved my visits to Sligo and found myself going with increasing frequency. I'd a long weekend planned there at the height of the tension over whether Helen might take a case. Eamon texted me on the Thursday night as I was packing my small bag:

**Martha, I'm sorry but Shauna arrived down unexpectedly this evening. She's in terrible form but won't say specifically why. I**

**think it would be best if perhaps you don't come down tomorrow. I hope you understand. Xx E**

Shit, I thought. Here comes the fallout. Dammed if I'd said nothing to Stephen about Shauna and probably dammed now because I did. Eamon knew the gist of the conversation I'd had with Stephen but had said very little. I'd been looking forward to the escape and especially to the break from being chief cook and bottle-washer in our household in Dublin. Not to mention the break from Matt fretting over the Helen-Stephen situation. Where might all this land me? Shauna was one strident woman and not one to be messed with. Stephen was better off without her but if Eamon had to choose between her and me…

**Hi Eamon, sorry to hear that. I understand, of course. Let me know how it goes. I suspect I'm not her favourite person at the moment. Xx**

I spent Friday deep cleaning the kitchen. Then I moved to cleaning the main bathroom but didn't get far before I found myself sitting in the shower, Windolene and cloth in hand, looking at the streaked glass and saying, fuck it, fuck it, before spraying the entire glass side panel with Windolene while sniffing loudly.

Zara walked in with a towel around her, ready for a shower.

She looked at me rubbing ferociously at the glass. 'It's Matt's week to clean the bathroom,' she said.

'Yes, I know. I took a notion, got in the mood for cleaning or something.' I stood up and stepped out of the shower. 'All yours.'

'Are you crying, Mum?' Zara said, bending her head sideways and peering into my face.

'No, I'm fine. I got Windolene in my eyes. You know what I'm like.' I dabbed my eyes with the cloth.

'Weren't you supposed to be in Sligo this weekend?'

'Yeah, but Shauna went down and Eamon thought it best if I didn't…'

'She's pissed off with you alright. Not one bit happy that you told Stephen not to go out with her.'

'That's not what I said to Stephen. That's not it at all. Ask him. He'll tell you. I left him to decide for himself.'

'But you may have put it a certain way…'

'Well, I do think he's too much on his plate already and I admit, I don't think it would be wise for him to start a relationship so soon out of rehab and—'

'Well, you're in deep doodah with Shauna.'

'I suspected as much but what was I to do?'

'Say nothing. Let them work it out for themselves.'

'And how might that end?'

'I don't know but at least it would be their problem and not yours…'

'Ah Zara, I wish it was that simple…Nothing's that straightforward…Anyway, I'm going to order takeaway. And open a bottle of wine. Want to join me after your shower?'

'Sure, but I'll have a beer. And I'm heading out in about an hour or so.'

I felt a lonely night-in coming on and visualised a dark film with just me and Chuckie on the couch. But as it happened a few of Zara's friends called while she was in the shower and I was ordering takeaway. I fed and watered them and they lifted me out of my feeling sorry for myself state before they headed out on the town for the night.

Saturday came and went with no word from Eamon. My glumness returned with a vengeance. I reached for my phone endlessly and jumped when it finally rang at 9:00 p.m. It wasn't Eamon. It was Mum inviting me over for lunch with Fergal and her the next day. I accepted with gratitude and a warning that I'd be lousy company.

I decided that maybe Eamon had drafted a message to me and just forgotten to hit send so I texted him again:

**Hi Eamon, I wanted to let you know that I miss you, I love you and I hope things are going okay with Shauna. xx**

It was Sunday evening before he phoned me.

'Sorry Martha, I didn't get a chance to call you sooner. Shauna was fairly full-on and I'd guests in the cottage and the boiler went there and…'

'Sure, you were busy. Too busy to even send a text.' This wasn't what I'd planned to say but it's what came to me in the moment.

'Martha, I didn't know what I might have said in a text to you, given the situation…'

'Eamon, we were supposed to spend the weekend together. You cancelled because Shauna decided to visit which I accept was possibly a good enough reason…But you don't know what you might have said in a text? You couldn't find a suitable response to my text on Saturday that said that I miss you, I love you? I can think of lots of short and sweet possible answers.'

'Well, I'm sorry but none came to me when I was in the throes of the weekend.'

'Did you try to think of a suitable response? Did you not think I deserved one?'

'I was trying to convince Shauna that it wasn't your fault that Stephen had too much on his plate to start a relationship with her, or anyone. And that I was fairly certain from what you had told me, that you hadn't told him not to have a relationship with her…But would it, Martha, would it really have been that bad if they'd given it a shot and worked it out for themselves?'

'Eamon, have you any idea how vulnerable Stephen is at this time? Do you understand how much he has taken on? And that he's only

fresh out of rehab? Not to mention how messy it might have been for us.'

'Maybe we have to allow them to make their own mistakes.'

'That's one very oversimplified view of it. Stephen is recovering from the fallout of making his own mistakes with the possibility hanging over him of more dark consequences to follow. He's living in my care. We're providing him with stability and support. And you think I should have just stood back and said nothing?'

'I think you're being way too hard on me there, Martha. I'm not unaware of all that but they are adults and—'

'And, was your Shirley not an adult too when she made a few mistakes? And you stood back and—'

'Hold on a minute, Martha. That's unfair. This is different. Very different.'

'How different? We're on different pages here, Eamon. It's probably best if we ended this conversation now. I'm feeling triggered by you not taking the time to send a simple response to my text. I don't think it was too much to expect after all the conversations we've had. I wasn't asking to come between you and Shauna. I just think…it doesn't matter. Let's leave it for now.'

My voice faded into tears and I hung up. I put my phone in the drawer in the Kitchen and went to bed.

I tried reading a book but it was useless. Then I tried the newspapers but decided that the weekend lead article about drug addiction was more than I could bear. I dug out my old sim-less phone from the drawer of my bedside locker and put on a YouTube interview with Gabor Maté where he talked about compassionate enquiry. I'd heard the interview before and had found it consoling as it was again on my second hearing.

Eamon had triggered my old insecurities and I knew that. I also knew that I had come to rely on him to not let me down, to be there

for me and I was happy to be there for him. But not to send me a text, I interpreted as rejection. How was it not rejection? Was it acceptable that he had given all his attention to his daughter? Or did he feel driven to do so because he felt that he'd not been there for his daughters in the past when they needed him? Were we both trying to make up for our past shortcomings? I decided to sleep on it.

When I retrieved my phone from the kitchen drawer a text had arrived:

I'm sorry Martha. You're right. I should have sent you a text. It is the very least you deserved. And yes I did miss you. And I do love you. It seems I've learned little from all the fallout with Shirley. I reverted to form and went back to avoiding confrontation with no consideration for how my silence would come across to you. I am truly sorry. I could come up on Tuesday and take you out to dinner if you'd like? And we can talk about things. And agree to disagree, or not. But mostly I hope we can agree to move on together and work on getting over this bump in the road. You mean too much to me to want to lose you. And I hope that you understand that there will be times when I will put my daughters before us. I've a lot of making up to do. Just let me know if dinner suits and I'll book somewhere. XX

I replied:

I'm sorry too. I didn't react well on the phone. Perhaps you and Zara are both right and I should have said less. Dinner on Tuesday would be good. I really miss you and love you. xx

Dinner that Tuesday evening was difficult. We agreed that Eamon needed to have a conversation with Shauna, just as I had needed to have a conversation or two with Fiona to help her accept Eamon's role in my life.

Eamon's first attempt at talking to Shauna about us didn't go well. But then Shirley stepped in and told Shauna to cop herself on that she'd a queue of willing decent suitors, and that dating Stephen would

be unnecessarily complicated and result in her losing a friend rather than gaining a boyfriend. She told her to let Stephen find his feet and be grateful that Eamon and Martha have each other; she even said that we are well suited, probably better matched than Eamon and their mother had been, and wasn't I so kind and understanding about Shirley and her struggles? And Stephen and his, just as Shauna had been so good and supportive to her when she'd been struggling.

Eamon heard some of this from Shauna and some from Shirley, each with their own slant on it.

As I drove home from Sligo the following Sunday evening, the nearer I got to home, the more the thought of a rape case being taken against Stephen filled my mind.

I wondered for the umpteenth time why Helen would consider doing that to herself. How could she remember enough even to think of taking a case? How would she separate what actually happened from what Melissa said had happened? Once Stephen found out, what might he do? One possibility screamed at me.

Stop thinking like that, Martha. Stop it. No good comes of worrying about what might happen.

I arrived on our road and was about to turn into our driveway but there was a small blue Hyundai parked beside Matt's Golf, leaving no room for my own Golf.

'Feck it,' I said to Chucky. 'Somebody has let someone park in the driveway, knowing that I was due home!'

I had no choice but to park across the driveway as there were no other available spaces nearby. I was like a bag of cats when I stomped into the kitchen where Matt was sitting at the table with a young woman.

'Mum, you're home. How was your weekend?' He clapped his thigh and reached out his hand to call Chuckie over for a pat.

'Fine but I can't park—'

'Do you remember Orla, Mum?' Matt said looking from me to the petite brunette who looked up at me with earnest eyes.

'Orla. Yes, of course. Sorry. I'm a bit out of sorts. I recognise you now.' I dropped the food bag I'd been carrying onto the counter.

'Hi Mrs— Sorry Matt said you've changed your name. I don't know what to call you.'

'Call me Martha. I'm not old enough yet to be Mrs!' I reached out my hand to her outstretched one and we shook hands warmly. 'Nice to see you again,' I said, looking at a number of beer cans and the remains of an Indian takeaway which had been eaten straight from the delivery boxes.

'I ordered enough for you too, Mum. It's on a plate in the oven and there's wine in the fridge too.'

'Thank you. That's kind of you.'

'Let me sort it. Orla, tell Mum why you're here.'

I looked from Matt to Orla sensing good news rather than bad and pulled out a chair and sat down.

'Helen found me on Instagram and got in touch out of the blue yesterday. We've had a long chat.'

'Oh!'

'Yes, she's very happy in Australia and is getting married at Christmas to a wonderful Frenchman, whom she met there. They plan to settle in Australia for now and then maybe move to France.'

'That's good news,' I said, thinking those didn't sound like the plans of someone about to embark on a rape case.

'She thanked Orla for trying to look out for her when the shit hit the fan and she said she's sorry she turned her back on her...and on the rest of us.'

Matt put a large glass of wine into my hand and put the bottle down in front of me with the label turned so I could see it was my

favourite Gewürzt. I mouthed thanks and looked at Orla, with a smile and a nod to will her to continue.

'She said back then she was really struggling because she couldn't work out what was going on or what had or hadn't happened. It took her a long time, long after she went to Australia, to realise that Melissa had controlled the narrative, made it all about her, like she got off on the attention it gave her to be at the centre of the drama…At the party, Helen admitted she'd taken enough drink and drugs to be beyond knowing what had actually happened and this terrified her. She had never done that before and the next day, she messaged Melissa to see if she could shed some light on the situation. Melissa decided that she knew what had happened and went on to claim that Stephen had bragged about it—'

'You know Stephen, Mum, he never bragged about anything. Not that. Nothing. Ever. As Orla said earlier, Melissa is a toxic bitch. Always has been.'

I nodded and so did Orla.

'She's proper dangerous with it. Helen found it impossible for a long time to tell Melissa that she wasn't sure if anything had happened, or if it had, if she had consented, or if either Stephen or she had been fit to know if either had consented. When she did eventually pluck up the courage to say it, in a long message, Melissa got angry with her. She called to her house and screamed at her that she couldn't let Stephen get away with it. She told her other stories about things that Stephen was supposed to have done to other girls. At the time Helen believed her or else suppressed any doubts that she felt about those stories.'

'Holy shit,' I said. 'What a bitch. Poor Stephen. Poor, poor Stephen…But why is Helen telling you this now?'

'When Marc proposed to her, she felt she couldn't say 'yes' until she went for counselling and dealt with whatever it was that had been

holding her back all these years. As part of dealing with it, she got in touch with Melissa and confronted her but Melissa told her she should be confronting Stephen, not her – confronting him in court, she said, nothing else would get her peace, she said. Through talking to Marc and her counsellor, Helen's gut told her that Melissa was sticking to her narrative, not because it was true, but because it suited Melissa's own agenda. Helen decided to call a few of our old friends, including me, to see what we had to say. We all said the same thing: Melissa is a dangerous bitch. Stephen is and was a decent skin and hadn't done any of the things Melissa had said he did as far as any of us knew and we reckoned we'd have heard, if he had. The others couldn't give Helen any update on Stephen. She'd known he'd taken to drugs and she told me she knew now that it was her fault for being a coward and not speaking up. 'How can I ever undo the damage I've done?' she said. I heard her crying as she said it. I told her he is alive and doing well living with you guys. She had feared it was too late and that he was long dead from drugs or a fight over drug debt or something...'

'He could be dead if fate hadn't stepped in, what with Dave and rehab and all that,' I said, feeling a mixture of anger and relief as I stuck my fork at the potatoes in my saag aloo.

'And you, Martha. If you hadn't stepped in, he could be in the bottom of the canal by now.'

'And for what? Because neither Melissa or Helen could bring them-selves to tell what they knew of the truth. Why did Helen let Melissa walk all over her? Why is Melissa so twisted to want to hurt Stephen of all people? I guess it's because Melissa's some class of a manipulative narcissist – a dangerous breed, don't I know.'

'I think you're right on that front, Mum,' said Matt, rubbing my arm in acknowledgement of my insights into narcissism.

'I know it may seem like it's in the past but the hurt and damage is in the now. Even if we do our best this time, we don't know how it

will end…I hope…I really hope Stephen comes out the other side of this and stays clean and strong.' My voice rose with fear and passion as I spoke.

'Mum he will. I know he will because you inspire him to be strong. He told me so only yesterday.'

'I hope that between us all, we will be enough to give him the wherewithal to be stronger than the forces that might pull him down. I really do hope so. Nothing is certain.'

*Acknowledgements*

The biggest fear I have with acknowledgements is that I'll leave some-one important out and if I do, I apologise; it doesn't mean that I don't value you.

This book was years in the making and many people and events inspired it. To all my friends and family who have come through sig-nificant struggles and remained wholehearted, I salute you. To those who encourage and support others, know that what you do matters. I am lucky and grateful to have such people in my life, both amongst my family and friends.

A big thank you in particular to Pauline Brennan, Fiona Tierney, Eimear Shanahan and Suzanne O'Connell for their ongoing encour-agement that has kept me writing.

Thank you to Jess Jordan, my editor at Vulpine for all your great work with the edits and to Sarah Hembrow also at Vulpine, for all your wonderful enthusiasm and support.

Last but not least, thank you to my husband, Brian for all our shared experiences. Long may we be there for each other and enjoy the journey together, not least with the four amazing young adults we somehow created. And again, apologies for any teasing that you get in being compared to Patrick!

After thirty years as a reluctant accountant, Vanessa retired from figures to focus on writing and over the last seven years has taken part in writing workshops at Bantry Literary Festivals, The Irish Writers Centre and The Big Smoke Writing Factory.

When not escaping to West Cork or further afield, the author lives in Clontarf with her husband and two of their four children – two have flown the nest – their Greek dog, Kanella – rescued by their youngest daughter – and their cat, named, Cat.

Find her on Twitter @VanessaPearse1

Milton Keynes UK
Ingram Content Group UK Ltd.
UKHW022346270924
448939UK00003B/50